PEOPLE AT HOME
Living in a Warwickshire Village, 1500-1800

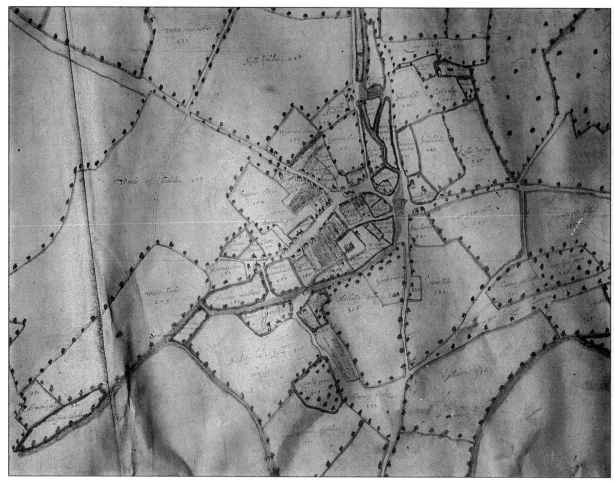

Section of the map of the Stoneleigh Abbey Estate made by John Goodwin, 'Practitioner in the mathematic', in 1597, showing Stoneleigh village. This map sheet still hangs at Stoneleigh Abbey.

PEOPLE AT HOME
Living in a Warwickshire Village, 1500-1800

N. W. Alcock

Phillimore

1993

Published by
PHILLIMORE & CO. LTD.
Shopwyke Manor Barn, Chichester, Sussex

ISBN 0 85033 863 8

Printed and bound in Great Britain by
THE BATH PRESS

Dedication

This book is dedicated to the people of Stoneleigh, known and unknown. Their records drawn up day by day and year by year, their carpentry, their thatching and masonry, were honest and serviceable for the moment, and enduring for the centuries.

It shall be inventoried and every particle and utensil labelled to my will as:
Item two lips indifferent red
Item two gray eyes with lids to them
Item one neck, one chin

Twelfth Night, Act I, Scene 5

Contents

List of Illustrations

Frontispiece: Stoneleigh village in 1597

List of Inventory Texts

Acknowledgements

I could never have carried out this study without help from many others. For the opportunity to study the houses and cottages of Stoneleigh, I am especially grateful to their owners and occupiers who have let me measure, draw and photograph on innumerable occasions. I hope they find a reward in the pictures I have drawn of their homes in their historical context. Generations of students working in Open Studies classes have made the original documents accessible in transcripts and card indexes. They are regrettably too numerous to mention individually, but without them the work would have been impossibly protracted. Before her early death, Peggy Ford abstracted and correlated the parish registers of Stoneleigh and Ashow, providing invaluable background evidence. Dr Pat Hughes has kindly prepared the remarkable cut-away reconstructions in Part IV, a task requiring an exceptional combination of artistic and historical skill.

Both the late and the present Lord Leigh have encouraged this work and allowed full access to the records of the Stoneleigh estate, including those retained at the Abbey. Permission to reproduce texts and photographs of documents from these records has kindly been given by the Trustees of the Stoneleigh Abbey Preservation Trust. Dr R. Bearman, archivist of the Shakespeare Birthplace Trust, Stratford-on-Avon, has these archives in his charge; he has been unstinting in his assistance. The photocopies and transcripts of inventories and the indexes are now deposited there. The Shakespeare Birthplace Trust has also generously underwritten a substantial part of the publication cost. The archivist and staff of the Lichfield Joint Record Office have made it easy and pleasant to work on their probate records. I would like to thank all these, as well as the many others who have provided suggestions and advice.

N. W. ALCOCK

Preface

A book about a single village is often no more than parochial piety—the celebration of happenings and history of purely local interest—but occasionally villages and their stories are of greater significance. No village can ever truly be called typical, though Stoneleigh is similar to many others in Warwickshire (and the Midlands as a whole).* However, the chances of history have singled it out in ways that give a unique insight into the community and its life.

Although I have passed through the village of Stoneleigh almost every day for 20 years and enjoyed its vista of timber, brick, thatch and tile, the realisation came only slowly that this glimpse of a past world was incomplete, showing the shell alone, but lacking the people who lived in the houses, their farms, their furnishings, their life.

The first steps in learning about Stoneleigh and its people, which eventually led to a fuller picture, were taken in 1970, when a group of extra-mural students surveyed most of the buildings in the village; this work was in due course published and is still one of the few studies of timber-framed building techniques in the Midlands, though the deficiencies of its limitation to one village are more apparent now than they were in 1973. The exploration of the historical background was also undertaken by extra-mural students, working on the estate records and the wills and inventories of the people of the parish. A small book recorded some of our discoveries.[1]

It was only as this work went slowly on that the far-reaching possibilities of the Stoneleigh evidence began to appear. Its astonishing combination of an excellent and varied group of historic buildings, of outstanding probate records, and of comprehensive estate documents allows us to take the picture of village life in past centuries far beyond the simple framework of building history, of furnishing patterns, or of manor court presentments. At the same time, the challenge presented by the material carries problems with it, in its bulk, in the methodology for its analysis, and especially in its presentation. I discarded the initially attractive idea of a source book of annotated probate inventories and building plans, because this seemed to evade the responsibility to understand and explore the implications of the evidence. Equally, though, no amount of quantitative analysis can take the place of real examples. No two inventories are quite identical and ultimately their individuality defeats abstraction. The present volume therefore includes about 50 inventory texts and half this number of building descriptions. These are included in separate 'house-boxes', to distinguish the architectural details from their social interpretation. They provide brief descriptions, noting significant structural and decorative features, aiming to give some feel for the character of the house and its decoration, and to explain how the existing form relates to the original structure.

In the heart of the book (Part II) real buildings and specific probate inventories reveal the lifestyle of individuals, from the early 16th century when medieval traditions were still strong,

* This book speaks throughout of <u>Stoneleigh</u> and <u>the parish</u>, but in reality its scope is somewhat wider. The small parish of Ashow adjoins the south-west side of the much larger Stoneleigh parish. It has been in the same ownership as Stoneleigh for almost all of the last 800 years, and within the Leigh Estate was administered with the various hamlets of Stoneleigh parish. For the most part Ashow is therefore included silently with Stoneleigh.

up to the later 18th century. It is divided both chronologically and by house size. This has been preferred to a division by status or wealth, because it is the size of the house that constrains the the life within it; the analysis shows that in the 17th and 18th centuries (but not the 16th century) house size and social status were closely linked. Each chapter establishes the pattern of rooms listed in the inventories, and then compares and matches this with existing houses. Finally, the life lived within these rooms is examined from the evidence of their contents.

Not all correlations of inventories and buildings are straightforward, and the discussion highlights some of the problems encountered. The reader should not conclude either that building or inventories are useless, as has sometimes been suggested, but rather that both may contain characteristic defects. These usually involve the omission of rooms, whether by passing them over silently, or through their demolition. However, when their respective biases are borne in mind, both are true witnesses to village lifestyles.

Part I sets the scene, with a description of the parish and its history, and an outline of the evidence for reconstructing life within it. In Part III this evidence is used to examine aspects of life in Stoneleigh for which vignettes drawn from individual documents are inadequate, and the analysis needs to be more quantitative. This section deals especially with the patterns of farming, occupation and wealth. The final chapter places our view of Stoneleigh in a wider perspective; it attempts to confirm the validity of the picture drawn in Part II, by correcting for the inevitable bias in the documentary record and the incomplete survival of historic buildings. It also contrasts the houses in Stoneleigh with those elsewhere in Warwickshire and further afield. Finally, the character of life in a handful of typical Stoneleigh houses is recreated visually in a sequence of drawings.

In one respect the Stoneleigh villagers remain hidden from us, in their beliefs and mental attitudes. The manor court rolls can distinguish a quarrelsome farmer from his more placid neighbours. The selection and arrangement of household goods occasionally gives hints of austere gatherings in the parlours (p.148), while the preambles to one or two wills seem to reflect religious views held more strongly than usual. The Quarter Sessions records mention a small Non-conformist meeting in Ashow in 1669, and another in Stoneleigh in 1685, while in 1683 a dozen people were presented for not attending church. Such beliefs may also underlie the absence of rather more burial entries from the parish registers than might be expected by chance. Beyond these hints, the inner life in Stoneleigh can only be guessed at.

The picture drawn in the following chapters shows the community in Stoneleigh steadily adding to their material comfort, improving their farming practices and from time to time renewing their buildings. Can its calmness and cloudlessness be a true reflection of their life? Were there no disasters, no plague, no famine, no destruction of war? The answer seems broadly to be that life was calm. The influenza epidemic in 1558 led to about four times the number of deaths expected for that year, but in 1665 the plague side-stepped the village. In the Civil War, Sir Thomas Leigh was strong on the Royalist side; the King more than once visited Stoneleigh, and Parliamentary troopers on one occasion broke into divine service 'to the great affrightment of the people'. The armies skirmishing around Coventry passed through the parish and several inhabitants sought recompense for the damage they caused.[2] Yet as a whole these problems caused no discernable interruptions in the progress of domestic improvement in Stoneleigh.

1. *Stoneleigh Houses* and *Stoneleigh Villagers.*
2. Philip Tennant, *Edgehill and Beyond* (Alan Sutton) 1992, p.70.

Abbreviations

Ag. Hist.	J. Thirsk (ed.) *Agrarian History of England and Wales, Vol. IV: 1500-1640*, Cambridge, 1967 and *Vol. V: 1640-1750*, Cambridge, 1985.
Banbury Inventories	E. R. C. Brinkworth and J. S. W. Gibson (eds.), *Banbury Wills and Inventories: Part one, 1591-1620; Part two, 1621-1650*, Banbury Historical Society, vols 13-14, 1976, 1985.
CRO	Coventry City Record Office.
Gloucestershire Inventories	J. S. Moore (ed.), *The Goods and Chattels of our Forefathers*, Phillimore, 1976.
Leger Book	R. H. Hilton (ed.), *The Stoneleigh Leger Book*, Dugdale Soc. *24*, 1960.
Lich.	Probate records at Lichfield Joint Record Office (cited by name and year).
Manor	Stoneleigh manorial records (cited by date); SBT.DR18/30/24.
Map	Maps of Stoneleigh, Stareton and Ashow (cited by date); for references, see p. 14.
Oxfordshire Inventories	M. A. Havinden, *Household and farm inventories in Oxfordshire, 1550-1590*, H.M.S.O. (1966) (cited by inventory number).
Q.S.	*Warwickshire County Records: Quarter Sessions Order Books*, 9 vols, 1935-64.
PRO	Public Record Office.
Reg.	Stoneleigh or Ashow parish registers and Bishops' transcripts; for references, see p. 15.
SBT	Shakespeare Birthplace Record Office, Stratford-on-Avon.
Stoneleigh Houses	N. W. Alcock, J. G. Braithwaite, M. W. Jeffs, 'Timber-framed buildings in Warwickshire: Stoneleigh village', *Birmingham Archaeological Soc. Trans.*, 85 (1971-3), 178-202 (off-prints distributed under the title *Stoneleigh Houses*).
Stoneleigh Villagers	N. W. Alcock, *Stoneleigh Villagers*, University of Warwick, 1975.
Telford Inventories	B.Trinder and J. Cox, *Yeomen and Colliers in Telford*, Phillimore, 1980.
VCH	Victoria County History: Warwickshire, vol. IV unless otherwise stated.
WRO	Warwickshire County Record Office.

Note: Historic currency and land area units are used throughout for consistency with documentary sources; £1 = 20 shillings(s); 1s = 12 pence(d). 1 acre(ac) (0.405 hectare) = 4 rods (r); 1 rod = 40 perches (p).

Part I

Chapter 1

Introduction

John Rushe [holds] a cottage which was the tithe barn and a yarde 4s.

[SBT.DR18/30/24/161; 1570 rental]

Houses are silent witnesses to history. The cottage in Stoneleigh, Warwickshire, 9 Birmingham Road (Figure 1) is a two-bay house of poorly-preserved timber-framing with a later brick extension. Its structure suggests that a 16th-century date is more likely than the 17th century, but beyond that its historical significance appears very limited. It lacks any indications that might identify the social standing of its inhabitants or reveal their lifestyles. It is not even well-enough preserved to make a good architectural example.[1]

Probate inventories are second only to standing houses as evidence for building history, but they are far from silent. They deafen us with their strident chatter: here a court cupboard, there a silver spoon; this is the kiln-house, that, the matted chamber. Although they are precisely dated and often include the status of the deceased householder, individually they too lack historical context. Groups of inventories can be used more effectively, showing the range of wealth, numbers of rooms, ownership of clocks or pewter bowls.[2] However, such studies suffer through

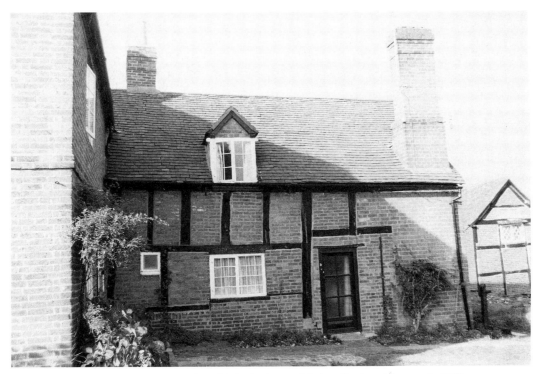

1 *9 Birmingham Road, Stoneleigh, the home of Robert Stocken, labourer, in 1630.*

ignorance of the relationship between the inventories and the community as a whole. Do they record 1, 10 or 60 per cent of households, and how similar were the remainder?

In Stoneleigh and Ashow[3] we have the opportunity to give tongues to houses and to force inventories into orderly declamation, by uniting the extraordinarily rich evidence from these villages. Beyond the individual buildings and documents we can reveal how a community of English villagers organised their lives, how within the same timber-frame as their parents, they could rearrange their rooms and possessions to suit changing lifestyles.

A detailed map and survey of the Stoneleigh Abbey estate in 1597 (Frontispiece) includes the house later known as 9 Birmingham Road; it and its half-acre croft were in the tenure of Robert Stocken. A sequence of rentals shows that he had succeeded Joan, widow of John Rushe, and that the conversion of this cottage from the tithe barn noted in the rentals took place in 1569. Robert Stocken continues as tenant in later rentals, until his death in 1630. We can therefore link the will and inventory of Robert Stocken of Stoneleigh, labourer, with this house, demonstrating the lowly social status and wealth (just £9) of its tenant. The inventory lists just three rooms, corresponding to those in the standing building:

Hall	living room and kitchen, with the only fire
Parlour	'wher they lye' Robert and his wife's beds
Chamber over the lodging parlour	an old bed and miscellaneous furnishings, probably used by any of his four children who were at home

Later estate records show that the holding was greatly enlarged after 1735, so that by the late 18th century it had become a 100-acre farm. The house had been correspondingly enlarged with a substantial brick block and the original cottage was merely a back wing. This change was atypical for village holdings, which were more often reduced to cottages with their land added to holdings outside the village. Indeed, in the 19th century this happened to 9 Birmingham Road, and the 18th-century farm became three cottages.

Winding together these three strands of evidence, buildings, probate and estate records, strengthens them all. The houses are re-furnished and re-occupied; the rooms in the probate inventories acquire walls, doors and windows; the skeletal list of names in the estate rentals become real people. Their thoughts and mental attitudes still escape us, but their every-day realities of life, the comforts and discomforts of their homes, the muck in their yard and the corn in their fields can truly be recaptured.

Physical Space and Social Space

The standing buildings and room-by-room inventories for Stoneleigh provide an unparalleled source for understanding lifestyles, but their interpretation is not always straightforward. For a building, this has to start with a close examination of the structure, to establish the date of first construction and the original plan. Architectural researchers have too often ignored alterations in the quest for the primary form, but these are equally part of the house's history and need also to be understood. Its decorative details are also important, giving realism to the occupants' physical surroundings.

Identifying the functions of a building's rooms from the evidence of its structure is more difficult, even if the plan is of a standard regional type.[4] The main heated room can usually be identified from its large fireplace, or in a house of medieval origin from the soot-blackening of the roof timbers. This was normally the 'Hall', the traditional name for an all-purpose living and cooking room (as recorded in probate inventories and other sources). A larger house might have a second hearth in a less prominent position (an end room or wing perhaps), taken to be the kitchen. Beyond this, the building's structure and fittings give hardly any clues to the functions of its other rooms. In Gloucestershire, many attics have the remnants of distinctive racks for cheese;[5] despite the considerable evidence for 'cheese rooms' in Stoneleigh (p.57), no racks have survived. Many former dairies have 'thralls', stone slabs for keeping butter and milk cool, but these seem to be 19th-century in date. From modern habits we might expect service rooms

downstairs, sleeping and storage upstairs, but only the first assumption is generally true in the 17th century. From necessity, the study of buildings in isolation has to emphasise structural interpretation and typology and the comparison of plans—physical space rather than room function. We can observe such developments as the insertion of upper floors, but not understand their social implications.

The names in a room-by-room inventory seem altogether more straightforward. For example, the inventory of Thomas Casemore, yeoman (1684) lists some living and working rooms (Hall, Kitchen), some for service and storage (Buttry, Dary House, Cheese Chamber) and some sleeping rooms (Parlar, Little Parlar, Chamber over Parlar). The analysis and comparison of such sets of names gives a view of the space available and its organisation. We can correlate this with social status, and (in Stoneleigh at least) with the size of land-holding.

This simple analysis leaves questions unanswered. Do we really understand what these room names mean? Was a hall or chamber the same sort of room in 1550 as in 1720? Did everyone use their hall in the same way? Fortunately, loooking more deeply at the probate inventories helps us solve these problems, by extending our analysis to the contents listed for each room. Some of the answers are well known. In an 18th-century farmhouse, the hall was not the simple passage we know it as today, though equally it was not used in the same way by the 18th-century yeoman as by his 16th-century predecessor. The transformation of the parlour from a sleeping room to a living and entertaining room was a slow process, advancing differently at different social levels (and in different parts of the country).[6] Chambers were often for storage as well as for sleeping, and their names sometimes reveal this specialisation: the Apple Chamber, or the Cheese Chamber. However, a cheese rack could appear in another chamber—sometimes even sharing it with a bed. We can only hope they were not simultaneously occupied too often.

Probate inventories appear as ideal tools to answer these classic questions of the social use of space, and they have often been used in this way, though not for the extended period possible from the Stoneleigh evidence.[7] However, the house we see in an inventory description is physically one-dimensional (apart from the occasional 'chamber over the parlour'), and located in a temporal vacuum. It could have been put up the week before its occupant died, and been demolished as soon as the inventory was completed. In reality, life within the house is constrained by its physical structure. We can examine this to a limited extent from sequences of inventories for the same house, but far more effectively by correlating the inventories with the building itself. This has occasionally been attempted for individual houses, but in Stoneleigh we can bring inventories and houses together to an unequalled extent, and reunite their social and physical space. We can see how in one house the 16th-century kitchen became the buttery and then the parlour, within the framework of a three-bay late medieval husbandman's house (p.42), how in another what should apparently have been the hall, was in reality the kitchen, becoming the dining room 150 years later (p.156).

The House and the Inventory

The matching of inventories and houses may not be automatic or even simple, and the possibility of alternative interpretations needs to be remembered. Clues gleaned from the structure are important, particularly in placing upper rooms. The order in which rooms were enumerated is presumably that taken by the appraisers working their way through the house, and any acceptable matching should produce a plausible itinerary. It is fascinating sometimes to see the sequence of rooms interrupted by a listing of linens or other goods, and realise that they have lifted the lid of the chest just noted, and are enumerating its contents.

Matching inventories is generally most successful with smaller houses which obviously provide fewer alternatives. Several surviving houses clearly no longer contain as many rooms as are listed in their inventories; indeed, both the addition of service rooms to houses and their later removal were characteristic developments in Stoneleigh (p.55). The opposite problem is rarer but more disturbing, the listing of fewer rooms than we see in the structure, even though a full range of household goods is included in appropriate locations. We have to accept that some of the

rooms had not been used by the deceased. Socially the house was smaller than it appears physically. The inventory illustrates (say) a three-room rather than a five-room house. Whether the other two rooms were unused or were occupied by relatives or lodgers is not significant for the interpretation of the inventory. In one case we can establish that the house was shared between a widow and her son-in-law (p.54). Fortunately for the understanding of the buildings and inventories, such arrangements were rare in Stoneleigh.

Generally, discrepancies between pairs of inventories (of husband and wife, or of successive tenants) are common but minor, the inclusion or exclusion of one or two service rooms for example. Such discrepancies might arise from oversights by the assessors, but seem more often to relate to small changes in use in the house, say, with one rather than another room as the buttery or the dairy.

Tradition and Innovation: Old and New Fashion

The reflection of changing lifestyles in room names and uses shows only half the picture. Many changes were probably superficial, perhaps no more than the shuffling of household goods from one room to another. Gradually, though, new living arrangements would carry with them a need for different furnishings—a second table in the hall, or a set of chairs in the parlour. At the same time new styles might replace old, joined furniture or Delftware instead of trestle tables and pewter. Probate inventories provide essentially the only evidence for the changing social habits of ordinary people.[8] These changes are very difficult to follow in detail. We have only vague ideas of what household goods reflect new fashions most clearly; ideally, every object in each inventory should be examined and the description correlated with date, wealth, and the owner's status. The task is extremely tedious to perform for any group of inventories large enough to provide meaningful information; the 400 Stoneleigh inventories must enumerate 50-100,000 items. Some studies have applied hand-tabulation, marking different types of furnishings on forms; this is fairly effective at revealing the pattern of living (showing beds and chests in one type of room, tables and fire irons in another), but sacrifices fine detail to the general pattern. So far, the application of computers has also involved pre-coding the information, with the same result. It seems that the linguistic or lexicographical tools still have to be developed by which a computer could use the full original descriptions to identify and classify the objects in a document as complex as a probate inventory.

For the present study, fashion and innovation have been followed through impressions, rather than statistical analysis. Some feeling for changing lifestyles comes from the appearance of a few types of household goods which seem to reflect fashion most clearly, such as clocks and mirrors, and the disappearance of others, e.g. 'painted cloths'. The direct comparison between sets of inventory texts for the same house throws into relief the changes taking place throughout the house. They provide the clearest view of Stoneleigh people making the choices among different lifestyles—following or ignoring fashion—constrained by poverty or with their wealth providing an opportunity for display.

Notes
1. In the first study of timber-framed houses in Stoneleigh, it was included only in an appendix of houses containing fragments of timber-framing (*Stoneleigh Houses*, p.201).
2. L. Weatherill, *Consumer Behaviour and Material Culture in Britain: 1660-1760*, Routledge, 1988. U. Priestley and P. J. Corfield, 'Rooms and room use in Norwich housing, 1580-1730', *Post-medieval Archaeol.* 16 (1982), 93-123.
3. See footnote, p.xv.
4. Rarely the case in Stoneleigh, where the houses have exceptionally varied forms.
5. L. J. Hall, *The Rural Houses of North Avon and South Gloucestershire, 1400-1720,* Bristol, 1983.
6. As an example, the use of the parlour for living was much more frequent in 17th-century Cornwall than in Warwickshire. V. Chesher, personal communication.
7. Priestly and Corfield, 'Norwich housing'; E. S. Cook, 'Domestic space in the Federal-period inventories of Salem merchants', *Essex Institute Historical Collections*, 116 (1980), 248-263.
8. For the gentry, diaries and household accounts can add to the picture. Weatherill, *Consumer Behaviour*, p.4.

Chapter 2

The Place

This and the following chapter describe the parishes of Stoneleigh and Ashow, and the evidence for their study. It sets the scene for the detail of Part II. The two parishes (Figure 2) stretch around the south-west quarter of the city of Coventry, extending some 7½ miles (12 km.) south-east to north-west, with a greatest width of 3½ miles (5 km.). The river Avon and its tributary the Sowe run through their southern end, while the northern part is drained by the smaller Finham[1] and Canley Brooks. Along the rivers, the land is alluvial, but to the north-west very mixed soils are found, including heavy clays (used by medieval potters in the Canley area). The land there rises to over 400 ft. (120 m.), but most of the south-east end is at 200-250 ft. (60-75 m.).

This wide tract contains some dozen settlement centres. The largest of these survive as nucleated villages, all at the southern end: Stoneleigh (45 houses in 1597), Ashow (25 houses) and Stareton (13 houses). Several settlements in the north of the parish were substantial in the medieval period but by 1600 had been reduced to a few houses or a single farm. In the 17th and 18th centuries, this part of the parish grew in population as new farms were carved out of older ones and as cottages sprang up on waste land.

Landscape

Warwickshire is traditionally considered to contain two very different geographical regions, separated by the river Avon.[2] To the south-east lies the Felden, dominated by open-field villages and almost without woodland. The north-western part is the Arden, heavily forested, with enclosed fields and isolated farmsteads predominating over nucleated villages. It concentrated on pastoral farming, in contrast to the arable husbandry of the Felden.

Stoneleigh and Ashow are bisected by the Avon and illustrate both the truth of this description, and the complexities that can characterise a transitional area. In the late 16th century (Figure 3), the land along the Avon and Sowe showed the typical Felden pattern almost to excess, with no less than five open-field systems (for Ashow, Finham, Kingshill, Stareton and Stoneleigh). These were enclosed at intervals during the next two centuries (1650, 1706, *c.*1580, 1598 and 1766 respectively). The north-western half of the parish appears to be a typical Arden landscape, but to some extent this resemblance depends on the moment of observation. Open fields had certainly existed in three of its hamlets (Canley, Fletchamstead and Hurst); the first was enclosed by agreement in the 16th century.[3]

The Arden woodland can be clearly identified, even on the modern map. Waverley Wood in the south-eastern corner of the parish is part of a large wood extending through Bubbenhall, Weston-under-Wetherley and Cubbington, that marks the eastern boundary of the Arden. In the 16th century, wood sold from here went to purchasers from all over the Felden, anything up to 15 miles away.[4] Waverley Wood is the relic of a much larger wooded area, known as Echills. This was the wilderness chosen by the Cistercian monks in 1155 for their new abbey at Stoneleigh. Further west, the woods were even more extensive, covering much of the parish. Although many medieval assarts were created here,[5] much managed woodland survived into the 18th century and

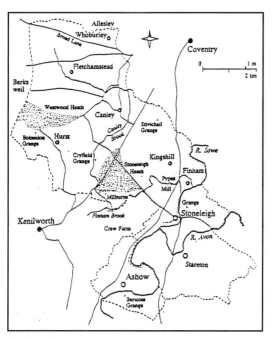

2 *Stoneleigh and Ashow: topographical features.*

later. 'Westwood', a large area north-west of Hurst, shows a different development. It was used as common wood-pasture by the inhabitants of both Stoneleigh and Berkswell (in contrast to the remaining woods which seem to have been reserved to the Abbey). However, by 1533 it was called Westwood Heath;[6] the deterioration in its quality must have been entirely due to over-grazing, as the soil is no different from that of neighbouring farms. In 1611, a warrener's lodge was built in the middle of the Heath, whose rent included 500 couple of coneys. It was enclosed in 1816. Stoneleigh Heath (enclosed 1766) probably followed a similar development, though this is less clearly documented. The parish also contained a number of smaller heathy commons: Chantry Heath near Stoneleigh village, Crackley Heath near Cryfield, and Hearsall Common (mainly in St Michael's parish, Coventry).

The tongue of Kenilworth parish projecting into Stoneleigh was occupied until the mid-17th century by another large wood, Kingswood. The parish boundary (perhaps laid out in the 12th century), was probably drawn to mark the division between the wood (Kenilworth) and the fields of Stoneleigh on the one side, and of Milburne on the other.

Ownership

In the Anglo-Saxon period, Stoneleigh appears to have been the centre of a large royal estate, including Kenilworth, Ashow, Leek Wootton, Baginton, Ryton and probably several adjoining parishes.[7] Only Stoneleigh and Kenilworth remained in Crown hands in 1086. Kenilworth was given by Henry I to Geoffrey de Clinton; the latter founded a house of Augustinian canons there in 1126-7, to which the king granted the tithes and advowson of Stoneleigh. Henry I also endowed a hermit with land in Fletchamstead which was presented by Henry II to the Knights Templar. Henry II made a more important grant in about 1155, of land in Stoneleigh to provide a new site for a Cistercian Abbey, founded some fifteen years earlier at Radmore in Cannock Chase. Although the grant was probably intended to include the manor of Stoneleigh, this was only clearly confirmed to the abbey in 1204.[8] The monks also acquired the manors of Ashow and Bericote (a separate Domesday estate) in the 13th century.[9] In the course of the 14th and 15th centuries, Stoneleigh Abbey acquired almost all the holdings within the two parishes, apart from land already in the possession of other religious houses.

After the dissolution, several of the choicer parts of the abbey lands were rapidly sold, notably the abbey site itself, its granges at Bericote, Bockendon, Cryfield, Kingshill, Milburn, and Stoneleigh, and the various mills in the parish. The bulk of the tenanted land at Stoneleigh and the manor itself were bought in 1562 by Sir Thomas Leigh, a successful merchant in the Levant trade (and Lord Mayor of London). On his death, Stoneleigh passed to his second son Thomas who became a baronet in 1611; his grandson (a supporter of Charles I) was created Baron Leigh of Stoneleigh in 1643. The abbey estate remained the property of his descendants until the 1980s, though much of the northern part of Stoneleigh parish was acquired by Coventry Corporation in

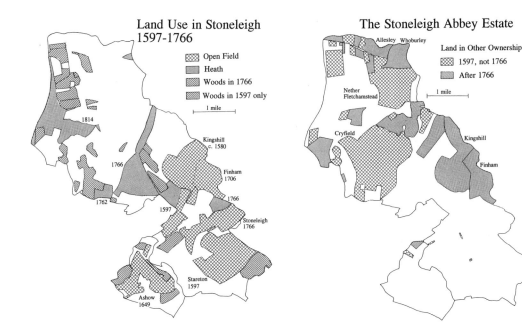

Land Use in Stoneleigh 1597-1766

- Open Field
- Heath
- Woods in 1766
- Woods in 1597 only

1 mile

1814
Kingshill c. 1580
1766
Finham 1706
1762
1597
1766
Stoneleigh 1766
Stareton 1597
Ashow 1649

The Stoneleigh Abbey Estate

Land in Other Ownership
- 1597, not 1766
- After 1766

1 mile

Allesley Whoburley
Nether Fletchamstead
Cryfield
Kingshill
Finham

3 *Stoneleigh and Ashow: land use in the 17th and 18th centuries. Dates are those of enclosure of open fields and heaths.*

4 *Stoneleigh and Ashow: land not forming part of the Stoneleigh Abbey estate in 1597 and in 1766. Glebe holdings are omitted, as are the open field lands of the two freehold farms in Stoneleigh and Ashow. The isolated farms on the west of the parish (Bokendon Grange and Westwood Heath Farm), part of the land at Canley and Crew Farm (Ashow and Kenilworth) were bought in the 19th century.*

the 1950s, and developed as housing estates. The most significant discontinuity in ownership took place in 1806, when Stoneleigh was inherited by Rev. Thomas Leigh of Adlestrop, a descendant of the eldest son of the first Sir Thomas Leigh, following the death without heirs of Edward Lord Leigh.

From the later 16th to the 19th century, the Leigh family systematically acquired freeholds in Stoneleigh and Ashow, and to some extent in the neighbouring parishes of Cubbington, Kenilworth, and Leek Wootton (as well as elsewhere in Warwickshire and further afield). Thus, in Stoneleigh and Ashow their holdings increased from 6,072 acres in 1597 to 9,042 acres in 1766 (Figure 4). The relatively few substantial freeholdings in Stoneleigh in the 17th and 18th centuries mostly belonged to nearby estates. Finham and Kingshill were owned by the Bromley and Gregory families, with their main houses in the adjoining parishes of Baginton and Stivichall. The northernmost portion of Stoneleigh parish formed part of the adjoining manor of Allesley, and was in the 16th century partly waste, partly Allesley Park, both of which were converted to farmland in the 17th century. An estate in Fletchamstead (550 acres) belonged to the Smith family of Crabbets, Sussex until it was bought by Leigh in 1698, and Bokendon Grange (140 acres) was owned until 1865 by the descendants of a Coventry merchant, Catesby Oadham, whose daughter married an Essex landowner. Two minor estates were owner-occupied: Whoburley (the Wade family), and the largest Canley freeholding (the Symcox family and then John Webster, the noted cattle breeder, p.192).

Occupations

Almost everyone in Stoneleigh was a farmer, practising mixed husbandry with good access to pasture and meadowland as well as arable. Keeping stock on the fallow fields was subject to stints, but they were fairly generous (Chapter 11). As a result, the balance of farming seems to have been similar, whether open or enclosed fields were used. The most detailed evidence for farming practice comes from the probate inventories (Chapter 11). They reveal two trends within the mixed husbandry between the 16th and the 18th centuries. The first is the expected appearance of new crops: peas, beans, vetches, and clover, and the replacement of rye by barley. The second is the development from 1550 of cheese-making which grew to be a major part of the farming economy. The now vanished Warwickshire cheese was despatched as far as London and was once celebrated as the favourite of Queen Anne.

Land tenure

The most significant feature of tenure in Stoneleigh was its informality. Apart from a few grants by copy of court roll in the earlier 16th century, copyhold was non-existent. Some tenants were described as 'sokemen of the manor of Stoneleigh', but they were virtual freeholders with minimal obligations and their inheritance fines fixed at a year's rent. The major freeholdings were created by Crown land sales after the Dissolution, and their only burden was attendance at the manor court. A few of the larger tenants had written leases, but even by the 18th century these made up less than 10 per cent of the total number. Their leases were standard with few agricultural conditions imposed, though a requirement to carry a ton of coal to Stoneleigh Abbey each year was often included. Life leases were usual in the 16th century, though by the later 17th century leases for 21 years had taken their place.

Most tenants held at will, which in reality implied life tenure at a fixed rent. This seems to have been controlled by custom, accepted without controversy by both lord and tenant. A heriot of the best beast or possession was taken. The succession of a widow seems to have been automatic. William Farr in his will (1564) left to his son 'the interest of my house according to the custom of the lordship'. The rentals show that such succession was not uncommon, though in the absence of good parish registers before 1660 we cannot check whether a child of suitable age was ever passed over. There seem to be more examples of family farms in the 18th century than earlier, and several examples are mentioned below.

Although rents were generally kept constant for an individual and his widow, increases on change of tenant were common. It is difficult to disentangle the effect of such increases from the additional rent for new purchases and some rents remained unchanged for very long periods. The overall picture is one of steadily rising rent receipts, increasing from £416 in 1599 to £3,146 in 1766. A systematic revaluation took place after the succession of Rev. Thomas Leigh in 1805, with the rent roll rising from £3,950 in 1807 to £7,424 in 1812.

As well as the main holdings on the estate, from the late 17th century onwards an increasing number of cottages were built on small plots of waste land (see Chapter 7). These paid rents of 6d. to 1s. a year, collected principally to demonstrate that the cottages belonged to the estate and were not freeholdings. These rents were administered separately from the main holdings and are not as fully recorded.

In the 16th century, the distinction between cottagers and other tenants was more legalistic. The tenants were divided between those holding significant amounts of open field land (a half yardland (about 20 acres) or more) and those with only a few strips or none at all. The latter were defined as cottagers; they had a special right to common pasture for two cows and one horse. It was the tenant's tenurial status rather than the character of the house that decided whether it should be called a cottage.

Notes

1. Also known as the Odibourne Brook where it passes through Kenilworth.
2. These were recorded by John Leland in his *Itinery* (compiled in about 1540), but had certainly existed for centuries earlier. See D. Hooke, 'Anglo-Saxon landscape', in T. R. Slater and P. J. Jarvis, *Field and Forest*, Norwich, 1982.
3. The medieval topography has yet to be studied in detail, but some evidence has been identified. For Fletchamstead, for example, P.R.O. E315/40 (10) is an undated deed listing numerous open field strips. Open fields at Canley and Hurst are mentioned in 1392; *Leger Book*, p.liv; for Canley, incidental references are also found in the earlier 16th century, e.g SBT. DR18/10/18/24/3.
4. For Stoneleigh, SBT. DR18/30/24/274, Wood Book of Sir Thomas Leigh, 1596-7; for Bubbenhall, N. W. Alcock, *Warwickshire Grazier and London Skinner*, British Academy, 1981, p.177.
5. *Leger Book*, p.xlix ff.
6. SBT. DR18/30/24/73.
7. *Leger Book*, p.7 provides an outline for the early history of Stoneleigh and its members, which finds support in the pattern of parish boundaries.
8. *Leger Book*, pp. xii-xvi; 114-6.
9. For Bericote, see *VCH*, IV, p.13; their acquisition of Ashow is poorly documented, and may have been a piecemeal process.

Chapter 3

The Evidence

A remarkable range of evidence can be called on to illuminate past life in Stoneleigh. This chapter examines its range in time and space, to clarify what information is accessible and what inevitably hidden. The principal period of interest, the 1530s to the 1750s, is defined by the survival of probate inventories. Broadly, the first date corresponds to that of the earliest standing houses (late 15th/early 16th century), and the last to the period when traditional timber-framing was superseded by brick building. This change is relatively insignificant in itself, but it coincides with the appearance of different house types, and with changing lifestyles within them; only the beginnings of these trends are revealed by the probate evidence.

Other documentary sources are less well synchronised with the probate evidence. Manorial records, for example, die out in the beginning of the 18th century, while the parish registers only become useful after 1660. It is necessary at any particular date to bear in mind what aspects are well-recorded, what unclear.

Documentary Evidence

Probate Records

Until 1857, death and its consequences was a matter for the church. The consistory court met regularly in St Michael's Church, Coventry, and it was there that most executors of Stoneleigh people took their wills and inventories to be proved. These documents are now preserved in the Diocesan Record Office at Lichfield. A few wills, generally those of the most prosperous villagers, were proved in the Prerogative Court of Canterbury (PCC), and are now in the Public Record Office; all wills proved during the Commonwealth period are also there.[1]

Table 3.1: *Numbers of Stoneleigh Probate Records*

Period	Inventory + Will[a]	Inventory Only[a]	Will Only	No Records	PCC[b] Will	PCC[b] Admin	Total Inv	Total All	Per Year
1533-1565	24 + 13	2 + 2	8	14	1	0	41	63	1.9
1566-1600	21 + 12	6 + 6	5	10	4	2	45	60	1.7
1601-1625	39 + 8	11 + 2	9	4	9(1)	2	60	73	2.9
1626-1650	31 + 7	13 + 6	5	3	5(1)	0	57	65	2.6
1651-1660	-	-	9	1	9	1	0	10	1.0
1660-1680	21 + 13	13 + 5	6	1	5(2)	1(1)	52	59	3.0
1681-1700	27 + 10	12 + 5	2	2	1(1)	1(1)	54	58	2.9
1701-1725	36 + 19	12 + 9	9	3	1(1)	0	76	88	3.5
1726-1750[c]	30 + 4	9 + 0	28	12	3(2)	0	43	83	3.3
Totals	229 + 86	78 + 35	81	50	38(8)	7(2)	428	559	2.6

a Inventories with room names, plus (+) those without.
b P.C.C. probates (included in the previous columns); figures in brackets are those with inventories. The listing of P.C.C. wills after 1700 and of P.C.C. administrations is incomplete.
c Six inventories dating from after 1750 have been identified; five include lists of rooms.

Stoneleigh is exceptionally well-endowed with probate evidence (Table 3.1). A total of 559 probate records have been identified from 1533 to 1750, a date after which probate inventories virtually ceased to be made.[2] More significant than the simple count of probate records is their character. The least useful are the 9 per cent for which the only information is the probate itself (only numerous before 1580 and after 1725).[3] Even these identify a resident with property worth the effort of going through the probate process; they also provide the executor's or administrator's name. Wills survive for 71 per cent of the probates (on their own in 14 per cent).

As freehold property was virtually non-existent in Stoneleigh, apart from the few major estates, it is clear that wills were being made for the orderly disposal of personal property, household and farm goods, rather than to satisfy any legal need to arrange the transfer of land (as has been suggested elsewhere).[4] The bequests made by heads of households were dominated by family circumstances and the position in the life cycle. If either wife or children survived (but not both), then most or all the property was left to that party; with both alive, the decision depended on whether the children were yet independent. The wife was always provided for, sometimes absolutely, sometimes for life or until remarriage, sometimes by an arrangement for her to be cared for by a son (usually with an alternative laid down if they did not 'agree together'). If neither wife nor children were alive, then the family goods tended to be left to the nearest available relatives.

The major evidence for the study of lifestyle and living conditions comes from probate inventories. At Lichfield, these survive from 1532, the start of the main probate series, in contrast to many other dioceses whose earliest inventories are mid-17th century. The Stoneleigh inventories are even more numerous than the wills, surviving for 77 per cent of the probates up to 1750 (427 in all, with six later ones also identified). They are particularly valuable for social history because three-quarters (307) were taken room-by-room. This proportion is exceptional even within the Lichfield diocese; room names are very rare in early inventories from the northern parts of the diocese, though Coventry inventories generally use them. Of course, their omission did not always reflect poor work by the assessors. Consideration of the contents suggests that about half the inventories without room names relate to people who were not independent householders. These inventories are of interest in their own right, illustrating alternative lifestyles (Chapter 9).

Room names are almost as frequent in the earliest inventories as later, so that detailed reconstruction of lifestyles can start when medieval traditions were still firmly established. The highest proportion of inventories without room names is found in the early 18th century, prefiguring the rapid decline in the taking (or perhaps the filing) of inventories after 1725. At this time others list only unspecified 'goods in the parlour', etc. Despite these deficiencies, the inventories clearly define house development in the 18th century.

The Stoneleigh inventories have two additional attributes making them exceptionally valuable for historical analysis. The first is the economic context that can be provided for most of them, through identification with a specific holding in the estate records (discussed below). The second is their thorough social coverage. A comparison with the parish registers for the periods when these are reliable shows that 35-40 per cent of adult males buried in the parish have left probate records. Furthermore, the records extend virtually to the bottom of village society including labourers, though the proportion for those of low social status and for women is much smaller than for the middle ranks. The social mix is analysed in detail in Chapter 10, and the problem of correcting for the bias in the probate evidence is examined in Chapter 12.

Estate Records

For this study, the most useful of the voluminous records of the Stoneleigh estate are those concerned directly with tenant land-holdings, the maps, surveys and rentals. These provide links in one direction between wills and inventories and the farms or cottages to which they relate,

and in the other from existing buildings to the corresponding estate holdings, and through them to their probate records.

I MAPS AND SURVEYS

The whole Leigh estate in Stoneleigh and Ashow was mapped in detail twice, in 1597 and in 1766, respectively by John Goodwin, 'Practitioner in the Mathematic', and by Matthias Baker. Both maps are accompanied by detailed surveys listing the components of each holding. That of 1597 was extensively annotated, corrected and updated by Sir Thomas Leigh himself (in a singularly illegible cursive hand).[5]

Further maps with accompanying surveys cover Ashow in 1650, recording the newly enclosed fields, and Stareton in 1680, apparently relating to a redistribution of land between holdings; several small plans of individual farms, fields and woods also exist. A detailed map of Stoneleigh village of about 1813 is particularly important because it lists both tenants and occupiers of the village cottages (p.131).[6]

Remarkably, as well as these Leigh estate maps, each of the major 18th-century freeholdings was also mapped: Allesley estate (Neale family, 1770); Bokendon Grange (Oadham family, c.1700); Kingshill (Gregory family, 1758 and 1787); Finham (Bromley family, c.1809); Whoburley (Clowes family, 1760).[7] However, for none of these estates are their other records anything like as extensive as for Stoneleigh Abbey.

II RENTALS

Nearly continuous runs of estate rentals exist for two-thirds of the period of study. From the original Leigh purchase in 1562 until 1626, almost all the half-yearly rentals survive, and less formal rentals for 1635, 1640 and 1645 can be correlated with the main series.[8] The rental of Michaelmas 1571 is particularly detailed, and was taken in precise topographical order around Stoneleigh village, making it almost a survey. Starting again in 1699, a nearly complete sequence runs to the present day, apart from occasional gaps when volumes are missing (e.g. 1727-32).[9] From the monastic administration, rentals survive irregularly for 1466-1501 and 1533-38. Four rentals of the estate while in Crown hands bridge the gap to 1561, but the entries cannot be completely linked to the next rental, partly because of the many changes of tenant in the epidemic years of 1558-9.[10]

The maps and surveys of 1597 and 1766 can readily be related to the rentals, so that the great majority of estate holdings can be traced from 1561 to 1645 (with rather fewer traceable from 1533 or earlier), and again from 1699 onwards. Inevitably some changes, involving the amalgamation or division of holdings, are incompletely understood, though additional partial maps and surveys (such as those for Ashow and Stareton) help to explain them. How the gap in the later 17th century can be filled is examined below. For the freeholdings bought during the build-up of the estate in the 17th-18th century, the appropriate deed bundles can almost always be identified, though their information on occupiers is less complete than in the rentals.

III MANORIAL AND OTHER RECORDS

The Stoneleigh estate archives includes a great variety of material which is valuable for back-ground information, and one or two items that are unusual in a national context, such as original presentments for the 1522 Certificate of Musters, and to the commissioners for the Inquisition of Depopulation of 1548.[11]

The major source of information about the village people and their activities, after the probate records, lies in the voluminous manorial records. From these, the standing of individuals in the community is revealed by the functions they performed—juror, ale-taster, constable, etc.—while something of their character emerges from their appearances as minor malefactors. Both individual items and the general 'pains' (orders made for the community as a whole) help to define farming activities. They are, however, a biased source. From them we would see Stoneleigh much more as a swine-keeping than a cheese-making community, because pigs needed to be

ringed to prevent their destructive rooting while cheeses were entirely innocent—though ale-brewing and bread-making received innumerable mentions.

In origin, the Stoneleigh estate included several manors, but by the 16th century it was administered as a single jurisdiction, subdivided into the Infra or Home, and Extra or Foreign courts, the latter covering Ashow, Stareton, and the Leigh property in the adjoining parishes of Cubbington and Leek Wootton. After a few 14th- and early 15th-century rolls and a sequence from 1478 to 1506, the main series runs from 1537 to 1748; its only substantial gaps are 1554-61; 1622-46; 1703-13; 1724-38. Until 1546, three-weekly 'little courts' were held, as well as the twice-yearly views of frankpledge; in the 17th century, the latter were held on the Thursdays after Easter and Michaelmas. From 1686, the Easter court was abandoned and the records are sparse thereafter with many missing years.

Until 1622, the records normally take the form of parchment fair copies, but thereafter they survive as paper stewards' files, normally including both the original record of court proceedings and the fair copy made in preparation for the next court. These files regularly include suitor lists (names of those required to attend the court), often updated with changes of tenants, which are invaluable as substitutes for rentals in this period. For 1739 to 1748, the court roll was kept in a book. The next recorded court, for 1764, directly follows that for 1748, suggesting that none were held in the intervening 15 years. After two more years, the manor court was finally abandoned.[12]

Parish Records

Only with the parish records does the extraordinary strength of the Stoneleigh evidence falter. The registers of both parishes were poorly kept; that for Ashow was apparently used for pipe spills by an 18th-century churchwarden and only survives from 1725, though Bishop's Transcripts exist from 1660. The registers do reveal that Ashow was a centre for clandestine marriages between 1743 and the passing of Lord Hardwick's Marriage Act in 1753. Its registers include entries for people from as far away as Devonshire and Ireland. For Stoneleigh, the earliest register begins in 1634, after the appointment of Edward Maunsell. It is of outstanding quality, including complete occupational descriptions in Latin. Frustratingly, it breaks off in 1640 and only restarts in 1665, on the appointment of Edward Agborow. He kept the register well until 1681, when it again falters, with only a few entries in the following years. From the presentation of his successor in 1692, the register appears to be of good quality.[13] The frustrating lack of information on family structure and relationships for almost the whole period up to 1660 is to a small extent remedied from wills and probate acts (which generally give the names of widows or next of kin). However, this evidence is too incomplete for demographic study.

Other parish records are also very sparse before 1800, though they do include small groups of parish apprentice indentures and settlement certificates, and overseers' accounts from 1757. The Leigh estate records contain a number of documents that would normally be in the parish chest, such as the papers relating to the construction of a parish workhouse in the 1780s. This material is insufficient to illuminate fully the lives of the indigent members of the community, as is possible with more complete series of parish records.

National Records

The main series of national records useful for this study are those relating to the Hearth Tax, which are uniquely well-preserved for Warwickshire.[14] For Stoneleigh, seven detailed assessments survive from 1662 to 1674.[15] They were compiled conservatively so that names can be followed from one assessment to the next, and replacements identified; this is particularly valuable because of the lack of rentals at this period. Within Stoneleigh village, the order seems to be social rather than topographical, perhaps that used for the lost church rates; the assessment for 1663 contains the extra names of five men and five women at the end of the list, corresponding to the 10 almshouse hearths listed as a single entry in other years.

Identifications

One great strength of the Stoneleigh evidence lies in the ability to link probate and estate material, to identify sequences of inventories, and to relate both inventories and standing buildings to each other and to the corresponding holding in the estate records. Overall, this has been extremely successful, identifying more than 85 per cent of the room-by-room inventories. However, our ability to make these links varies both geographically and temporally. The greatest difficulties affect the freeholdings, and especially the estates at Finham and Kingshill. Neither have long series of survivng rentals,[16] and only the occupants of Stivichall Grange and of the main house at Finham can be identified from other evidence. To a lesser extent, similar difficulties affect the tenants of the Fletchamstead, Canley and Hurst freeholdings, though after their acquisition by the Leigh estate they appear in the rentals and surveys.

Within the 200-year period for which inventories survive, the identification of tenants is generally straightforward for the periods 1562-1645, and 1700-1750. Starting from the detailed maps of 1597 and 1766, almost all the estate holdings can be traced forward and back through the rentals.[17] A few problems arise for holdings which were bought by the estate after 1597 whose size may be uncertain, and for holdings split up or combined before 1766, if the component parts are uncertain. The large group of squatter cottages that grew up during the early 18th century poses more problems (Chapter 7). Although these were considered part of the estate, their rents were collected separately, and the first surviving rental is of 1729; not all its entries can be correlated with those in the 1766 survey, and some of the surprising number of earlier probate records for these cottages can therefore be recognised but not pin-pointed.

Identifications before 1562 are made difficult by the upheaval in the estate administration caused by the Dissolution. Fortunately, conservatism both in values of rents and in the arrangement of the rentals helps in making correlations. However, the holdings of a number of tenants with probate records cannot be identified.

The greatest difficulties with identifications arise in the second half of the 17th century, because of the lack of rentals. Fortunately, an almost yearly series of manorial suitor lists starts in 1652. A clean copy of the previous list was generally updated at the next court by marking the new tenant's name against the old one. They are not perfect tools for tracing tenancies. There was no need for the names to be kept in the same order (though they generally were), and they can be ambiguous when several tenants change at the same time. Also, of course, they do not identify the division or amalgamation of holdings. However, they allow most of the tenants leaving probate records to be identified.[18] They are supplemented for the period 1662-1674 by the Hearth Tax returns, which provide similar lists of names, in a standard order. For Stoneleigh village, two partial surveys (1650 and 1663) are also valuable. Each covers only half-a-dozen tenants, but they include full lists of open field strips with abuttals, and the tenants of another dozen holdings can be matched through these. For Stareton and Ashow, the maps and surveys (1650 and 1684 respectively) provide enough information in this period to identify every tenant with probate records.

Despite the occasional problems, taken as a whole the sources available for identifying probate records are extremely powerful. Of the entire group of 559 records, 65 per cent can be identified with their holding.[19] Of the most important group, the 307 inventories with room names, no less than 270 are located. From the opposite viewpoint, 120 holdings have at least one identified detailed inventory, ranging up to six inventories for the best documented. A rather larger inventory set is useful for analysis of the agricultural economy, as crops and livestock are always listed even if the rooms are omitted.

Standing buildings

The surviving early buildings in the parish provide important though enigmatic evidence for lifestyles. The village of Stoneleigh itself contains one of the best groups of timber-framed houses in any English village, comprising some 20 houses of varied type, dating from the 15th to the

5 *Stoneleigh village in 1766, with houses numbered as in Appendix 1 (holdings with probate records) and Appendix 2 (those without). Solid squares mark houses that have survived, open squares mark other houses and outbuildings. Only holdings 28 and 31 had disappeared completely between 1597 and 1766. [Redrawn from SBT.DR18/25/77]*

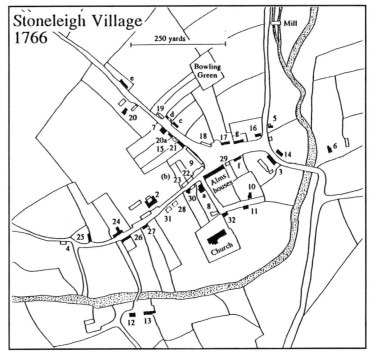

18th centuries (Figure 4). Elsewhere in the parish we find another 20 timber-framed houses; in addition 40 houses of stone or brick are early enough to be of significance to this study (summarized in Appendix 2). The architectural details are not in themselves of great significance in interpreting lifestyles, but they provide the essential evidence for dating the houses and for identifying both the original layout of each house and the changes it has undergone.

As evidence, they are particularly valuable because they perfectly complement the probate inventories. The latter relate predominantly to the large holdings, with only a few for the smallest. In contrast, more small houses survive than larger ones. Of the 50 holdings in Stoneleigh village in 1766, 31 are described by detailed inventories, while of the 26 early houses, 17 relate to these holdings but 9 others stand on holdings for which no inventories exist. Elsewhere in the parish, the proportion of early houses surviving is lower. This is particularly true for the northern end of Stoneleigh where the expansion of Coventry has swept away almost all early buildings. However, the survivors do include both larger and smaller houses. It is also noticeable that the houses in Ashow and Stareton villages have been much more heavily altered than those in Stoneleigh; as Stoneleigh is the most visible of the villages, lying along the main Coventry to Leamington road rather than on a side lane, a conscious decision may have been taken by the Leigh family in the 19th century to preserve its romantic old-world appearance. They did erect one group of four Gothic cottages in the 1840s (with a coach house for family use during morning service), but took no more steps towards rebuilding it as an estate village.

Most of the timber-framed houses are simple in plan, originally with two or three squareish rooms in a single range; a considerable number have additions in timber-framing, usually lower than the original house (e.g. pp.66, 102). The suggestion that doors were frequently in gable ends[20] has been reassessed; this was certainly the case for some of the 17th-century cottages but conventional side doors have been identified in several early houses and two cross-passages have been recognised. Now the houses have upper floor rooms throughout, but when built they were often only partly floored over. Few of the timber-framed houses were built with usable garrets.

Structurally the houses are of three types, corresponding approximately to their dates. The earliest houses use *crucks*, pairs of timbers rising from the ground to the roof apex set between each bay (structural unit), supporting the rafters and walls (Figures 11-15). Surviving examples in Warwickshire have been dated from the late 14th to the early 16th century.[21] In the other two structural types, each truss contains two wall posts, capped with a tiebeam and carrying a pair of principal rafters (Figure 5). These two types are distinguished by the form of braces. The earlier houses use large curved braces to the tiebeams and in the walls (in contrast to the cruck houses whose walls apparently contained no braces at all). The earliest examples of this type predate the latest cruck houses. One in Stoneleigh is known to have been constructed in 1490; others may be 15th century, though they seem mainly to date from the 16th century. The use of curved braces was apparently superseded shortly before 1600 by short straight braces, in the third structural type. They were used both in the trusses and in the side walls, which are generally framed in square panels, either two or three panels high. This type continued in Stoneleigh well into the 18th century (e.g. Figures 30-35). The pre-1600 examples generally have clasped purlins (e.g. section in Figure 18b) but in later houses (and a few early ones) the purlins are carried on the backs of the principal rafters (Figure 5). This led to the development in the later 17th century of roofs in which the principal rafters were inset substantially from the ends of the tiebeam, and often strongly bowed (e.g. Figure 35, base). At the same time some storey-and-a-half houses are found with interrupted tiebeams to allow easy communication at first floor level. None of the examples are described in detail here; they include South Hurst Farm and Church Cottage, Ashow.

The original wall panels in all these houses seem to have been filled with wattle-and-daub. A few such panels survive, but almost all have been replaced in brick; indeed, many walls have been partly or completely rebuilt in brick, mainly in the 19th century. Most roofs seem originally to have been thatched, though many are now tiled or shingled.

The original floors in the earlier houses were carried on heavy square-section joists running axially. By the later 16th century, this construction was superseded by the use of a main axial ceiling beam (usually combined with 'half' beams along each side wall, carrying smaller transverse joists). These ceiling beams and the fireplace lintels provide almost the only decorative detailing in the houses. Their lower edges carry chamfers, which are terminated in 'chamfer stops', sometimes no more than a smooth curve (a 'run-out' stop), but often given a stepped or ogee form ('step' or 'scroll' stops), and sometimes of a more complex form. Very occasionally, beams were moulded rather than chamfered.

Building stone can be obtained in the neighbourhood (a coarse sandstone), but was mainly used for footings and chimneys. Two 17th- and one 18th-century stone houses survive, and two of these are of particularly high status (pp.81, 156). Brick as a principal building material is much more widespread, though it only came into use during the 18th century.

Notes

1. The 17th-century PCC administrations of intestate estates are incompletely indexed, and the 18th-century records lack any place index. Some PCC probates for Stoneleigh certainly remain unidentified in these groups. References to probate records are generally by name and date of inventory (occasionally the year before the date of probate, under which the records are filed at Lichfield); the references by year only in Part II can be identified from the summary table for the appropriate chapter. Printed inventory texts are identified by bold numbers.

2. Only six post-1750 Stoneleigh inventories have been found: four (1752-56) in the Lichfield probate records (checked for 1751-75), one in the Leigh estate archives (1771), and one in the PCC (1778). They are omitted from the statistical analyses.

3. A number of pre-1580 Lichfield records (primarily wills) have been lost. Probates lacking documents after 1725 relate to people dying intestate, whose estate was administered without an inventory being deposited.

4. A few Stoneleigh people held freehold or copyhold property elsewhere. This is mentioned in 15 per cent of the wills, with no great difference between the periods before 1600 and after 1700.

5. In 1597, Goodwin presumably carried out a chain survey, but Baker used a plane table and his original 12in. card squares survive in the estate archives (SBT.DR18/25/77). He used the back of some squares for a map of

the open field strips in the Stoneleigh fields. Unfortunately, although the strips are numbered, the key has not survived. Two of the three sheets of the 1597 maps are still at the Abbey, with one at Stratford (SBT.DR18/25/69a; photostat copies WRO.Z139/1; Z141/1). In its survey, a few items are wrongly keyed to the map, and one or two holdings are apparently omitted. The best copy of the 1766 map and survey is still at the Abbey (photostat WRO.Z142(l)); another is SBT.DR671/31. The estate was mapped again in 1854 and 1871 (SBT.DR18/25/82a; /31/715).

6. SBT.DR671/7-8 (Ashow); DR671/12 (Stareton); DR18/25/78a (Stoneleigh, *c.*1813), dated from the names of the tenants.
7. Respectively: WRO.CR623; Bodleian Lib. Gough maps 32, f.35b [WRO.Z474(u)]; SBT.DR339/31-2; SBT.DR10/1470, 1431; WRO.CR949.
8. These are in the series of manorial documents, SBT.DR18/30/24.
9. These are in the volumes series, SBT.DR18/31. The earliest are less formal than the rest (vol. 471, 1699-1701 and DR18/30/24/405-502, 1704-9).
10. Those for 1488-1500 are among the Gregory estate records, SBT.DR10/1523-6. The Crown rentals are SBT.DR18/30/24/105,107 and /10/101/2, and PRO.SC12/16/43.
11. SBT.DR18/30/24/85 and 83, 106.
12. These records are in SBT.DR18/30/24, apart from those for 1547-51 (PRO.SC2/207/80).
13. The registers are WRO.DR177/1 and DR156. Copies of the Ashow Bishop's Transcripts are in WRO.Z386(sm). Those for Stoneleigh also survive from 1660, but do not contribute any additional information.
14. T. Arkell, 'Assessing the reliability of the Warwickshire Hearth Tax returns of 1662-74', *Warwickshire History*, 6(6), 1986, 183-197.
15. WRO.QS11/1,5,18,30,58 and Z336/1,2(L) (photostat copies of PRO.E179/259/9,10)
16. Finham is rather better than Kingshill, but major changes took place in the 17th-18th centuries, reducing the number of tenants from twelve to two by the 1780s. As the map of Finham records the final position, it is of no help in locating earlier tenants.
17. The survey/rental for 1571 is particularly helpful in the earlier period, its additional detail helping to resolve several ambiguities, such as those arising when the almshouses were constructed (p.141).
18. Some of the remaining uncertainties arise because of the gap between the last rental (1645) and the first suitor list (1652). Some changes of tenant in this period have been impossible to correlate. At the end of the 17th century, the position is better with a suitor list for 1702 and the first rental in 1699.
19. Many of those not located relate to non-householders.
20. *Stoneleigh Houses*, p. 198.
21. N.W. Alcock, R.R. Laxton, C.D. Litton, to be published.

Part II
Village Homes

Chapter 4

Old Style: Small Houses 1532-1600

A room to live in, a room to cook in, a room to sleep in—this was the typical style for those who still lived in the old way, as did most people in Stoneleigh in the middle years of the 16th century (inventory summary in Table 4.1, p.53).[1] It made no difference whether they were among the most prosperous like Thomas Burbery farming 70 acres and leaving an estate of £160, or the poorest like John Lorde with a one-acre croft and three strips in the open fields. Others had the same three rooms but rang the changes on them: a second chamber, a buttery or a bakehouse instead of the kitchen. Another group (not exclusively the poorest in the community) lived even more simply, in hall and chamber only—apart from the eccentric John Sothern of Stareton who had a kitchen but slept in his hall.[2] The uniformity of the plans of these houses did not, however, extend to their contents where wealth was closely related to the quality of household goods. Similarly, the size and height of the rooms and the workmanship of the carpentry often reflected the status of the occupants. The inventory (1556) (**1**) of Humphrey Hilles, an elderly husbandman living in Hurst, shows a characteristic three-room example. His household goods were of modest quality, though he did have one of the first cheese presses in the parish. (For a re-creation of his house, see p.204)

1 *Humphrey Hylles, husbandman (1556)**
He was the tenant of South Hurst Farm (38 acres) from before 1522. His will divided the plough team between his son Henry and his widow Gelian, and he left a cow, calf and two sheep to his other son Nicholas, while his daughter Margery had the profit of a calf and two sheep. None of his children are identifiable again in Stoneleigh, though his widow remained as tenant until 1570.

Inventory appraised by Wyllyam Scloygh [Slough], Homfre Partreche, 8th October 1556.

	£	s	d
In the Halle			
On tabull, 3 cheres, a cuppeborde, a rownde tabull, on forme, 2 qwyscions with penty clothes		6	0
In the Parler			
4 Coffers, a beddestyd, a matrys, 2 coverynges; a bolster, 3 pere of schettes, 2 peloberes		10	0
In the Kechen			
3 Potts & a posnet, 4 pannes, a scellet, a scemer; a spytte, a pere of goubardes	1	0	0

(continued overleaf)

* Either in the text or at the top of each inventory, the available information about the deceased is summarised, particularly to identify their life-cycle position. The inventories are given verbatim, apart from the heading, the omission of the word Item that often starts each line, and occasionally of other repetitive wording. Semicolons divide separate lines in the original which lack individual sums. Values are in £ s d, converted from Roman to Arabic numerals where necessary, and normalised (e.g. from 22d to 1s 10d). For unusual words not identified in the text, see the Glossary (p.221).

<u>In rement</u>
A cotte, a dublet	5	0

[In the Kechen, erased]
9 Pecys of peutur, 3 socers, a chaffyg dysche; 3 condelstyckes, 2 saltecellers	6	8
3 Bordeclothes, a towell	4	0

3 Lomes, 3 paylles, a chesse presse, a knedyng trough; a pere of pottehokes,
a gredeyron,
a fyrescho[vel], on axe and a byll	2	8

<u>In Corne</u>
6 Strycke of rye, 3 quarters of wottes	1	10	0

<u>In Hey</u>
4 lode of haye	1	0	0

<u>In Cattell</u>
4 steres, 6 kyne, 2 calves	11	6	8
4 mares & a coltte	1	13	4
10 scheppe	1	0	0

<u>In Swyne</u>
4 swyne and 6 stores	1	6	8

<u>In Henns & Dockes</u>
8 hennes & a kocke, 4 caponnes, 5 dockes
A yron bounde wayne, 3 yokes, 2 towys, a coppesoll, a pynne, a plought & all that
longes therto, a pere of harowys, a oxharo, a cartte; dysches, trenchers, ladell with
other trymtram as olde bordes	14	4
Total 21	5	4

Several medieval four-room houses survive in the parish, and the inventory descriptions show that (with only one or two exceptions) these were the largest houses before the changing lifestyles of the later 16th century began to have an influence. The inventories have no single pattern of rooms but add either a buttery, a second chamber or a shop to the hall, kitchen and chamber of the three-room houses. The tenants of one or two larger houses also lived in the old style, but it is not easy to draw a line between those with unmodernised medieval houses and those who had begun to improve their houses; the 16th-century inventories listing five or more rooms are therefore discussed together in the next chapter.

The inventories for these small houses do not identify specific rooms as being on the upper floor; an eight-roomed house had the only 'chamber over the parlour' recorded before 1565. However, the use of the rooms and comparison with standing buildings shows that 'seler' did not mean a cellar for storing barrels or the like, but a solar—a secondary upper floor chamber for sleeping and storage. The second chamber in a house may also have been upstairs, even when the inventory does not state this explicitly.

Were these houses really medieval or do they demonstrate a stage of improvement that had taken place before 1550? As will be seen, the surviving medieval houses match the inventory descriptions. So do a handful of medieval documents that directly describe houses in Stoneleigh. The most interesting of these is a list dating from 1481 of four holdings that needed repairs to all their buildings (Table 4.2).

Table 4.2: *Stoneleigh Houses in 1481 [SBT.DR18/30/24/17]*

Tenant	House
William Reve, villein (*nativus*)	Hall, chamber, kitchen, barn, oxhouse, bakehouse (*Le Bakhous*)
John Celum	Hall, chamber, barn, oxhouse
Roger Warner, villein	Hall, chamber, kitchen, barn, oxhouse
Thomas Frankelyn, villein	Hall, chamber, kitchen, barn, oxhouse

An earlier manor court roll (1438) refers to two houses of three bays.[3] These few examples relate the smaller 16th-century houses in Stoneleigh and their inventories directly to their medieval predecessors. The Stoneleigh houses also match other evidence for medieval houses in the West Midlands; they also demonstrate that names such as *aula, camera, coquina* (hall, chamber, kitchen) relate to rooms within the house rather than to separate buildings.[4]

But were there even smaller houses with just one room? Some people were certainly lodgers or had retired to just one room of their house. Their inventories are characteristic, with bedding and clothes, and usually a chest but no other furnishings (Chapter 9). Obviously these inventories do not describe complete houses. However, a quarter of the 16th-century inventories for householders list no rooms.

The evidence is strong that these were not one-room houses. Several inventories list the contents in an order and a detail that strongly suggests that room names have just been omitted; for others we know that a house with several rooms already existed (e.g. inventories for Alis Tuter and Thomas Pype, discussed below). Occasionally 'all the household goods' were simply lumped together, a habit found occasionally in inventories of all periods. For several households, the appraisers seem to have collected all the goods in one room, as with William Dodley of Ashow whose 1599 inventory has a series of headings: Linnen; Beddinge; Woodd (including beds, tubs, etc.); Brasse; Pewter; Iron; Cattle; Fruits of the Ground; Woodd without the House; Woodd in the Stable. Revealingly, the inventory includes one item 'all the paintinges in the chamber and the hall', which shows that the appraisers had not bothered to take down the hangings.

Although the proportion of inventories relating to the poorest tenants in Stoneleigh is very small, those that do exist for this early period are no different in their character from those for moderately prosperous members of the community. It is impossible to *prove* that none of the inventories describe single-room houses, but we can be certain that if any such houses existed, they were few indeed. As the next section of this chapter shows, the same conclusion can be drawn even more strongly from a study of the cruck houses in the village.

Standing Buildings

Underlying the comparison of inventory descriptions and standing buildings are certain assumptions derived from our knowledge of housing of this period in the Midlands.[5] Structurally, the early houses in Stoneleigh fall into two groups (p.18), built respectively with crucks, and with posts and tiebeams (box-framed). The cruck houses appear to have been the dominant Midland type in the 14th and 15th centuries, but by the 16th century box-framed houses were equally common. A variety of plan forms are found, especially for box-framed houses, but the characteristic late medieval/16th-century house (whether cruck or box-frame) had a linear plan with three rooms. The central room is always presumed to have been the main living room, and to be the 'hall', following the evidence of inventories. One end of the house (the 'upper end')[6] contained a bedchamber, sometimes called 'parlour' (p.50). If the house had a room on the upper floor, it is expected to be at this end and might be called the 'solar'. At the other 'lower' end is a third room whose function can only be deduced from the inventories.

The majority of 16th-century inventories matched to standing buildings relate to box-frame houses, which also provide a wider range of plan forms. They are therefore examined first. Some early houses are considered in later chapters if their inventories belong there (11-12 Coventry Road, Stoneleigh in Chapter 5, 8-9 Vicarage Road, Stoneleigh in Chapter 6).

Two-room houses

Although two or three surviving medieval houses may have had only two rooms originally (e.g. 3 Birmingham Road, Stoneleigh, p.42), none of the simplest, two-room inventories correspond to them.[7] Pypes Mill has a two-bay plan with an original upper room; its 1557 inventory description is more complicated and strictly belongs in the next chapter, but is examined here because of the light it throws on the development of the house.

Pypes Mill, Stoneleigh (Figures 6a & b)

This is one of the most significant of the medieval houses in Stoneleigh, because of the survival of a deed relating to it dated 10 September 1490.[8] By this deed, the rector of Ashow endowed an obit in the Abbey church of Stoneleigh. He had:

> newe made and reryd up a watyr mille called a walke mylle with flodeyates and a newe house with ij bayes ... in a croft callyd Rabcroft bysyde Fynham Brygge

The location of the mill identifies it as the present Pypes Mill, and the standing structure is clearly the rector's two-bay house.

In paying for the mill to be built, presumably during the previous summer, the rector had spared no expense. The house is close-studded with the most substantial timbers of any house in the parish, very unusual in character for Warwickshire in which small scantling timbers are generally used. The house was leased in the early 16th century to two successive members of

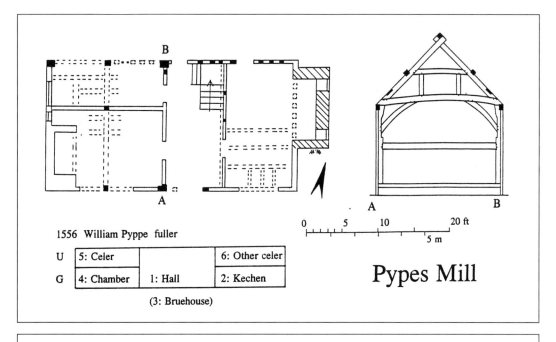

1556 William Pyppe fuller

U	5: Celer		6: Other celer
G	4: Chamber	1: Hall	2: Kechen
		(3: Bruehouse)	

Pypes Mill

0 5 10 20 ft
5 m

Pypes Mill has two unequal bays, the main truss with very heavy posts (12 in. square) and curved braces. The walls are close-studded, also with exceptionally large timbers, standing on a high sill (mostly removed); they have intermediate storey posts. The mortices for an original window survive in the rear wall. The west room has an unchamfered transverse beam morticed into the intermediate posts, with large axial joists (8 in. across); a trimmer defines the stair position. The partition in this room is not original, but could be early. The east room (kitchen) has a massive sandstone stack, inserted as it cuts across the original stud mortices. Its ceiling joists are 6 in. across, with a trimmer for a second stair. The present stair is modern, probably replacing an earlier one. The partition between central and east room is an insertion, with flimsy studs, presumably added when the end chimney and floor were inserted. The present south door position is original, and that in the kitchen was an early addition.

The roof over the original hall (central and east rooms) is very heavily soot-blackened.

6a *Pypes Mill, Stoneleigh: plan, section and inventory interpretation.*

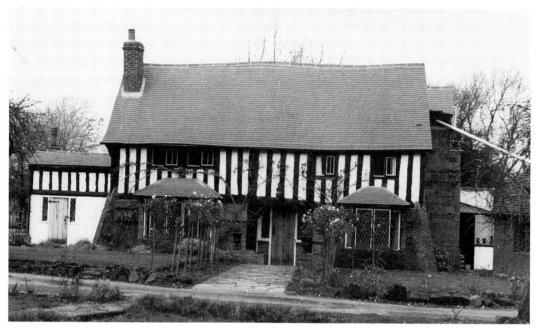

6b *Pypes Mill, Stoneleigh, from the south. A two-bay house built in 1490.*

the Pype family who gave it their name. Thomas Pype's inventory (1544) does not list rooms, but that of his kinsman William (1557) (**2**) complements the structural evidence for this precisely dated house.

2 *William Pyppe (fuller) (1557)*
He left his lease of the mill and all his goods to his wife Katren and son John, but his overseers were to take them over for the latter's benefit if Katren supported her brethren with them.

Inventory appraised by Peter Evotte and Wyllyam Lee, 16th February 1556[/7].

In the Haull			
2 Tabulles, 2 formis, one chere, 4 qwyscions; on halmere, pentyt clothes	5	0	
In the Kechen			
5 Pentyt [cloths, -] platers, 3 socers, a brason morter, a pestell, a latron bason, a chafynge dysche; 4 candylstyckes, 2 brasse pottes, 2 posnettes, 4 brasse pannis, a caldren; 2 spyttes, 2 goubyrones; a pere of pottehokes and hengges of yron	1	0	0
In the Bruhousse			
3 Lomes, 2 paylles, 4 tubbis, dyshes; trenchers, a steppefatte, a bultyg wyche [*boulting which*]; a kymnell, a chyrne, 2 wylles, a troyght, a tanker; cuppes and pottes	5	0	
In the Chamber			
A bedsted, a matrys, a coverlet, 2 bolsturs, a blanket, 5 pere of hurden schettes; one pere of flaxon schettes, a dyapur burdeclothe; a hourdon burdeclothe, 2 flaxon towelles, a lenen testur, a cheste, a coffer, a balons, 2 pentyt clothes, wyeght stones of ledde [*weights*]	1	6	8
In Aperell			
One clothe gowne, 6 clothe cottes, a wolstyd cotte, a dublet, 2 pere of housse, a pere of bottes; a pere of schoyes [*shoes*]	13	4	

<u>In the Celer</u>
Two bedstyddes, a feturbed, a flockebedde, a maturys, 4 coverlettes, 2 bolsturs
of fedurs; a pello, 2 testyrs,2 chestes 1 6 8
<u>In a other Celler</u>
A beddestydde, a laver, and 20 pounde of lede; 4 pounde of woll, 3 pounde of
flockes 5 0
<u>In Cattell</u>
2 Kyne, 2 herlynge [*yearling*] calves, 3 6 0
2 Mares, 5 colttes 4 0 0
33 Scheppe, of the qwyche 20 be hoyes [*hogs?* (yearlings)] 6 13 4
 Total 15 15 0

The six rooms listed show that the house had already been developed from the original two-bay house (which probably had three rooms, hall, chamber and solar[9]). For the kitchen, the furnishings and especially its painted cloths suggest that it was not a detached subsidiary building. Rather, the conversion of the house to its present form had probably taken place, giving three ground floor rooms, chamber, hall and kitchen. The small central hall would still have been open to the roof but the kitchen chimney and upper floor had been inserted (with the separate stair in the position shown by the ceiling joists). This would have carried the 'other celler', in contrast to the original one over the chamber. The brewhouse may well have been in a separate building with access from the rear door of the kitchen. It is notable that these developments converted a smaller than usual medieval house (two bays, though generous in size) into one of standard plan, with rather small rooms. Clearly this made the house more convenient for tenants of middling social status. The extra space was perhaps needed in the first instance for Thomas Pype's widow who was permitted to lodge in the house by his will. Accommodation was also needed for the apprentices (also mentioned though not named in his will). They may have bedded down in the mill itself, but a room with its own access over the service end of a house was traditionally the one used by servants,[10] so they may have slept in this 'other celler'.

The Hearth Tax assessments for a later tenant, Thomas Grissold, initially list two hearths. He is then said to have stopped one up, perhaps that in the brewhouse. His inventory (1674) does not include room names.

Motslow Cottage, Stoneleigh (Figures 7a & b) and Crew Farm, Ashow

As at Pypes Mill, the hall of Motslow Cottage was reduced in size at an early date, though here we cannot pin-point the change through inventory evidence. It is an excellent example of a medieval house with three ground floor rooms only, originally including a two-bay open hall. It thus matches the most usual early inventory type, although the sizes of the rooms differ from those of the other standing houses. In its social context, it resembles 1-2 Stareton (p.35). It was a freeholding, with one yardland (about 28 acres in Stoneleigh), and belonged in the 15th century to William Staleworth, *armiger*.[11]

By the mid 16th century, the house was owned by the Hudson family (until 1668 when it was bought by Lord Leigh).[12] No room-by-room inventories have been identified and the later development of the house cannot be followed in detail. The Hudson family also possessed a second and rather larger freeholding, Crew Farm, on the edge of Ashow and Kenilworth.[13] The present farmhouse is early 18th century, but Edmund Hudson's inventory (1556) gives a view of another freeholder's house. It must have been similar to Motslow but slightly larger, with four rooms, hall, chamber, kitchen and buttery, all probably on the ground floor.

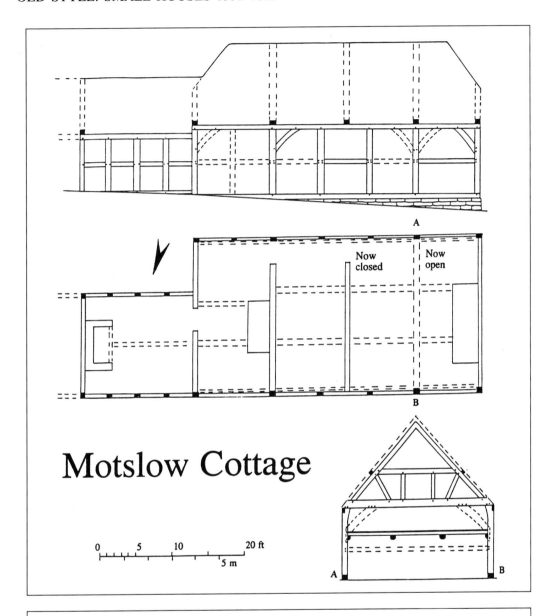

Motslow Cottage is of four bays, originally with a two-bay central open hall, though the central truss is unusual in lacking wall posts (a 'flying' truss). It is exceptionally wide (20 ft. span). The trusses are of the same form as at Pypes Mill, though not so massive, but the wall-framing uses square panels, with curved wall-braces. The entry appears to have been through the east end wall. The original house may date from the later 15th century.

Probably in the later 16th century, the hall was reduced to one bay and the end room enlarged. Possibly at the same date, the ceiling was inserted, carried on two main and two half beams (chamfered with step stops), and a narrow extension was built at the east end (later floored); this was probably the service end of the house. Later still (c.1700) a further bay was added at this end in very poor timber-framing.

7a *Motslow Cottage, Stoneleigh: plan, elevation and section.*

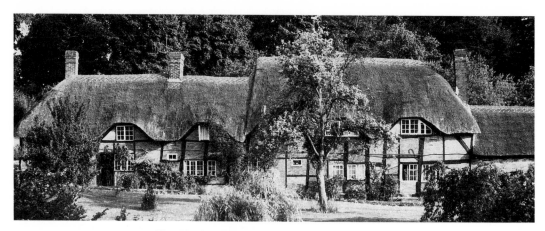

7b *Motslow Cottage, Stoneleigh, from the north.*

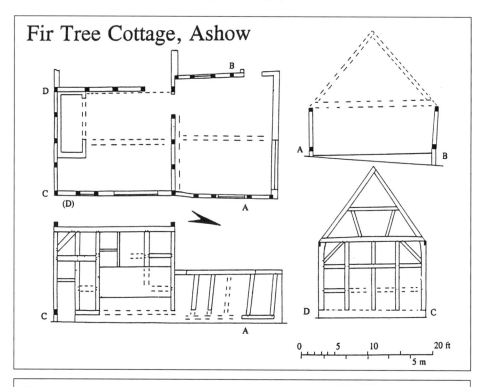

Fir Tree Cottage, Ashow

0 5 10 20 ft
5 m

The earliest part of Fir Tree Cottage is only a fragment, but its structure is remarkable. It is exceptionally wide (19 ft.) but only 6 ft. 6 in. to the eaves. The wall framing consists only of widely spaced studs without horizontals apart from sill and wall plate. Unfortunately, the entire roof structure has been removed. Its date can only be guessed as 15th to 16th century. The southern bay is 17th century (late?) and includes much re-used timber. It has an original fireplace and upper floor; the small joists have slight chamfers with run-out stops, and the beam has a scroll stop. The door was apparently at the south end against the stack (now blocked by the stair).

8 *Fir Tree Cottage, Ashow, plan, elevation and sections; the earliest part is the low right-hand bay.*

Fir Tree Cottage, Ashow (Figure 8)

This fragment of a medieval house with a 17th-century extension comes closest to matching Motslow as an early box-frame building. It is notable for its width and for the very low side walls, clearly those of a single-storey house.

Taken together, these two houses demonstrate the existence of an alternative early carpentry tradition to that of the cruck buildings of the parish (next section). An inventory of 1610 (**24**) probably describes the original house, but the 17th-century reconstruction means that it cannot be matched to the existing building.

1-2 Coventry Road, Stoneleigh (Figure 9)

This house also has a three-room ground floor plan, but on an altogether smaller scale than Motslow Cottages, befitting the much lower status of its occupiers, several of whom were craftsmen - and not very prosperous ones; it was associated with six acres of open field land. Two 16th-century inventories (**3**, **4**) relate to its tenants. The first is notable as the earliest surviving inventory with room names.

3 *John Allyt 'wayfer' (weaver) (1537)*
He was tenant of a cottage in Stoneleigh (rent 5s.) only from 1533, and died intestate.

Inventory appraised by Ryc' Heyll, Thomas Baker and John Le, 15th March 1536[/7].

In the Hall		
A hangyng of penyt cloth		8
A small taboll with 2 formys	1	0
A cobbord and 2 stolles	1	0
In the Cha[m]bor		
A hyngyng of penyt cloth		8
2 Beydstedes		8
A feyderbeyd with 2 bosters	5	0
5 Pellos		10
3 Mattres	5	0
4 Couforletes	3	4
A conttor [*counter*] tabell and 3 cofferes	6	8
In the Kychin		
3 Bras Pottes & a pan	6	0
2 Spettes and a payr of gobordes [*cobirons*]		8
4 Candelstekes		6
3 Peyttor deyssys	1	0
A bruyng fatt	2	0
In the Schop		
A brodlom and all sych geres that longyth to the sam; 3 Narrow lomys and that belongyth to them	26	8
20 Pond of whyt wollon yarne	5	0
4 Ston of woll	16	0
In hys aperell		
A vyollet gown ford [*furred*] with blake lambe and a gown of tamy [tammy] leynt [*lined*] with blake knyng[*coney?*]	16	0
A scelfed [*sleeved*] jaket of blake; a scleffles [*sleeveless*] jaket of blake	4	0
A gown of vyolled for a woman	4	0
In a Hous of Postellment [*place to keep savings*]		
In the sayd hous the sum ther of	10	0
In Napre		
3 Payr of schettes	2	0
A taboll cloth		8
10 Yardes of lenyn cloth	2	6

5 Schetes	5	0
A taboll cloth of dapore;a pleyn taboll cloth	4	0
5 Towells	4	0
4 Schortes	1	4

The gros sum 6 17 3

4 *Henry Waren (fuller) (1597)*

He was the son of William Waren of Fletchamstead (d.1562), and was himself succeeded by his son Thomas. He took over the tenancy of his cottage at some date between 1551 and 1559, and from the 1570s jointly held the fulling mill at Stoneleigh Abbey. He was frequently appointed as juror, tithingman, thirdborough and ale-taster. (Fulling is a process in finishing newly woven woollen cloth. It is steeped in urine, treated with fullers' earth, to absorb grease, and beaten mechanically [in the mill] to thicken it. It is then stretched between posts [known as tenters], attached to tenter-hooks, the nap raised with teazels and cut off with large shears on a shearing board.)

Inventory appraised by Robert Baker, James Hoo, Richard Durham and Thomas Hunt, 24th October 1597.

His apparell	13	4
5 Paire of sheetes	16	0
2 Boardclothes	4	0
3 Shirtes and a wiper or handtowel	3	0
One flockbed in the <u>Parlour</u> and a bolster, one hilling and a blanket and the bedstead	20	0
One flockbed in the [Saller, erased] <u>Chamber</u> a bolster and a blancket and a twylliclothe with the bedstead	13	4
In the <u>Shoppe</u>, one flockkbed, a bolster and one paire of sheetes, a blancket and a twylliclothe	16	0
2 Cofers	4	0
[Probably the Hall]		
One table, 2 formes and the benches	6	8
One chaire and 2 stooles		12
One payle and 2 lomes and a barell	2	0
Half a dozen dishes and half a dozen trenchers		4
2 Brasse pottes and a kettle	10	0
One platter, 3 pewter dishes, 2 sawcers, and two saltsellers and one candlesticke	2	6
One axe and a hatchet, a byll , an adds, one auger	4	0
A broche, a pair of tonges, a paire of cobyrons and a paire of pothookes and pothangers and a brandyron	2	4
One tenand sawe	2	0
For walkers earth	1	4
Cheeses	10	0
3 Paire of sharman sheres	20	0
One cart and two harrowes	13	4
2 Lathers and certaine bords	?5	0
Certain wood in the yard and a field	13	4
2 Acres a rye	40	0
2 Acres in Forwardmore	26	8
His hay	40	0
His corne in the barne	20	0
3 Kyne and heifer	6 0	0
7 Sheepe, yong and old	25	0
A grey mare	1	0
One store pigg	5	0

Total 24 13 2

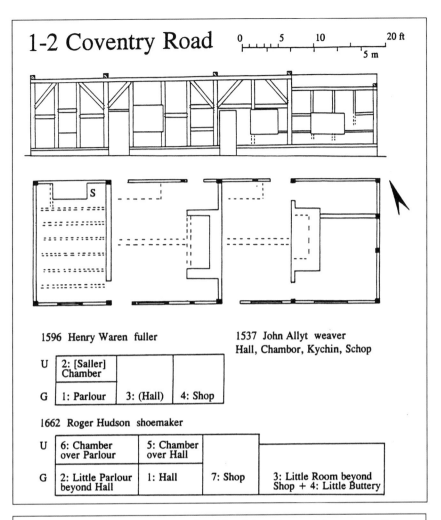

1596 Henry Waren fuller

U	2: [Saller] Chamber		
G	1: Parlour	3: (Hall)	4: Shop

1537 John Allyt weaver
Hall, Chambor, Kychin, Schop

1662 Roger Hudson shoemaker

U	6: Chamber over Parlour	5: Chamber over Hall		
G	2: Little Parlour beyond Hall	1: Hall	7: Shop	3: Little Room beyond Shop + 4: Little Buttery

The original part of 1-2 Coventry Road is of three bays, with an upper floor at the west end carried on 4 in. square joists (with trimmer for a stair). Although the external framing appears to be of standard Type III form with straight diagonal braces, close inspection shows that these were inserted, pegged at the bottom but crudely lapped over the studs at the upper ends. The original framing probably had a simple pattern of studs with mid-rails, as found in some late 16th-century houses (e.g. 8-9 The Bank, left side of Figure 10b).

The lintel of the inserted fireplace and ceiling beam in the central bay are chamfered and roughly stopped; the beam in the east bay lacks stops, and its fireplace is late. A bay was added at the east end in the 17th century; its wall plate was raised in the 1930s to align with that of the original house.

9 *1-2 Coventry Road, Stoneleigh: plan, elevation and inventory interpretation. The diagonal braces are insertions. (Elevation of lower bay redrawn from a 1920s photograph kindly loaned by Mrs. S. Thorley.)*

1-2 Coventry Road is certainly a 16th-century open-hall house, but on architectural grounds it dates from the later part of the century, not the 1530s. Although John Allyt had the same number of rooms as Henry Waren, he therefore lived in the predecessor of the present building, presumably a single-storeyed medieval house. The match with Henry Waren's inventory is easy, given the assumption that the name of the hall has been omitted. The correction in the inventory from 'saller' to 'chamber' is particularly helpful in indicating that this was the upper end room, over the parlour. A further inventory, that of Roger Hudson (1662), gives a good list of the rooms

but describes most of the contents as 'other lumber'. It shows the addition of the chamber over the hall and of the final bay to the house, containing 'a little room' and a little buttery; the term 'little' is used in several inventories for what appear to have been axially divided rooms.

6-9 The Bank, Stoneleigh (Figures 10a & b)

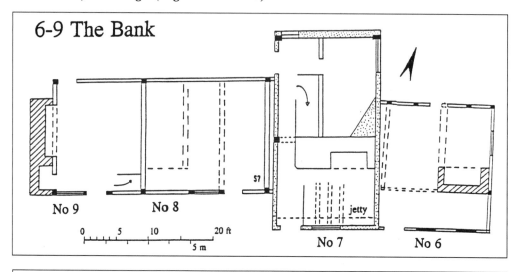

The earliest portion of this complex house is the single bay at the east end (no. 6), originally part of a longer structure. Its western part was replaced (probably by the mid-16th century) by a jettied two-bay crosswing, containing a large fireplace (no. 7); this has large curved braces to the gable tiebeam and the upper floor is carried on square joists. In about 1600, a further two bays were added to the west and still later, a lean-to was built in front of the original bay. The suggestion (*Stoneleigh Houses*, p.193) that the western bays were a separate house is not supported by the documentary evidence, though it may have been separately occupied from time to time. In 1813 (*Map*), six people are named as occupants of the whole house.

10a *6-9 The Bank, Stoneleigh, plan.*

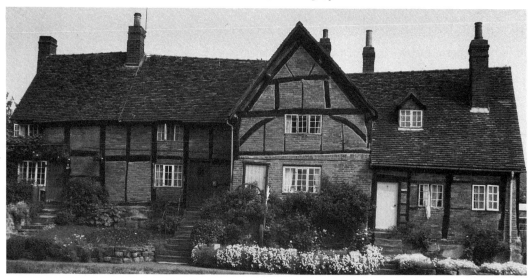

10b *6-9 Bank, Stoneleigh, from the south.*

Architecturally, this house is more complex than those just considered, and it provides an important corrective, in indicating that a simple inventory can sometimes have hidden complications.

The house seems to have reached its present form by about the middle of the 16th century, but the match with the characteristic hall, parlour and kitchen, named in the inventory of John Lorde (1557), is apparently non-existent.[14] It would seem therefore that the addition of the cross-wing must have taken place after this date, and that the inventory must relate to the original house, now represented only by the eastern room. However, in the kitchen, after the churn and two vinegar barrels, the appraisers listed four bedsteads (the only beds in any 16th-century kitchen). A reasonable explanation is therefore that they had gone upstairs to the upper rooms in the cross-wing. This suggests that by 1557 the house had the hall and cross-wing pattern we see today. The kitchen, which had the only fire-irons in 1557, must have been the front room of the wing, with the parlour behind it and the hall in the older part of the structure. The fully developed house is recorded in 1670, in the inventory of Edward Stirton, tailor. He had a 'hall or kitchen' and a parlour, corresponding to the front and back rooms of the wing, with two chambers over, and a buttery in the former hall (apparently still unfloored). One of the two newer rooms (8-9 The Bank) was his shop, which also contained three spinning wheels, while the 'room next to the shop', containing barrels and a dough trough, was a general purpose service room. John Lorde held only three acres, and it remains a mystery why this unusually well-built house was associated with such a modest land-holding.

1-2 Stareton (Figures 11a & b)

The excellent documentary evidence for this house shows a characteristic sequence of development up to the moment in the late 17th century when it reached its present form. It was associated with a half-yardland holding, corresponding to about 27 acres in the open fields, and was the only freeholding in Stareton; in the early 16th century it was granted to the Blacksmiths' Guild of Coventry, to support an obit.[15] In July 1555, it was leased by the blacksmiths for 31 years to Thomas Tuter of Stareton, husbandman, with a covenant that he would within two years:

> build and set up in the said messuage one chymney of stone, and make a chamber flower
> over one parler ther of tymber and bordes with dors and wyndowes to the same.[16]

He had to do this within two years, but he died at the beginning of 1558, and his inventory (**5**) shows no evidence for the upper floor.

5 *Thomas Tuter of Stareton, husbandman (1558)*
He left a widow, a son (to inherit his lease) and seven daughters (probably still children).

Inventory appraised by Alexander Hoo, Thomas Kockes, Rychart Granger, 4th February 1557[/8].

In the Haull			
On borde, on haulmere, 2 cherys, 3 pottes, 4 cauldruns, 16 pecys of peutur, a fryne panne; a scemer, a chaffydysche, 3 candylstyckes; a byll a axe, a hachet		10	0
In the Chamber			
3 Beddes, a matrys, a flockebed, 2 coverynges; 3 twylleclothes, 2 bagges, lynen yorne, 2 coufres, 2 quychenys, a flaxon schette, 5 hurden schettes		10	0
In rement 2 gackettes, on dublet, a pere of housse, a hatte, 3 surttes, on tabulclothe, on towell; 3 bolsturs, 3 pelloyes, 4 poundes of wolle; a toye [perhaps troye = sieve ?]		5	0
[Probably the Kitchen]			
2 Lomes, 2 paylles, a troye [*trough*?], a bultyg [*boulting*] tubbe; seffes, a pere of pottehokes, a spytte; a pere of goubyrons		2	0
4 Oxon, 3 kyne, 3 caulves, a mare and 6 scheppe	6	0	0
A wayne, youkes, towyes, a haro, a ployght		16	0
In corne and heye and on hyve of beys		3	4
4 Hennes and a kocke, with other trym tram		1	0
	Total 8	7	4

The two rooms named in this inventory might be matched with the two-room plan of the existing house, but it seems likely that the group of pots and fire irons listed after the apparel was in the kitchen of a three-room house. Thomas's widow, Ales, died in 1562 but her inventory gives no room names, illustrating the danger of equating such an inventory with a one-roomed house. Their wills leave no doubt that both inventories relate to the same house. Thomas left his lease to his son, with Ales allowed to reside there during widowhood, but she charged her daughter Avis with the upbringing of two younger daughters, and gave:

> my goodwill to have the rest of the years I have of my house after my decease ... desyring my landlord to be good unto her in it for the poore innocens sake. The cause why my goodwill is not that my son Thomas Tuter should not have it according to his father's menyng is that he hath contrary both to God's laws and his father's will disordered himself towards me his mother and his poore sesters both with evell wordes and strockes, therefore I dare not commit my trust to him as I do to his sister Avys.

The next tenant of the Blacksmiths' freehold was Simon Tyler, whose inventory (1575) (**6**) gives the same picture as that inferred for Thomas Tuter: a three-room house with hall, parlour and kitchen, lacking upper rooms.

6 *Simon Tyler of Stareton (1575)*
He took over the tenancy in about 1566 and died intestate, leaving a widow Isabella (from the administration grant) but no recorded children. He was on notably bad terms with his neighbours, fined in the manor court twice for making an affray (1566, 1567); for letting his pigs into another tenant's close to destroy his grain (1575); for putting his sheep into the Rye Field against the will of the other inhabitants (1575); for his wife and another tenant's wife carrying away their neighbour's hedge (1569).

Inventory appraised by Alyxsaunder Howe, Thomas Holland, Simon Grouwer, 24th May 1575.

In the Parler			
A bed with the appurtenances, and 2 peyr of sheites and 3 couffers and 2 paynted cloathes		6	8
In the Hall			
A table, a forme, a cubbard and other implementes in the Haull		6	8
In the Kechen			
Brass and pewter in the kechin		6	8
2 Keine and a callf	2	13	4
One mare	1	0	0
2 Pigges		3	0
The poulterie		2	0
Corne in grasse	4	0	0
10 Shepe	1	10	0
His reparell		5	0
Total	10	13	4

Although Thomas Tuter may never have put in the chamber floor, the improvements he was required to make were characteristic of the beginning of the housing revolution. More evidence of the insertion of chimneys at this period comes from the will of William Waren of Fletchamstead (1562), which states 'I will that a chymne be made'; his house was equally simple, with hall, chamber and kitchen.

After Sir Thomas Leigh's purchase from the Blacksmiths' Guild in 1598, the next inventory descriptions of the Stareton house (1616 and 1640) list six and seven rooms:

> 1616: Leonard Hemmings, husbandman. Hall, Bedchamber, Chambers above, Nether House, Boulting House, Mylke House

> 1640: John Heminges, woker (fuller). Chamber, Upper Chamber, Other Chamber, Hall House, Buttery, Nether Roome

In the Hearth Tax it has only one hearth, showing that the 16th-century kitchen had been replaced by an unheated service room.

In 1679, Lord Leigh leased the farm (now with 31 acres) to Richard Camill, 'his servant', for life 'in consideration of his true service' (SBT.DR18/1/1113), though he only occupied the house from 1685 (probably when Joseph Hemmings died). He must then have reconstructed the house in its present form, with a compact two-room lobby-entry plan, with two chambers and attic rooms above them. His stone chimney has back-to-back ground floor fireplaces and another fireplace on the first floor for his bedroom. Remarkably, he kept the decorated fireplace beam that had been inserted a century earlier, while he renovated the house around it.

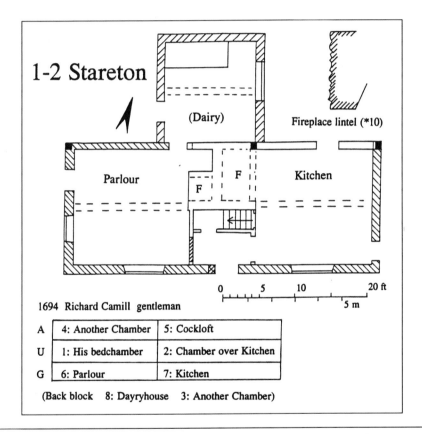

1-2 Stareton

(Dairy)

Fireplace lintel (*10)

Parlour

F

F

Kitchen

0 5 10 20 ft

5 m

1694 Richard Camill gentleman

A	4: Another Chamber	5: Cockloft
U	1: His bedchamber	2: Chamber over Kitchen
G	6: Parlour	7: Kitchen

(Back block 8: Dayryhouse 3: Another Chamber)

The two-room lobby-entry plan house, is now cased in brick apart from part of the rear (north) wall which retains timber-framing with short straight braces; the stair rises to give access to the attics. The house was probably rebuilt in the late seventeenth century. Two roof trusses (principals and collars, one with incurved feet) flank the central chimney. This is of ashlar sandstone and has a remarkable 16th-century moulded lintel for its larger fireplace. The ceiling beams are chamfered, that in the east room with simple run-out stops and the other with straight-cut stops. In the late 18th century, the house was refronted in brick in a characteristic estate style with a projecting plat band and with single brick-on-edge segmental window arches; this was used, for example at Dale House Farm (c.1775) and 16 Birmingham Road, Stoneleigh (1767). The brick rear range was probably rebuilt in brick when the main range was cased. It has a chamfered but unstopped beam. In the 19th century the house was detached from its land and divided into two cottages.

11a *1-2 Stareton: plan and inventory interpretation.*

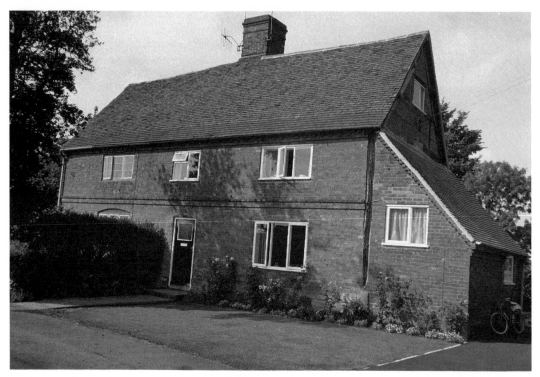

11b *1-2 Stareton. Eighteenth-century brick-casing of a late 17th-century timber-framed lobby-entry house.*

His eight-room inventory (1694) (**7**) shows a lifestyle transformed to match the house. The two main rooms were the kitchen and parlour (notably a living, not a sleeping room), and the dairy in a rear block. The best bedchamber was over the parlour with other chambers over the kitchen (perhaps for the children, with a cradle ready for the new baby), and the dairy (with the linens in a trunk). One attic room, called a chamber, held corn and cheese, while the other (the cockloft) was in fact a bedchamber.

7 *Richard Camill of Stareton, gentleman (1694)*
Richard Camill and Elizabeth Holloway were married in 1683 in Ashow, and their eldest daughter, Sarah, was probably born soon afterwards. The death of a widow Elizabeth Holloway is recorded in 1684, but no other references to the family have been found, suggesting that the daughter (and perhaps also the mother) was a servant at the abbey, like her husband. He is termed 'gentleman' in the manor suitor lists. The baptisms of two other children are recorded, Holloway (1691) and Mary (July 1694). His widow was tenant until her death in 1709, when Holloway followed her (at the tender age of 18). He held the farm until 1760, followed by his widow and son Thomas, tenant until his death in 1815. It is notable that from about 1578 (when Leonard Hemming was first named as a Stareton juror) till then, the farm was held only by these two families. There was an apparent interruption from 1645 to 1674 when John Lynes (died *c*.1652) and then his widow Anne were tenants, but it is very probable that Anne was the widow of John Hemming, the previous tenant. Joseph Hemming who took over at her death was almost certainly John's son, noted as less than 15 years old in the latter's will (1640).

Inventory appraised by Edward Croft, Francis Casmore and Francis Clayton, 17th January 1693[/4] [PRO.PROB4/25461]

His wearing apparrell and money in his purse	10	0	0
In his Bedchamber			
One bedstead, a feather bed and boulster, two pillowes, a paire of blankets and a coverlid, six cheires, two stools, one blanket, two glasses, one paire of andirons, a fire shovell and tongues, and a paire of bellowes	6	18	0
In the Chamber over the Kitchen			
Two bedsteads, two featherbeds and boulsters, a rug and two paire of blankets with a sett of curtaines and vallance, a chest of drawers, two trunks, two boxes, a table, two chaires, two lookeing glasses, a cradle, a great bible and severall other bookes	9	6	0
In another Chamber			
One trunck, one paire of Holland sheets, foure paire of flaxen sheets, foure paire of hempen sheets, three table cloaths, two dozen of hempen napkins, foure paire of pillow drawers, a diaper table cloath and one dozen of diaper napkins	7	0	0
In another Chamber			
Wheat and rye, a parcell of chese, one paire of bucketts and some other implements	8	15	0
Twelve pound of yarne		16	0
In the Cockloft			
One paire of bucskins, two paire of doe skins, a bedstead, a flockbed, a boulster, three blankets, two spinning wheels, a parcell of woollen yarne, a still and severall other implements	3	18	0
In the Parlour			
Two tables, six leather chaires, foure other chaires, a paire of andirons, fire shovell & tongues	2	0	0
In the Kitchin			
Three brasse kettles, two brasse potts, three skellets, a warming pan and a fryeing pan	2	10	0
Seaven pewter dishes, a cheese plate, a pye plate, two dozen of trenchers and plates, three fowling peeces and a jack	2	10	0
Two spitts, a dripping pan, a paire of racks, a paire of andirons, fire shovell & tongues, pot hookes and hangers		15	0
Foure chaires, a bacon rack, two tressel boards, a chopping knife, a cleaver and two tables		10	0
In the Dayryhouse			
A cheese presse, six barrells, two tubs, a churne, two kimnells, three pales, a dough cover [kiver], a trencher rack & 3 dozen of trenchers	1	10	0
2 Flitchins of bacon	1	0	0
Six milch cowes, 5 heifers, 2 calves	42	0	0
One mare or nag & a filly	13	6	8
Thirteene sheepe	6	10	0
Eleaven lambs	3	6	0
One hogg	2	0	0
A parcell of oats in the barne	2	10	0
A rick of hay and hay in the barne	7	0	0
Three acres of corne growing on the land	4	10	0
Nine silver spoones	3	0	0
Implements & other things forgotten		5	0
Debts sperate & desperate	201	0	0
Total	343	15	8

Cruck Houses

The cruck-built houses are the most remarkable group of medieval houses in Stoneleigh, providing our best insight into the character of medieval Warwickshire villages. Four almost identical houses in Stoneleigh village are of three bays, while two more now contain two bays. In addition, one Ashow house contains a cruck truss and in two Stoneleigh houses cruck blades are reused as tiebeams.

Of the six cruck houses in Stoneleigh, four—(a) 1 Birmingham Road (Figures 12a & b), (b) 22-25 Birmingham Road (Figure 13), (c) 2 Church Lane (Figure 14), (d) 8-9 Vicarage Road (Figure 15)—are very similar in structure. Each is of three bays, with evidence (definite or probable) for one being floored; in (a), the floor has been removed, but the mortice for its transverse beam remains, while in (b), the beam is visible, but the joists are concealed. Three houses have confirmed soot-blackening in the central bay (a, c, d) from the hearth in the hall, and two also show traces in the unfloored end bay (a, d). The original wall-framing is well-preserved in (a) (Figure 12) and (b), but has been replaced in (c) and (d). For (a), the probable door position in its lower bay is indicated by a stud for a door jamb, but no window positions can be identified. None of the houses had any original decorative features, though they differ in the quality of their carpentry. Wind-braces were used in all bays of (c) and in the central and inner rooms of (a) and (d)—not visible in (b).

2 Church Lane has the best-formed crucks, though its two complete bays are notably shorter than in (a), (b) or (d). The inserted parlour ceiling has chamfers and step stops for the joists, the central beam and the one surviving side beam; the joists run behind the chimney, showing that to be a later addition (present in 1675 as a screen is listed in inventory **11**). The inserted ceiling beam in the hall is scarfed to the projecting end of that of the parlour; it is

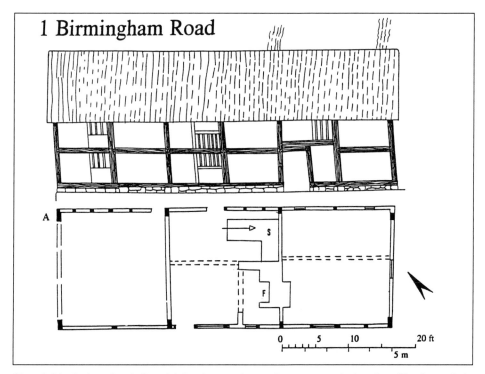

12a *1 Birmingham Road, Stoneleigh, plan, section and reconstructed elevation. The form of the doorhead is unknown, and the windows are entirely hypothetical both in position and form.*

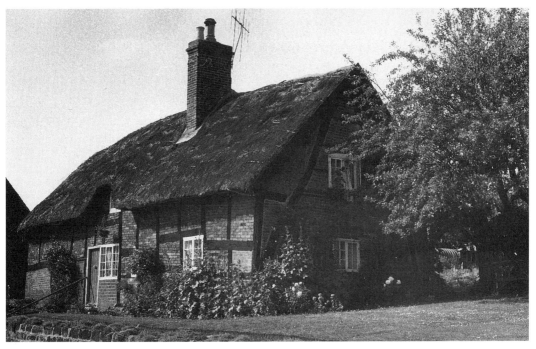

12b *1 Birmingham Road, Stoneleigh, from the south.*

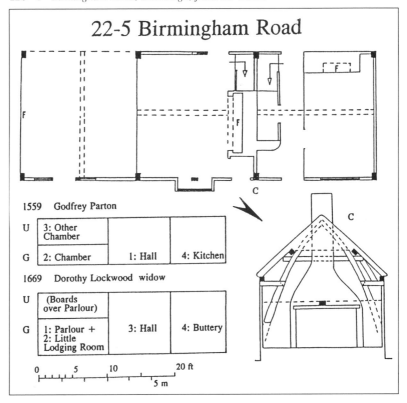

22-5 Birmingham Road

1559 Godfrey Parton

U	3: Other Chamber		
G	2: Chamber	1: Hall	4: Kitchen

1669 Dorothy Lockwood widow

U	(Boards over Parlour)		
G	1: Parlour + 2: Little Lodging Room	3: Hall	4: Buttery

0 5 10 20 ft

5 m

13 *22-5 Birmingham Road*

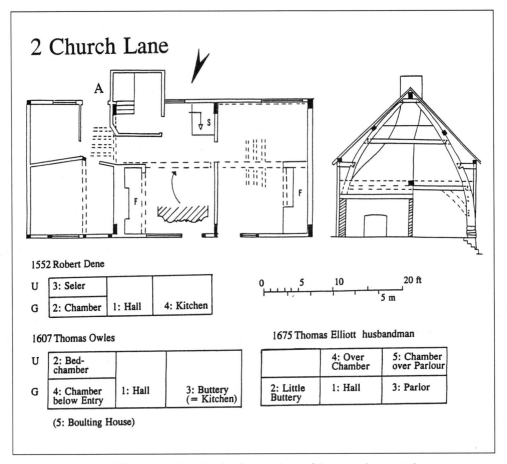

14 *2 Church Lane, Stoneleigh: plan, section and inventory interpretation.*

moulded (though reused). The hall joists are also chamfered and stopped and have a trimmer for a stair (in the position of the present stair). The cruck truss at the east end has been replaced with a tie-beam truss. This bay was probably shortened at the same time, requiring the adjoining section of the original floor joists to be replaced; a beam was also inserted for a passage partition.

8-9 Vicarage Road gives the clearest plan evidence of any of the cruck houses. The west bay has a chamfered transverse beam with the heavy square joists of an original floor. A trimmer beam identifies the position of the ladder stair, while the mortice for a post shows that the bay was subdivided. The east bay has an axial beam, chamfered with straight-cut stops, and the central bay has a very rough axial beam, probably inserted last, well after the addition of the chimney whose lintel is considerably better finished.

Of the other cruck houses, 3 Birmingham Road has two bays, now almost entirely brick-cased; the west end was reconstructed in the 17th century with a cruck blade re-used as the tiebeam, and the house might have been shortened then. It has no original floors and lacks any decoration. Croome Cottage also has two cruck bays, with a square-framed added bay. Its curious situation, well outside the village centre and extremely close to the road ('e' on Figure 5), is explained by the documentary evidence. It first appears in the rentals in 1572 as a small holding cut off from a larger one, consisting of 'Barn Cottage and a croft adjoining'. Croome Cottage adjoins a large field called Barn Close, and was therefore probably converted from a barn in 1572;

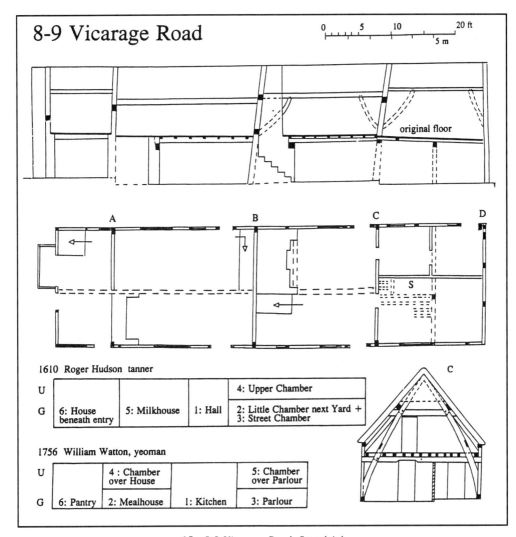

15 *8-9 Vicarage Road, Stoneleigh*

the third bay was probably added after 1600. The original wall-framing is too poorly preserved to show any distinctive barn features. Trinity Cottage, Ashow (Figure 16) contains four bays. The first two (inner room and hall) have box-frame trusses, and the closed cruck truss separates the third and fourth bays, which may have been service rooms (or possibly even for farm use); the structural evidence indicates that the cruck and box-frame sections are of the same date.

The documentary evidence throws little light on the difficult question of building dates for the cruck houses. For five of the nine houses (including those with re-used crucks), the tenants can be traced back through the rentals to 1533 (before which there is a gap) and to 1522 for two others. None show changes of rent that might indicate new building. Of the others, Croome Cottage formed part of another holding before 1572, while Trinity Cottage, Ashow cannot be traced before 1566. The Ashow rentals for this period are very confused, and its apparent earlier absence is not significant. Rentals are lacking for the two former Kenilworth Abbey properties (2 Church Lane and Bridge Cottage) before 1550, but they can be identified in the Stoneleigh return to the 1522 Certificate of Musters (SBT.DR18/30/24/85).

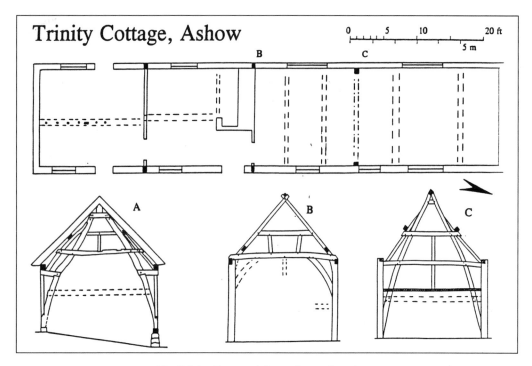

16 *Trinity Cottage, Ashow, plan and sections.*

Definitive evidence of the medieval dates for these cruck houses has been obtained recently using dendrochronology. This indicates late 15th-century dates for two of these houses (1 Birmingham Road and Trinity Cottage), and an early 16th-century date for a third (22-5 Birmingham Road). In Warwickshire generally, cruck houses have been dated between the late 14th and early 16th centuries [N.W.Alcock, R.R.Laxton, C.D.Litton, in preparation].

Correlation with the rentals and surveys demonstrates that despite their structural similarity, they had very different economic and social contexts (Table 4.3). The status of some tenants more obviously match these small landholdings than do their substantial and well-constructed

Table 4.3: *Cruck houses and their land*

The houses are in Stoneleigh, apart from Trinity Cottage, Ashow.

House address	Land in 1597		House size
	House and croft	**Field land**	
	(r = rod; p = perch)		
1 Birmingham Road	2r 24p	-	3 bays
3 Birmingham Road	30p	-	2 bays
22-5 Birmingham Road	1r 20p		3 bays
(After 1575)	3r 36p	2ac	
Croom Cottage,	3r 16p	-	2 cruck bays; probably
Birmingham Road	-		converted from barn in 1572
2 Church Lane	1ac 3r	14ac	3 bays
8-9 Vicarage Road	2ac		3 bays
Trinity Cottage, Ashow	1r	15ac	4 bays (1 cruck truss)
10 Vicarage Road	3r 30p		reused cruck blade
Bridge Cottage	3ac 1r	28ac	reused cruck blades

houses. From 1533 to 1551, 1 Birmingham Road was occupied by John Hoygskyns (or Hodgkins), and then until 1571 by his widow Joan. He is only recorded in the court rolls as an occasional juror. For her, they note the heriot paid as a cottage tenant on her death; her best possession was a *broach* (spit), valued at no more than 4d. She was succeeded by John Jones and he in his turn by his widow, Elizabeth (tenant 1589-1606). Their occupation was that of ale-brewers and sellers, typical of the poorest cottagers. 'John Jones' wife' (later widow Jones or Elizabeth Jones alias Jenkyn) was presented at virtually every court for breaking the assize of beer. In 1585 John was fined 1s. for allowing four villagers to play cards in his house. He was once ale-taster (surely a rash appointment) and once tithing-man, but otherwise played no part in village government.

None of these tenants left inventories, but two do relate to tenants of higher status living in cruck houses. In that of Godfrey Parton (1559) (**8**), the hall, chamber, other chamber (presumably upstairs) and kitchen fit exactly with his three-bay house (22 Birmingham Road, Stoneleigh; Figure 13).

8 *Godfrey Parton (1559)*
He was tenant only from 1550, though he was possibly the son of John Parton, recorded in Stoneleigh in the 1530s. The main information about him comes from his exceptionally detailed will. He had a wife Alice (who did not follow him as tenant) but no children, though he bequeathed 20s to each of his godchildren. As well as numerous personal bequests, he left a cow to the church wardens to be hired out, its rent paying to light 12 torches; 2s to each of 27 poor houses; 5s each to mend the stone bridge and 'Hudson's bridge' (leading to Motslow); 5s each to the poor of Baginton, Stareton, Bubbenhall, and Ashow, and 10s to those of Kenilworth.

Inventory appraised by Edward Sotheron, Thomas Dene, 19th April 1559.

In the Haull			
On tabull, on fourme, a lyttel tabull, 3 pentyt cloyes, 2 cherys, a lyttel cuppeborde, 5 qwssyons, a pere of pottehokes		3	4
In the Chamber			
On bedde, a matryes, on bolstur, a hyllinge, on blanket, a twylle, 2 pentyt clothes, a banker, 2 coffers, 8 pere of herden schetes, 2 bordclothes, 2 towelles, 6 napkens, 2 pere of flaxon schettes	1	0	0
In Rement			
A gaket, a gyrken, a pere of housse, a dublet, 3 scurttes, 2 clokes, a hatte		5	0
A bedde with a feturbede, a hyllynge, a bolster, a curten, a lyttel coffer;			
In a other chamber a bedde with a feterbed, a bolster, a pere of blankettes, a coverynge, a curten, 2 pentyt clothes, a fetherbed, 4 pylloyes, 2 coverlettes, a bolstur; a twylcloth, 2 bagges	1	6	8
A flockbedde, 2 bolsturs, a hylly		1	8
In the Kechen			
6 Pottes, 6 pannes, 4 kettelles, 2 dobnettes, one skellet, a scemer, a brandart, a pere of goubyrons, 2 spyttes	1	0	0
3 Fattes, 4 herthen pottes, 2 sutars; 4 chesfattes		3	4
A baket [*basket*?], a knedyng troye [*trough*], a saltte tubbe, a bultyng fatte, 2 barelles, 2 lomes, 4 paylles; 2 kymnelles, a strycke, a chyrne, 3 syffes		2	0
2 Axes, a hachet and a handebyll, a pere of herdencomys, 3 nougers [*augers*], a naddis [*adze*]; a homer [*hammer*], a pere of pynssons [*pincers*]		1	8
3 Quarter of mallte, 3 quartar and a halfe of rye	3	0	0
In Cattell			
4 Kyne, 4 yonge bestes, 2 steurys, 6 swyne and 6 scheppe	6	13	4
3 Basons, a chaffyedysche, a fryne panne, 13 pecys of peutur, 6 condylstyckes, a salte		5	0
3 Loudes of wodde		3	0
4 Flechens of baken		10	0
	Total 14	15	1

He had considerably more crops and stock than could be supported by his very small holding, and he must have farmed additional land, perhaps in Baginton where he had family connections (with the gentry family of Goodier).

The 1669 inventory of Dorothy Lockwood for the same house shows that it had changed very little in the ensuing century:

> 1669: Dorothy Lockwood, widow: Parlour, (boards over the parlour), Little lodgeing room, Hall house, Buttery

Indeed in one respect it seems less developed, with the only indication of an upper floor being the valuation of the boards over the parlour.[17] Her hall and buttery must correspond to Godfrey Parton's hall and kitchen. As well as a bed, the 'little lodgeing room' contained a barrel and garden tools, so is likely to have been on the ground floor. The upper end of the house may have been axially divided (as at 8-9 Vicarage Road, p.42), or this may have been a small lean-to room.

Robert Dene's holding (2 Church Lane, Stoneleigh) was the largest among the cruck houses, and this appears both in his overall wealth and in the crops and farm stock listed in his inventory (1552) (**9**).

9 *Robert Dene (1552)*

His holding was former Kenilworth Abbey property, which had been occupied by his father, Robert a Dene, a miller in 1522; Robert the son also rented a shop (from 1536). The latter's son Thomas took over this shop in 1552, when he became tenant of a different Kenilworth Abbey property, and he was frequently cited in the manor court as a common butcher, perhaps also his father's trade (possibly using the broad and little boards noted in the inventory). Robert left specific household furnishings and valuables (spits, cobirons, aumbreys, silver spoons) to his wife, his two sons and his daughter. His will also mentions a house in Coventry that was to be sold but which (as real estate) is excluded from the inventory; this might have been worth about £10.

Inventory appraised by Thomas Burbere, Thomas Donton, Wyllyam Ferre, 8th June 1552.

In the Halle			
A folden tabull, a halmere, a coffer, 2 cherys; 6 quyscions, 2 fourromes, pentyt clothes		11	4
In rement			
A gowne, 2 dublettes, 3 jackettes; 2 pere of housse, 2 scurttes	1	0	0
In the Chamber			
A beddestyde, 2 coffers, a wyche, a chere; a halmere, a lyttell fourm	1	0	0
In the Seler			
3 Bedstyddes, 2 coffers and a lettell sprusse coffer		2	4
In maslen 2 basons, a laver, 14 candelstykes, a morter of brasse, 2 salttes, 3 peutur pottes, a chafyng dysche, a iron pannar, and 3 leden wyghttes		14	0
In the Kechen			
15 Pecys of putur, 4 pottes, 3 posnettes, a chafin; 4 brasse pannys, a scellet, a scymmer, a pere of pottehoukys with a chene, a grydyron, a pere of tonnges, 5 spittes, 5 gouberttes [*value given as* xlxis]	2	11	0
3 Lomys, 2 fattes, 4 payllys, dyschys, trenchers with oder implementtes		2	0
In Beddyng			
2 Feturbeddes, 2 matreys, 2 coveryngs, 2 coverlettes, 2 twylly schettes, 6 pere of schettes, 4 bosturs, 3 pylloys	2	7	8
3 Bagges, a feu pentyt clothes, 2 heggyns, 3 yron wegges; 2 axys, a hachet, 2 byllys, 2 nougars [*augers*], a pere of pynssouns; a brodde bordde, 2 lyttell borddes		4	0
2 Stolys, a strycke, 2 maltte syffes, a hoppe		2	0
5 Towelles, 4 bordeclothes		3	0
6 Selver spones		12	0

12 Quartar of maltte, 2 quartar of rye	7	0	0
4 Oxon, 2 sterys, 6 kyne, a heryng [*yearlyng*] calffe; a mare and a coltte	16	0	0
5 Score and 10 scheppe	12	0	0
6 Swyne, 4 pygges, 2 hennes and a kocke	1	2	0
13 Acurres of rye, 9 acurs of wottes	6	0	0
A iron bounde wayne, 3 youckes, 3 touys, 6 hokes	2	0	0
A pere of scleddeyrons, 2 ploys, 2 scharys, on cultur; a oxe haro,			
2 smalle haroys		13	4
In wodde	1	6	8
Sum	55	12	2

However, his house is identical to that of Godfrey Parton, further illustrating the lack of dependence of house size on tenant status or prosperity. Robert Dene's second bedchamber, named 'seler', can definitely be located upstairs, both from its name and from the presence in the house of early joists at the north end (p.42).

2 Church Lane features in two further detailed inventories, given here to illustrate the range of evidence for an important house (**10, 11**). The structural evidence taken with the inventories shows that three major improvements led to the house being turned round in the course of the 17th century. These developments show characteristic patterns: extensions on the ground floor, the insertion of upper rooms and the disappearance of kitchens. Of course, the contents also reflect later living patterns.

10 *Thomas Owles (1607)*

He was tenant only from 1600 to 1607, though he seems to have been fairly elderly. He had a wife and four children, three still living at home; the fourth, Francis, who succeeded to the tenancy, had four children of his own. Thomas also owned a house in Coventry (left to his wife for life and then his eldest grandson), and held the lease of another (left to his son). The younger grandchildren had a cow each.

Inventory appraised by James Hoo, William Farr and Thomas Whithead, yeomen, and Henry Bellingham, clerk, all of Stoneleigh, 28th February 1606.

All his wearing apparrell		10	0
In the Hall one side table, one forme, two benches and a chere		5	0
One cubbard		5	0
In the Bedchamber on standing bed with two boulsters, one pair of sheets, two course hillinges		6	8
A little coffer with a bed hilling and two paire of sheetes therein		10	0
In the Buttery, two spinning wheels		12	0
Two brasse pottes, one pann, two kettles, a frying pann		13	4
Twelve peuter dishes and platters, one peuter candlestick, a [whit *erased*] brass candlestick, 2 salts, one chaving dish		13	4
All the dishes, spoones and trenchers			6
One pair of tounges, bellowes, with the pothookes and hangers in the chimney		1	4
In the Chamber below the entry, one bedsteed with a hilling upon it, on axe and hatchet, a bill, one old tubb, two steanes		3	0
In the Boulting House, three payles, one loome, one tubb, with all the shilves about the house		2	6
In the Barne, the ry unthreshed	1	5	0
Foure strickes of oates threshed		4	0
About 3 loades of hay	1	0	0
All the wood and muck in the yard	1	0	0
Five kine, one stear, one heighford	12	0	0
13 sheep	3	0	0
3 store swine		15	0
Six henns and a cock		3	4

Two flechons of bacon		5	0
A dozen of small cheses		3	0
Two acres of corne in grasse	1	13	0
Total	25	0	0

11 *Thomas Elliott, husbandman (1675)*

He was preceded by his father, Thomas (tenant 1650-55), a turner (*Q.S.* VI, 115, an indictment for taking 5 loads of wood belonging to Henry Tym) and then his mother, Patience (1655-66); his widow, Mary, remained as tenant until 1704. He had three children, born 1666-72. As well as being parish clerk [*Reg.*], he was Surveyor of the Highways in 1673.

Inventory appraised by Henry Philipps, Edwarde Godwarde and William Elliot, 28th April 1675.

Wearinge apparill and the purs		1	10	0
In the Hall				
4 brass ketles and one brass pott		1	16	8
5 putter dishes, one flaggone, 5 putter parengers, 1 salt, 1 candlestick, 2 sosors, 2 bassons			12	0
1 brass skimmer			1	0
A table frayme, 1 joyne forme, 2 joyne stools			10	0
Fire suffle [*shovel*], the tongus and the belows			1	6
1 flichen of backone			10	0
1 cubberte, 3 ould chears with other lumber			4	0
In the Little Buttrey				
Woodenware and a fryeinge pan			6	8
In the Parler, 2 bedstids, 2 flock beds, 2 pare of blanckits with valins and bolsters		1	10	0
The worminge pan			2	6
5 pare of sheets with outher linnins		1	6	8
12 yards of linnine and wollinge		1	0	0
1 chest, 2 coffers, 1 boxe, 1 doughkiver, one scrine and 3 sives			10	0
In the Over Chamber				
1 wolinge wheel and 1 linnine wheel			2	6
3 boards			2	0
1 pounde of wool and 1 pounde of woolinge yarn			2	0
The colors [*collars*] and the geirs			13	6
In the Chamber over the Parler				
Oulde yorn			1	0
One oulde bench				6
1 coffer and 6 pounde of corse wool			2	6
Without Doors				
1 nagge and 3 marrs		7	6	8
4 heffers and 3 yearlings		9	10	0
Corne one the Ground				
The winter corne and lenten tilth		4	0	0
The plough and harowe and plough yorns [*irons*]			19	0
The shefe corne in the barne		2	0	0
The rack and manger and a ladder			5	0
The tumbrille carte and drafts			10	0
Total	35	15	8	

The correlation with the 1607 description shows that there must have been an extension to the original house containing the boulting house; the room called 'buttery' was used as the kitchen and presumably occupied the west end.[18] By 1675, the third room of the house (Robert Dene's kitchen) had become the best room, with chamfered and stopped joists and its own

fireplace. In the hall, a chimney and a ceiling were inserted, and at the other end a passage was made behind the hall chimney. The hall, parlour and two upper chambers can easily be recognised in the inventory. Presumably the little buttery was at the north end, 'little' because it occupied only half the bay. The third upper room seems to have been ignored; it was perhaps derelict, as the need to rebuild the end truss suggests.

Living in the Medieval House

Lifestyles in the earlier 16th century show distinctive differences from those of succeeding periods, though it remains an inference that life in these houses of medieval plan was itself medieval in character, because we lack any comparative evidence from the 15th century or earlier. In the 16th century, just as the houses themselves vary little with the status of the tenant, so the uses to which the rooms were put appear remarkably uniform from one house to another. The inventories do reveal contrasts in the quantities of possessions and in their value but very little difference in the general pattern.

This is most clearly seen for the halls and kitchens, and especially their fireplaces, for which 20 of the 31 inventories in Table 4.1 give clear descriptions.[19] A prosperous villager's fireplace held:

> A gridiron or brandart: a flat rack on which pots were stood[20]
> A pair of cobirons or gouberts: bars which leaned against the chimney-back or were free-standing on feet; they had a series of projections or hooks which supported spits at various heights over the fire
> One or more spits (occasionally called 'broch')
> A pair of pothooks (not always with pothangers)

Less well-equipped fireplaces often lacked the gridiron and occasionally the pothooks.

These fireplaces were strictly functional. If the house had a kitchen, the fittings were in it and the hall had no fire equipment at all. Indeed, looking at inventories with kitchens, we can hardly tell that their halls even had a fire in them; we can take comfort from Thomas Burbery's pair of bellows (1568) that his hall really was heated. Exceptionally, Godfrey Parton's hall (**7**) contained his pothooks. Did it have a proper chimney with a hearth, easier to hang pots over than the kitchen's open fire? The presence of pothooks in the hall rather than the kitchen has been noted in early Worcester inventories, leading to the suggestion that the boiling of water was the one cooking process clean enough to take place in the hall.

One inventory (George Kockes, 1558) suggests a different and perhaps earlier lifestyle. He had an unheated kitchen presumably used for food preparation while cooking went on in the hall. This corresponds to the pattern of the three-room houses with an unheated buttery.

The distinction between hall and kitchen also appears in their other furnishings. The kitchen always held the pots, pans, kettles and looms (large pots), and usually the plates or trenchers. In more prosperous houses they also collected a number of special purpose utensils that would later find a place elsewhere: for dairying (churns, cheesefatts, suters), for brewing (brewing fatts and once a quern for grinding malt), for sieving flour (bolting whiches or tubs), or for kneading dough (kneading troughs or trays); of these, only the dairying equipment was at all common. Without exception the kitchens contained no furniture, not even a bench or table-top, though the lids of kneading troughs (and perhaps brewing vats) might have provided a working surface for the better-off (e.g. **1**). They also provided no storage apart from some containers for food in bulk (vinegar barrels and bolting whiches).

Halls were furnished for living, to a uniform pattern: a table, a bench or two, a chair, a cupboard (often termed 'halmere', i.e. aumbry), and painted cloths (hangings). What was kept in the cupboards is not stated, but as food is never listed in the inventories it is the most likely candidate.[22] The main extravagances in the more prosperous homes were a chair or two or another table, and half a dozen cushions or a bench cloth (banker).[23] It is rare for the style of

furniture to be noted, but Thomas Ravis (1567) had a turned chair, as did John Jessey (1590), who also had a cupboard of plain work and four 'plain country bedsteads'.

The contrast with halls in houses without kitchens is striking. When no separate kitchen was provided, the two functions were simply combined in the hall. These contained exactly the same furnishings as already noted (though only one had cushions), but they also had the kitchen fireplace equipment and the cooking pots and pans—and in the case of Margaret Ball (1559) her goosepen. Maybe this held her two geese and a gander, but her son's inventory (Thomas Balle, 1573) suggests a more likely interpretation. It notes what may well be the identical object, a 'gosse pen', but qualifies it 'or disshe bourd' and goes on to list the pots, basins and pans standing on it.[24]

Like the halls, the chambers were simply and uniformly furnished. Most held two or three beds, and after these their principal contents were coffers (small trunks); at least two coffers were to be found in most chambers and a couple of houses had five. One inventory (John Taylor, 1564) lists a press, probably in his chamber. Half the chambers had painted cloths, rather fewer than in the halls. In the larger houses, the parlour or main chamber[25] often held an extra chest, while four chambers contained whiches, another chest-like container; this term was later used specifically for flour, 'a bolting which', but the placing of these examples indicates a more general use for them.

Just as the hall and kitchen were combined in smaller houses, so their chambers also served for general storage and as butteries or dairies. Looms and barrels, fatts and churns might therefore be found in them. In the larger houses, the solars or second chambers were used for storage (particularly for wool) as well as sleeping. Surprisingly, the two inventories mentioning basins and lavers (William Pype (**4**) and Robert Dene (**8**)) place them in the solar not the principal chamber.

Though the prosperity of the tenants is not reflected in the furnishing of the chambers or the halls, it does appear in their bedding whose quality varies dramatically between, for example, Robert Dene (**8**) and William Nycolles (**12**). Similarly, the small luxuries and comforts that modest wealth could bring appear in the possession of pewter plates rather than trenchers, in silver spoons, and brass rather than iron candlesticks. The wealthiest yeoman in this group, Thomas Burbery (1568), had used his money for better table ware, including 22 pewter platters, 8 pottenger dishes, 10 counterfeit dishes and 2 flower pots.[26] He also had a carpet cloth in his parlour, probably laid on the chest there.

This chapter concludes with a view of life in the smallest 16th-century Stoneleigh houses, illustrated by the inventory of William Nycolles of Finham (**12**), whose two rooms show all the overlapping functions that have been described above. His holding size is not known, but it was probably small (like most of the Finham tenancies), and in status he may have occupied the borderland between husbandmen and labourers.

12 *William Nycolles (of Finham) (1556)*

He was a tenant at Finham from before 1533, and his will mentions his son John (a tenant in Kingshill and then in Stoneleigh village, 1569-76) and daughter and her husband (a tenant in Finham), and their six children. John Nicholles, husbandman and John Hobley, wiredrawer (his son-in-law), aged respectively 40 and 60, gave evidence in the manor court in 1572 (SBT.DR18/30/24/170).

Inventory appraised by Petur Evotte, Robart Denton, Jhon Lyghtfotte, 8th October 1556. Several sums are left blank in the inventory, but the final total corresponds to those listed.

> In the Haull
> On tabull, on fourm, on halmere, pentyt cloys; a pere of pothokes with a chene,
> a candelstyck; 3 pottes, 2 pannes, 2 scellettes, 6 pecys of peutur; a spytte,
> a fryne panne

<u>In the Parler</u>
On bedstyd, a matrys and all that belonges to the bedde, a coverlette; a qwyche,
a corte [cot?] to a bedde; 4 pere of schettes, 2 twyllyclothes, 2 towelles 6 8
A steppefatte, 1 paylle, a chyrne, a hechyll 6 8
A byll, a axe; 2 bounde wenes; 3 towys; a coppe pyn, a pere of harrowys with a
ployght and all that therto belonges 1 10 0

<u>In Cattell</u>
4 Oxen, 2 kyne, a heffer, 2 mares 4 15 0

<u>In Corne</u>
On quarter of rye and so myche more as hasse madeys sedens and fonde ther
breddecorne; 2 quartars of wottes 1 2 8
A lode of heye

<u>In rayment</u>
2 gackettes, on dublet, 2 pere of housse, a pere of schoys, 2 schurttes -
Dysches, ladell, trenchars and other trymtram -
2 Gesse 3 4

 Sum 8 4 4

Notes

1. Inventories listing two to four rooms, 1537-1600 are summarised in Table 4.1. Shops (i.e. workshops) are counted with the rooms in the house, rather than with the farm buildings. The few that can be identified in standing structures are part of the main house or additions to it (like other service rooms) (e.g. p.33).

2. His inventory, which seems to be complete, lists a hall containing table, cupboard, chests and bedding, and a well-equipped kitchen including fire-irons.

3. PRO.SC2/207/79.

4. R. K. Field, 'Worcestershire peasant buildings, household goods and farming equipment in the later Middle Ages', *Medieval Archaeol.* 9 (1965), 137-45 and C. C. Dyer, *Standards of Living in the Later Middle Ages*, Cambridge, 1989, p.160f.

5. See, for example, M. W. Barley, *Houses and History*, Faber, 1986, p.145f. and *The English Farmhouse and Cottage*, Routledge, 1961, p.21f.

6. The terms 'upper' and 'lower end' are derived from houses in the long-house tradition (not found in Warwickshire) which are built down a slope, and in which the lower room is a byre. Terms such as 'Upper Chamber' were occasionally used in the Stoneleigh inventories, and may indicate a room at the 'upper' end of the house, rather than one on the upper floor. N. W. Alcock, M. W. Barley, P. W. Dixon, R. A. Meeson, *Recording timber-framed buildings: an illustrated glossary*, C.B.A., 1989, p.9.

7. All but one of the two-room inventories relate to houses in Kingshill (where identifications are not possible) or Stareton though it is hard to see this as more than chance. The only house in Stareton with any early features is 1-2 Stareton (p.35).

8. SBT.DR10/996. SBT.DR18/3.52.37a is the lease by the Abbot of Stoneleigh, dated 10 March 1492, of the mill 'which walkmylle .. by the movynge mens [means] and eyde [aid] of Sir John Sparry, parson of Assho was of late newe made ...'.

9. Thomas Pype's inventory seems to list the contents by room, even though no room names are included, and does not include any group that might correspond to a brewhouse.

10. C. Carson, 'Segregation in vernacular buildings', *Vernacular Architecture*, 7 (1976), 24-29.

11. A remarkable 17th-century folk-tale was recounted by the vicar of Stoneleigh to William Dugdale that must relate to this house and is plausible though not provable:
There is a tradition among the common people of Stoneley that anciently there was a goodly house standing upon the hill called Motslow Hill on the south part of the church which was the habitacion of a knight who going to the warrs left his lady great with child, and that upon the news that he was slayne, she ript up her own belly and was buried therefore upon the north side of the church in the churchyard under a stone whereupon is portraied the figure of a woman and a child which remaynes to this day [Bodleian Library, Dugdale.15, p.144]. This knight was probably William Staleworth; the house was recorded for many years as belonging to his unnamed heirs.

12. The early deeds for Motslow Cottage (from 1427) are in SBT.DR18/10/107, with later ones in 10/72, 10/75 and 10/103. The entire Hudson family property was bought by the Leighs in various parcels between 1668 (the Stoneleigh holding) and 1815 (the residue of Crew Farm). Although its occupiers are only known intermittently and no probate records have been identified, there are no likely candidates among the inventories giving room names not identified with particular holdings (Appendix 1, p.211).

13. Crew Farm seems originally to have stood in Ashow, probably in the moat that must have existed in Moat Close, one of the fields belonging to the farm. In Edmund Hudson's will and inventory, he is described as of Ashow. However, by 1597 (*Map*), the farm was on its present site, just over the parish boundary in Kenilworth (Figure 2).

14. The identification of this inventory is unequivocal, with a match between John Lorde's name in the 1551 rental and his successor in the 1559 rental, both in position in the list and in rent paid.

15. The freehold was granted by Geoffrey de Staverton to one Peter Aleyn in the 13th century, to be held for the rent of 1lb of cumin (*Leger Book*, p.238). The grant for the obit is CRO.Corp. Misc. Deeds, 21 Henry VIII/5. In 1598 it was bought by Sir Thomas Leigh (SBT.DR18/10/100).

16. CRO.Corp. Misc. Deeds, 2-3 Phil/Mary/1.

17. This description probably relates to an original upper floor (p.40). It may be that at this period *any* upper floor could be considered to be the tenant's property. Such a view would help us understand the surprising number of floor-boards valued, unlikely all to be newly inserted.

18. A 1650 Parliamentary Survey (SBT.DR18/3/49/2) lists the house as having four rooms down and two up, corresponding to the 1607 description. The Hearth Tax assessments give either one or two hearths, noting in 1666 that one had been concealed.

19. Some of the remainder include them under general headings, such as 'other iron'.

20. 'Brandart' is the normal 16th-century term, which is generally taken as equivalent to 'gridiron' (e.g. Oxfordshire Inventories, p.319). However, the inventory of Thomas Couper lists both, demonstrating some distinction. The alternative 'trivet' is used in one inventory (Richard Cotton, 1583).

21. By Dr Pat Hughes.

22. Perishable commodities such as food did not have to be included in probate inventories. The Stoneleigh inventories seem to use the terms aumbry and cupboard interchangeably and they do not occur together. An aumbry is generally taken to be a cupboard for food with ventilation holes or an open-work door, while 'cupboard' originally had the literal meaning of 'board to place cups on'. Victor Chinnery, *Oak Furniture: The British tradition*, 1979, p.319 states that this was still its meaning until the end of the 16th century, but this is inconsistent with the Stoneleigh evidence.

23. This does not fully bring out the uniformity of the hall furnishings. Of the 27 inventories with details of the hall furnishings, all had a table, all but five a form and all but four one or more chairs. One only lacked cupboard or aumbry and 17 had painted cloths. Ten had extra tables, including one round table, one little table and one chair table.

24. Several other inventories include goose or hen pens (presumably the same): William Syers (1598); Thomas Nelson (1627) (an old hen pen); Thomas Smallwood (1605); Edward Sothern (1602). Oxfordshire Inventories includes 'the broch and the penn' (36) and 'a cupbard and a penne' (37), but also the confusing 'goose panne' (22, 30) meaning a large pan to catch goose fat. Some 18th-century Irish dressers were called 'hen-pen dressers', but these had actual chicken coops in their lower sections! The goose pen probably had a series of vertical turned bars, between which the plates were stacked, resembling the bars of a poultry coop.

25. The inventories show no distinction at all between the furnishings of parlours and principal chambers.

26. Pottengers were deep dishes used to serve pottage. Of the two meanings of 'counterfeit' (i.e. copied; see Glossary), the most likely here is a set of dishes with matching decoration. Flower pots were probably used to place flowers in; they were of metal and only moderately valuable, so not very large, possibly to be imagined as tall and slightly bulbous.

Table 4.1: *Old Style: Small Houses (2-4 rooms), 1532-1600**

Inv	Date	Name	Status	Hld	Loc	Acr	£	Rooms (and Farm Buildings)
		Two Rooms						
	1559	Margaret Ball	Widow	74	Ca	59	13	Hall, Chamber; Barne
	1538	William Convey		63	St	15	9	Hall and Parler
	1547	Thomas Gekoc			St(?)		15	(Hall), Chamber; Barne
	1593	Thomas Harper		60	St	44	29	Hall, Chamber
	1538	Thomas Hobley			H		8	Hall, Bedchamber
12	1556	Wyllyam Nycolles			H		8	Haull, Parler
	1553	John Sotherne		57	St	78	41	Halle, Kechen; Barne
		Three Rooms						
	1568	Thomas Burbery	Yeoman	4	S	66	160	Hawlle, Parler, Kechen
	1571	Agnes Chapman	Widow	X1	Hu		15	Hale, Buttery, Chamber
	1561	Richard Chapman	Husbandman	X1	Hu		24	Halle, Kechen, Chamber
	1581	John Clarke		63	St	15	10	Halle, Kichen, Chamber; Barne
	1583	Richard Cotton	Labourer	23	S	0	33	Halle, Chamber, Sellar
	1558	Thomas Couper		56	St	88	17	Haull, Bakehousse, (Chamber)
	1567	William Farr	Husbandman	5	S	29	30	Hall, Parler, Kitchinge
	1559	John Gesse					18	Haull, Chamber, (Kitchen)
	1592	John Godfrey	Husbandman		H		13	Hawlle, Chambor, (Kitchen); Barne
	1574	Agnes Hancorne	Widow	75	Ca	49	89	Halle, Buttere, Parler; Barne (Stated inventory total £101)
1	1556	Humfrey Hylles	Husbandman	86	Hu	38	21	Halle, Parler, Kechen
	1586	William James		62	St	18	16	Hall and Kitchin, Chamber; Barne
	1557	John Lorde		17	S	3	12	Haull, Parler, Kechen
5	1558	Thomas Tuter	(Husbandman)	66	St	29	8	Haull, Chamber, (Kitchen)
6	1575	Simon Tyler		66	St	29	11	Parlor, Haull, Kechen
	1562	William Waren			Fl		31	Halle, Chamber, Kechen
		Four Rooms						
3	1537	John Allyt	Weaver	14	S	4	7	Hall, Chamber, Kychin, Shop
9	1552	Robert Dene		11	S	16	56	Halle, Chamber, Seler, Kechen
	1549	James Gaundy	[Fuller]	43	A/S	9	85	Hall, Chambers, Kechen
	1556	Edmund Hudson		52	A	28+	7	Halle, Chamber, Chechyn, Buttere
	1558	George Kockes		59	St	71	45	Haull, Parler, Kechen, Celer; Werkehousse (farm tools)
8	1559	Godfrey Parton		21	S	3	15	Haull, Chamber, Other chamber, Kechen
29	1556	William Powres		44	A	10	2	Halle, Kechyn, Botter, Chamber
	1584	Christopher Shawe			Cr		33	House, Nether Chamber, Chamber over Haull, Milkehousse; Barne, Howse (hay)
4	1597	Henry Waren	[Fuller]	14	S	4	25	Parlour, Chamber [*Saller*, erased], Shop, (Hall); Barne

* In this and the other tables of inventory names, the following conventions are used:

Inv The number of the inventory text

Date That of the inventory if dated, otherwise that of probate (sometimes the following year).

Name As in the probate grant, under which probate records are filed at Lichfield Record Office.

Status/occupation As in will or inventory; if these differ, that for the will is given first. If the status is given in (), it is derived from another document, and if in [], it is surmised from the inventory (generally for craftsmen).

Hld and Loc The holding number and location, as in Appendix I (which gives cross-references to other probate records).

Acr The holidng acreage. This relates to 1597 (inventories dated before 1701) or 1766 (after 1701), apart from holdings in Stareton and Ashow, for which the areas in 1683 and 1649 are used for inventories between 1650 and 1700. These figures should not be considered precise guides to the amount of land held, because they ignore sub-letting, additional land leased, etc.; those in () are particularly uncertain.

Value (£) Net total of the inventory. If substantial debts are listed, the gross total is also given.

Room names Those in [] are inferred; those in () are not included in the total count (e.g. the mentions of loose boards, when they carry no goods). Plural names (e.g. chambers, cocklofts) are counted as two, as are pairs of names (e.g. Hall and Parlour).

Hth For inventories dated between 1660 and 1700, the number of hearths recorded in the Hearth Tax is given if known; a * indicates that this refers to a predecessor or successor of the person named. E indicates exemption from payment in one or more lists.

Chapter 5

New Wealth, New Houses

Introduction

Soon after the darkness lifts from the homes of the Stoneleigh villagers, revealing the medieval lifestyle described in the last chapter, we begin to see great changes in living standards. It was no longer acceptable for prosperous yeomen like Thomas Burbery to live in three or four rooms, indistinguishably from their humbler fellows. To the basic hall, chamber and kitchen, which had contented them since the 15th century or earlier, they added extra chambers, store rooms and service rooms. In 1600, no self-respecting yardlander had less than seven rooms in his house, and they were joined by the most prosperous craftsmen, the millers, fullers and tanners. By mid-century, the largest farmhouses matched and indeed surpassed those of the freeholding minor gentry in the parish.[1]

In this pattern of improvements, Stoneleigh is a classic example of 'The Great Rebuilding', as originally recognised by W. G. Hoskins: an improvement in living standards triggered by farming prosperity in the later 16th century, leading to the rebuilding and modernisation of houses in the period 1570-1640.[2] Later study has shown that this rebuilding is by no means synchronised across the country and its causes are not so clear-cut.[3] An examination of wealth in Stoneleigh (Chapter 11) shows that after correction for inflation there was no increase in real wealth from the mid 16th to the mid 17th century. Nevertheless, the villagers must have had a perception of prosperity from rising agricultural prices, as well perhaps as a fear of unspent money losing its value. This was the stimulus for the more prosperous of them to apply their surplus income to improving both the structure of their houses and the quality of their household possessions. The resulting differentiation between richer and poor members of the community is revealed in the houses of the village.

A division is made here between large houses and middling ones. This chapter examines the 80 inventories listing five rooms or more for the period to 1600 and those with eight rooms and upwards for 1601-1700 (Table 5.1; p.88); all but two can be related to identifiable holdings. These limits are somewhat arbitrary, but are intended to differentiate the homes of the most substantial villagers in the 16th-17th centuries, the yeomen, from their lesser neighbours, the husbandmen. Their houses are the subject of the next chapter while larger houses in the 18th century are examined in Chapter 8.

This wealth of evidence illuminates one aspect of the probate evidence: its accuracy. 'Pair' inventories rarely agree precisely, but their essential information is consistent. As an example, the Stoneleigh village inn oscillated between 11 and 14 rooms in the period from 1620 to 1742, while showing no indication of rebuilding. Other pairs show similar variations of one or two rooms without alarming discrepancies. No doubt some rooms were passed over because they were empty, while entries such as 'in the chambers' or 'the cocklofts' leave the precise numbers of rooms uncertain.[4] The omission of rooms because they were occupied by someone else is only occasionally suspected. Mary Stringfield (1673;6) was the widow of the rector of Ashow (1663;8). She was still living in the Rectory, but did not use the Study, the Little Parlour, or the room over it. As she is not listed in the Hearth Tax, she must have shared the house with the new rector, Thomas Allestree, who was her son-in-law. In other houses (e.g. Thomas Stacie, 1665;12), rooms clearly used by other people are included in the inventory.

Patterns of Housing

The revolution in housing documented in Table 5.1 began quietly enough. The separation between houses of medieval character and those beginning to be modernised is not as clear-cut in reality as is assumed here, and several five-room houses can be grouped with the former. In contrast, the four-room inventory of Christopher Shaw (1584) notes two features linking it firmly to the new styles: the *milkhouse* (found in only three other houses before 1600), and the *chamber over the hall*. These two changes, the addition of specialised service rooms, and the multiplication of upstairs chambers account for almost all of the increase in house size after 1600.[5]

Before 1600 the main developments concerned the chambers. As well as the hall, kitchen and usually buttery, most of the larger houses had three or four chambers and a parlour or two (always used as bedchambers). The only chambers with specific uses were for servants (4) or maids (2), with one guest chamber recorded (on a large Stareton farm, holding 59). This probably refers to a room used by a lodger, and by 1627 it seems to have become a lodging parlour.[6] The most frequent service room after the buttery was the dairy (or milkhouse; 4 houses), then the bolting house (3) and brewhouse (or yelding house; 2). Inventories **2**, **16** and **19** relate to smaller houses in this group, showing some of the typical features. That for Thomas Cox (1580) (**13**) gives a full picture of an improved 16th-century house, almost certainly built in 1558 (p.61). Its room names illustrate the confusion between solars and cellars (not generally below ground at this period). The 'saller next the kiln' was a cellar, like the 'darke cellar' named in 1597, but those over the hall and kitchen were solars. Including the cellar and the house for the malt kiln (presumably built in and so not valued), it had three service rooms.

13 *Thomas Cox of Ashow (1580)*

Thomas Cox took over one of the largest holdings in Ashow (50 acres) by 1550, and he also rented a smaller holding from 1566, which was sublet to a cottager. He died intestate, leaving a widow Anna and a son James, who succeeded him. The household also included at least one servant, John Poores (assaulted by one of his neighbours in 1577; Manor). He was a prominent member of the community, frequently serving on the manor court jury, sometimes as constable.

Inventory appraised by Thomas Fitzherbert, Robert Hudson, Edward Asshton, Alexander Rogers, 8th December 1580.

In the Saller next the Kilne		
A garnard [*garner?*] there	8	0
A quarter of dredge malte	8	0
Tow tubbes & other small implementes ther	2	6
In the Saller over the Hall		
Tow bordes & one paire of tresselles	1	8
A baskett and three seves	1	0
A strick and a malte syve	1	4
A fatt and tow barrelles	3	0
Certeyne teowe	5	0
One hopper & tow repinge hookes		8
Tow riplinge combes and a hatchell	2	0
4 Bordes, a forme & three tresselles	2	0
3 Syves & a malte sive		8
A weighinge beame & a paire of scayles	1	8
2 Strick of salte	1	2
A chease rack & 17 cheasses	2	6
Tow dossen of woodden dysshes	10	0
Five rewes of onyons & a cheare	1	0
A pare of bottes & a litle hand baskett	1	2
A boxe of wood & 2 coffer lockes	1	0
Five peaces of leaden weightes	3	0

In the Sallor over the Chamber

	£	s	d
Tow ioyned formes & one other forme		3	0
An iron bounde chest		2	0
A tonge tree for a wayne & 3 small bordes		1	0
A beddestedd, a flockbedd, a bolster, a coverlett & tow paynted clothes hanging about the same bedd		14	0
Another bedstedd, a flockbedd, tow twillowes, a blanckett & tow bolsters		8	0
Tow twillows, one flockbedd, a bolster, a coverlett, a paire of blanckettes, a hillenge & a tester over the bedd	1	10	0
Three bagges & tow half strick bagges		3	0
Three strick of wyndrowed dredg		2	6

In the Chamber above the Hall

	£	s	d
A beddstedd, a fetherbedd, a mattress, three blanckettes, 3 pillowes, 1 pare of sheattes, a coverlett and tow bolsters	2	0	0
A beddstedd, one flockbedd, one blanckett, towe coverlettes, one paire of shettes, one bolster & 2 pillow		10	0
One presse, a buffe jerkin, a lether dublett, one paire of hoose, a lynnen dublett, a firse cott, a chamblett dublett, a paire of britches, a gowne & a russett clock [cloak]	1	6	8
4 Coffers, one fosser, 4 shertes, halfe a dossen of table nakpins, 4 pilloweberes, tow pare of flaxen sheates, one bord clothe, tow towelles & a whitt tester for a bedd	2	3	0
4 Paire of shettes & tow borde clothes		18	0
Tow paynted testers & hanginge clothes about the chamber		4	0
A banker		2	0

In the Buttrey

	£	s	d
A powthering tubb, 3 barrelles, a meel with other implementes in the same		10	0
Three lomes, a barrell, a churne, a fatt, tow theales, a bord, 3 bottelles, a clensinge syve and a lanthorne		8	0

In the Hall

	£	s	d
A cubberd	1	0	0
A bord and a frayme		9	0
A cheare		1	0
A litle bord & the disshe bordes		2	0
Tow benches		1	0
Three quysshens		1	0
A lannd iron, tow paire of potte hanginges, a paire of tonges, a fier showell, a paire of bellowes & a paire of pott hookes		2	6
The painted clothes in the hall		3	4
One peece of leade		3	4
Tow brasse pannes		7	0
Tow brasse pottes		5	0
An iron pott		2	6
Tow dabnettes		3	4
Five kettelles		8	0
A chaffing dishe		1	0
Five candlestickes		1	4
A skimer, a brasen ladle & a skellett		1	0
8 Platters		8	0
Five pewter dishes		2	6
11 Pottenger dishes & a dishe pottenger		5	0
Tow pewter basons		1	0
Tow sawcers & 4 flower pottes		1	0
A pestell, a morter & a salt seller		1	2
A dossen of trenchers		4	0
4 Pailes, a kemnell, 4 boles, a platter of wood and a pott lede		2	0

	£	s	d
Half a dossen of sponnes		4	0
In the Kitchen			
A panne		3	4
A kemnell and a bolting tubb		4	0
A brewinge lomme and a tubb		1	4
A brandiron			8
An old bedd		3	4
Tow spittes & a pare of cobberdes		3	4
A heare for a kilne		3	4
A spynning whele			6
A steape fatt and a chese presse		7	0
In the Barne			
The rie, otes & boltinges there	8	0	0
The heay there	1	6	8
The corne sowed in the feild & now ther growing	4	0	0
46 Sheapp at 3s 4d a peece	7	13	4
A mare	1	10	0
4 Kinne	6	0	0
3 Heyfers	2	4	0
3 Swynne	1	0	0
Five duckes, 4 geese, a gandard & tenne hennes & capons		5	0
A hawvell [hovel] & other wood & pailes		5	0
A buckett & cheyne		2	0
A grindle stone		2	0
Total	51	9	10
Debtes owing unto the same Thomas Coxe			
Henrye Reves	1	7	0
Walter Yates		12	8
Wiggens of Kenelworth		16	0
Thomas Dadley thelder		3	4
Sum	2	19	0
Debtes which the said Thomas Coxe dothe owe			
Frannces Court	4	6	8
John Frier	2	0	0
Ales Dadley		10	0
More to Frannces Courte	1	15	8
More to the same Frannces		17	0
Sum	9	9	4

1601-50

During the first half of the 17th century, houses changed much more. This is most obvious in the continuing addition of chambers, most of which were certainly upstairs; of the nine chambers in the largest house (16 rooms), six were certainly upstairs.[7] Generally, the members of this group of houses had three to five chambers and a parlour, which can generally be counted with the chambers; only two 'living' parlours are found before 1650. 'Servants' (7 houses), 'mens' (6) and 'maids' (5) chambers were common. There seems to be no obvious reason for providing rooms just for male or female servants, but only one household had both. An intriguing trend is the appearance of named bedchambers, sometimes reflecting new styles in decoration. Humphrey Taylor had a Green, a Long and a Black Chamber, while the Stoneleigh inn (holding 9) had its Unicorn Chamber, and Upper and Lower Well Chambers. It must have been a splendid building though, disappointingly, it does not survive.

An important change after 1600 was the appearance of chambers used for storage: most often cheese (9 houses), but also apples (3), corn (1) and malt (1); a malting chamber and a 'kill' (kiln) were probably for work more than storage, though neither inventory is explicit.

Main rooms were also changing. Only in three or four of the smaller houses in this group did the tenant still cook in the hall, while butteries had become much more common than before 1600, and several houses had two of them.[8] Other specialised service rooms were hardly less numerous, with 22 dairies and 12 bolting houses among the 31 houses. After these came rooms for brewing though here different aspects were emphasised in different houses: kiln houses for malting (4), mill houses for grinding the malted grain, lead houses (2) or brewhouses (1) for the brewing vats or leads. Might the vicar's study also be called a service room?

Specialised chambers for storage have already been mentioned, but storage in special 'houses' is also found, probably implying ground floor rooms, not necessarily detached but probably not part of the main structure. They included wool and cheese houses, a dish house and a pewter house (two references to the same house; 1612; 1647). Many houses also had less specialised store rooms: 'nether houses', cellars, cocklofts, backhouses, and simple 'rooms', while the 'entry', named in a couple of inventories, seems to have been another place in the house where oddments might turn up.

The proliferation of rooms gives these early 17th-century houses a distinctive character in relation to their immediate predecessors, both in the variety of their names, and in their number. Chapter 12 analyses this change quantitatively, but it can easily be seen in the sizes of the largest houses, rising from a maximum of nine rooms before 1600 to almost double this in the next half century.[9] The characteristic features of the early 17th century are seen in the 15-room inventory of Humphrey Hoo (1616) (**14**), including the proliferation of chambers for sleeping and for storage, as well as an impressive collection of 'houses'.

14 *Humphrey Hoo the elder of Stareton, yeoman (1616)*
The Hoo (occasionally Howe) family was exceptionally long-lasting in Stoneleigh. The first representative, Alexander, became tenant of a Stareton holding in 1549, with the obligation to construct a house of six bays within three years, probably the nucleus of the family house (Manor). He described himself as a clothier and he (or perhaps his father) was under-master of the Coventry Guild of Fullers in 1537. Humphrey succeeded both to the Stareton holding and to the lease of a fulling mill near Stoneleigh Grange in 1582, by which time his father had retired; his inventory lists only money. Humphrey's farm (1½ yardlands) was assigned 94 acres in the 1598 Stareton enclosure (rent £2 13s. 4d.). He was a prominent member of the community, frequently appraising inventories and acting as juror or tithingman, though he was also presented for watering hemp in 1585, 1592 and 1609 (*Manor*). Humphrey gave up the mill lease in 1595, but remained involved with fulling, probably in partnership with his brother James (tenant of two fulling mills in Stoneleigh village); he employed a fuller, Alexander Leake, presumably to run the business (p.167).

Humphrey left two daughters and a son, another Humphrey. He owned three houses and 20 acres of land in Leamington Priors, left to his unmarried daughter Elizabeth, though Humphrey could buy her out for £100 if he wished. The second Humphrey succeeded his father as tenant (paying £10 rent); he died in 1660 by which time a third 'young' Humphrey (Manor, 1658) was tenant of another Stareton holding. The latter's son Joseph was also a Stareton tenant, and his grandson Humphrey was bailiff in the 1740s.

Inventory appraised by Nicholas Samon, Thomas Sothern of Stareton, John Mallery of Whitnash (son-in-law), all yeomen, 10th September 1616.

All his wareing apparrell bothe woollen and lynnen	1	0	0
In the <u>Hall</u> one long table with frame, two old cubbordes, two cheers, half a dozen			
joyned stooles, one round table, one forme, halfe a dozen quishens, two landyrons, pott hangers	1	10	0

In his <u>Bedchamber</u>, one joyned bedsteed and one other bedsteed, one fetherbed
and two flockbeddes, two pare of blankettes, two hillinges, three boulsters,
one pillow — 2 10 0

One joyned presse, two coffers, one cheer — 10 0

In the <u>Maydes Chamber</u> two old bedsteedes, one flockbed, a pere of blankettes,
one hillinge, one boulster, one old presse — 6 8

In the <u>Buttery</u> nyne litle barrells with steanes, bottels, shilves and one dry vessell — 10 0

In the <u>Little Chamber by the Hall</u>, one bedsteed, one fetherbed, one flockbed,
three blankettes, one hilling, two pillowes, two boulsters, two coffers,
two joyned stooles — 2 10 0

In the <u>Chamber beneath the Entrie</u> two joyned bedsteedes, one fetherbed,
one flockbed, three blankettes, one hilling, two boulsters, one pillow upon the
one bed, and upon the other bed one flockbed, two boulsters, a pere of blankettes
and on hilling — 2 0 0

One old cubbard, a forme, halfe a dozen of quishens — 13 4

In the <u>Killhouse</u> one steepfatt, two loomes, one old barrell, on chees presse — 10 0

In the <u>Kychen</u> two moulding bordes, on boulting tubb, two kneding kyvers,
one kymnell, one longe trough, two loomes — 13 4

One pere of rackes, three pere of cobyrons, one pere of landyrons, one yron grate,
seven spittes, two brandyrons, one fyrshovell, one pere of tongues, one pere
of bellowes, potthangers and potthookes, three dripping panns, a grydyron — 1 10 0

In the <u>Myllhouse</u> one mautlmyle, on leade with other ymplementes there — 13 4

In the <u>Mylkhouse</u> six payles, one cherne, one powdring trough, on powdring tubb,
one loome, two kyvers, mylke panns, cream pottes, nyne cheesfattes, three sutors,
two meels, two wodden platters with all the shilves and other ymplements — 10 0

In the <u>Dish-house</u> eight brasse pottes, fyve kettles, one great brasse pann and on
litle brasse pan, two dabnettes, one posnet, two chafing dishes, two skymmers,
two brasse basons and a yewer, six brasse candlestickes — 5 0 0

Three dozen of platters, halfe a dozen of saucers, ten pewter dishes of one sort
and six of another sort, one flagon, two pewter basons, half a dozen of butter
dishes, two porringers, on pewter salt, two little pewter dishes, one bason and
yewar of pewter — 2 6 8

In the <u>Corne Chamber</u> one long table and frame, three formes, one coffer — 5 0

In the <u>Chamber over the Hall</u>, fyve coffers, a salt barrell, one old vessel to
put mault in, three linen wheeles, one woollen wheele — 6 8

In the <u>Mault Chamber</u> one bedstead, one flockbed, one boulster, one blanket — 5 0

One heare cloth — 3 4

In the <u>Cheese Chamber</u> all the cheese with bords and shilves, two tubbs with
other ymplementes — 1 0 0

Sixteen sylver spoones, one guilt salt and a guilt goblet — 5 0 0

Twentie pere of sheetes, eight table clothes, two dozen of table napkins,
halfe a dozen of pillowbeers, two towells, two cubbard clothes — 8 0 0

One kettell and a spice morter — 6 8

45 Fleeces of woole — 8 0 0

45 Sheepe and 24 lambes — 16 0 0

Eight mylch kyne and a bull, two heighfors — 30 0 0

One yoke of oxon — 7 0 0

Two mares, one yearling colt — 6 0 0

All the hay in the barne — 6 0 0

All the rye in the barne — 20 0 0

All the oates in the barne — 6 8

Four hogges — 2 0 0

Two waynes with yokes and tewes, harrowes, plowes and plow yrons,
wayne rops
and all the plow tymber about the yard — 6 0 0

All the theales, bordes, tymber and all the fyre wood about the yard	2	0	0
Ladders, sythes, forkes, rakes, spades, showels, mattockes and all such ymplementes		10	0
Fyfteen hens and cocks, six ducks and one drake		5	0
All the hurdles and fleakes		6	0
Two gryndlestones		10	0
The lease of the house for 17 years to come	30	0	0
Three pewter chamberpottes, with dishes, spoones, ladles, trenchers and all other ymplementes about the house yet not priced		10	0
Total	169	8	8

1660-1700

Compared to the first half of the century, the houses in this period appear slightly smaller; the mean size of houses in inventories listing eight or more rooms dropped from 11.1 rooms (31 examples) to 10 rooms (24). Service rooms were noticeably less frequent. Only half the inventories record butteries (supplemented by three pantries and one larder), while only six had more than two named service rooms. Although dairies remained standard (16 houses), bolting houses had almost gone out of use (one only). The only buildings specifically for brewing were the two brewhouses and two millhouses, though other houses had back kitchens which probably served the same purpose. However, a scouring house and a washhouse show the beginning of new ways of living. Members of the gentry joined the clergy in having studies, and they also had the first closets listed.

This period provides the first large house with kitchen and parlour as its main rooms instead of hall and parlour (1694; **7**) (a change that took place considerably earlier in middling houses) though in another house the main room was a 'Hall or Kitchen'(1670). A less significant name change was the use by Laurence Nicholls (1667) of 'House' rather than 'Hall', though Richard Bolt's 'Dwelling House' probably had the 'Chamber over the Kitchen' above it.

Chambers still made up the largest group of rooms in each house. Servants' chambers were no longer named as such (only 3 examples), clearly because most chambers were given such names as 'Parlour chamber' or 'Chamber over the Parlour' (which had become synonymous). This trend may account for the general disappearance of named storage chambers, apart from one malt and one corn chamber. However, virtually every house included a cheese chamber.

The inventory of Robert Burbery (1682) (**15**) provides an example from the later 17th century, characteristic in its rooms as well as their contents.

15 *Robert Burbery of Finham, husbandman (1682)*

He was probably only resident in the parish for a short period and little is known of him. He was a member of the home jury in 1678 and surveyor of the highways for Finham in 1680. The exceptionally lengthy preamble of his will suggests strong religious views: 'I committ my spirit into the hande of Almighty God ... in the comfortable hopes through the death and mediation of Jesus Christ ... of a joyfull and glorious resurecion at his blessed appearing.' He left his four young children £10 each, with the residue for his wife Elizabeth.

Inventory appraised by Thomas Gibbs of Canley, yeoman and Benjamin Lines of Stivichall, husbandman, 26th January 1682.

His wearing apparrill & purse	6	0	0
In the Parler			
One joyned beddstidd, a woole bed, a coverlid, two blankits, a sett of curtains & vallanse £3, one court cubart 6s 8d, one chest & two cofers £1, one trunke & one box 10s, one round table, a joyn forme & a chear 6s, one glass 5s, thirteen pare of sheets £4, two duzen & a halfe of napkins £1, five table cloaths 10s, six pillowdrawers 6s, seven ells of cloth 9s	11	12	8

<u>In the Hall</u>
One long table & forme, one joyned forme with one other table, one cofer,
a joyn stool & a chear £1, one press cubart 13s 4d, a sadle & a pillion 10s,

a clock 5s	2	8	4

<u>In a Little Room there</u>

A bedstid, a flockbed, a coverlid & blanketts		10	0

<u>In the Chamber over the Hall</u>
One joyn bed, a fetherbed & bolsters, a coverlid & blankits, with curtains &
vallanse £5, one other joyn bed, a wool bed, a coverlid & blankits £2 10s,
a trucle bed & beding with a rugg £1, three cofers 6s, a screen 5s, a trunke

& three boxes 10s	9	11	0

<u>In the Chees Chamber</u>

Chees to the value of £1 10s, apples £2	3	10	0

<u>In the Cocklaft</u>

Six straw whiskets, a bedsteed & beding	1	4	0

<u>In the Kitchen</u>
Nine pewter dishes £1, foure sawsers & half a duzen of parengers 6s, one flagon
& a pinte, a quart, two candlesticke, two salts, one tunn 12s, three brass potts,
£1 6s 8d, six brass kettles £1 3s, a warming pan, a brass candlestick, a skimer,
a basting ladle 6s, two tables & severall formes, chears & stools 13s 4d,
a bacon wrack 5s, six flichens of bacon £3, a grate, a fier shovell, two pare

of tongues, a spitt & pott hooks & hangers 10s	9	2	0
Books to the vallue of 10s, woolen yarne 10s	1	0	0

<u>In the Dary House and Buttery</u>
A cheespress & som cheesbords 7s 6d, two tinn driping pans & som other
tinn things 2s, a powdering tubb 2s, foure cowels, four pales & one churne,
five barrills and other wooden ware £1 10s, six baggs 5s, two axes with som

spades & mattocks 5s	2	11	6
Eleaven yards of woolen cloth	1	7	6
Seventeen strike of barley	1	14	0
Foure younge fillies £10, five mairs £14, one maire & coalt £2	26	0	0
Five score & eighteen sheep	33	0	0
Five cowes £13, foure heafers & a bull £7, foure calves £2 13s 4d	22	13	4
Foure store swine	2	0	0
Two waggons £8, one carte & three tumbrills £6, two plowes & foure harrows £1 10s, gears for seven horses & other implyments for husbandry £1 10s	17	0	0
Eight quarter of peas £8, oats £13, corne in the barne £6, hay at £4	31	0	0
Twenty acres of wheate & rye growing upon the ground	40	0	0
Other lumber, impliments & things forgotten	1	0	0
Total	223	4	4
In debts desparate	2	0	0

The said deceased dyed seazed or possessed of a lease of a certaine messuage known by the name
of Hillinghull Grange with certain closes of pasture & meadow ground thereunto belonging ... in
a certain indenture of lease ... from Loveisgod Gregory esq. bearing date 22 Dec 1677 ... for 21
years [no value given]

Building and Rebuilding

As a whole, the inventories reveal the great improvement in living standards that started in the
later 16th century. The dramatic effect of rebuilding on individual houses is seen in several
sequences of inventories. A good example is a yeoman farm in Ashow (holding 37). The house
was already substantial in 1580 (Thomas Cox) (**13**), when it had seven rooms, three of them
upstairs. It had almost certainly been rebuilt about 20 years earlier, when Thomas Dadley left
£6 in his will (1558) to Thomas Cox for the 'buyldyng of his house agayne'; the old house had

presumably burnt down. By 1613, when Thomas's son James died, the house had been doubled in size to twelve rooms, with the addition of a pewter house, dairy, malt chamber and two other chambers. Similarly, the two-room inventory of John Sotherne (1553; holding no.57) mentioned in the last chapter makes a great contrast with the seven and ten rooms of his long-lived son, Edward (1602), and great-grandson, Thomas (1636).

Prosperous craftsmen could achieve the same improvement, and this is nowhere more marked than for the Farre family. William Farre, who died in 1567, was a husbandman farming 30 acres (holding 5) and living in three rooms. His son and successor, another William, was a tanner of considerable wealth (including £175 worth of leather), though still with farming interests. When he died in 1609, his house had twelve rooms, and four later inventories (1644-1716) list eight to nine rooms.

Standing buildings, such as 11-12 Coventry Road and Manor Farm (Figures 18, 19), show that these improvements often involved extending an earlier house, rather than sweeping it away, as is also found in middling houses (Chapter 6).

Living in a New Style

The most immediate effect of the enlarging of the houses was simply an increase in the quantity of household goods—the bedsteads and bedding for the extra chambers along with the oddments that collected there, as well as the dishes, tubs and barrels that needed special dish-houses or extra butteries to hold them. Changes in comfort and in styles of living were slower to come, hardly noticeable before 1600 and gradual thereafter. A few inventories from around 1600 show improvements to the house itself, with wainscoting in the hall and glass in the windows, while window lattice and shutters are noted once (Thomas Smallwood, 1605). Such enhancements were probably so standard in substantial houses that the appraisers generally ignored them. The assignment of a lease for Hurst Farm in 1605 gives a more complete list of items that might be considered to be 'tenants fittings'; the grantor would give up:

> the keys of all doores at every room ... and the lockes and boltes upon every door, and all the loose boardes in and about every chamber, without ... having the wante of any of them, soe as ther be in every chamber fully soe many as shall furnishe and fitt every flower wher they soe remayne.
> and the frame of joyce and timber in the one end of the barne...
> and all the glased windowes with the casements, and all such leade as is for gutters or otherwise fastened to any parte of the house, with such setles as are aboute the hall or kitchen. (SBT.DR18/3/57/1)

Through to 1700, the hall typically contained a long table associated with a form;[10] a smaller round or 'falling' table was also standard. At first, only a pair of chairs for the master and mistress provided better seating, but stools became common after 1600 and, by 1700, John Gibbs of Ashow provided seven chairs for his household and visitors. Cushions were very numerous to start with, though they almost vanished by the end of the century, perhaps as upholstered seats became more common. As in the earlier houses, a cupboard was found in virtually every hall, though its contents remain concealed.

The hall fireplace was only fully equipped in the few houses without a separate kitchen. Others sometimes had andirons or bellows and tongs; by the end of the century a couple had iron grates (probably fire baskets for burning coal), and fire-screens are also recorded by then. Pothangers were quite often found in early 17th-century halls, showing that water was regularly boiled there rather than in the kitchen.

Though the hall furniture was little changed from before 1600, it improved in quality. Tables and stools were generally *joined,* and *court cupboards* (from 1665)[11] superseded *joined cupboards* (common by 1625). Painted cloths remained as the standard decoration before 1600, disappearing by 1625, while several 16th-century inventories mention table carpets. Halls held

surprisingly few inessentials: a picture (Elizabeth Morrey, 1624);[12] a great bible, a desk, an hourglass and pictures (Nicholas Samon, 1638); another hourglass (Thomas Lorde, 1675); a clock (Robert Burbery, 1682; Basil Holbech, 1687, 1695); two bibles and other books (Thomas Garrett, 1684). Books were more often in the parlour as were frivolities like Thomas Hill's pair of playing tables (1567), though surprisingly William Robinson's pair of harpsichords was in his pantry (with his £31 worth of silver plate and spoons) (1668).

The simplicity of the halls is partly the result of parlours developing from bed-chambers to living rooms. The first records of living parlours were in the homes of Anthony Spencer (1604) (20), Humphrey Taylor (1634), and Stephen and Anne Wilson (1633; 1650). In the next generation they were found exclusively in the homes of local gentry (Thomas Stacie of Finham, 1665; Samuel Wade of Whoburley, 1668; William Robinson, the tenant of Stoneleigh Grange, 1668; Christopher Leigh, 1673; 18); only after 1680 did they spread further.

The comfort and display, so lacking from the halls, appears dramatically in parlours like that of Anthony Spencer (20). The tenant of Nether Fletchamstead, William Meigh (1695) (22) had a particularly fine range of furnishings in his parlour including Russia leather backstools (chairs),[13] while his two upstairs chambers contained 15 chairs and 4 stools 'all lately bought together'.

Those parlours that remained as the principal sleeping room generally contained benches as well as chests and coffers, even in the 16th century, and by the later 17th century most held a table and chair.[14] In 1593, Thomas Holland had a desk in his chamber with a few pieces of linen inside it, 'whereon was two smale silver spones, a thynn whope ring of golde, two silver hokes and a silver pyn'. Presses or court cupboards became more common during the 17th century, as did looking glasses (rare before 1660). No one else matched Richard Camill's two glasses in his bedchamber and two others in the chamber over the kitchen (1694; 7).

Beds were often valued as complete units, from a modest 10s. for one in a subsidiary chamber, to a remarkable £10 for Thomas Stringfield's bedstead, down bed, three down pillows, rug, curtains and valance (1663); joined bedsteads and feather beds (worth £3-5) were more typical. Two inventories (1580; 12 and 1608) noted painted bed curtains or testers. A few people had luxurious (and expensive) Holland sheets,[15] but flaxen, hempen and hurden sheets were more common, in descending order of quality (and price: 9s., 4s. and 3s. a pair in 1687). Perhaps the rarest items of bed furniture were cradles, no doubt because they were quickly passed on for reuse by younger members of the family.

In the 16th- and 17th-century kitchens, the main fireplace had essentially the same equipment as in the early small houses: a pair of cobirons, several spits, pot hooks and hangers, bellows and tongs. Either a gridiron or a brandart was also standard before 1600, but became less common thereafter, suggesting that pots were then hung from the pot chain rather than stood on the gridiron.[16] Some early kitchens were certainly open, like Edward Sotherne's which had 'beef and bacon in the roof' (1602).

In the 17th century, spit jacks and furnaces appeared, as did some new implements like flesh forks and fire pans. The precise nature of a furnace is elusive, though it seems to have been a large vessel for heating water, similar to a copper.[17] Bake-ovens had no moveable parts that might have been regarded as chattels, and so are not listed in inventories, though they are sometimes identifiable indirectly from the 'peal', used to remove the bread (e.g. Richard Bolt, 1687). They seem only to have been introduced late in the century; examples can be seen in standing buildings from around 1700 (Figure 32).[18] The bread itself only appears twice, with the beer, beef and bacon in Thomas Hill's inventory (1631) (17) and in William Syers' inner buttery with two 'grease pots with grease' (dripping or tallow for candles) (1598). Like the five strings of onions (1580) (13) and the six earthen cream pots and a gallon of butter in a pot (1627), most households must have had such foods even when they went undescribed. In Richard Dadley's inventory (1601), 'the larder' valued at 15s. probably covered such items, rather than describing the room containing them.

The kitchen or buttery normally held the pewter and dishes, though Thomas Smallwood (1605) displayed some of his on the joined cupboard in the hall:

> On the cubbard head, eight peeces of pewter, foure candlestickes, two saltes and an aquavite bottle and a pewter pott and skimmer.

The most valuable items might be kept more safely. Robert Osman had his glass case in his chamber, and Richard Dadley displayed his 'copper and glasses' on the press in his lodging chamber. Most inventories in this group list substantial quantities of pewter and brass (e.g. **14, 20**), often with three or four dozen pieces. After 1600, many households also had a few more valuable items: a gilded cup and saltcellar (1636); a black jack with a silver brim (1638); a silver bowl and 3 silver spoons (1683). Thomas Nelson owned a gilt bowl and salt, 10 silver spoons and an 'alkemie' bowl[19] (1627). He also had a coffer for silver, though this was in a different room, and these objects were probably standing on the court cupboard in his bedroom.

More mundane items must often have been present but are only occasionally recorded, e.g. the lawn sieve, leather bottle, flour box and oatmeal box, and 'pair of pepper corns' in Thomas Cox's dairy (1639), or Richard Camill's three dozen trenchers in a trencher rack (1694; **7**). The detail given for Richard Griffine's buttery (1585) is altogether exceptional:

> 5 earthen pans, 2 earthen pots, 3 cups; 2 treen platters, 1 drinking cup of wood, 1 trough with the cover, 1 dozen trenchers, 6 wooden dishes.

Surviving Houses

Surprisingly, standing buildings to match the houses described in these inventories are much rarer than for the small medieval-style houses considered in the last chapter, fewer than half-a-dozen surviving reasonably unaltered. This is not a matter of chance but arises because the houses were systematically replaced. This rebuilding is examined in Chapter 8, but it is worth emphasising that the better survival of the smaller houses in Stoneleigh is the opposite of the usual expectation that standing buildings are the largest and best of those originally present. It may well be that critical examination would cast doubt on this presumption elsewhere.

With only a small sample from many houses, it is not surprising that they have little in common. Furthermore, all have been altered to a greater or lesser extent, and matching them with their inventories is often uncertain.

Ivy Farm, Canley (Figures 17a & b)

Only one house, Ivy Farm, Canley, seems to be entirely of the early 17th century (apart from its 18th-century dairy). It gives the clearest indication of the housing standards to be expected for a medium-sized tenancy (about 50 acres). The 1627 inventory of Johanna Hancorne lists ten rooms, compared to the eight or so in the standing building, but it lacks helpful locations like 'chamber over the hall', that would help in matching house and inventory. The extra rooms may have been in a service bay in the position of the later dairy. A second wing is also possible, giving a H- or U-plan, as found in a farmhouse at Hill of much the same date as Ivy Farm.[20] The inventory of Johanna's father-in-law, John Hancorne (1571), shows that, even before its rebuilding, Ivy Farm was a substantial house (8 rooms), perhaps created by additions to a medieval house, swept away in the 17th-century rebuild. His widow Agnes occupied only three rooms in the house (1574).

11-12 Coventry Road, Stoneleigh (Figures 18a - c)

A characteristic addition to an earlier house is seen in 11-12 Coventry Road, Stoneleigh, the house of a two-yardland farm built in the early or mid-16th century.

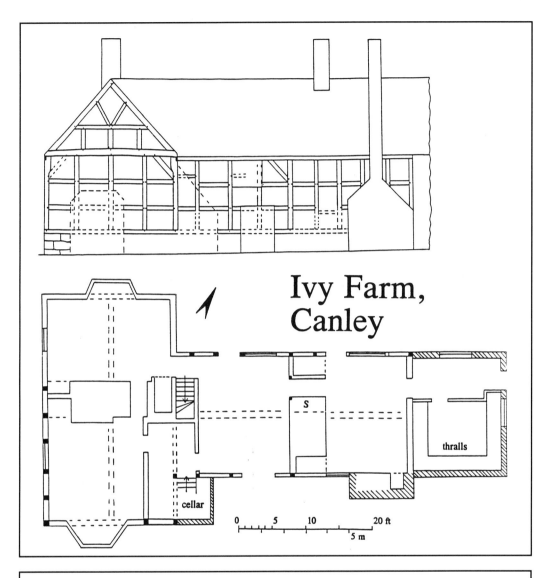

Ivy Farm, Canley

Ivy Farm appears to be of one build of the earlier 17th century, apart from the added dairy with thralls (c.1800). Much of the framing of the wing has been cased in brick. Most internal features are concealed, but some beams have scroll stops. The original stair position was possibly between the main range and the wing, as the beam has stops beside the partition, though another stair rose beside the main fireplace where a blocked door on the west side indicates the presence of a lobby entry at one period.

17a *Ivy Farm, Canley, plan and elevation.*

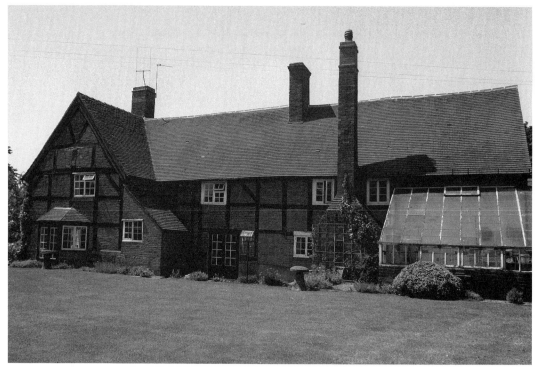

17b *Ivy Farm, Canley, from the west.*

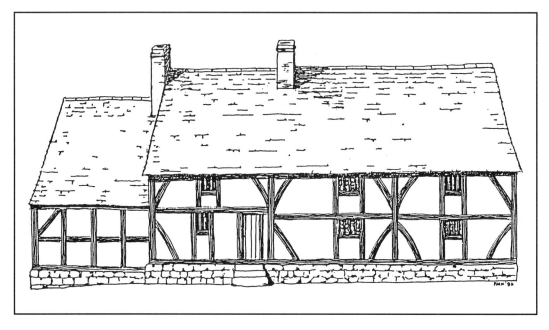

18a *11-12 Coventry Road, Stoneleigh: reconstructed elevation. Drawing by Dr Pat Hughes.*

18b *(facing page) 11-12 Coventry Road, Stoneleigh, plan, section and inventory interpretations.*

11-12 Coventry Road

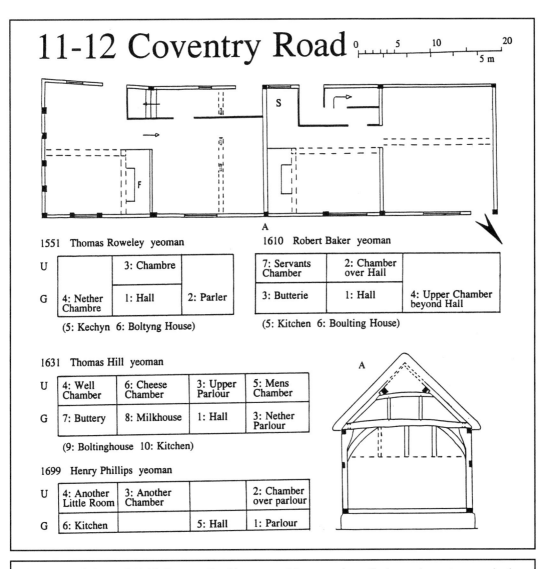

0 — 5 — 10 — 20
5 m

1551 Thomas Roweley yeoman

U		3: Chambre	
G	4: Nether Chambre	1: Hall	2: Parler

(5: Kechyn 6: Boltyng House)

1610 Robert Baker yeoman

U	7: Servants Chamber	2: Chamber over Hall	
G	3: Butterie	1: Hall	4: Upper Chamber beyond Hall

(5: Kitchen 6: Boulting House)

1631 Thomas Hill yeoman

U	4: Well Chamber	6: Cheese Chamber	3: Upper Parlour	5: Mens Chamber
G	7: Buttery	8: Milkhouse	1: Hall	3: Nether Parlour

(9: Boltinghouse 10: Kitchen)

1699 Henry Phillips yeoman

U	4: Another Little Room	3: Another Chamber		2: Chamber over parlour
G	6: Kitchen		5: Hall	1: Parlour

The three early bays of 11-12 Coventry Road have curved braces to the wall plate and recent re-examination has identified the pegholes for large curved down-braces as well. Pegs for the door jamb and the position of the beam together locate the entry and cross-passage. The central stack is early (bricks 10 in x 5 in x2 in), and the space beside this probably held the stair. The central beam has heavy chamfers and step stops (16th century), but that in the west bay has scroll stops (post-1600). Studs for upper windows survive in all three bays (with one remaining window sill). This might suggest that there were original upper floors throughout. However, the inventories for both Thomas Roweley and Robert Baker list fewer than six rooms in the main house. strengthening the architectural evidence that only the hall was originally floored. The low bay at the east end uses straight diagonal braces and has inset principals; it must date from somewhat after 1600 (between 1610 and 1631 from the inventory evidence). Its chimney is early.

In the 17th century a lower bay was added at the east end. The partition in the adjoining room contains an early door, showing that the lower end was re-organised at this period, probably to provide a stair for the added bay.

The sequence of rooms in Robert Baker's inventory appears very confused, 'hall, chamber over hall, buttery, upper chamber beyond hall, kitchen, bolting house, farm building, servants chamber'. If one assumes that the 'upper chamber beyond the hall' was on the ground floor, i.e. 'upper' in status (contrasted to 'nether' in Thomas ·Roweley's inventory), and that the servants' chamber was in the house but overlooked at first, then a tentative assignment is possible (Figure 18b). Otherwise, the sequence implies that the assessors went up to the chamber over the hall, down to the buttery, then up again to the far end chamber, while ignoring the ground floor room at this end. The servants' chamber might be placed at either end, but is assumed to be at the lower end.

In Thomas Hill's inventory the location of the upper parlour is critical. The two joined beds and the joined press in it seem to correspond to the two bedsteads and a press in Robert Baker's 'chamber over the hall'; he left his household goods to Thomas Hill. Although parlours upstairs are unusual, they are occasionally found (e.g. 'parlour over the hall' in the inventory of Thomas Jenkes of Warwick, 1590 [published in N.W.Alcock (ed.), *The Past in Warwick*, 1992]). The 'buttery' can be firmly placed in the added bay.

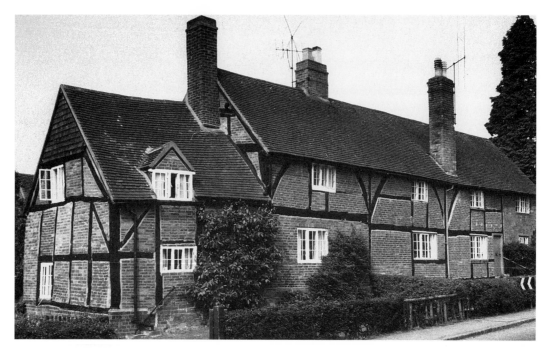

The first inventory for this holding is that of Thomas Roweley (1551) (**16**). The architectural evidence for the main part of this house is not precise enough to show either that it must have been built by this date, or the converse. However, Thomas Roweley held by a lease for a term of years which he bequeathed to his wife. Its security might well have encouraged him to spend money on a new house.

16 *Thomas Roweley, yeoman (1551)*

Apart from his will and inventory, he is recorded only as appraising inventories in 1547 and 1549. He left a widow, Isabell (his second wife), and three young daughters, Margery, Isabel and Agnes. He also made numerous small bequests of clothing, sheep or money, including a sheep to each of his servants. His wife received the lease of the farm, and may have continued to live there, as the succeeding tenant, Walter Dowsewell, was appointed executor in a second probate grant following her death (1557); a third grant to Margery and Agnes shows that by 1563 they were of age. In 1559, they were each left 10s. by Godfrey Parton (**7**).

Inventory appraised by John Parker, William Slowghe, Thomas Burbery, Roger Calawey, Thomas Eburhall, 16th September 1551.

The Hall			
2 Foldynge tabulles, 2 formys, a coborde, 2 payntyd clothes, 2 carpettes, 8 cussyns	1	4	0
The Parler			
A trusse bed with a fether bed, with the hoole appurtenences, 4 cofers, one cobord, 2 pentyd clothys and a forme	2	0	0
The Chambre			
2 Trusse beddes with th'appurtenances, 3 pentyd clothys, one cofer and a chere	2	2	0
The Nether Chambre			
A trusse bedd with all the appertenences, 2 cofers, 2 tables, 3 pentyd clothys	1	6	8
20 Pere of shetes, 6 table clothis, 8 towelles, 12 napkyns	2	17	4
Apparell			
2 Gownes, 3 cotys, 2 dublettes, 2 pere of hoose, one wolsted cote, 3 shertes, with cappes and hattys	4	11	0
A dosen of sylver sponys with 2 ryalles in gold	3	0	0
4 todde of wolle	2	13	4

The Kechyn

8 Brasse pottes, 10 possenettes, 6 pannes, 7 ketelles, a skemer, & a chafer	5	2	4
2 Chargers of pewter, 21 platers, 16 pewter dysshes, 10 sawsers, 3 salt sellers, 3 pewter pottes	2	1	8
4 Latten basons, 10 candulstykes, 2 yorys [*ewers?*] and 3 chafyng dysshes		15	8
3 Brochys, 2 coberdes [*cobirons*], one pere of pothookes, one pere of awndernes, a fyre shole, a gred iron with other implementes		8	10
2 Brewenge ledys	1	6	8
The Boltynge Howse			
2 Fattys, a boltynge tubbe & all necessaryes there	1	0	0
Item in the Cytye of Coventry			
A ledde, a federbedd with thappurtenances and 3 brasse pannes	3	5	0
Catalles			
10 Kyne & hefers & 3 calves	8	3	4
8 Ront oxon	10	13	4
One nagge, a mare & 2 coltes	5	0	0
8 Yonge besse	5	6	8
9 Swyne, great & small		26	8
140 Shepe & 59 lambys	22	0	0
40 Quarters of rye £16, 40 quarters of otys £6, 4 quarters barley & pese 20s	23	0	0
The wayne, yokes, towes & all thyngys to husbondry, a grynston & a bukkett & chene	3	0	0
In dettes owenge by Raff Gresold	2	13	4
Total	114	17	10

The first four rooms in the inventory apparently describe the three-bay house, with central hall, parlour beside it, chamber (probably over the hall), and nether chamber on the other side of the hall. The inclusion of apparel, silver and wool at this point suggests a separation between these first rooms and the last two, something rarely hinted at in the early inventories, placing the kitchen and bolting house in a detached service block. Thomas Roweley must also have had storage space for his substantial quantity of crops, even though no farm buildings are named.

In 1610 the inventory of Robert Baker lists only one extra room, though it also records a remarkable number of farm buildings: a corn barn, a hay barn, a cart house and a stable, as well as a further timber frame for a two-bay barn still to be erected.[21] The changes since 1551 were small but characteristic: the insertion of a second upper chamber and the conversion of a ground floor chamber to a buttery. Cooking was still was still being carried out in the separate kitchen. The next tenant after Robert Baker was Thomas Hill, his kinsman and executor. By now the house certainly included the small east extension, with the second early fireplace in the house, and the latter's inventory in 1631 (17) shows that improvements had gone considerably farther. Characteristically, he had glass in both hall windows (although the deletion of the item shows that the appraisers decided it was a fixture, not to be valued); Robert Baker only had glass in the windows on the street side. The house now had three more rooms, a dairy and two chambers, one being for cheese (but also containing corn bins), typical improvements at this period. The bolting house and kitchen are again listed at the end, presumably still being in a separate building. The latter contained the cheese press and brewing 'fatt' (vat) (as for Robert Baker). However, cooking was now taking place in the buttery (i.e. the room in the added bay with the second fireplace)! Clearly, the traditional room names had been retained, despite changes in their uses. Thomas Hill's home is re-created in Chapter 12, Figures 52 and 53.

17 *Thomas Hill, yeoman (1631)*

He was the 'kinsman' of Robert Baker, and succeeded the latter as tenant of the two yardland farm in 1610, being left the residue of his goods. Thomas served as juror, tithingman and constable for Stoneleigh on several occasions. He had only one child, Alice, who was unmarried in 1631 and was left an equal share in the household goods with Thomas' wife, Elizabeth. Robert Baker left Alice £10 (to be paid when she was 15), his best bedstead and bedding, and his best brass pot. Elizabeth remained as tenant until after 1640.

Inventory appraised by Henry Bellingham, Goodier Otton [or Hoton], John Hoo, Thomas Hoo, 18th October 1631.

	£	s	d
All his waring apparrell both lynnen and woollen	4	0	0
In the <u>Hall</u> one large joyned table		13	4
[*deleted* All the waynscott & benches with the glasse in the street & yard window]			
Three cheers, four joyned stooles, a long forme, a litle table		9	4
One joyned cubbard		14	0
One pere of bellowes, a fyre showell, a pere of landyrons, pott hangars, a pair of tongues		2	6
In the <u>Upper Parlor</u> two flock beddes, two fetherbeddes, two longe boulsters, three short pillows, three pere of blankettes, two hillinges, two ioyned bedsteeds, four coffers, a trunke, on joyned presse, two litle boxes, two pere of curtaynes with all other ymplementes in that roome	15	0	0
In the <u>Nether Parlor</u> one flock bedd, one fetherbed, one boulster, one pere of blankettes, one hillinge, one litle court cubbard, two coffers, one joyned bedsteed, two little boxes with all other ymplementes in that roome	8	6	8
In the <u>Well Chamber</u> two flock beddes, two pere of blankettes, two boulsters, three pillowes, a hillinge, a half-headed beedsteed and one coffer	3	12	0
In the <u>Mens Chamber</u> one flockbed, a duble twylly, a blankett, two boulsters, a hilling and a borded bedsteed with all other ymplements in that roome		18	4
In the <u>Cheese Chamber</u> all the cheeses with shilves, two coffers for corne	1	5	0
In the <u>Buttery</u> foure pannes, six ketteles, three brasse pottes, two chafing dishes, eight candlesticks, a warming pann, a morter with spettell [*pestle*]	6	10	0
Two dripping panns, three spittes, two pere of cobyrons, one brendert, twenty great platters with other peweter	3	10	0
An old cubbard, 3 barrells with other ymplements in tbe Buttere		13	4
Four litle wheels and one great wheele, one coffer, one todd of woole, six stricke of apples with all other ymplementes there	2	10	0
In the <u>Mylkehouse</u> two gallons of salt butter with mylk pannes and crem potts, the ches fattes, shilves, basketts and all other ymplements there		13	4
In the <u>Boulting House</u> a great cover [*kiver?*], a boulting tubb, a kneding trough with other ymplementes ther		10	0
In the <u>Kychen</u> a cheese presse, a stepe fatt, a great coule, six payles, three loomes with all other ymplementes there	1	10	0
In Lynnen seaven pere and a half of flaxon sheetes; sixteen pere of hemp sheetes, 3 dozen of napkins and a halfe, eight table cloths, ten pillowbeers, foure towells	10	0	0
Eight cushens		5	0
Bread and beer, beife and bacon		10	0
All the rye and wheat in the <u>Barne</u>	20	0	0
All the oats, hay, pease, barly	9	0	0
One cart and a tumbrell	3	0	0
Two plowes, two small harrowes and a great harrow	1	0	0
An iron croe, a great saw, five yron wedges, two oxe tewes, three bills, an ax, a hatchet, two pere of yron greers [*gears?*] with forkes, rakes, reaping hookes and other ymplementes for husbandry	1	0	0
Woode and coles	1	6	8
Seaven skore of sheep younge and old	30	0	0
4 Mares	9	5	0
Fyve kyne, two heifors in calf, five weighing [*weaning*] calves	1	0	0
All the corne sowed in the feildes	25	0	0
One hogg		13	4
Henns and cocks		5	0
Six pere of geers		10	0
All other trash and rumble thinges within the house and without		3	4
Total	183	2	2

In 1699, the inventory of Henry Phillips (Table 6.1) only lists six rooms in all, three probably upstairs and three down. The omission of some of the rooms in the main block (perhaps used by a relative or lodger) means that we cannot be sure that the detached kitchen and bolting house had been removed.

Manor Farm, Stoneleigh (Figures 19a & b)

Of all the surviving houses, this gives the best impression of the rambling character of the large early houses. Its structural development was remarkably complex, starting from a three or four-bay block, similar to 11-12 Coventry Road. Precise dating for most stages is impossible, but one date is firm: the record in the Hearth Tax in 1664 of nine hearths, increased from five the year before, with the note 'the house rebuilt and not finished'. The alterations included the insertion of the four fireplaces in the east wing, probably also the re-framing of the old front wall, and perhaps the addition of the rear room in the east wing. This work had been set in train because the house was about to be taken over by the Leigh family themselves; for the next ten years, it was occupied successively by Christopher Leigh, esquire, great-uncle to Thomas Lord Leigh, and Christopher's widow. His inventory (18), both in the contents and the rooms listed provides a fascinating contrast with those of even the most prosperous villagers. Only the principal rooms, kitchen (bay I), hall (III), parlour (VI) and inner parlour (VII) can be confidently recognised in the existing house. Some of the unidentified service rooms may bave been in a block closing the courtyard at the rear, which is drawn on the 1766 map.

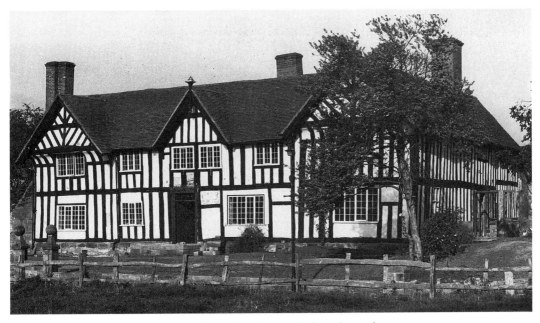

19a *Manor Farm, Stoneleigh from the south.*

The name has no historical significance, this being merely the largest farm in the village. Although now appearing symmetrical, its development is complex. The earliest section (early/mid 16th century) comprises the three west bays of the front range (I-III); this has a small stone cellar under bay II. The roof of bay I is sooted, from an open hearth which was superseded by the large sandstone kitchen stack, and this bay lacks the large axial beams with step stops of the other bays. The central rear stack has been much reconstructed and its date is uncertain. This range was originally close-studded, but at a different spacing to that seen at present. The rear bay of the west range (IV) has a clasped purlin roof (like the main range). It was originally free-standing, before the roughly-built linking section (V) was added. Its brick chimney was added in about 1700, causing the removal of the studs of the end wall, and its floor seems to be of the same date.

The very smart bays VI-VII were added in about 1600, with close-studded framing, small ground-floor flanking windows, a first-floor oriel window and a jettied gable with coving. At the same time, the facade of bays I-III were re-studded to match, and a matching gable added to bay I; the small central gable seems to have been an afterthought. Later in the century, this range was extended (bay VIII). The framing here was clearly intended to match that of the adjoining bays, but has a higher plinth and visible corner brace.

Bays VI-VII were apparently unheated when built, and the addition of the chimney with double fireplaces on each floor can be matched with the Hearth Tax evidence. The fireplaces have moulded stone surrounds with four-centred arches and integral stone mantel shelves. *(See over for plan and elevation.)*

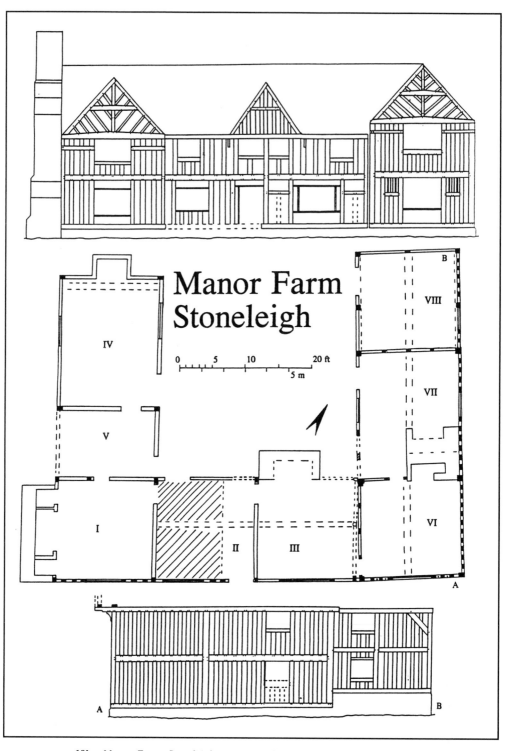

Manor Farm Stoneleigh

19b *Manor Farm, Stoneleigh, principal elevation, plan and side elevation.*

18 *Christopher Leigh, esquire (1673)*
The Honorable Christopher Leigh was the fourth son of the first Baron Leigh and great-uncle
to the holder of the title in 1673. Apart from one bequest from a Stoneleigh widow in 1657,
he had no apparent relationship with the parish; of his inventory appraisers, the first was the
estate steward and the second the innkeeper. The manor of Leighton Buzzard had been held by
the Leigh family since 1610 on successive leases from the Dean and Chapter of Windsor, and
was presumably settled on him by his father (*VCH* Beds, III, 399).

Inventory appraised by Charles Duckworth of Stoneleigh, gentleman, and John Wigson of
Stoneleigh, gentleman, 6th May 1673 [SBT.DR18/4/63].

Inprimis in readie money	80	0	0
His wearing apparell	50	0	0
A gold watch	20	0	0
In his Study			
His bookes, a deske, a stand, a box, etc.	50	0	0
In the Hall			
A table, 6 chaires, andirons, and pictures	2	0	0
In the Kitchin			
A dozen pewter plates, 8 pewter dishes, 4 sawcers, 3 bigg kettles, a little one,			
4 brasse pottes, a jacke, 2 pair of pewter candlestickes, 3 brasse candlesticks,			
3 iron candlestickes, a racke for plates, a pair of bellows, a mortar and pestle,			
a grater, a driping panne, 3 spitts, an iron to sett before the driping pan,			
3 pewter porringers, rackes, potthookes, 3 chaires, a salt tubb, a fire shovell			
and tongues, 3 smoothing irons, 2 heaters, a flesh forke, 3 chafeing dishes,			
a basting ladle, 3 skelletts, 2 pewter basins, 2 gridirons, a cleaner, a jacke			
weight, a rubbing brush	25	0	0
In the Larders			
A table, 2 stooles, a cullender, a marketing basket, a drudging box,			
a powdering tubb, a meale tubb, a mousetrapp, a salt, etc.	3	0	0
In the Dary			
A cheese presse, 2 benches, a churn, milke pannes, steane potts, cheese fatts,			
butter & cheese, a cheese ladder	5	0	0
In the Pantry			
A napkin presse, a bin for bread, a table, a cisterne, 7 dozen of trenchers, a case			
of knives, 12 salts, glasses, crewetts, and 2 juggs	5	2	0
In the Cellar			
Beere, six hogsheads, 2 barrells, 3 basketts, 2 barrells of veringre [*vinegar*]	10	3	0
In the Ale Cellar			
Ale 2 barrels, 1 dozen of glasse bottles	2	8	0
In the Brew Howse			
A brasse furnace, a larg mash fatt, 2 coulers, a garner, a bucking tubb, 5 pales,			
3 bowles, 5 barrells, a bolter, 4 corn baggs, a search, pott rackes and a peale	15	0	0
In the Parlor			
Seaven pictures, a clocke, 6 chaires, 6 stooles, a table, 2 side boards, 3 carpitts,			
and 3 flower potts	56	5	0
In the Inner Parlor			
A base viol, a violin, a grate, fireshovell & tongues, a table and a stoole,			
a skreene for linnen	15	0	0
In Mrs Leigh's Chamber and Closett			
A bedd and beddstidd, a quilt blankett counterpoint, a sett of cloath curtaines and			
linnen curtaines, a greate cabinett, a chest of drawers, a tortoise shell cabinett,			
a cellar for bottles, a combe box, another box, a wooden standish, 2 hanging			
shelves, a tortoise shell powder box, another powder box, 4 chaires, a trunke,			
a table and carpitt, a sideboard, 2 lookeing glasses, a grate, a fire shovell and			
tongues, a pewter standish, 4 brushes, 2 flower potts, a sett of hangings, a hand			
skreene, a reading glasse, 2 hookes and plate	70	0	0

	£	s	d
In Mr Leighs Chamber			
A bedd & bedstidd, curtaines, blankets, a close stoole and hangings	15	0	0
In the Chamber over the Parlour			
A bedd and bedstidd, bedcloaths, valens, curtaines, a stove, a long box, a trunke, a close stoole, a standish	10	0	0
In Mrs Leigh's Closett over the Parlour			
Many bottles of excellent strong waters, 10 boxes, linnen yarne, flower potts, white pots & other things	10	0	0
In the Chamber over the Kitchen			
A bed and bedstidd, beddcloaths, a materice, 2 trunkes, a chair, andirons, a fireshovell and tongues, bellowes, a box, a lookeing glasse, 2 mantles for a child, cradle, linnen and all other necessarys for a child	29	2	6
In the Mans Chamber			
A bedd and beddcloaths, a materice, a bench	5	0	0
In the Chamber over the Brewhowse			
Two warmeing pannes, a still, 3 pair of andirons, a skreene, 2 wheeles, 9 bird cages, linnen lines, wafer irons, a linnen baskett, 3 whiskets, a reele, charcoale and a forme	7	0	0
2 Guns and 3 swords and belts	15	0	0
For 2 cowes and 2 mares	21	4	6
For 3 hoggs	3	10	0
For flax	3	0	0
Candles and a pair of snuffers	1	11	0
Oates 1qr, Rye 1qr 1 stone	2	8	0
Malt 6 quarter	6	0	0
For flaxseede, mucke and wood	2	0	0
2 Pigg troughs, 2 bucketts with a chaine, a ladder and a lanthorne		16	4
Linnen of all sortes	15	0	0
For 28 sheepe	6	12	0
In the Stable			
Three saddles, bridles, saddle cloaths, horse cloaths, a provender tubb, 2 forkes, a shovell, a locke, a logger, a curry combe and brush, a main combe, a hatchett, a bill, a hammer and pinsins	8	0	0
In the Barnes			
Six load of hay	8	0	0
Six load of coales	5	0	0
Broome	2	0	0
Debtes due upon specialties	400	0	0
Debts due upon Real Securities			
Due that is secured by land in the County of Worcester	200	0	0
A lease of the Manor of Laighton in the County of Bedford, the tolls of Laighton markett, & other lands mencioned in the sayd lease	1580	0	0
Total	2765	4	4

The next inventory, John Holbech (1687), lists only ten rooms. His will shows that the farm was held on a joint tenancy between him and Francis Clayton, and the rooms ignored in the inventory may have been used by his co-tenant. One significant feature of this pair of tenants is that John Holbech was consistently described as 'gentleman', while Francis Clayton called himself 'husbandman', though his neighbours, including John Holbech in his will, used the term 'yeoman' of him. The lack of correlation of status and wealth is demonstrated by a comparison of the total value of the two inventories, £100 and £294 respectively.

Neither Francis Clayton's will (1714) nor the estate records suggest that the farm was still divided at his death, though his inventory lists only 13 rooms. His kitchen and backhouse had fire implements, and a screen in the hall confirms the presence of a fireplace there; the backhouse was probably bay IV. The rooms in the best wing cannot be recognised in the inventory, so this part of the house may still have been sub-let.

South Hurst Cottages, Hurst (Figures 20a & b)

Like Manor Farm, this house shows a sequence of development from the 16th to the late 17th century, and it is illustrated by a particularly good series of inventories (**19-21**). The farm was of middling size, 54 acres in 1597.

The 1569 inventory of Humphrey Partrige (**19**) describes a house with four main ground-floor rooms, hall, buttery and two chambers, with one chamber over. The kitchen was perhaps in a wing or detached, as it was visited after the first-floor room. The contrast to the smaller houses of the same date is notable, particularly in the presence of fire-irons and cooking implements in both hall and kitchen.

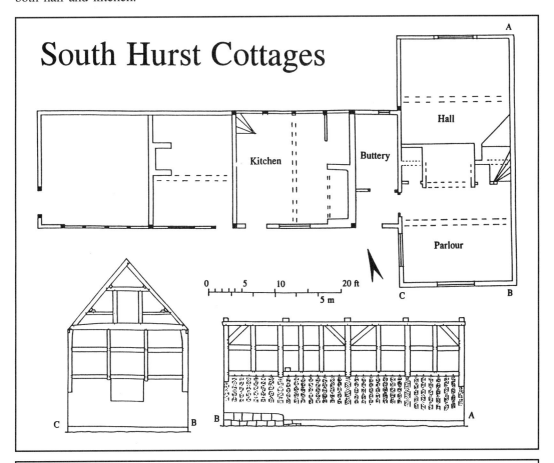

The main block of South Hurst Cottages, the head of the T-shape, dates from the late 16th century and was exceptionally well constructed (although much of the framing has been replaced in brick). Its notable decorative details include the framing of the principal elevation with close-studding below square framing, and ovolo-moulded door frames for the parlour and buttery. The beams and joists of the hall, parlour and buttery are chamfered with scroll stops and the clasped-purlin roof contains intermediate trusses (without wall posts) with chamfered and stopped tiebeams; the white limestone chimney has diagonal brick stacks.

This block replaced part of a 16th-century building, a bay and a half of which survive in the stem of the T; the two bays beyond this were rebuilt in the 17th century with re-used timber of poor quality.

20a *South Hurst Cottages, Hurst. Plan and elevations.*

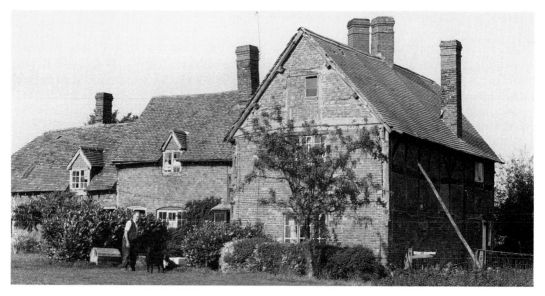

20b *South Hurst Cottages, Hurst in 1974, from south.*

19 *Humphrey Partrige (alias Dowland) of Hurst (1569)*

Humphrey's father, Richard, died in 1537, and in 1545 (*Manor*) his mother Agnes, and her sons Thomas and Humphrey became tenants of a messuage in Hurst. Humphrey served on the manor jury and as thirdborough (sub-constable) for Hurst a couple of times, but otherwise had little involvement with the parish administration. He left each of his five daughters £8 when they reached the age of sixteen. The residue went to his wife who succeeded him as tenant for just a year before the family disappeared from the rentals. In 1569 she was the unique woman member of a manor court jury.

Humphrey's brothers Simon and Richard were left a jerkin, doublet and boots, and a coat and hose respectively. Simon, who also died in 1569, was probably living at home, as his inventory shows no household contents; he left his goods to Humphrey's daughter Mary. Richard may be the Richard Dooland, one of the first occupants of the almshouses in 1577 (p.141).

Inventory appraised by Water Frecleton, John Benyone, Thomas Balle, Nicholas Tofte, 2nd June 1569.

In the <u>Halle</u>, a table, a forme, 2 cobordes, a chere, 2 other lyttyll formes, 2 shylfes, a pere of bellys, a pere of tonnges, a grydyerne, one anndyerne with 2 potthengles and the pentyd cloth abowt the halle	10	0
In the same <u>Halle</u>, 6 brasse pottes, 3 panes, 2 kettles, a skemer, a lytyll skelett	1 10	0
In the same <u>Halle</u>, 6 platteres, 6 pewter dysshys, 4 sawsers, 3 saltes with 6 candelstykes, a bason, 2 chaffyng dysshes, a lavor	1 0	0
<u>The Buttrey</u>		
4 lyttyll lomes, a cherne, 2 vergys barrelles, 3 palles, 3 bottelles	4	0
<u>In the Chamber</u>		
2 bedstyds, 2 matterys with testors therto appertenyng, 2 coverlettes, 2 pere of blankettes and 10 pere of shyttes, wereof one pere of flaxene and one pere of hemton, 3 coffers, a forme, a lantorne, a melesyve	1 10	0
<u>In a Nother Chamber</u>		
A framyd bedstyd, a fether bede, flokebede, 4 pyllows, 4 bolsteres, a coverlett, 2 cofferes, a chere	1 10	0
<u>The Chamber Over</u>		
A bedstyd, a matteris, a coverlett, 3 chylffes, a chesse rake, a cradle with some old iron	6	8

In the Kechyn
A spytte, a pere of cobbords with tobes (?), a brandard and other such necessary

		£	s	d
stoffe			13	4
4 Bord clothes, 6 napkyns, 2 pillowberes			6	8

In the Barne

		£	s	d
6 Trave of rye			13	4
A wane, 3 plowes with yokes, towes there unto appertenyng, a colter, a share and certen plow tymbre, 3 harrowes			40	0
6 Dayes grese of rye [*sprouting*]and 6 dayes erthe of ottes [*sown*]	9	0	0	
4 Score sheep	12	0	0	
4 Oxen, 7 kyne and 11 young besse, wereof 4 yerelynges, 3 2-yere oldes and 4 of 3-yere oldes	20	0	0	
3 Mares	3	0	0	
3 Swyne, 6 henes and a coke			22	0
In apparrell			13	4
Total	55	19	4	

Anthony Spencer, gentleman, took over the farm in 1595 and had transformed the house by his death in 1604. He replaced one end with a smart new block including hall and parlour, chambers, and the only cocklofts to be recorded before 1660. In addition, his lifestyle in the new house was more sophisticated than any of his fellow tenants. The excellently-furnished parlour was his main living room, not the hall. Indeed, the structural evidence shows that in this house *alone*, the lack of hearth fittings in the hall arose because there was no chimney there. The room must have been principally a work-room for his servants. The service rooms have not survived, but they can confidently be placed on the site of the later back range; the thumbnail sketch of the house on the 1597 map clearly represents a T-shaped building.

20 *Anthony Spencer of Hurst, gentleman (1604)*
Nothing is known of the family connections which gave him his status of 'gentleman'. The court rolls only note his being excused attendance on several occasions (1599-1602). He left no will, but his widow, Susanna ('Mistress' Spencer in the rentals), succeeded him as tenant for two years.

Inventory appraised by Thomas Higginson of Barkeswell, gentleman, Robert Baker, James Hoo and George Gosse of Stonely, yeomen, 3th March 1603[/4].

In the Hall
Three tables with frames, one forme, two stoles, one cupbord and two spynning

		£	s	d
wheeles			16	8

In the [Parlour - left blank]
One table with a frame, one playne courte cupbord, two lether chayres, one little grene chayre, two grene stoles, fower lowe wanscott stoles, fower hie wanscott stoles, three olde carpittes, one of tapistrie and two of darnixe, sixe tapestrie cusshions, two olde needlework cushions, sixe olde grene clothe cushions, two darnix cushions and the old darnix hanginges in the Parlour, a paire of lowe

		£	s	d
creepers, a pair of tonges, a fier shovill and a paire of bellowes		3	17	4
One paire of olde playing tables and certeyne olde bookes			2	6

In the Buttrye
Fower greate barrells, two smale barrels, fower firkyns, a powdring tubb, a salting troughe, a hamper, a little table, a flaskitt, a tressell with certaine wodden

		£	s	d
ymplementes, dishes and trenchers		1	0	0

A bason and ewer, three little pewter basons, a pewter cullinder, fiftene pewter platters, seaven pewter dishes, one pye plate, twelve sawsers, fower little caudle pottes, three saltes, fower pewter candlestickes, twelve spones, nyne sallett dyshes,

		£	s	d
fyve pewter chamberpottes and three lowe brasse candlestickes		2	0	0
Certaine stone pottes, glasses and two bottles			2	0

In the Chamber over the Parlour

One standing bedstead with vallans and curtyns of olde darnixe, an olde fetherbed, a bolster, an olde tapistry coveringe, three blanckittes, two pilloos and a matt	2	0	0
Two playne courte cupbordes, fower stooles and two olde chayres with backes		10	0
A flatt olde iron-bound tronke and a little coffer		13	4
Two paire of flaxen sheetes, 13 paire of hempen sheetes, eighte table clothes longe and shorte, fyve payre of flaxen pillowbers, fower dozen of flaxen napkyns and three shorte towells	2	0	0
The olde darnix hanginges and two olde cupbord clothes	1	6	8
One paire of creepers and a fier shovill		1	0
The wearing apparrell of the said Anthony Spencer	5	0	0

In the Chamber over the Buttery

A standing bedstedd with redd olde curtyns and vallans, a fetherbed, a bolster, one pillow, three olde blanckettes, one being of fustian, and an olde rugg	1	10	0
An olde redd chayre, a table, an olde standing chiste, two tronkes and two wanscott boxes, two little stoles and the olde saye hanginges of red and grene		10	0

In the Chamber over the Hall

Two bedsteedes, two mattes, one fetherbedd, one bolster, fower pillowes, one olde worne tapistry heeling, 3 olde blanckittes	1	0	0
Two bordes and two tressells, a strawe whiskitt with a cover and three tubbes		2	8
Twentie and fower cheeses and one pott of butter		10	0
Oten malte in the tubbes		6	8
Three hampers, a hand baskitt for the Buttry, a payre of waightes with certaine lynnen yarne and lockes of wooll		2	6

In the Cocklofte over the Chamber over the Parlour

A playne lowe bedsteed, a fether bed, a bolster, a mattres, a covering, 3 old blanckittes, a little table, an olde canopie, an olde flockbed and a hamper		13	4
About a quarter of light otes, an olde saddle, a hyve and a spade tree		6	8

In the Servantes Chamber

Two bedsteedes, one olde fetherbed, one mattress, two bolsters, one pillow, fower blanckittes and two heelinges		10	0
Plowe tymber and certeyne olde bordes		2	6

In the Kilne and Backhouse

A cheese presse, six olde tubbes, a stricke, a heare syve with maulte syves and other olde lumber		6	8

In the Bolting House

A bolting tubb and a fatt		2	6

In the Kitchin

Fyve bras pottes, one brasse posnett, fower kettles, two dabnettes, one chaffing dishe, two skymmers and a basting ladle	2	0	0
Fyve spittes, two andyrons, two pott hanngers, two payre of potthookes, one payre of rackes and a payre of tonges		10	0
Three flittches of bacon		6	8
Chopping knyves and other smale ymplementes in the Kitchin		1	0

In the Daie Howse

Fower payles, eleaven mylk panns, a churne with other ymplementes and a dryping pan		5	0

In the Shedd

Certaine bordes and theales		6	8

In the Barne

Rye in the Barne unthrashed	2	0	0
Corn in grasse	2	0	0
Haye		13	4
Six kyne	9	0	0
Two old nagges and two mares	6	0	0
Fiftie and six sheepe	11	0	0

Three swyne	10	0
A carte with three harrowes, one plowe, two lathers [*ladders*] with carte geeres		
and ymplementes of husbandry	1 6	8
The wood in the yarde	4	0
Three stockes of bees	3	0
In the Stable		
One saddle, two brydles, a pannell with forkes and other thinges belonging to		
the stable	3	4
Total	62 2	6

By 1717, the inventory of John Franklin (**21**) shows that the house had not changed much, but it was being used in a much more typical way. Anthony Spencer's parlour was now the 'dwelling house', combining the uses of kitchen and living room; indeed, the room over it was the 'chamber over the kitchen'. The former hall had become the dairy, and the kitchen in the rear range was the 'back room'. The rest of the back range was not mentioned at all, and perhaps was in farm use. It is characteristic of the later 17th and 18th centuries that the house had become much simpler (Chapter 8). All the specialised service rooms in 1604 had disappeared, apart from the dairy which took the place of a former living room.

21 *John Franklin of Hurst, husbandman (1717)*

He was tenant from 1677 and was regularly a member of the manor jury and thirdborough for Hurst (1677-93). He left a widow, Jane (d. 1721) and children John (1678-1754), Thomas (1679-1751), Anne and Jane. He was succeeded by his son John, and then his grandson (also John). The £23 rent was unchanged from 1699 to 1766.

Inventory appraised by John Barrs, Thomas Isatson, 18th April 1717.

Ready money and wearing apparrell	5	0	0
In the Dwelling House			
Two tables, 1 screen, 1 cupboard, 3 joyned stooles, five chaires, 1 coffer,			
1 forme, 1 boarded chaire, 1 salt box, 1 dozen of trenchers, 1 bacon cratch,			
8 pewter dishes, 5 porringers, 6 spoones, 2 brasse potts, 2 small brass kettles,			
1 cann, 1 pewter candlestick, 1 spitt, 2 fireshovells, 1 pair of tonges and			
bellowes, and 1 brass furnace	3	5	0
In the Dairy			
Four flitches of bacon and other meat in salt, 5 Barrells, 1 chourne,			
2 cheese presses, 7 tubbs, 4 pailes, 2 bucketts, 1 powdering tubb,			
2 kivers & 2 formes	9	16	0
In the Back Roome			
One malt mill, 1 kneading tubb, 2 formes and iron and other lumber	1	10	0
In the Chamber over the Kitchen			
One joyned bedsted, 3 pillowes, 3 blanketts, 1 hilling, 1 joyned prese			
or cupboard, 1 chest, 1 table, 1 forme, 1 cradle, 1 trunk, 1 joyned chaire,			
2 chaires, curtaines & vallens, 8 pair of flaxen sheets, 7 paire of course			
flaxen sheets, 1 pair of hempen sheets, 7 table cloathes, 2 pillow beeres,			
6 napkins, 1 cradle cloth	5	8	0
In the Chamber over the Dairy			
Two joyned bedsteads, 3 flockbeds, 2 pair of course sheets, 4 blanketts,			
4 flock pillowes, curtaines & vallens, 1 coffer, 1 stoole, 2 chaires and			
1 draw box	3	2	6
In the Chamber over the Entry			
One bedstead, 1 flockbed, 1 flock pillow, 2 blanketts and 2 sheets		14	0
In the Chamber over the Back Room			
A sett of cheese tresells, 14lb of flaxen yarne, 9lb of flax, 40 cheeses and			
1 barrell	3	10	0

In the Cocklofts
One joyned bedstead, 1 flockbed, 2 sheets, two blanketts, 2 flock pillowes,

1 todd of wooll, 3 stone 1/2 of tutawed flax	1	14	0
One stone horse and 6 geldings	25	0	0
12 Melch cowes	42	0	0
7 Heifers and 2 bulls	20	0	0
9 Year-old calves	10	0	0
11 Weaning calves	3	13	4
1 Sow and 1 store pig	2	0	0
Ewes, lambes and hogrells, number 50	23	0	0
3 Waggons, 2 tumbrells and 1 old wheel	11	0	0
Harrowes and plowes	2	0	0
40 Thraves of sheafe corne	8	0	0
8 Loads of pease in the straw	8	0	0
5 Loades of oates in the straw	5	0	0
Hay, clover, vetches	9	0	0
About 10 acres of wheat and rye growing	22	0	0
33 Acres of oates and peas and barley growing	20	0	0
5 1/2 Quarters of barley	4	0	0
Iron geeres etc. for 8 horses	2	18	4
Stone, timber etc. for rick staddles	1	10	0
Old iron, fire fuel and other lumber	1	0	0
Total	253	16	6

Granges and Large Farms

The most important group of larger houses for which we have inventories but few matching buildings are the former monastic granges, which became the largest farms in Stoneleigh parish after the Dissolution: Bokendon, Cryfield, Kingshill (Helenhull or Stivichall), Milburne and Stoneleigh Grange. These made attractive packages for purchasers of monastic property, and they were all acquired by members of the local gentry before Sir Thomas Leigh bought the estate.

Milburne Grange already stood out in 1556, as the first house with two service rooms (dairy and yelding [brewing] house).[23] Kingshill Grange is recorded in inventories for three generations of the Hill family, Richard, Thomas and Cuthbert, to whom it was leased in the mid-16th century.[24] They were all prosperous yeomen and, indeed, Thomas and Cuthbert Hill were very wealthy, with estates valued at over £900. They leased other property, and also owned land in Canley, and in Sowe, Stivichall, Ryton, Shilton and Balsall. Their house was large by the standards of the period, with five rooms in 1547 and seven in 1568. By the latter date, the number of chambers had risen from two to five, with three of them upstairs,[25] while the number of beds listed increased from four to eleven—no doubt to accommodate Thomas Hill's large family (at least seven children), as well as his servants. Richard Hyll's buttery (containing pewter, brass and silver) probably became their 'inner parlour'. In Thomas and Cuthbert's inventories, the metalware is given a separate heading 'Vessels', after the inner parlour and before the kitchen; they were probably still in the same room, in the two iron-bound chests and three coffers there.

By the early 17th century, Kingshill Grange had fallen on hard times. Its land was probably being farmed from Stivichall Hall, the home of its owners, the Gregory family. In 1616, the manor court required squatters to be ejected:

> Mr. John Gregory shall ridd and amove the tenants or dwellers, viz. Thomas Hall, Robert Willson with their families now inhabiting Henoll [Helenhall] Grange, before St Luke's Day.

In 1638 (Reg.; Allesley) a home was needed for the son of the family, Loveisgod Gregory and his new wife. The Grange was rebuilt for them with striking results.

Stivichall Grange (Figures 21a & b)

It used expensive materials new to the parish, a delightful yellow-brown stone (probably from Hornton in north Oxfordshire) with ashlar masonry and mullioned windows. The house was not large, probably having only eight rooms, but its plan is unparalleled in the parish, either before or since. No inventory survives to confirm his use of the rooms, but they can confidently be deduced.[26] Of the two rooms on each floor, those at ground level must have been a kitchen and buttery or other service room. Next came the main living rooms, entered directly at the end, essentially as a *piano nobile*; they might have been 'dining room' and 'parlour' in a house of this style. Above this were two principal chambers, with two servants' chambers in the cocklofts. Two fireplaces on each of the main floors provide the Hearth Tax complement of six hearths.

This house provided no more accommodation than a local farm, but our knowledge of the social context behind its building explains why it differed so radically from them in its character. However, the specific source of the ideas behind its plan is less clear. It has some relationship to buildings such as hunting lodges, small but smart enough to impress an owner's guests (e.g. Langford Old Hall, Nottinghamshire, built *c*.1637), or masons' houses, intended to display their skill.[27] However, no close parallels for its plan are known and its wider affinities may even lie in the contemporary ideas of the Palladian villa.

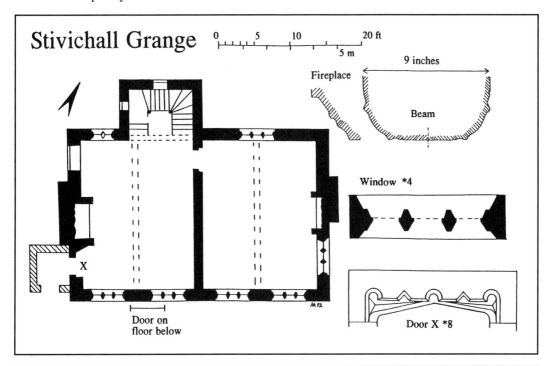

Stivichall Grange has two rooms on each of the three floors and the attic, with fireplaces for all except the attic rooms. The principal entry is at the side on the first floor, through a door with an exceptionally decorative head; the small porch cuts across the string course, and must have been an afterthought. The ground floor entrance has a four-centred head. The house has fine details, including mullioned windows, moulded fireplace lintels and internal doors with four-centred arches, and beams with a very decorative moulding, quarter-rounds combined with small quirks, steps and ogees. The open-well stair rose from ground to attics; it was apparently undivided from the principal rooms and the beam at this point is moulded like the main beams, but a panelled partition possibly stood under it. The house was severely vandalised in the 1970s and some details may have been destroyed.

21a *Stivichall Grange, Kingshill. First-floor plan and enlarged details of beam and fireplace mouldings, windows and doorhead.*

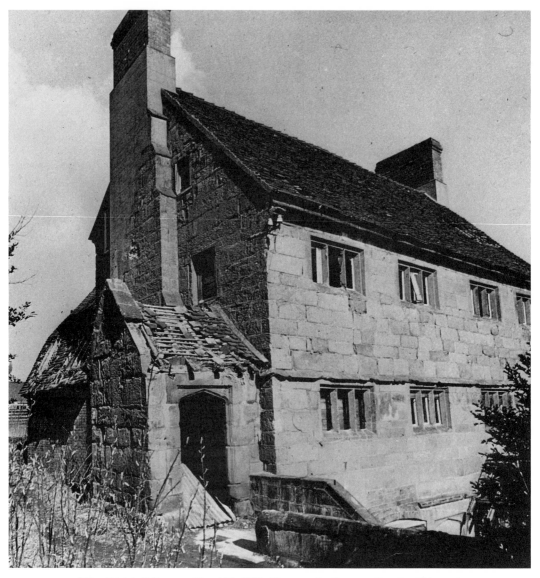

21b *Stivichall Grange, Kingshill, 1972. Photograph:* Coventry Evening Telegraph

Stoneleigh Grange

Stoneleigh Grange and Cryfield Grange were the largest houses in the parish (apart from the Leigh houses), with 16 or more rooms recorded in the 17th century. In 1668 William Robinson, gentleman, was living in considerable comfort in Stoneleigh Grange with three main living rooms, Hall, Parlour and Study, and five chambers; three of these were distinguished as red, green and hair-coloured, matching the colours of their bed-curtains, coverlets and chair upholstery. As well as the kitchen, he had a dairy and a wash-house, the last also used for brewing. Storage rooms made up the rest of the house, including pantry, buttery, cheese and corn chambers, and cocklofts.

Cryfield Grange

> This house is large and complex, with an L-shaped plan. The main structure is of many dates, including 15th-century blind wall arcading and ashlar masonry and a vaulted cellar, a 16th-century decorative timber framed porch, 17th-century stair and 18th/19th-century brickwork. However, no clear plan type or room functions can be identified for any period, making its detailed interpretation virtually impossible, let alone matching the house with its complex 17th-century inventory description.

For Cryfield Grange, 16 rooms are recorded in the inventories of Stephen (1633) and Anne Wilson (1650; **55,** p.194), a very wealthy yeoman and his widow; Stephen left no less than £1,330. Both inventories record a hall and living parlour, but one surprising change had taken place in the house in the period. Anne had returned to the old-fashioned style of cooking in the hall, and had no separate kitchen; the inventory is clear on this point, with the cooking implements listed explicitly in the hall. Stephen Wilson's bolting house was used for storing dough (in a dough kiver), for bolting flour (in a bolting which), and for some stages of brewing (in two yelding fatts); it also held a mustard mill. The main brewing was done in the backhouse (four cowles and a brewing fatt). By 1650, the brewhouse had taken over from the backhouse, but Anne no longer had a bolting house, and neither the bolting which nor the dough kiver were listed. Anne retained the other service rooms, buttery, dairy and mill house (for the malt mill), as well as three storage rooms: cellar, cheese chamber and corn chamber. Her inventory scribe mistakenly wrote 'cheese' for 'corn', having already listed the cheese chamber with the cheese rack (and in Stephen's inventory 215 cheeses); the second 'cheese' chamber contained only a garner and four quarters of oats. Both Stephen and Anne had corn in the barns and, in Anne's April inventory, growing in the fields.

In the later 17th century, the farm was radically reorganised. From Steven Wilson's 659 acres, by 1766 (*Map*) the main farm only covered 280 acres. Two separate substantial farms had been created, and in addition two new houses seem to have been built at Cryfield Grange itself (Chapter 6), though these disappear again before 1700. The 18th-century brickwork in the house, confirms that much of the old house had been rebuilt.

The contrast between the Wilson inventories and that taken in 1708 when Zachariah Groves died reflects these changes. He was also wealthy (£459), but the house is hardly recognisable. It had kitchen and parlour as living rooms, corresponding to Anne's hall and parlour, though he slept in the parlour, unlike Stephen or Anne. However, beyond this he had only a cheese chamber and four upstairs chambers, two used just for storage. In all he had only four beds, compared to Stephen and Anne's dozen.

Two large farms in Fletchamstead are similar in character to the granges. Fletchamstead Hall (the former Templar manor) was bought by Sir Thomas Leigh in 1564. It was used by the Leighs as a second house in the early 17th century, and was probably much enlarged at this date. A section of the 1626 inventory of Sir Thomas Leigh lists the contents of 47 rooms there. These included a great gallery, at least 20 chambers, a porter's lodge, a larder, pastry, pantry, platehouse, bakehouse, flesh-house, wash-house, and seed house (containing a water squirt for the gardener to use).

The Hearth Tax shows it had come down in the world, occupied by Thomas Flynt of Allesley, with 24 hearths, then five of these pulled down, and the house split up between five separate tenants; at just this date, the Leighs took over Manor Farm in Stoneleigh village, rather than renovating the old house. By the early 18th century, it was similar to the other large farms in the parish, with 12 rooms in 1713. A remarkable picture survives of the house in romantic decrepitude (Figure 22), showing a main rambling timber-framed range with two cross-wings, and a stone Renaissance-style porch.[28]

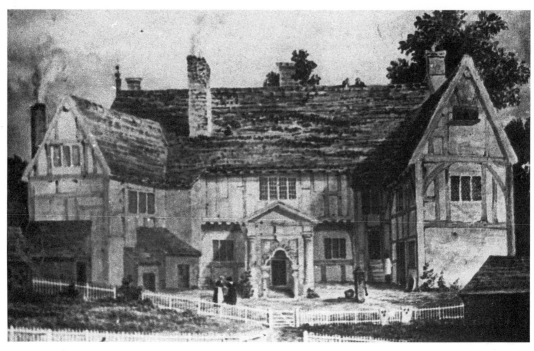

22 *Fletchampstead Hall, (for picture source see note 28)*

The second large farm in Fletchamstead, Nether Fletchamstead Hall, was only bought by the Leighs in 1698 from Sir John Smith. However three 17th- and three 18th-century inventories (**47**) can be identified for its tenants. The first, that of Humphrey Taylor (1634), has already been mentioned because of its two living parlours. The others show a consistent pattern, with five or six chambers, accompanied by a relatively large number of service rooms. That of William Meigh (1695) (**22**) is characteristic of these large farms.

22 *William Meigh of Fletchamstead, yeoman (1695)*
He appears as tenant of Fletchamstead Hall (Leigh property) in 1670, and was succeeded by his son, another William. He was a frequent member of the jury, constable, surveyor of the highways and thirdborough. He left no will, but four children were born between 1682 and 1692 (Register); his son William married in 1694, and must have been born *c*.1670. He took over Nether Fletchamstead Hall (Smith property) after John Taylor's death (1681). The evidence to identify his holding is (i) his widow was granted a new lease by Smith in 1696 (SBT.DR18/1/996-8) (ii) she is tenant in the 1699 rental (iii) he is listed as first Smith tenant in 1698 (even though dead by then; SBT.DR18/10/42). This is clinched by the close similarity of the rooms in his and John Taylor's inventories (Table 5.1).

Inventory appraised by Joseph Symcox, Thomas Gibbs, 26th June 1695.

His wearing apparrell and money in the house	13	1	9
In the <u>Chamber over the Parlour</u> and <u>Chamber over the Hall</u> two bedsteads with two feather beds, curtaines, valence, counterpanes, ruggs, blankettes and other things to them belonging with 15 chaires and 4 stooles which were all lately bought together	22	0	0
In one of the said chambers, one other joyned bed with a feather bed, curtaines, valence & blankettes with a table and cupboard	5	10	0
In the <u>Chamber over the Buttery</u> two old bedsteads with a little feather bed			

and a flock bed with the blankettes & bedding to them belonging	2	0	0
In the said chamber, a chest & a presse iron, one old cupboard & one old chair	1	6	8
In the Chamber over the Millhouse one flockebed with the bedding thereupon and one chair		13	4
In the <u>Chamber over the Kitchen</u> one joyned bedstead with a feather bed, curtain & valence and blankettes thereupon	2	10	0
One chair & four stooles covered with red cloth		8	0
One cofer & a cupboard in the said chamber		8	0
In the <u>Chamber over the Backhouse</u>, a piece of old bedstead & one old cofer		2	0
Ten quarters of oates and barley in the said roome	5	0	0
In the <u>Cheese Chamber</u> corne, cheese, & daglocks	1	0	0
In the <u>Kitchin</u> 8 pewter platters with a basen, flaggon & other pewter dishes	1	5	0
Brass pottes & kettles, a spit, dripping pan & other small implements of iron with cobberds, landirons, pothookes, hangers, one old table, two old gun barrells & a warming pan	1	15	0
In the <u>Hall</u> one long table & form, a little table, a fire shovell and tongs, landirons and one iron grate lately bought	1	6	8
In the <u>Parlour</u> one old drawing table, a little round table, a cupboard, one chest, one armed chair, six old backstooles of Russia leather with a little grate, fire shovell & tongs		10	0
In the <u>Millhouse</u> a malt mill, most part of an ewter (?) for a cart, wheeles with other old iron, a dough trough, one old tubb	2	18	0
In the <u>Daryhouse</u> a cheese presse, with house linins, 10 barrells, shelves and other wooden ware in the <u>Celler</u>	3	0	0
In the <u>Halle</u> an iron clock and a grate		15	0
In the <u>Yard</u> 3 old tumbrill bodyes, 2 old cart bodyes with 3 pair of wheeles, one of which is iron-bound	5	10	0
In the <u>Barn</u> corn about 15 thrave	3	0	0
A fan & 7 old cribbs in the <u>Yard</u>		10	0
Eight acres of rye at the Home Liveing	16	0	0
Six acres of rye at the Parke	12	0	0
Three acres of wheat at the Park	6	0	0
Seaven acres of maslin corn	14	0	0
A grinding stone, a role, & 2 old plowghs		8	0
A score of sheep that came from toward Dudley & 4 rams	6	10	0
A score of the best ewes	7	10	0
Twenty seven other sheep & lambs	8	10	0
A sowe & two piggs	2	10	0
A score of lambs, one sheep sold to a bucher for	7	2	0
Two mares with 2 horse foles & one 3 year old filly	19	0	0
One 3 year old mare with a blinde mare	9	0	0
A stoned colt of 2 years old	10	0	0
One 2 year old heifer, 3 yearling bulls & a heifer	8	5	0
Hay, fitches, geares for 5 horses & a hackney saddle	3	10	0
Five melch cowes & a sucking calfe	17	10	0
2 ricks of oats & barley	20	0	0
4 Acres of barley on the Home Ground	7	0	0
Mowing grass in the Home Liveing	27	0	0
One plow and a harrow		10	0
In the Park 7 two year-old heifers	16	0	0
13 Yearling heifers	17	0	0
2 Filleys (£10) two piggs (£1 18s)	11	18	0
A wagon	5	10	0
A rick of corn (£2) & 2 ricks of barley at Park (£25)	27	0	0
5 Melch cows	20	0	0

Three 3-year old & 2 two-year old melch kine & a bull	17	10	0
12 Weaning calves (£7), 3 yearling calves (£10)	17	0	0
A pig (10s), a plough & harrow (3s)		13	0
6 Acres of barley, 4 of oates	10	0	0
5 Acres of oats, pease & fitches	3	0	0
7 Days mowing of grasse in the Park	6	0	0
7 Hundred weight of cheese at Park	7	0	0
2 bedsteads with beds & blankettes	3	0	0
A bedstead, a dough kiver & other lumber		5	0
2 Potts, a kettle, 2 pailes, 2 gallons, 2 tubbs	1	12	0
2 Platters, a brasse ladle (2s) a cheese presse (3s)		5	0
An old table & form, a presse & a cupboard		8	0
About a tun of old hay	2	0	0
Debtes			
William Meigh [*younger?*] owes	10	0	0
Sarah West & Mary West	42	0	0
Mr Thomas Lant for hay & a bull	7	4	0
William Meigh for part of some corn in the Park	4	0	0
Widow Townsend	4	8	0
Owing for woll	1	3	6
Farmer for garden ground rent	1	10	5
Daniell Meigh owes £3 but its thought to be desperat	3	0	0
Thomas Sly about 18s thought to be desperat		18	0
Johnathan Kimberley owes		15	0
Richard Kimberley	3	0	0
[Total (not given)	520	14	4]

A couple of landowners on a modest scale were represented in the parish by the resident owners of Finham and Whoburley; these were each estates of a couple of hundred acres, not accompanied by much property elsewhere. Their owners undoubtedly belonged to the gentry. However, neither their houses (10-11 rooms in the 1660s) nor their living styles differed from those of the major tenants. The latter hovered on the border between gentry and yeomen, though only John Holbech of Manor Farm and William Robinson of Stoneleigh Grange gave themselves the title of 'gentleman'.

Stoneleigh Abbey

In the 16th century, Stoneleigh Abbey itself resembled these granges. Before its sale to Sir Thomas Leigh, it was leased by the Crown to Thomas Dadley. A description of about 1550 indicates that much of the Abbey was only 'stone walls of houses wasted'.[29] However, it had a well-built gatehouse of '3 over romes and 3 nether romes with 3 chymneys'. This was probably where Dadley lived; his 1558 inventory lists seven rooms and shows that he had furnished them most comfortably, with 24 yards of painted cloth in the hall. His bed was also of the best:

> one standing bedstyd with testarres of reade and blewe vellet with curtayns of red and grene saye; two feyther beddes & one bolster; two quyltes; six pillowes of fustion; one coverlet; seven turned bedstaves.[30]

Thomas Dadley lived very comfortably in yeoman style. However, the distinction between such prosperous tenant farmers or minor gentry and the aristocracy was immense. Five inventories also survive for members of the Leigh family listing between 80 and 100 rooms at the Abbey (which had 70 hearths in 1665, larger by a factor of two than any other house in Warwickshire). In every respect, they are beyond comparison with the ordinary people of the parish.

Notes

1. In the 1660s, Samuel Wade of Whoburley and Thomas Stacie of Finham had respectively 11 and 12 rooms, but the largest houses in the parish apart from the Abbey were held by tenants.
2. W. G. Hoskins, 'The rebuilding of rural England: 1570-1640', *Past and Present*, 4 (1953), 44.
3. R. Machin, 'The great rebuilding: a reassessment', *Past and Present*, 77 (1977), 33; N. W. Alcock, 'The great rebuilding and its later stages', *Vernacular Architecture*, 14 (1983) 45.
4. They are counted as two rooms in calculating totals.
5. Rebuilding of course must have taken place before the occupant of a new house died, but unavoidably the inventory dates are used as if the houses had been built then.
6. Guest chambers are very unusual as inventory rooms. They have only otherwise been noted in a very large house in Witney, Oxfordshire (*Oxfordshire Inventories*, 107), and in eight houses in a large Berkshire survey; C. R. Currie, *Smaller domestic architecture and society in N. Berkshire, c.1300-c.1650*, Ph. D. Thesis, Oxford, 1976, p. 273.
7. Including the 'lathshooters chamber', presumably a synonym for 'garret', though a description of 'laths suted or unsuted' (**35**) suggests 'splitting'.
8. For the one larder, see p.63.
9. Setting to one side the 17th-century inventories for Stoneleigh Abbey and the other Leigh family houses.
10. The recurring phrase 'table and form' is contrasted to 'the benches'. It suggests that the form was fixed to the wall behind the table, or perhaps to the table itself.
11. The first example is in 1604, but in a parlour, not a hall (**20**).
12. Apparently added since her husband's death in 1616. She also had painted cloths there. Painted cloths also disappear from Banbury inventories at about this period.
13. A normal term for an armless chair in northern England, otherwise unrecorded in Stoneleigh.
14. John Gibbs' five chairs and two tables are exceptional, though they matched the seven chairs in his hall (1700).
15. Fine linen, *Telford Inventories,* p. 473.
16. The grate in inventory (**14**) was probably a gridiron.
17. The earliest furnaces were in kitchens, and the Stoneleigh inn had two (a lead and a copper one in 1638, two copper ones in 1670); by the 18th century they were found in back kitchens or brewhouses.
18. Village bakers obviously had ovens much earlier though the only relevant inventory (Richard Winsmore, 1620) includes no special implements.
19. Alkemy (antimony) probably describes a brass alloy, imitating gold.
20. This was one of the four substantial farms in Hill, but as part of the Gregory estate, its tenants and their inventories cannot be identified. The frame is rendered and its detailed architectural development cannot be established.
21. This inventory is published in *Stoneleigh Villagers*, pp. 16-18, but with a different assignment of the rooms.
22. The Leighs bought Stoneleigh, Bericote and Milburne Granges almost immediately. Cryfield grange was acquired in 1639 by Dame Elizabeth Egerton, a daughter of Sir Thomas Leigh, who bequeathed it to her Leigh nephew and his wife in 1649. Bokendon only became available in 1865, while Kingshill remained in the ownership of the Gregory family. Fortunately, because of their individuality, it has been possible to identify many of the grange tenants, despite their absence from the estate rentals. Bericote was the only grange in Ashow Parish, but in the 16th-17th centuries it was only farmed with about 20 acres, and its house was smaller than the other granges. In about 1700, the farm was enlarged to 250 acres and the house rebuilt.
23. The identification of Jane Wynter as its occupier is circumstantial, as she is nowhere named specifically as its tenant. However, Humphrey Reynolds, who held a 21-year lease of the grange from May 1537, left her all his leases for life, and in a case in Chancery, Jane Wynter asserted her right to Milburne Grange against his widow (PRO. C1/1391/56-9). See also J. H. Morrison, *The Underhills of Warwickshire*, privately printed, 1932, p.43.
24. SBT.DR18/3/59/5-6; SBT.DR10/1196-7.
25. The servants' chamber, named between those over the parlour and the hall, was probably over the kitchen.
26. A fragment of what was probably Loveisgod Gregory's inventory (1654) is recorded in a Gregory family notebook (SBT.DR10/2085). Although an inventory exists (**15**) for Robert Burbery, the tenant of Stivichall Grange from 1677 to 1682, the wording in the inventory shows that it relates to his house in Finham.
27. M. W. Barley, 'Langford Old Hall: a probable 17th-century hunting lodge', Trans. Thoroton Soc. Notts, 1988, 43-50; H. M. Colvin, 'Haunt Hill, Weldon' in E. M. Jope (ed.), *Studies in Building History*, 1961, 223-8.
28. A photograph in the Coventry and Warwickshire Collection (Coventry City Library) (Figure 22) shows a *c.*1840 watercolour (supposedly in Coventry Council House); The Birmingham Reference Library's Aylesford Collection includes another copy (*c.*1800). Both were probably taken from a lost early 18th-century original. The porch was retained when the house was rebuilt and is seen in later photographs.
29. SBT.DR18/30/24/91. It was perhaps prepared for the sale of the Abbey in 1545.
30. Bedstaves are considered to be a standard part of 16th-century beds but, surprisingly, this seems to be the only reference to them in Stoneleigh, unless Joan James' three bedposts (1608) should be included. V. Chinnery, *Oak furniture; the British tradition*, 1979, p.393.

Table 5.1: *New Style: Five rooms and over, 1547-1600; eight rooms and over, 1601-1700**

Inv	Date	Name	Status	Hld	Loc	Acr	£	Rooms (and Farm Buildings)
		Pre-1601: Five Rooms						
	1573	Thomas Ball		74	Ca	59	32	Halle, Chamber next Halle, Mads Chamber, Chamber over Hall, Nether Howse; Barne
	1553	Ralph Gressold	Yeoman	36	A	77	50	Hall, Chamber, Nether Chamber, Third Chamber, Kytchyn; Barn
	1585	Richard Griffine	Miller	48	A	6	13	Hall, Chamber over Halle, Buttre, Chamber at the Ende of the Halle, Sellar over the same Chamber; Corne Mylle, Barne
	1547	Richard Hyll	Yeoman	115	H		71	Halle, Parler, Other Chamber, Buttyre, Kechen
		Pre-1601: Six Rooms						
	1585	Thomas Handcorne		76	Ca	(28)	57	Servants Chamber, Stare Chamber, Chamber over Hall, Nether Chamber,[Hall], Chechen (*Gross £75*)
19	1569	Humphrey Partrige		81	Hu	54	56	Hall, Buttrey, Chamber, Other Chamber, Chamber over, Kechyn; Barne
2	1557	William Pyppe	(Fuller)	69	I		16	Haull, Kechen, Bruehousse, Chamber, Celer, Other Celler
16	1551	Thomas Roweley	Yeoman	3	S	59	115	Hall, Parler, Chambre, Nether Chambre, Kechyn, Boltynge House
	1600	Richard Worsley	Fuller	48	A	6	1	Halle, Lodging Chamber, Maydes Chamber, Nexte Chamber, Heigh Chamber, Kitchin, Myll (*Gross £8*)
		Pre-1601: Seven Rooms						
	1558	Thomas Dadley		1	I		259	Hall, Parler, Chamber, Bedchamber, Servants Chamber, Kychyn and Buttrie
	1567	Cuthbert Hill	Yeoman	115	H		931	Hale, Nether Parlour, Chamber over Parlour, Servantes Chamber, Chamber over Hall, Inner Parlour, Kichyne; Barne
	1567	Thomas Hill	Yeoman	115	H		916	*Rooms and most contents identical to Cuthbert Hill*
		Pre-1601: Eight Rooms						
	1581	Henry Berydge	Rector	50	A	8	62	Parler, Halle, Butterye, Chamber next Halle, Maydes Chamber, Next Chamber, Next Chamber (*second*), Boutinge Howse; Barne
13	1580	Thomas Cox		37	A	50	45	Saller next the Kilne, Saller over the Hall, Sallor over the Chamber, Chamber above the Hall, Buttrey, Hall, Kitchen, [Kiln]; Barne, Hawvel (*Hovel*) (*Gross £51*)
	1582	Thomas Dadley		39	A	52	35	Chamber, Next Chamber, Loft in South End of the House, Next Lofte, Hall, Buttrye, Chichin, Milck House; Barn (*Gross £53*)
	1571	John Hancorne	Husbandman	75	Ca	49	107	Hall, Buttrye, Lyttle Chamber by Hall, Chamber beneath Hall, Over Chamber, Other Chamber, Boltinge House, Keachyne; Oxe Howse, Another Howse (corn and tools), Barn
	1593	Thomas Holland	Husbandman	59	St	71	43	Hall, Chamber next the Hall, Guestes Chamber, Mayds Chamber, Buttry, Upper Rome, Chamber over Hall, Kitchin; Barne, Hovill
	1585	Baldwyn Warde	Husbandman	39	A	52	177	Nether Chamber, Chamber next the Halle, Lofte at South End of the Howse, Next Chamber, Hall, Buttrey, Kytchin, Mylkehowse; Barne, Stable
	1556	Jane Wynter		70	I	47	57	Hall, Parler, Chamber over the Parler, Other Chamber, Kychen, Day Howse, Yelding Howse, Menes Chamber
		Pre-1601: Nine Rooms						
	1597	John Benion	Yeoman	93	I	149	199	Haule, Parler, Nether Chamber, Chamber over Haule, Darke Cellar, Chamber over Parler, Kichin, Dehouse, Backhouse

Date	Name	Status	Hld	Loc	Acr	£	Rooms (and Farm Buildings)
1598	William Syers	Yeoman	74	Ca	59	187	Hall, Little Inner Parlor, Parlor next Hall, Inner Parlor next Street, Servants Chamber, Chamber over Hall, Buttry, Inner Buttry, Kytchen; Hovill next the Kytchin, Barne

1601-50: Eight Rooms

Date	Name	Status	Hld	Loc	Acr	£	Rooms (and Farm Buildings)
1611	Martin Delene	Parson	50	A	8	44	Hall, Parlour, Upper Chamber, Next Chamber, Next Chamber, Deahouse, Butterie, Mans Chamber
1618	Walter Heynes	Yeoman	90	I	(22)	80	Cheese Chamber, Chamber above Hall, Chamber over Kychen, Hall, Dayhouse, Buttery, Kychen, Boulting House
1608	Richard Hewett	Fuller	27	S	1	23	Hall, Inner Chamber, Garden Chamber, Further Seller, Chamber over Entrie, Milke House, Shopp, Entrie; Barne, Stable, Hovell
1617	John Munckes	Husbandman	61	St	43	131	Hall, Bed Chamber, Mayds Chamber, Buttery, Mylke House, Cheese Chamber, Chamber over Hall, Kychen
1644	Francis Perkins(on)	Yeoman	5	St	29	257	Hall and Kitchen, Parlor, Lowe Chamber next Parlor, Chamber over Parlor, Room over Lower Chamber, Two Other Upper Chambers; Barn
1602	Edward Sotherne	Yeoman/ Husbandman	57	St	84	70	Hallhouse, Nether Chamber next Hall, Inner Chamber, Upper Bed Chamber, Upper Loft, Chamber over Hall, Buttry, Kychen; Barne

1601-50: Nine Rooms

Date	Name	Status	Hld	Loc	Acr	£	Rooms (and Farm Buildings)
1639	Thomas Cox	Carpenter	42	A	15	45	Hall, Chamber over Hall, Little Buttery, Dayrie House, Little Chamber below, Space between Hall and Little Parlor, Little Buttery in Hall, Kitchine, Little Chamber next to Space; Barne *(Gross £51)*
1601	Richard Dadley	Husbandman	35	A	70	77	Hall, Nether Chamber, Upper Chamber, Appel Chamber, Parler above Entrey, Menne Servants Chamber called the Mill Howse, Kychene, Buttrey, Kychen Entrey, (Larder); Barne, Haye Howse
1627	Thomas Nelson	Yeoman	59	St	79	103	His Lodging Chamber, Next Chamber, Chamber over Hall, Maydes chamber, Lodging Parlor, Hall, Kitchen, Dayry House, Boulting House; Corne Barne, Hovill
1605	Thomas Smallwood	Husbandman		Ca		58	Hall, Butterie, Milke House, Little Parler, Parler next Hall, Parler next Streete, Chamber over Hall, Chamber over Parler, Kitchen; Barne, Duckcote, Hovel for pigsty, Shed
1640	Anne Sotherne	Widow	57	St	78	286	Hall, Parlour, Chamber, Servants Chamber, Butteries, Bolting House, Lead House, [Kitchen]; Garner
1617	Alice Wright	Widow	107	Fl	(19)	92	Her Bedchamber, Son's (Thomas) Chamber, Son's (William) Chamber, Hall, Chamber over Hall, Nether Roome, Butterie, Loft over Entrie, Other Loft; Two Hovells, Nether House, Barne

1601-50: Ten Rooms

Date	Name	Status	Hld	Loc	Acr	£	Rooms (and Farm Buildings)
1627	Johanna Hancorne	Widow	75	Ca	49	114	Hall, Parler, Littell Chamber, Littell Parlour, Nethere Chamber, Millhouse, Upper Chamber, Kiching, Boulting House, Day House; Barne *(Repeated for two sons John and Richard, deceased at the same time)*
1631	Thomas Hill	Yeoman	3	S	59	183	Hall, Upper Parlor, Nether Parlor, Well Chamber, Mens Chamber, Cheese Chamber, Buttery, Mylke House, Boulting House, Kychen

Inv	Date	Name	Status	Hld	Loc	Acr	£	Rooms (and Farm Buildings)
	1611	James Hoo	Fuller	28	S	24	78	Hall, Parlor, Mayds Chamber, Nether Chamber, Shopp, Buttery, Dayry House, Kychen, Cheese Chamber, Boulting House; Barne
	1636	Thomas Sotherne	Yeoman/ Husbandman	57	St	84	341	Chambers, Parlour, Servants Chamber, Hall, Two Butteries, Bolting House, Lead House, Kitchen; Barne

1601-50: Eleven Rooms

Inv	Date	Name	Status	Hld	Loc	Acr	£	Rooms (and Farm Buildings)
	1624	Elizabeth Morrey	Widow	56	St	98	163	Hall, Parlor, Buttery, Kytchen, Cheese House, Boulting House and Kyll House, Chamber over Hall, Mayds Chamber, Chamber over Parlor, Manservants Chamber; Stable and Cowhouse
	1638	Robert Osman	Innholder	9	S	20	196	Hall, Parlear, Kitchin, Dayry House, Buttery, Store Chamber, Unicorne Chamber, Upper Well Chamber, Neather Well Chamber, His own Lodging Chamber, Seller
	1638	Nicholas Samon	Yeoman	55	St	158	200	Hall, Parlour, Inner Low Chamber, Other Chamber, Buttery, Dayry House, Kitchin, Kitchin Chamber, Cheese Chamber, Middle Chamber, Apple Chamber

1601-50: Twelve Rooms

Inv	Date	Name	Status	Hld	Loc	Acr	£	Rooms (and Farm Buildings)
	1612	James Cox	Yeoman	37	A	50	209	Hall, Pewter House, Lodging Chamber, High Chamber, Bourded Chamber, Malt Chamber, Kilne Howse, Little Parlour, Butterye, Servants Chamber, Dea howse, Kitchin; Barne, Stable, Oxehowse, Wane Howse
	1609	William Farre	Tanner	5	S	29	319	Street Chamber, Chamber next Yarde, Entry that goeth into the Chambers, Hall, Buttery next Hall, Upper Chamber towards Street, Upper Chamber next Yard, Roome over Hall, Malt Chamber, Boulting House, Kitchen, Butter next Kitchen; Barne, Tanhouse
	1647	Thomas Jeacocke		37	A	50	208	Lodging Chamber, Little Parler, Buterie, Little Roome joyning to Buterie, Pewter House, an Upper Chamber, Store Chamber, Maulk Chamber, Milke House, Servants Chamber, Kitchin, Hall, (Chimnie); Barne
	1616	William Mourey	Yeoman	56	St	98	156	Hall, Parlor, Buttery by Parlor, Chamber over Hall, Chamber over Parlor, Mayds Chamber, Manservants Chamber, Dayry House, Boulting House, Kychen, Kyll House, Woole House
20	1604	Anthony Spencer	Gentleman	81	Hu	54	62	Hall, [Parlour], Buttrye, Chamber over Parlour, Chamber over Butterye, Chamber over Hall, Cocklofte over Chamber over Parlour, Kilne and Backhouse, Bolting House, Kitchin, Daie Howse; Shedd, Barne, Stable

1601-50: Thirteen Rooms

Inv	Date	Name	Status	Hld	Loc	Acr	£	Rooms (and Farm Buildings)
	1632	Henry Billingham	Vicar	32	S	1	70	Studdye, Chamber over Parlor, Chamber over Hall, Chamber over Dayhouse, Chamber over Entry, Chamber over Kitchin, Appell Chamber, Parlor, Hall, Seller, Dayhouse, Kitchine, Another Roome
	1620	Walter Hunt	Yeoman [Innkeeper]	9	S	20	125	Well Chamber, Unicorn Chamber, Chamber over Hall, Chamber below next Yeard, Lodging Chamber next the Street below, Hall, Seller, Parlor beneath the Entry, Bakhouse, Roome over Backhouse, Kychen, Chamber over Kychen, Dayry House; Barne
	1634	Humphrey Tayler	Yeoman	101	Fl	(251)	166	(Bedchamber), Greene Chamber, Longe Chamber, Blacke Chamber, Cheese Chamber, Kill Chamber, Servants Chamber, Little

Inv	Date	Name	Status	Hld	Loc	Acr	£	Rooms (and Farm Buildings)
								Parlour, Great Parlour, Buttery, Kitchin, Nether Kitchen, Dayhouse; Barne

1601-50: Fourteen Rooms

Inv	Date	Name	Status	Hld	Loc	Acr	£	Rooms (and Farm Buildings)
	1629	Alexander Preist	Yeoman Innkeeper	9	S	20	124	Hall, Unicorne Chamber, Well Chamber, Chamber over Hall, Lodging Chamber next the Street below, Chamber below next Yard, Parlor beneath the Entry, Backhouse, Loft over Backhouse, Maulting Chamber, Mans Chamber, Kytchen, Dayry House, Buttery; Barne, Common Stable and Loft, Other Stable and Loft

1601-50: Fifteen Rooms

Inv	Date	Name	Status	Hld	Loc	Acr	£	Rooms (and Farm Buildings)
14	1616	Humphrey Hoo	Yeoman	58	St	94	169	Hall, Bedchamber, Mayds Chamber, Buttery, Little Chamber, Chamber beneath Entrie, Killhouse, Kychen, Myllhouse, Mylkhouse, Dish House, Corne Chamber, Chamber over Hall, Mault Chamber, Cheese Chamber; Barne
	1616	Margaret Hoo	Widow	58	St	94	169	*Inventory identical to Humphrey Hoo*

1601-50: Sixteen Rooms

Inv	Date	Name	Status	Hld	Loc	Acr	£	Rooms (and Farm Buildings)
55	1650	Ann Wilson	Widow	79	Cr	(348)	771	Chamber over Parlour, Chamber over Buttry, Chamber over Hall, Cheese Chamber, Servants Chamber, Chamber over Millhouse, Lath-shooters Chamber, Chamber over Dairy House, Cheese Chamber, Dairie House, Mill House, Brewhouse, Celler, Parlor, Buttery, Hall; Farther Barne, Corne Barne, Hay Barne
	1633	Stephen Wilson	Yeoman	79	Cr	(348)	1330	Hall, Parlor, Chamber over Parlour, Little Chamber adjoining, Chamber over Hall, Cheese Chamber, Servants Chamber, Great Chamber, Next Chamber, Kitching, Buttery, Dery House, Myll House, Backhouse, Boulting House, Seller; Barne

1601-50: Larger

Inv	Date	Name	Status	Hld	Loc	Acr	£	Rooms (and Farm Buildings)
	1626	Sir Thomas Leigh		100 1	Fl I		4621	47 rooms in 'Fletchamstead House' 81 rooms in Stoneleigh Abbey (SBT.DR18/41)
	1639	Dame Katherine Leigh		1	I		3981	86 Rooms (SBT.DR18/4/2)

Inv	Date	Name	Status	Hld	Loc	Acr	£	Hth	Rooms (and Farm Buildings)

1660-1700: Eight Rooms

Inv	Date	Name	Status	Hld	Loc	Acr	£	Hth	Rooms (and Farm Buildings)
	1692	Edward Agborrow	Vicar	32	S	1	154	4	His Bedchamber, Study, Chamber over Hall, Parlour, Kitchen, Hall, Sallar, Back Kitchen
7	1694	Richard Camill	(Gentleman)	66	St	31	344	1 *	His Bedchamber, Chamber over Kitchin, An other Chamber, Another Chamber, Cockloft, Parlour, Kitchin, Dayryhouse; Barne (PRO.PROB4/25461)
	1684	Thomas Casemore	Yeoman	56	St	88	75	2	Little Parlar, Hall, Parlar, Chamber over Parlar, Cheese Chamber, Kitchen, Buttry, Dary house
	1670	Matthew Falkoner	Husbandman	8	S	29	65	2	Chamber next to Entry, Middle Chamber, Chamber next to Orchard, Buttrie, Chamber over Hall, Hall, Kitchen, Chamber over Kitchen; Barne
	1684	Catherine Garrett	Widow	5	S	29	164	2	Parlor, Other Parlor, Hall, Little Buttery, Kitchen, A Little Room there, Upper Chambers (possibly three, as Thomas Garratt)
	1693	Zachariah Grove	Yeoman	93	I	149	153	3 *	[Parlor], Parlor Chamber, Chees Chamber, Over the Kitchen, Another Chamber, Buttery, Dayrye, Hall (= Kitchen?)
	1695	Ann Holbech	Widow	77	Ca	152	551	7 *	Kitchen, Hall, Parlor, Dary House, Kitchen

Inv	Date	*Name	Status	Hld	Loc	Acr	£	Hth	Rooms (and Farm Buildings)
									Chamber, Green Chamber, Hall Chamb Cheese Chamber; Barne
	1687	Basil Holbech	Yeoman	77	Ca	152	1551	7	*Rooms identical to Ann Holbech*
	1667	Laurence Nicholls	Yeoman	74	Ca	59	235	2	House, Middle Chamber, Further Chamber, U per Chamber, Cheese Chamber, Mens Cha ber, Dayry House, Kitchin; Barne
15		*1660-1700: Nine Rooms*							
	1682	Robert Burbery	Husbandman		Fi		225		Parlor, Hall, A Little Room there, Chamber o Hall, Chees Chamber, Cockloft, Kitch Daryhouse and Buttery
	1668	John Clarke		34	A	36	158	2	Parlour, Little Room within Parlour, Chamb over Hall, Cheese Chamber, Chamber over P lour, Hall, Kitchen, Dairy Room
	1683	Thomas Garrett	Yeoman	5	S	29	205	2	Parlor, Great Parlor, Hall, Little Butte Kitchen, A little Room there, Upper Chamb Another Chamber, Cheese Chamber; Barne
	1699	William Lee	Yeoman	70	I	207	378	4*	Hall, Parlor, Parlor Chamber, Cheese Chamb Hall Chamber, Chapell Chamber, Old Roc Kitching, Kitching Chamber; Barn
	1663	Thomas Stringfield	Rector	50	A	14	280	4	Studdy, Hall, Kitchen, Chamber over Kitch Chamber over Hall, Loft, Butterye, Little P lour and over it; Barne
		1660-1700: Ten Rooms							
	1687	Richard Bolt	Husbandman	112	Fl	(15)	264	2	Dwelling House, Parlour, New Buttery, Be Buttery, Chamber over Parlour, A Chamber the Staire Head or Malt Chamber, Cheese Cha ber, Chamber over Kitchen, Boulting Hou Another Roome called a Buttery or Dairy
	1687	John Holbech	Gentleman	2	S	73	100	9 *	His Bedchamber, Chamber over Kitchen, Chee Chamber, Chamber over Parlour, Parlour, Little Room, Hall, Kitchen, Brewhouse, Da House
	1676	Thomas Malyn	Husbandman	64	St	29	80	2	Halhouse, Parlour, Scowringe House, L Chamber, Buttery, Cheese Chamber, Cham over Hall, Kitchen, Roome next the Kitch Chamber; Barne
		1660-1700: Eleven Rooms							
	1675	Thomas Lord	Miller	28	S	24	51		Parler, Little Buttery Beyond Parler, Dey Hou Hall, Kitchin, Roome by Kitchin, Roome yond Kitchin, Chamber over Parler, Cham over Hall, chamber over Kitchin, Entery
	1668	Samuel Wade	Gentleman	113	Fl	(145)	273	6	Kitchen, Dayry and Buttery, Hall, Parlor, B Window Chamber, Matted Chamber over Parl Little Chamber adioyning to Matted Chamb Manns Chamber, Porch Chamber and Stud Stable
		1660-1700: Twelve Rooms							
	1665	Thomas Stacey	Gentleman	114	Fi		93	10	His Bedchamber, Cheeschamber, Ralphs Cha ber, Mr Kevits Chamber, Pantry, Kitche Milkhous and Larder, Bruhous, Parlor, Lit Hall and Clozitt
		1660-1700: Thirteen Rooms							
	1671	Christopher Brooks	Inholder	9	S	20	98	3	Lodging Chamber, Nether Well Chamb Unicorne Chamber, Upper Wel Chamber, St Chamber, Hall, Parlour, Hunts Chamb Daryhouse, Kitchen, Chamber over Parlo Chamber over Kitchine, Cellar; Barne
22		*1660-1700: Fourteen Rooms*							
	1695	William Meigh	Yeoman	101	Fl	(251)	547	10*	Chamber over Parlour, Chamber over Ha Chamber over Buttery, Chamber ov Millhouse, Chamber over Kitchen, Chamber

nv	Date	Name	Status	Hld	Loc	Acr	£	Hth	Rooms (and Farm Buildings)
									over Backhouse, Cheese Chamber, Kitchin, Hall, Parlour, Millhouse, Daryhouse, Celler, [Buttery], [Backhouse]; Barn

1660-1700: Sixteen Rooms

nv	Date	Name	Status	Hld	Loc	Acr	£	Hth	Rooms (and Farm Buildings)
	1680	John Tayler	Yeoman	101	Fl	(251)	127	10	Chamber over Kitchen, Chamber over Hall, Chamber over Parlor, Chamber over Dary and Millhouse, Chamber over Backhouse, Cheese Chamber, Garrets, Parlor, Hall, Pantrey, Sealler, Backhouse and Kitchen, Millhouse, Dary; Barne, Haybarne

1660-1700: Seventeen Rooms

nv	Date	Name	Status	Hld	Loc	Acr	£	Hth	Rooms (and Farm Buildings)
	1668	William Robinson	Gentleman	33	S	47	466	3	Red Chamber, Haire-colored Chamber, Greene Chamber, Chamber over Kitchen, Maids Chamber, Hall, Parlour, Studdy, Pantry, Buttery, Kitchen, Wash House, Dairy House, Cheese Chamber, Cocklofts, Corn Chamber; Barne

1660-1700: Twenty Rooms

nv	Date	Name	Status	Hld	Loc	Acr	£	Hth	Rooms (and Farm Buildings)
8	1673	Christopher Leigh	Esquire	2	S	73	2765	9	His Study, Hall, Kitchin, Larders, Dary, Pantry, Cellar, Ale Cellar, Brew Howse, Parlor, Inner Parlor, Mrs Leigh's Chamber and Closett, Mr Leighs Chamber, Chamber over Parlour, Mrs Leigh's Closett over Parlour, Chamber over Kitchen, Mans Chamber, Chamber over Brewhouse; Stable, Barnes (SBT.DR18/4/63)

1660-1700: Larger

nv	Date	Name	Status	Hld	Loc	Acr	£	Hth	Rooms (and Farm Buildings)
	1672	Thomas Lord Leigh		1	I		16471	70	102 rooms (SBT.DR18/4/4)

* For notes, see Table 4.1, p.53

Chapter 6

The Middling Sort

Introduction

Most husbandmen or middling craftsmen would neither aspire to, nor be able to afford the luxury described in the last chapter, whether in furnishings or in the buildings to contain them. However by about 1600, when the homes of yeomen have become clearly differentiated from the uniform medieval three-room houses, we can recognise a distinctive group of houses associated with these men of middling status. Their homes contained five to seven rooms (applying the same broad approach as in the last chapter) (Table 6.1; p.116). Sequences of inventories show that the expectations for improvement described in the previous chapter extended well down the social scale. Thus, in Stareton, John Clarke (1581) and his wife Alice (1608) lived in a modest way in three rooms (hall, one ground floor and one upper chamber). Their son Henry died in 1624. Although only describing himself as a labourer (pessimistic for the tenant of a 20-acre farm), he had enlarged the house to seven rooms, by adding a chamber over the hall, a buttery, a kitchen and a nether-house (for odd farm implements). With a relatively small farm it is no surprise that the improvement was not maintained; the house is recorded again in 1717 with only four rooms. The inventory of Henry's neighbour Joan James (1608) shows that the improvements at this social level might be modest. She too had inserted a room over the hall where she kept corn, bacon and oddments, but her appraisers could only describe it as 'in the flore over the hall'.

Patterns of Housing

In the first half of the 17th century, these middling houses had characteristic layouts. Typical five-roomed houses included a hall, two chambers and two service rooms in a four-unit plan with one chamber upstairs and one down (e.g. **23**). This ground-floor chamber was less often called a parlour at the beginning of the century than later. A minority of five-room houses had two upstairs chambers (over hall and chamber) with one service room, in a three-unit plan. In contrast to the 16th-century houses, the most common service room was a buttery (11 examples) rather than a kitchen (8); three houses had both. Other choices of service room included four dairies and one each: bolting house, cheese chamber, shop, bower house, dross house and nether house; the last three were general purpose storage or work rooms. Robert Baker's inventory (1628) (**23**) is characteristic of this social level and period.

23 *Robert Baker, husbandman (1628)*
He was the cousin of the yeoman of the same name (p.69), and succeeded his father in a 29-acre holding in Stoneleigh in about 1616. His son-in-law Matthew Faulkner followed his widow as tenant and they were joint executors; his grand-daughter Elizabeth Faulkner received two sheep. Matthew's wife is not mentioned in Robert's will but she was not dead, as the birth is recorded in 1635 of a daughter to Matthew and Elizabeth Faulkner who was named Dionisia or Deanes (after her grandmother). Robert's other daughter and her husband received ten sheep, three young beasts and a bond for £2, which had been promised as a marriage portion.

Inventory appraised by David Draper, yeoman, Thomas Hill, Alexander Preist and Henry Bellingham, 18th March 1627[/8].

	£	s	d
All his apparell both lynnen and woollen	2	10	0
In the Hall one long table, a forme, one old cubberd, two cheers, a shilf with other implementes in that roome		10	0
In the Litle Chamber ioyning to the Hall an old bedstead, two flockbeddes, one boulster, two pillows, two blanketes & a coverlet, one great chest, a coffer with all other implementes in that roome	1	10	0
In the Great Chamber ioyning to the Hall one joyned bedstead, one fetherbed, one matteris, one boulster and one pillow, three blankettes and a coverlet	2	0	0
In the same roome, an other old bedstead, a flockbed, a boulster, a double twilly, three coffers with all the paynted clothes and other implementes in that roome		6	8
Seaven pere of hyurden sheetes, two table clothes, two pere of pillowbeers, one towell, one dozen of table napkins	2	0	0
In the Chamber over the Hall foure flitchens of baken and certayn peeces of martillmas beef	2	0	0
A quarter of oates		6	8
33 Small cheeses		13	4
One bushell of rye and three strickes of beare barly		8	0
One strick & a strockles [sic], a cheese cratch, three old coffers, six syves, one old wich, foure bundells of hemp, certayn woollen yarne, one theale, one shilf, a cherne, two litle tubbes with certayne other ymplementes in that roome	1	0	0
[Probably in the Kitchen] One basen of latten mettle, six platters, foure sawcers, four pewter dishes, one salt, half a dozen spoons		10	0
Two ladles, eight wooden dishes, a dozen and half of trenchers			12
In the Kitchen two brasse pottes, fyve kettles, one chaffing dish, three brass candlestickes, one pere of cobyrons, one awndyron, one potthanger and two pere of potthookes, one brandydyron, one spitt, a dragg	2	0	0
One old cubbard, an old wich, a table, a litle forme, a chese presse, a hen penn, one woollen wheel, two lynnen wheeles, two cowles, three litle barrells, on loome, three payles, three theales	1	0	0
Two axes, on hatchet, one bill, one mattock, two shovels, two yron wedges, a cart ropp, a pott of salt butter, certayn brickes with other smal ymplementes in that room		10	0
Two kyne and two stears	6	0	0
Foure calves	2	13	4
One skore of sheep	5	0	0
In the Rye Barn one cantch of rye	3	0	0
One cantch of bear barly		10	0
One cantch of oates	1	0	0
In the Hay Barne one cantch of hay	1	0	0
One sucking calfe		6	8
In the fore yard one curb for a well with the chayne, buckett and trough		6	8
Three store swine	1	0	0
All the acres sowed with rye	9	0	0
Six henns and a cock and two duxs and one drake		3	4
All the wood in the yard and in the feild	1	6	8
All the compasse in the yard		10	0
Total	51	19	2

Six-roomed houses almost always added a second upstairs chamber to the typical five-roomed plan, giving a hall, three chambers and two service rooms. With seven rooms, most houses also included three chambers, combined with a hall, kitchen, buttery or dairy, and another service room.

The second half of the century saw some modest plan development which was then followed by a radical change in the naming of the rooms. After 1660, 'house' or 'dwelling house' appears as an occasional alternative to 'hall' but by 1700 the combination 'hall and parlour' as the names of the two principal rooms had been superseded by 'kitchen and parlour' in almost every inventory.[1] In five-room houses, the possession of both hall and kitchen, occasional before 1650, was no longer desired. However, a few of these smaller houses boasted two parlours; William Darnell (1666) had a bed parlour and a best parlour, the latter furnished as a hall.

During the later 17th and early 18th century, the most typical arrangement of five rooms had a kitchen and a parlour accompanied by two chambers; the fifth room gave the only provision for domestic service. This was rather more often a buttery than a dairy, and a couple of 18th-century houses contained a pantry—essentially a new name for 'buttery'. Only a few tenants chose to specialise by devoting one of their chambers to cheese, and they naturally tended to have a dairy rather than a buttery.

In six-roomed houses between 1660 and 1700, the inventories show that the extra room had just one use—as a cheese chamber. This is recorded explicitly in eight of the eleven houses, while two more had a quantity of cheese in another upstairs chamber. These chambers were often used for apples as well, and the panniers for bringing them home from the orchard are noted once (1613). After 1700, the chambers were simply identified by the ground-floor room below them. Although cheese chambers were no longer mentioned, the majority of the houses used one of the chambers for cheese.

The seven-roomed houses show a more varied pattern. Before 1700, the majority had both hall and kitchen, accompanied by a parlour, three chambers and either buttery or dairy. Later, with either hall or kitchen but not both, most houses acquired one of a variety of extra service rooms. When the structure of the house was unchanged, the new service room was probably obtained by conversion of the earlier kitchen.

Husbandmen at Home

Individual inventories shows that the names of the rooms require care in their interpretation. The most important change, the disappearance of the hall, did not correspond to a complete change of use. In 1600 the furnishing of the hall was uniform: a big table and form, sometimes with a small table as well, usually a chair[2] and often a cupboard or shelves; later in the century, old-fashioned houses that retained halls might have rather more storage in them, e.g. a press (1676) or a dresser and bacon rack (1690). The first grates (burning coal rather than wood) appear just before 1650 (1641; 1649), though they were only frequent after 1700.

A separate kitchen contained the dishes, cooking pots and fire-irons that were otherwise in the hall but, in contrast to the period before 1600, kitchens might include some furniture: a table, a dish-bench, a coffer. However, the changes that led to the merging of hall and kitchen by the end of the 17th century are prefigured by a fluidity in their organisation. The kitchen of Robert Baker (1628) (**23**) had become a workroom as well as a cooking room, with its cheese press and spinning wheels; the hen-pen was a rack for dishes (cf. p.50).

The inventory of John Wright (1612) is also typical of middling houses in the early 17th century. The position of the fire-irons, brass and pewter suggests that his cooking was done in the hall, while the kitchen was primarily used as a dairy. Though a fragment of his house survives (Figure 7; p.31), it cannot be related to the inventory.

24 *John Wright of Ashow, fuller (1612)*
He was only tenant for about three years of a 25-acre holding. He probably used Bericote mill for his fulling; his son Lewis apparently married the daughter of Henry Elliott, its tenant (noted in Elliott's probate, 1626).

Inventory appraised by Timothy Deloene, rector, Henry Gooder, William Gramer, Stephen Willson, 21st April 1612.

		£	s	d
All his apparell		3	0	0
In the Hall				
1 Table and frame and 1 longe forme			8	0
1 Cupbord			15	0
1 Cheyre			1	0
In Brasse				
1 Great kettle			13	4
4 Lytle kettles, 1 chaffing dishe & 2 possnightes			13	4
3 brasse potts & 1 possnitt		1	4	0
In Pewter				
1 Great charger, 7 platters			13	8
10 Pewter dishes & 2 bassone bolles			13	0
7 Sawcers, 3 saltes, 2 porringers, 1 pewter cupp			4	0
2 Pewter candlestickes & 3 brasse candlestickes			5	0
2 Spittes, 1 pare of cobyrons			2	6
1 Dussen of cushens			6	0
1 Pare of bellowes, 1 saltbox			1	0
In the Parlor				
1 Joynd beddsteed, 1 flocke bed, 1 coverlett, 2 blankettes, 1 pare of sheettes, 2 bolsters		2	13	4
1 Beddsteed			10	0
1 Cheste, 3 coffers, 3 boxes		1	0	0
1 Square table			3	0
1 Newe coverlytt		1	0	0
In Lynnen				
2 Pare of flaxen sheetes, 2 pillowbers		1	10	0
2 Pillowbers			3	0
3 Pare of hempton sheetes		1	6	8
2 Bordclothes, 1 towell, 6 nappkyns			13	4
1 Swoard & dagger, 1 rappier, 1 stonebowe, 1 pickforke & a spudstaffe			13	4
In the Buttery				
4 Barrells, 1 lombe, 3 earthen pottes with cuppes, glasses, dishes, trenchers, spoones with other ymplementes			15	0
In the Kyttchin				
3 kymnells, 2 payles, 1 piggin, 3 cheesse fatts, 1 fryinge panne			10	0
In the Upper Chamber				
1 Fether bedd, 2 pillowes, 1 coverlytt, 1 blankett		1	13	4
1 Table board, 2 wheeles, 2 payre of cardes with other ymplementes			6	8
In woole		1	0	0
3 Kyne		7	10	0
Money owinge to the said John Wright by specialties and otherwise		51	0	0
	Total	81	8	6

John Wright had more pewter than most at this social level; Robert Baker's 14 dishes, saucers and platters was more typical. In complete contrast to the yeomen, none of these inventories list precious metals, and the most sophisticated items mentioned were aqua vitae bottles (1613, 1622), two pewter sallet dishes (1641) and, at a later date, pewter chamberpots (common

from 1660). Brass or pewter candlesticks were also normal. The dishes, trenchers and spoons in John Wright's buttery were of wood. Several other inventories include similar groups, most clearly in 1610, 'a half dozen wooden dishes, half dozen spoons, one and a half dozen trenchers, a brush' (cf. **10**). Joan James' milkhouse (1608) gives a detailed list of the vessels there, 'seven litle milkpans, fyve yerthen pottes, two drinking glases, two yerthen posset potes, two black drinking pottes, two other jugg pottes, three bottells, two wooden meeles, a piggen, a tankerd'.

Frying pans and skimmers were found in particularly well equipped kitchens. At first they were of brass but by 1700 frying pans of iron had appeared (1700; 1722, **26**). At the same time iron rather than pewter or brass candlesticks and tin cooking pans[3] (**26**) are recorded, showing how industrial progress was affecting ordinary households.

By the later 17th century, the kitchens in houses without halls were generally very similar to the cooking halls of the preceding generation, as is seen in the inventory of Thomas Higinson (1689) (**25**), a typical example from this period (recreated in Chapter 12, Figure 51). The Ticknill ware in his dairy was coarse black earthenware from Ticknall, Derbyshire; it was fairly common from the 1680s, but was of little value, often listed with 'other trimtram'. A few householders (or their inventory takers) were still confused by these changing names, like John Man (1673) who had a kitchen without a hall, but cooked in his milkhouse.

25 *Thomas Higinson of Cryfield, yeoman (1689)*

He was one of four tenants who held portions of Cryfield Grange in the late 17th century, before the 18th-century pattern of two larger and one smaller farm became established (pp. 84, 109). He was tenant from 1680, when his house was probably built (or reconstructed from some of the old Grange buildings), and the court rolls show him farming land in the south-west corner of the Grange in 1681 and 1684. He died intestate, and his widow Elizabeth renounced the administration to her brother-in-law Gilbert Higinson of Shirley Street, Solihull, mentioning a daughter Elizabeth, who died only a year later (*Reg.*).

Inventory appraised by Thomas Gibbes, Francis Clayton, Lawrance Hands, William Meigh, 15th December 1689 (proved 1690).

	£	s	d
His wareing apparill & purse	5	0	0
In the Parlar			
One bedstid & sett of curtains & vallance, a fether bed, a flockbed & bolster, two pillow, a coverlid & a pare of blankitts £3, a table, a forme, four chears & a grate 18s, a little looking glass 6d	3	18	6
In the Chamber over the Parlar			
A bedstid, a fetherbed & bolster & sett of curtains & vallance, a coverlid & a pare of blankitts £2 15s, a cofer, a little trunke & a box 8s, nine pare of sheets, a table cloth, a duzen of napkins & som other linnen £3 5s, two bedstids & three bolsters, & three pillows, three pare of blankitts & two old beds £1 6s 8d, a cover, a forme & a pare of andirons 8s	8	2	8
In the Chees Chamber & another Chamber			
A parsill of chees £1 3s 4d, three quarters of barley £1 12s, fifteen fleeces of wooll 10s a pare of trestles & two cheesbords 2s 6d, an old bed & bedstid & three blankitts 6s 8d, two cofers & a parsill of fethers & two baskits 4s	3	18	6
In the Kitchen			
One long table & fourme & two little tables & a bench 14s, a cubart 3s, four chears, a cradle & some benches, a sault box 6s, four brass kettles & a skellitt £1, two brass potts & a warming pan 10s, nine pewter platters, four parengers, a flagon & a pint, a drinking cup, two sawcers & a duzen & four spoons, a candle stick & a brass ladle, a chamber pott, a tin driping pan & a lanthern £1 1s 6d, pott hooks & hangers, a fire shovell & tongues, a smoothin iron & two heals, & a gridiron & a pare of bellows 2s 6d	3	17	0

<u>In the Dary House</u>

A cheespress, a powdering tubb & som meal, five shelves, a little table, a frying pan & other implyments	1	0	0
Four barrill, four kivers, one tubb, one churne, four pales, four cheesfatts & a suter, three duzen of trenchers, two wheels, som Ticknill ware & a bottle	1	10	0
Twenty five sheep & lambs	4	0	0
Seven store piggs	3	10	0
A sow & six pigs	1	13	4
Two fatt hoggs	3	0	0
One nagg, five mares, two old horses & two colts	20	0	0
Five cowes, five heafers & six calves	20	0	0
Corne in the barne	5	0	0
Oats in the barne	8	0	0
Peas in the barne	3	10	0
A rick of hay & som in the barne	15	0	0
Corne growing upon the land supposed to be twenty acres	30	0	0
Five acres of land in tillage now ready to be sowed with rey	3	15	0
A waggon	6	0	0
A tumbrille	1	0	0
One great & two small harrows & a plow & five pare of gears	2	13	4
A trine of fellyes, three axeltrees, a pare of wagon sides & shafts, a pare of naves & some plow timber	1	0	0
Six baggs, a strike, a hopper, an iron crow, a sith [scythe], a spad & shovell & other implyments for husbandry	1	0	0
For lumber & things forgotten		5	0
Total	154	13	4

With halls and kitchens, names were changing more than function, but the opposite is true for parlours. They appear in almost all these inventories, and (at this social level) continued to be used for sleeping even in the 18th century; only two living parlours were recorded before 1700 and two after. Until about 1650, they contained the same beds and chests or coffers as found before 1600, perhaps with the addition of a table or a chair (**24**).[4] Later they might include a hanging press or 'a press to lay clothes in' (James Mayo, 1668), though one parlour had only a 'flaxed [flasket, a shallow basket] to put clothes in'; James Mayo also had two trinket boxes, but the one safe (a ventilated cupboard for food; 1691) seems out of place. Joined bedsteads were standard, with feather or sometimes flock' beds, though the total value of the bed hardly ever exceeded £3. John Cooke (a labourer, 1673) had only a bedstead and chaff bed in his parlour, but with a feather bolster (and also a 'standing' cradle).

The second half of the century brought some some extra comforts or luxuries: the occasional fire grate (1665) perhaps with a screen (1675), a warming pan (1675; **11**), a close stool, court cupboard (1670) or looking glass (1693), though these were very rare before 1700. By the 18th century we can expect the better-provided parlours to have enough tables and chairs to entertain, perhaps with a clock (1728) or some decoration. One living parlour (1713) had eleven chairs, two grates and a 'drawer to the windows' (surely a curtain), while the chamber had another dozen chairs and one of the two chests of drawers in this group; the other (also in a living parlour) was described as a 'dresser with drawers' (1720).

The 18th-century pattern is clearly shown by the inventory of Joseph Badhams (**26**) with his two pictures in the parlour, as well as the new-fashioned Delftware[5] accompanying the pewter and trenchers in his kitchen. His house was one of the few having all the rooms floored over, while the listing of clothes and the quality of the bed show that the best chamber was upstairs, even though the parlour held two beds (and the close stool).

26 *Joseph Badhams of Canley, husbandman (1722)*

He was tenant of Moat House just north of Canley village (36 acres), from 1689; although a timber-framed barn survives, the house was rebuilt as brick cottages after 1800. He was constable in 1713 and a juror then and in 1715, and appraised several Fletchamstead and Canley inventories. He had no children and left his property to his wife Barbara for life and then to his brothers' and sister's children. He had at least two servants, Thomas Badams (presumably a nephew, possibly born in 1707), and Ann Gleaves who witnessed his will. They were left £1 and £5 respectively in 1718 by William Smart, brother of Barbara Badams.

Inventory appraised by John Webster and William Holbech, 23rd April 1722.

In the Chamber over the Parlour			
Wearing apparrell & money in pocket	4	0	0
Nine pair of sheets, one dozen and halfe of napkins, four table cloaths, three pillowbears	3	17	0
Twenty pounds of hempton yarn		10	0
One featherbed, boulster and two pillows, one flock bed, three blankets, one kiverlet, one bedstead & curtains	4	0	0
Two chests, one old trunk, one coffer, one coat [court] cupboard, one flagg chair		10	0
A parcell of wool	1	0	0
In the Chamber over the Kitchen			
One flockbed, bedstead and blankets		5	0
Six cheese boards		2	0
A parcell of cheese	1	10	0
In the Chamber over the Dary			
One malt garner & malt	2	19	0
In the Parlour			
One feather bed, four blankets, two boulsters, one pillow, bedstead and curtains	2	5	0
One flock bed, three blankets, a feather boulster, bedstead and curtains		15	0
One close stool and pann, two chaires, one table, one trunk, one coat cupboard		10	0
One cushin, two pictures, four barrels		7	0
In the Kitchen			
Six pewter dishes, one dozen and halfe of plates, six porringers, one little cup, one bottle, one candlestick, four kettles, two bell-mettle pots, one brass skimmer, one warming pann, one tin pasty pann, one dozen of patty panns, one tin sause pann	1	18	0
One grate and fender, two fire shovels, two paire of tongs, two flesh forks, two lock irons, six heaters, two paire of pot links, one jack, two spits, one dripping pann, two iron candlesticks, one frying pann, one choping knife, one hanging iron to warm bear on, one hand saw, one paire of spit racks		19	6
One clock	1	0	0
A parcell of Delfe ware		2	6
Two tables, seven chairs, one forme, one old cupboard, one shelfe		17	0
One dozen of trenchers, a parcell of earthenware		1	0
One lanthorn			6
Four axes, one beetle, eight wedges, one hoock, one mattock		5	6
One beam and scales & waits		4	6
Two flitches and a halfe of baken	2	0	0
In the Dary			
One cheese press, three tubs, one churn, two pailes, three gallons, three cheese fatts, one shuter, one kimnell, one dough tub, one forme, one old cupboard, one old coffer, one paire of butter scales, one serch, two haire sives		17	0
A parcell of coarse earthen ware		1	0
Sowed on the Ground			
Five baggs of oats, seven strike of peas	2	1	0

Stock out of doors			
One mare, one filly	7	0	0
Twenty seven sheep	10	0	0
Six cowes, one yearling	20	0	0
Two piggs	1	10	0
One little rick of oats	1	10	0
One little rick of wheat	6	0	0
One little rick of hay	1	10	0
In the Barn			
Three calfes	1	8	0
One fann, one strike, three sives, one cartrope, five forks, one spade, two ladders		6	6
In the Stable			
One saddle, one pillion, one pannell, one cart saddle, two collers and harnes, one pare of plow traces, one paire of other traces, one bridle		8	0
In the Hovvell			
One plow, two harrows, one waggon	1	16	0
Good and bad debts	75	0	0
Lumber and trash and things forgot		5	0
Total	159	5	0

In the light of the evidence for room use, the disappearance of *hall* as a room name can be seen to reflect the rearrangement of its functions. By 1600 its use for eating and as the centre of normal household activities had been combined with the cooking that would earlier have had its own space. Moving the dairying and cheese-making into its own room must certainly have been convenient for these tasks as well as providing extra cooking space in the kitchen; this change is a significant reflection of the increase in cheese-making revealed by the inventories.

Later in the century some of the social functions of the hall were transferred to the parlour where respected visitors could be received and the family could gather, even though it remained the principal bedroom. The hall still retained the workaday tables and benches, but its predominant use for cooking was reflected in its new name. However for these middling villagers, development was limited by the modest house size. Whether this was controlled by social pretensions, or by economic necessity, it could not provide enough space for a living parlour as well as the necessary service rooms and subsidiary chambers.

Standing Houses

The standing buildings which we can identify with these middling inventories are remarkably varied, including a medieval house only partly modernised, timber-framed houses new-built in the 17th century, and one of the same date using stone—a great rarity in the parish.

Bridge Cottage, Stoneleigh (Figures 23a & b)

This was associated with a middling-sized farm, 56 acres in 1766. It shows the characteristic arrangement for a five-room house, with two full-height floored bays and a further low bay at one end, corresponding to the five rooms in the 1700 inventory of John Unton, whose 'little room' is an apt description for the end bay.

Bridge Cottage was sometimes called Van Diemen's Cottage, a name recorded in 1858 (*Map*). Two original bays are of type III framing, three panels high. The tiebeams are re-used cruck blades and the roof timbers carry a magnificent series of carpenters' marks, numbering joints up to at least 24 with a series of circles and strokes. It has slightly curved windbraces. The ceiling beam are chamfered but unstopped, though the joists have step stops. The added bay has similar framing (two panels high), but lacks any decorative features.

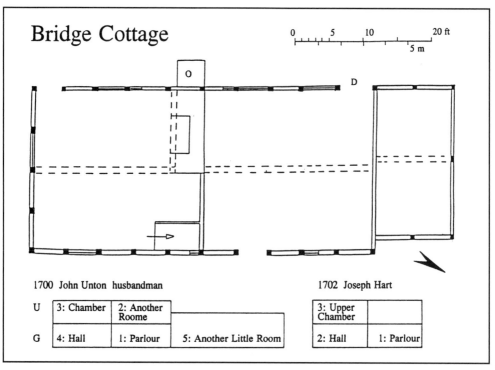

Bridge Cottage

0 5 10 20 ft

5 m

O

D

1700 John Unton husbandman

U	3: Chamber	2: Another Roome	
G	4: Hall	1: Parlour	5: Another Little Room

1702 Joseph Hart

3: Upper Chamber	
2: Hall	1: Parlour

23a *Bridge Cottage, Stoneleigh, plan and inventory interpretation (D marks original entrance; O = oven).*

23b *Bridge Cottage, Stoneleigh, from the south.*

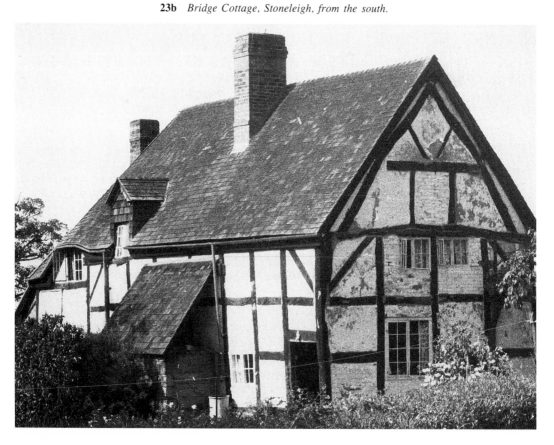

27 *John Unton, husbandman (1700)*
He was tenant from 1685, and was regularly a juror and once Surveyor of the Highways for Stoneleigh. He left his goods equally between his wife and daughter.

Inventory appraised by Francis Clayton, Richard Grisold, 24th February 1700.

His waring apparill and purse	2	0	0
In the Parlar a joyne bedstid, a fetherbed and bolster, a coverlid and blankitts with curtains and vallance	2	0	0
One chest, a trunke, a box and four chears & a table	1	0	0
In Another Roome a bedstid and beding belonging to it		16	0
In the Chamber a bedstid and beding and other implyments	1	0	0
In the Hall seven brass potts and kettles and a warming pan	2	0	0
Eight puter dishes, seven parengers and one pinte	1	0	0
In Another Little Roome three tubbs, three pales and two barrills		10	0
Pot-hooks and hangers, fireshovell and tongues and belloss		3	4
Two thine flichens of bacon	1	0	0
Corne and mault in the house	2	0	0
Two cows and three heafers	10	0	0
Two old mayrs	2	10	0
Thirty four sheep	8	0	0
A cart, a tumbrill, a harrow, a plow and implyments for husbandry	4	0	0
Corne growing one the land and som oats	13	0	0
Five pare of sheets, six napkins, a tablecloth and three pillowdrawers	1	0	0
Other lumber and things forgotten		5	0
Total	52	4	4
The said deceased dyed indebted the sum of	26	0	0

John Unton's widow, Mary, almost immediately married Joseph Hart (July 1700), who became the next tenant. He died only two years later, and his inventory comes as a surprise as it lists only Hall, Parlour and Upper Chamber.

28 *Joseph Hart (1702)*

Inventory appraised by Francis Clayton, Joseph Mayho; 11th May 1702.

His wearing apparel and purse	2	0	0
In the Parlour a bedstid and fetherbed & bolster & coverlid, blankitts, & a set of old curtains	1	10	0
Two chests, two boxes, a table & forme, six chairs and six stools		10	0
A trunke, nine pares of sheets and other linen, in all	2	0	0
In the Hall ten puter platters, seven parengers, a chamber pott, two candlesticks, a flagon & two pints	1	8	0
Four brass potts, eight kettles big & little, three brass ladles, two skimers, a warming pan, a chafing dish, two candlesticks	1	10	0
A table & forme, a press cubart, four chears, a pare of andirons, fire shovell & tongues, pothooks & hangers, a pair of bellows and a gridiron		10	0
Three flichens of thin bacon	1	0	0
In the Upper Chamber three old bedstids with woolbeds and bolsters & three pare of old blankitts	1	10	0
Twelve strike of mault	1	10	0
Tubbs, pales & barrills	1	0	0
Hay & corn	1	0	0
Two strapping cows, two year olds & a calf	6	5	0
Two old mayers	4	0	0
Fifteene ewes & lambs, forty sheep & two pigs	12	0	0

A cart, a tumbril, a harrow, collars, traces & other implyments for husbandry	4	0	0
Corn, oats & peas growing on the land	10	0	0
Implyments & things forgotten		10	0
Total	52	13	0
The said deceased dyed indebted the sum of	46	0	0

However, there are no obvious omissions from the furnishings listed and it would seem that he and Mary were using only these rooms. Mary is listed as tenant until 1704, when she was succeeded by Thomas Dee, her third husband.[6] Mary and John's daughter (another Mary) married her step-brother John Dee (Thomas's son by an earlier marriage) in 1714; John was in his turn the tenant of Bridge Cottage from 1724 and was succeeded by his son William in 1759. The tree shows some of the ramifications surrounding the tenants of this little farm and their families.

Table 6.2: *Family Relationships among tenants of Bridge Cottage*

Bold type indicates tenants. b = born; d = died (dates of christening and burial) Source: Stoneleigh *Registers* unless otherwise stated.

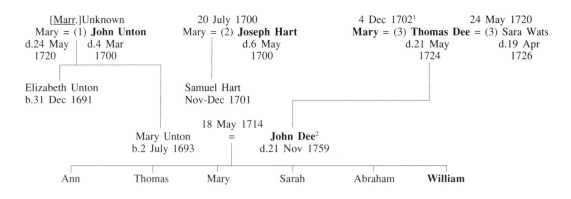

1 Bishops' Transcripts for St Michael's, Coventry: Thomas Day of Baswell [Berkswell] married Mary Hart of Stoneleigh.
2 Possibly the John son of Thomas Dee whose baptism is recorded in Honington parish register, 15 January 1687.

Roseland, Ashow (Figures 24a & b)

Although this house now has the appearance of a late 18th-century brick cottage, it too is a two-bay timber-framed house with an added third bay, here in an L-plan.

The holding was originally of 10 acres, increased in 1717 to 37 acres. The sequence of inventories (**29-31**) runs through from the mid 16th to the 18th century. The first (**29**), though lacking in detail, shows the typical medieval lifestyle in a single-storey house probably with three main rooms and a small buttery (in a lean-to?). By 1622 (**30**), one upper chamber had been added. Characteristically, although it still had a kitchen, this was used for storage and the buttery had been converted to a little chamber. The house was probably rebuilt soon afterwards, with the rear dairy added towards the end of the century, or perhaps when the holding was enlarged. Later in the century, perhaps when the brick casing was added, a sixth room was created by flooring the dairy. In 1730 (**31**), John Elliott probably slept in the parlour, even though it had the only tables in the house. His daughter and son-in-law (the next tenant) may have used the chamber, sharing this with the bags of wheat; its grate is notable as a step to greater comfort.

Both the main and rear ranges of Roseland retain some exposed timber-framing in their east walls, but most has either been replaced in brick or is rendered. The main range framing is three panels high with fairly heavy studs lacking visible braces; the rear range has one diagonal brace. The north gable has V-struts above the collar. The beams in both main rooms have scroll stops. In the 19th century, the parlour was subdivided to create a small dairy, perhaps when the chimney for a copper was added to the rear room. The main range probably dates from the middle or later 17th century, and it can be seen as a prototype lobby entry plan. The cellar (not accessible for recording) may have been inserted at this stage.

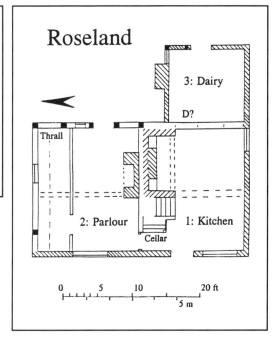

24a *Roseland, Ashow, plan.*

24b *Roseland, Ashow, from the west.*

29 *William Powres of Ashow (1556)*

He was tenant for 20 years, leaving a son Thomas (who succeeded him) and 'other children', with his wife Annys as executrix.

Inventory appraised by Sir Thomas Parker (rector), John Hembroyke (of Leamington), Thomas Latham, 'with wother men' 5th October 1556.

In the Halle			
A bord, a peer of trestules, a pentyd cloth, a chear, a amber' [*aumbry*]		1	4
In Kechyn			
On potte, 2 lettull panns, 2 plattres, 4 powter dysshys, a saltsellres [*sic*]		5	0
In the Botter			
2 lomys, on barell, 2 paylles		1	4
In the Chamber			
A matteres, a bolster, 4 peer of shettes, 2 coverlettes, on ewolle [*ewer*], 2 coffers,			
a tester with the bed		8	0
On kow, a caffe, 2 shype (?)	2	0	0
[Total	2	15	8]

30 *Thomas Powrse of Ashow, husbandman (1622)*

He was presumably the grandson rather than son of William, probably succeeding in 1595 when he swore fealty as a tenant. His father had to repair his house in 1572, 1576 and 1579, perhaps when the upper chamber was inserted. The son made numerous appearances in court for husbandry offences: overburdening the commons, unringed pigs, unmade hedges, dunghills in the street, unscoured ditches. He left a few bequests to his daughter Anne Roberts of Kenilworth and the residue to his wife Susanna who succeeded him as tenant but only for two years.

Inventory appraised by Timothy Deloene (rector), George Hubbold, Thomas Jeacocke, John Pores 1st July 1622.

Apparrell			
All wearinge apparrell	1	0	0
In the Hall			
2 old tables, an old cubbord, one fourme, 2 benches & certen shelves		10	0
2 brasse pottes, 2 kettles, a posnet, 3 candlestickes, a frying pan	1	0	0
The pewter, a paire of tonges, bellowes & all other implements		10	0
In the Bed Chamber			
2 flockbeds, 2 coverlets, 3 paire of sheetes & one odd sheete, one pillow,			
2 pillowbeeres, one towell, one blanckett with the bedsteeds	1	10	0
3 coffers, the woll & all other implements		10	0
In the Little Chamber			
A bedsteed & all implementes		3	0
In the Upper Chamber			
A boltinge tubb, a chest, a bille & all other implements		10	0
In the Kitchin			
A garner bottom, a kiver, pales, an old wheele & all other implements		12	0
In the Yarde			
The wodd and grasse		10	0
The corne on the grounde	1	10	0
The sheepe in the grounde	2	0	0
A cow in the grounde	2	10	0
One pigge		10	0
Total	13	0	0
His debts			
He doeth owe the summe of	3	13	0
[*Itemised in his will*]			

To one James Stotton	1	6	0
To one Owin Roberts	1	0	0
To one Widow Belcher	1	0	0
To Thomas Cox of this towne of Ashoe		7	0

31 *John Elliott of Ashow (1730)*
He took over both the house and an adjacent cottage (holding 46, later demolished); the main increase in the size of the holding from 10 to 37 acres probably took place in 1650, when holding 35 was dismembered. He served twice on the manor jury and once as thirdborough, and appraised two inventories. His bequests, £40 each to his wife and daughter, and £30 to his son-in-law, total more than double the value of his estate.

Inventory appraised by Joseph Gibbs, Thomas Harrison, 16th February 1729[/30].

Wearing apparrele and money in purse	4	10	0
3 cows, 2 uncalved heifers, 2 stirks & 2 yearlings	22	0	0
Corn unthrashed in the barne	4	0	0
In the Kitchen			
Five pewter dishes, 6 plates, 3 porringers, 12 trenchers, 6 chairs, fire shovel & tongs		18	0
In the Parlour			
One bedstead, bed, blankets, bolster, curtains & valance	2	10	0
1 oval table, 1 longe chest, 1 square table, 4 chaires		18	0
In the Dairy			
3 barrels, 1 cheese tub, 1 churn, 1 chees press & aliis		12	0
In the Chees Chamber			
Half a hundred of cheese, 1 bedstead, bed, bolster, blankets & curtains, oats thrashed, 2 wheels & other things	3	15	0
In the Other Chamber			
One bedstead, bed, bolster, coverlid & blankets, wheat thrashed, 2 barrels, 5 boards, 2 chaires, 1 grate, 5 pair of sheets, 12 napkins, 2 table cloths	4	5	0
13 sheep	3	18	0
Corn growing upon the ground	3	10	0
Lumber & things forgot		10	0
Total	51	6	0

8-9 Vicarage Road, Stoneleigh (Figure 15)
The complexities that can underlie a six-room inventory are well illustrated by this cruck house. Originally it had five rooms including a subdivided inner room, and was described in the manor surveys as a cottage, accompanied by 2 ac. land. By the time of Roger Hudson's inventory (1610), what had presumably been the kitchen (by comparison with the earlier descriptions of cruck houses) was the milkhouse; the addition at the north end was in place ('the house beneath the entry'), containing firewood and a bolting tub. The name is important as indicating the position of the entry which cannot be established from the structure because the outer wall framing has been replaced.

32 Roger Hudson, tanner (1610)
He was a member of a junior branch of the Hudson family, cousin to Edmund Hudson of Crew Farm (p.28). He held the cottage and two acres from 1580, with occasional appearances in the manor records as juror, ale-taster or tithing man, and was presented for not branding his sheep (1601), for watering hemp in the river (1585), for keeping a foal on the common pasture above his stint (1587), and for not appearing before the 'Clerk of the Market' (1582), an enigmatic offence! His heriot was a mare worth 30s (deleted from the inventory). His widow, who continued as tenant until 1625 was left £5 and the household goods, while his three younger sons received £4 each, with the residue going to the eldest son John. The younger sons all became

tenants in Stoneleigh, Edward succeeding his mother, Thomas and Roger taking up cottages in 1617 and 1623 respectively.

Inventory appraised by Edmund Hudson, yeoman, Robert Baker and Nicholas Clarke, 19th November 1610.

All his waringe apparrell both lynnen and wollen		13	4
In the Hall, on long table with tressels, a forme, a bench with a bord at the back of the bench, foure litle shilves, two dish benches, a litle square table, a cheere, a cubbard, one stoole		6	8
Two brasse pottes, foure kettells, a dabnet, a fyre shovle, a pare of tongues, a pare of pott linkes and hangers, a grydyron, a spitt, on chopping knife, a trowell	1	10	0
Six platters, six saucers, three latten candlestickes, one salt		5	0
Two loomes, two payles, a tankerd, a piggen, seven dishes, half a dozen of spoones, a dozen and halve of trenchers		3	4
Halfe a dozen of quishens, a pare of bellowes, a lynnen wheele, the paynted cloth one the wale, with all other implementes in the Hall		3	4
In the Little Chamber next the Yarde, one beddsteed with a flock bedd, a flock boulster a hilling, a twilly, a blanket(/?), a pare of sheetes		5	0
Three old coffers, a kneding tubb, a cherne, a loome, an old prese, with the paynted clothes about the bedd		3	4
Six yardes of white carsie and 2 yardes of russet cloth		16	0
In the Street Chamber, two coffers, a litle box, two playne bedsteedes, one fetherbed, one flock bedd, two pare and an odd blanket, a twilly, three hillinges, two boulsters, on pillow with a pillowbeere	3	0	0
Two pare of flaxen sheetes, three pare of hempen sheetes, two table clothes, a dozen table napkins, a towell, on more pillowbeer	2	10	0
In the Upper Chamber, 3 pare of sheetes and an odd shett, a cheere, with all the apples, woole and yarne, with tubbs, bordes and coffers	2	3	4
In the Mylk House, four shilves, two benches, foure mylk panns, two stean potes, a frying pane, a bottell, a oatmeale box with all other implementes in that roome		5	0
In the House beneath the Entry, a woolen wheele, a boulting tubb, a ladder, a forme with certayn brusse wood and all other thinges in that roome		3	4
In the Barne, all the hay with the implements in that house	1	3	4
About six load of wood in the Yard		18	0
Fyve sheep		15	0
One cowe [and one old mare *erased*]	1	13	4
Two swine	1	4	0
3 Henns and a cock		2	0
In the Tan House, all the barke, lether, with all that is in the Tanhouse	20	0	0
Total	38	12	0

The second description of this house, a century and a half later in the inventory of William Watton (1756) (**33**), shows a second upper room, probably that over the meal house (the former milk house) from its name and from the structural evidence, though this space was little used. The two little ground-floor rooms had been converted into one parlour, still used for sleeping. Otherwise, the only changes has been to the names of the rooms. After Watton's death, the house was divided between two tenants and the land let off separately. At this stage, the second fireplace and the remaining upper floors must have been added. By 1813 (*Map*) it had been still further divided and had four occupants.

33 *William Watton, yeoman (1756)*

He was tenant from 1722, marrying Elizabeth Biram, the widow of the previous tenant in 1723; Elizabeth Stoneleigh and Thomas Biram were married in 1702 when the latter became tenant.

Remarkably, although William Watton's appraisers called him a yeoman, at his burial the register described him as a labourer, the same status as Thomas Biram (whose inventory totalled only £14 14s). The inventory poses one problem: how the two-acre holding could have maintained the three horses, the wagon and plough, and the 27 sheep. The Stoneleigh rentals show clearly that he held no more land; however, as he left no will, we have no evidence about possible landholdings in neighbouring parishes. The burial of an Elizabeth Wootton in Long Itchington in 1757 may be relevant to this inconsistency.

Inventory appraised by Thomas Garlick, Richard Farmer, 8th September 1756.

His wearing apparel & money in purse	1	0	0
In the Kitchin			
Four brass kettles and an iron pot		15	0
Two pewter dishes, two plates and an old tankard & porringer		5	0
An old table, cupboard, chairs & other things		8	0
In the Meal House			
A dough trough, 2 tubs, 3 barrels & other things		8	0
In the Parlour			
Two beds, bedsteads & bedding	1	5	0
A box and coffer		4	0
In the Chamber over the House			
An old coffer and two wheels		5	0
In the Chamber over the Parlour			
Wool	1	0	0
A bed, bedding & two boxes		5	0
In the Pantry			
An old table & other things		1	0
In the Stable			
Three horses & their gearing	10	0	0
A waggon & cart	5	0	0
A plough & harrows		7	0
27 Sheep & lambs	7	10	0
In the Barn			
Corn	1	16	0
Hay in the Barn & a hay rick	1	5	0
A hopper & other things forgot & unseen		5	0
Total	31	19	0

Gibbet Hill Farm (Figure 25)

This was established as a 75-acre farm in the later 17th century on an isolated site, part of Cryfield Grange.[7] The original house still survives, a simple two-bay stone building. The only extra structure by the time its first identified tenant, Edmund Casemore, died (1728) was a well-house also used for the malt mill and probably detached from the main building. His four rooms must have been very crowded, and by 1740 the house had been enlarged to eight rooms (kitchen, brewhouse and buttery, dairy, parlour, chambers over dairy and kitchen, cheese chamber)—a more appropriate size for a substantial farm. The plan on the 1766 map shows extensions on the east of the original house. However, these additions were replaced in about 1800 when the house reached its present form.

> Little detail survives in Gibbet Hill Farm apart from the walling of the stone two-bay house; the original entrance position is unknown. The ceiling beams have roll stops and a fragment of an octagonal newel stair post survives at first-floor level. A three-light window (west side) and a two-light window (north gable, first floor) have stone mullions, glazing slots and window bars; the first has an ogee moulding, the second a simple chamfer. The walls were raised in brick and the house much extended in about 1800, producing a typical central-hall plan.

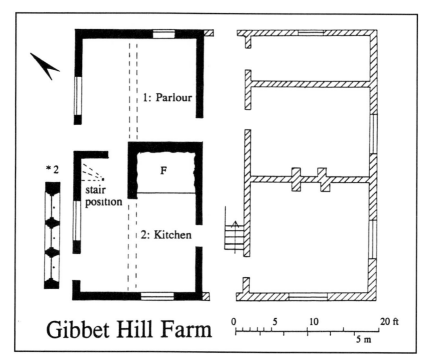

Gibbet Hill Farm

25 *Gibbet Hill Farm, Stoneleigh, plan and detail of window (in north kitchen wall). Stonework is shown solid, brickwork shaded.*

34 *Edmund Casemore of Cryfield (1728)*

He was tenant from 1704 to 1728, and was the son of Richard Casemore, tenant of the adjoining Tocil Farm. He left no will, but his marriage (1706) and the baptisms of children Richard, Ester and Sarah are recorded (*Reg.*); he probably had a third daughter Mary who married Benjamin Higginson, the next tenant of Gibbet Hill Farm (1729).

Inventory appraised by Thomas Watson, Thomas Gibbs, William Thompson, 12th September 1728.

Purse and wearing apparrell	6	0	0
Money due upon bond	100	0	0
In the <u>Parlour</u>, one feather bed & furniture to the same, one table, one cubbord, one chest, one fourm, two cheirs, one clock	3	10	0
In the <u>Kitchen</u>, five kettles, two potts, one warming pan, two copper canns & one mortar and pestill	3	15	0
Eleven pewter dishes, eight pewter plates, eighteen spoons, one chees plate, one salt sellar & one pewter flaggon	2	11	0
One jack, three spitts, two handirons, one grate & fendor, two paire of tongues, one fireshowle, one peall, one cleever, one iron furnace & grate, & foure candlesticks	1	18	6
One gun, six cheirs, one table, one dresser & benches, one chaffindish, fire hooks & links, one bacon cratch, one board & two pewter shilves		16	6
Six barrills, one brewing tubb, foure pailes & one chees cowle, two kivers, two churnes, four chees fatts, sixteen trenchers and one cheespress	2	10	0
In the <u>Chamber over the Parlour</u>, one feather bed & furniture to it, one hanging press, one truckle bedstead, one chest, one coffer	2	1	0

<u>Linnen</u>, three pare of course flaxen sheets, seven paire of course sheets, six napkins & one table cloath	2	2	6
A quantaty of cheese	2	10	0
One beam, scales and weights		9	0
In the <u>Chamber over the Kitchen</u> two beds & bedsteds, one table, one coffer & one sadle, a quantaty of malt & a quantity of wooll, five spining wheeles & other things	2	11	0
In the <u>Well House</u>, one buckett, one chain, one malt mill & one sithe		17	6
In the <u>Barn</u> and in the <u>Rickyard</u>, a quantaty of corn unthrashed	24	0	0
A quantaty of barley	9	0	0
One rick of oates	5	0	0
One rick of pease and beans	3	10	0
Hay and clover	24	0	0
Two stadles		13	6
<u>Cattell</u>, seven milking cowes & one bull	23	0	0
Three heifers & five calves	10	10	0
Five sheep and two lambs	2	16	0
Five mares & one foale	25	0	0
One sow and two piggs	2	10	0
Foure stocks of bees	1	0	0
A quantaty of poultry		10	0
<u>Implements</u>, two waggons, two tumbrills, two plows, two paire of harrows	10	10	0
Five pare of traces, five collers & five pare of holmes & bridles, two cart saddles, one hackney sadle, & one pannell	1	12	6
One fann, one strike, two sives and three riddles, tenn baggs, one beetle and foure wedges	1	2	0
Axes, hooks and lumber and things which are not herein before vallued		5	0
Total	276	11	0

Multiple Inventories

As well as the houses discussed in Chapter 4, whose 17th-century inventories fall within this group (1-2 Coventry Road, 2 Church Lane, and 6-9 The Bank, Stoneleigh), further evidence for these middling houses comes from holdings for which multiple inventories survive. Two are particularly notable, with four and five inventories respectively (Table 6.3.).

Table 6.3: *Multiple inventories for middling houses*

<u>Holding 84</u>: Hurst; 12 acres in 1597, increased to 41 acres by 1766 (probably in 1747)

1606	David Benyon	Nether Chamber, Heie Chamber, Other Heie Chamber, Buttery, Haul
1660	Thomas Smith (**35**)	Parlour, Buttery, Chamber over Parlour, Chamber over Hall, Dayehouse, Hall
1691	Francis James	Parlour, House, Dayry, a Chamber, Cheese Chamber
1728	Francis James	Parlour, Dwelling House, Dairy, Chamber over Parlour, Chamber over House

<u>Holding 49</u>: Grove Cottages, Ashow; 2 acres in 1597, with additional land in Bericote and Cross Grange; consolidated to 15 acres in 1650; 14 acres in 1766

1603	John Greene	Hall, Chamber, Buttery, High Chamber, Bower House
1610	Ralph Reade	Hall, Parlour, Upper Chamber, Buttery, Kytchin
1612	Abraham Boyes	Hall, Lodging chamber, High Chamber, Kitchen, Buttery
1650	Thomas Bryan	Lodging Chamber, Upper Chamber, Little Buttery and Spence, Hall House, Shop
1736	Thomas Stoaks	Shop, Kitchen, Chamber over Kitchen, Cheese Chamber, Darey
1771	Thomas Stoakes	Kitchen, Back Kitchen, Dairey, Tub House, Litle Pantry, Cheese Chamber, Boys Room, Girls Room

The first appears to have been a three-bay house with two upper rooms that had reached this form by 1606; it exchanged a dairy for a buttery in the 17th century but otherwise remained unchanged into the 18th century. The 1660 inventory of Thomas Smith is particularly informative for this house, showing how the chamber over the hall was used for storing cheese, cloth and yarn. Spinning was clearly one of the family's concerns and the new cloth in the chamber suggests that they also arranged for its weaving.

35 *Thomas Smith of Hurst, yeoman (1660)*
He had been a tenant since 1625, and was also a sub-tenant to John Hartley for part of Cryfield Grange. He had no children but left his household goods equally to his wife and his kinsman Francis James, with small bequests to his brothers and sister and their children. He was the grandson (or perhaps son) of Thomas Smith of Stareton (d. 1603), whose wife was Joan James. Despite his long tenancy, he appeared rarely in the manor court (juror on three occasions and once presented for watering hemp), though he was indicted at Quarter Sessions in 1642 for rescuing Edward Smith (his brother) from one John Fantam of Kenilworth who had arrested him (*Q.S.* VI, 69). He commended his wife to Lord Leigh as next tenant, but in fact Francis James succeeded him in the suitor lists.

Inventory appraised by Lawrence Nicholes, John Williamson, John Cooke, Thomas Croffts, John Abbatt, 15th May 1660.

The deceased's wearing apparell	3	0	0
Item in the Parlour, one bedstead & feather-bed and all that belongest to it	4	0	0
In the same roome, 3 coffers, one box, one table, tow joyne stooles, tow barrells	1	3	4
In the Buttery one cubbert, one dough trough, one forme		6	8
In the Chamber over the Parlour, two bedsteads, eight blankets, one hillinge, three bosters, three pillowes and three coffers	3	6	8
In the Chamber over the Hall, one table and forme, one cheese racke and half a hundred of cheeses and all other impliaments	2	0	0
In the same chamber, twelfe paire of sheets, nine pillowe beers, sixe table clothes, two dozen of napkins	8	5	0
In the same chamber eight yardes of new clothe, eightene pound of yearne and towe	1	0	0
In the Dayhouse, one loome, keaveres, five pailes, one churne, one cheese press and six benches and all other implements	1	6	8
In the Hall, one table and frame, and one joyne forme and one fallinge table and one woollen wheele and tow linnen wheeles, one chaire, two joyne stooles and other implements	1	0	0
In the same roome, six kettells, one pott and one brass pan, one wormeinge pan and one fryinge pan	2	0	0
In the same roome, eleaven platers, foure buttere dishes and foure sawecers, one candel sticke and one pewter can, one chamber pott, eight spoons	1	10	0
One yoke of oxen, foure cowes, three heifers, tow yeare-ould bulls, one yearlinge heifer, tow weaninge calves	33	0	0
Foretie sheepe	10	0	0
Three maires, one colte	10	0	0
One sow and piggs & one hogge	2	0	0
Corne and heaye in the Barne	3	10	0
Rye and oates growinge	13	0	0
One waggon, one cart, one cart (*sic*), one plowe, one harrow and all other implements belonging to husbandry	5	0	0
Sixteene loads of broome	1	4	0
Lath suted [*split*] and on suted and fire-wood	4	0	0
Three baggs, two pannills, one sadle		6	8
Three fliches of bacon & a halfe	1	10	0

One hundred of bords and tow rackes		10	0
One paire of cobberds, one spitt, one fire shoule, one paire of tounges, pott hangers and one paire bellowes		5	0
The beese and hempe in the garden	1	13	4
The soyle in the yard	1	10	0
In money and bands	9	0	0
Debts with out specialty	13	13	5
Total	139	0	9

Grove Cottage, Ashow (Figure 26)

This gives an excellent illustration of the social status for these houses of middling size. In origin it was a cottage[8] with only a half-acre croft and no common rights, but its tenants regularly rented closes in Bericote and Cross Grange containing 10-15 acres; these were consolidated with the holding when Ashow was enclosed in 1649.[9] Its tenant in 1603 was a husbandman, and the description in his inventory shows an old-fashioned pattern, with hall, chamber and just one upper room[10] accompanied by two service rooms; one of these, the Bower House, contained 'certain implements' and may well have been detached. It apparently then became the kitchen recorded in 1610-12, which was in reality a general working room, containing a cheese press and two spinning wheels, while cooking went on in the hall.

As Thomas Bryan (tenant 1612-50) was the village cooper, he needed a workshop, presumably converted from the kitchen; it contained the cooper's tools and part-made barrels. He was succeeded by John Coles, another cooper. After a short interlude (held by Rebecca Neale, widow, from 1694 to 1702), the next tenant was Thomas Stoaks (I), plowwright and carpenter. He probably rebuilt the house in its present form, with a lobby entry and two rooms on each floor; it is very similar to 1-2 Stareton, though lacking its attics. By his death in 1736, though surely not when built, the bedchamber was upstairs with kitchen and dairy on the ground floor; the workshop was probably detached.

The remarkable sequence of craftsmen did not end with this Thomas. He was succeeded by his son, another Thomas Stoakes who was also a carpenter, but much more than just a village craftsman. He had several apprentices, and carried out high quality carpentry at Stoneleigh Abbey in the 1760s, as assistant to Timothy Lightoller.[11] Presumably his wife Elizabeth farmed the Ashow holding when he was working elsewhere. By his death the house had acquired extra rooms (perhaps in a back range like that at 1-2 Stareton) (Table 6.3), for the back kitchen, service rooms and one of the chambers for his ten children. Thomas Stoakes himself seems to have slept in the Cheese Chamber, having moved the cheese ladder into the dairy.[12]

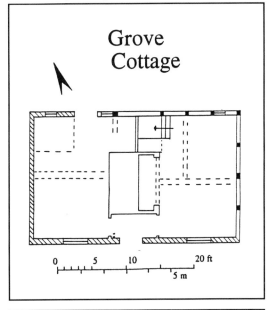

Much of the framing has been replaced in 18th-century brick (similar to that at Roseland), but the east gable and rear wall remain. As at 1-2, Stareton, two trusses define a chimney bay with back-to-back fireplaces and lobby entry; the eastern truss does not have wall posts. The house was probably rebuilt in the late 17th century, but it contains reused timber, including a cruck blade for the gable sill beam and a board decorated with strap-work used to support the joists.

26 Grove Cottage, Ashow, plan.

House Plans

These houses are simple enough for the comparison of inventories and standing buildings to identify characteristic plans. In the early 17th century, the five-room houses typically had one upper room. Bearing in mind the Stoneleigh habit of adding small service rooms to earlier houses, they may often have been early three-room plan buildings like 1-2 Coventry Road (p.33), 11-12 Coventry Road (p.67) and 8-9 Vicarage Road, Stoneleigh, each with one newer ground floor room. The six-room houses differ from these only in also having the hall floored, while seven-room houses perhaps had two added service rooms.

By the later 17th and early 18th century, it would seem obvious for houses with three-room plans to have been fully floored over, giving three ground-floor rooms and three chambers over. In reality, this development was very gradual. Of the twelve later 17th-century and five 18th-century inventories for six-room houses, at most eight show this plan.[13] Upper floors were still occasionally regarded as temporary. John Man's inventory (1673) valued 'two hundred and a halfe [feet] of bord over the house and the joyce' at £1, just as John Malin's (1640) had included 'a loose floor and overlayers [joists] over the parlour' (10s.).

Some of the later five- and six-roomed houses with two chambers may well have had basic two-room plans as at Bridge Cottage, Stoneleigh. As there, the service rooms might have extended the main range, but another possibility is that they were in a lean-to. This is hinted at in the 1650 description of the 'Glasshouse', Ashow (holding 53).[14]

> Small tenement or cottage consisting of five rooms, viz.
> One hall with one chimney,[15] floored with earth (length 13ft breadth 12ft)
> with a chamber over it of the same bignes
> One ground chamber floored with earth (length 13ft, breadth 10ft)
> with a chamber over it of the same bignes
> One little buttery
> One outroom, one heyhouse (length 15ft, breadth 11ft)
> One other barn (length 24ft, breadth 12ft).

We have direct evidence for lean-to rooms in the contract for a timber-framed house to be built at Cryfield in 1679.[16] It comprised two ground-floor main rooms with a chimney between them, 39ft. by 17ft. overall; the house had two chambers (and garrets over these), and a narrow lean-to, 8ft. wide along the rear. Although the building does not survive (and indeed it is not clear whether it was ever erected), the contract is sufficiently detailed for the house to be drawn out in detail (Figure 27). Such alternative interpretations need always to be kept in mind in attempts to recreate vanished houses.

Notes

1. Uniquely, 'sitting room' is given in the inventory of Matthew Brookes of Canley (1667), apparently instead of 'hall', for a room containing a trestle table, form, bench, chair and stool. Unfortunately only this room and the chamber are named in what was possibly a five-roomed house. The term is not recorded generally until after 1800 (*OED*).
2. The twelve chairs found in Ralph Reade's hall in 1610 are unparalleled.
3. I.e. tin-coated iron (tinware). This was being manufactured in south Wales from the later 17th century (C. Singer et al., *A History of Technology*, Oxford, 1957, III, 689). It must either have been imported or manufactured earlier, as probate inventories show it widely distributed in the Midlands from the 1660s. The tin dripping pan in **23** (1689) is a typical early example.
4. Painted cloths continued a little longer than in grander houses (until 1627).
5. This was rather fragile, and was more decorative than practical.
6. Thomas seems not to have been a very successful farmer. In 1720, he executed a deed of gift to John of all his possessions, no doubt to avoid what happened at his death—the seizure of his remaining goods by Lord Leigh's steward, for arrears of rent. This is recorded in a probate record dating from 1740, but the parish registers and the rental successions shows that Thomas died in 1724, the grant of probate being only obtained 16 years later, for reasons that are obscure (Lichfield Joint Record Office, Peculiar Jurisdiction probate records, 1740).

7. It was probably formed with the other Cryfield farms soon after 1678 when the then tenant, John Hartley died. In 1674, this part of the Grange was still a large field (SBT. DR18/1/937-9).
8. So described in 1610 (*Manor*).
9. The rent was unaltered between 1699 and 1766, and had only increased from £2 17s. to £3 19s. between 1613 and 1699.
10. The varied names given to this room show that High Chamber and Upper Chamber were equivalent names for a room on the upper floor.
11. A. Gomme, 'Stoneleigh after the Grand Tour', *Antiq. J.* 68 (1988), 265. Further information was kindly provided by Dr. Joan Lane.
12. His inventory (SBT.DR18/3/3/2) exists in two forms, one apparently recording the valuations (8 April 1771), the other (not in room order) the sale prices (11 April). His probate grant has not been found.
13. Making the most favourable assumptions, such plans can be identified in six inventories dating from 1660-1700 and two after 1700.
14. WRO.CR311/54 (1661 copy). By this date, the glasshouse itself was disused (p.182).
15. We know from an 18th-century repair account that the chimney was of wood: J. H. Drew, 'A glasshouse at Ashow', *Birmingham Archaeol. Soc. Trans*, 84 (1967-70), 186.
16. This was presumably one of the new houses on Cryfield Grange farm, already referred, though it cannot be located. N. W. Alcock, 'Warwickshire Timber-framed Houses: a Draft and a Contract', *Post-Medieval Archaeol.*, 9, 213-218 (1975).

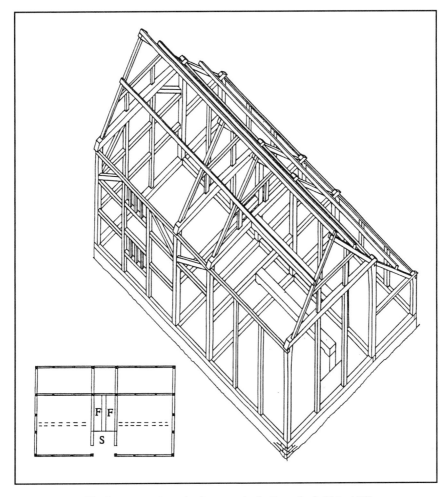

27 *Reconstruction of a house to be built at Cryfield in 1676.*

Table 6.1: *The Middling Sort: Five to seven rooms, 1601-1756·**

Inv	Date	Name	Status	Hld	Loc	Acr	£	Rooms (and Farm Buildings)
	1601-50: Five Rooms							
	1633	Robert Bagshaw			Ca		45	Upper Chamber, Next Roome, Parlour, Boultin House, Hall; Barn
23	1628	Robert Baker	Husbandman	8	St	29	50	Hall, Small Chamber next Hall, Great Chambe next Hall, Room over Hall, Kitchen; Rye Barr Hay Barn
	1606	David Benyon	Husbandman	84	Hu	12	30	Nether Chamber, Heie Chamber, Other Hei Chamber, Buttery, Hall; Barn (Gross total £43
	1612	Abraham Boyes		49	A	2	36	Hall, Lodging Chamber, High Chamber, Kitcher Buttery; Barn, Stable, Hey Barn (Gross total £50
	1640	George Chaulton	Day Labourer		Fi		10	Hall, Dross House, Milk House, Chamber, Uppe Chamber
	1628	Margaret Collett	Widow	47	A	4	28	Hall, Chamber, Upper Chamber, Butterye, Nether House; Barne (Gross total £34)
	1626	Henry Elliott	Fuller	34	A	20	-16	Hall, Parlor, Buttery, Kytchin, Upper Chamber Mill, Barne (Gross total £31, but debts exceed ing assets)
	1603	John Greene	Husbandman	49	A	2	23	Hall, Chamber, Buttery, High Chamber, A Bowe House
	1634	Basil Hall			Fl		74	Hall House, Parlor, Buttery, Chamber over Hall Chamber over Parlor; Barne (also house a Kenilworth)
	1615	Isabella Hunt	Widow	X2	Hu		37	Hall, Parlor, Dayhouse, Chamber over Parlour Chamber over Hall
10	1607	Thomas Owles		11	S	16	27	Hall, Bedchamber, Buttery, (in the Chimney) Chamber below Entry, Boulting House; Barne
30	1622	Thomas Powrse	Husbandman	44	A	10	9	Hall, Bed Chamber, Little Chamber, Uppe Chamber, Kitchin (Gross total £13)
	1610	Ralph Reade	Yeoman	49	A	2	44	Hall, Parler, Upper Chamber, Buttery, Kytchin
	1649	Edward Robins	Labourer	63	St	15	58	Nether Parlor, Upper Roome, Hall House, Chiting
	1641	John Trickett	Smith	94	I	0	17	Loer [sic] Chamber, Buttery, Upper Chamber Hall, Shopp
24	1612	John Wright	Fuller	41	A	25	81	Hall, Parlor, Buttery, Kyttchin, Upper Chambe
	1601-50 Six Rooms							
	1650	Thomas Bryans	[Cooper]	49	A	2	33	Lodging Chamber, Uper [sic] Chamber, Lyttell Buttery and Space, Halle House, Shope,
	1640	John Heminges	Woker (fuller)	66	St	25	63	Chamber, Upper Chamber, Other Chamber, Hall House, Buttery, Nether Roome; Barne
32	1610	Roger Hudson	Tanner	26	S	2	39	Hall, Little Chamber next the Yarde, Stree Chamber, Upper Chamber, Mylk House, House beneath the Entry; Barne, Tan House
	1610	Agnes Hunt	Widow	10	S	15	26	Hall, Bedchamber Below, Upper Chamber, Hall Chamber, Buttery, Kitchin; Barne
	1604	Thomas Hunt	Yeoman	10	S	15	34	Hall, Bed Chamber Below, Upper Chamber Chamber over Hall, Buttery, Kitchen; Barne
	1613	William Hunt	Yeoman	X2	Hu		44	Nether Chamber, Little Chamber, Hall, Chambe over Hall, Other Upper Chamber, Dayrye House
	1608	Joan James	Widow	62	St	17	41	Street Chamber, Next Roome, Upper Chamber Hall House, Milkhouse, In the Flore over the Hall (corn, bacon, etc.); Barne
	1609	Edward Malen	Husbandman	60	St	38	78	Hall, Boulting House, Bedchamber, Chambe over Bed Parlor, Chamber over Hall, Butterie Hovell, Hovel at the Barn's end, (Barn)
	1622	Margery Monckes	Widow	61	St	43	180	Parlor, Little Parlor, Hall, Chamber over Hall Store Chamber, Kychen; Two old Hovells
	1613	John Paine		82	Hu	4	21	Haule, Chamber, Other Chamber, Butterye, Uppe Chamber, Another Roome; Barne

Inv	Date	Name	Status	Hld	Loc	Acr	£ Rooms (and Farm Buildings)
1650	Francis Shrewsbury	Husbandman	38	A	48	127	Lodging Room and a Space by, Cheese Chamber, Upper Chamber, Hall, Kitchine
1640	John Westbury	Yeoman		H		80	[Parlour], Upper Chamber, Garrett, Chamber over Hall, [Hall], Dayry
1641	Mary Winsmore	Widow	12	S	22	97	Inner Chamber, Hall Chamber, Saller over the Chambers, Dayry House, Saller over the Hall, Hall

1601-50: Seven Rooms

Inv	Date	Name	Status	Hld	Loc	Acr	£ Rooms (and Farm Buildings)
1610	Robert Baker	Yeoman	3	S	59	115	Hall, Chamber over Hall, Butterie, Upper Chamber beyond Hall, Kitchen, Boulting House, [barns here] Servantes Chamber; Corne Barne, Hay Barne, Stable
1646	Thomas Burbery	Husbandman	4	S	66	67	Hall, Parlor, Kitchen, Chambers, Cheese Chamber, Dairy House
1624	Henry Clarke	Labourer	63	St	20	24	Hall, Lower Chamber, Buttery, Kychen, Chamber over Hall, Next Chamber, (farm stock here) Nether House (tools)
1639	John Greene	Carpenter		Ca		37	Upper Chamber, Next Chamber, Clea [Clay-coloured?] Chamber, Parlor, Bolting House, Hall, Kitchin; Barne
1616	Leonard Hemmings	Husbandman	66	St	25	44	Hall, Bedchamber, Chambers above, Nether House, Boulting House, Mylke House; Barne
1636	Richard Hewett	Fuller	27	St	1	56	Lodging Chamber, Streete Chamber, Further Sallar, Other Sallar, Hall, Buttery, Shoppe; Barne
1641	John Malin	Labourer/Husbandman	64	St	19	72	Parlour, Dayry House, (loose floor and overlayers over Parlour), Sallars, Little Parlour, Hall, Kitchen; Stable, Barne
1618	Hercules Spooner		74	Ca	59	141	Chamber, Cheese Chamber, Hall, Lower Chamber, Butterie, Mens Chamber, Kytchin
1620	Richard Winsmore	Baker	45	A	10	19	Hall, Bed Chamber, a Lodging Chamber, Upper Chamber, Buttery, Kitchin, Deahouse; Barne (Gross £23)

Inv	Date	Name	Status	Hld	Loc	Acr	£	Hth	Rooms and Farm Buildings

1660-1700: Five Rooms

Inv	Date	Name	Status	Hld	Loc	Acr	£	Hth	Rooms and Farm Buildings
	1689	Thomas Bagshaw		74	Ca	59	105	1	Parlor, Cheese Chamber, Room over Parlor, Kitchin, Buttery; Barn
	1691	George Baker	Carpenter		Hu		21		House, Parlor, Chamber, Buttery, a Backroom; Barn
	1696	William Clark	'Clothworker or Fuller'	43	A	12	0	1 *	Hall House, Chamber over Hall, Parlour, Chamber over Parlour, Buttery; Barn (Gross total £7)
	1673	John Cooke	Labourer	82	Hu	4	38	1	Hall, Parler, Buttry, Inner Chamber, Chamber over Hall; Barne
	1665	William Darnell	Husbandman	97	Fl	41	39	2/3	Bed Parlour, Kitchen, Best Parlour, Chamber over Kitchen, Chamber over Bed Parlour; Barne
1	1675	Thomas Elliott	Husbandman	11	S	16	36	2	Hall, Little Buttrey, Parler, Over Chamber, Chamber over Parler; Barne
	1691	Francis James		84	Hu	12	114	1	Parlor, House, Dayry, A Chamber, Cheese Chamber; Barn, Lofts (hay)
	1673	John Man	Carpenter		Fi		108	1	Parlar, Kitchin, Chamber over Parlour, Chamber over Kitchin, Milk-house, (bord over the house and the joyce); Barne, Laft over Stable
	1700	John Perkes		91	Hu	(129)	162	1 *	[Hall], Dayry, Parlor, Chamber, Thother Chamber
	1682	William Smith	Husbandman		Fi		23		(House erased) Hall, Parler, Dayhouse and Buttery, Chees Chamber; Barne (Gross total £74))

Inv	Date	Name	Status	Hld	Loc	Acr	£	Hth	Rooms and Farm Buildings
	1684	Mary Timms	Widow	38	A	46	107	1 *	Parlar, Hall, Daryhouse, Boolting House, Little Parlar
	1685	Daniel Tims	Husbandman	38	A	46	111	1 *	Parler, Hale, Little Parler, Dary House, Boolten, House; Barne
	1669	Thomas Tym		38	A	46	159	1	Hall, Parlour, Another Parlour, Dayry House, Boulting House; Barne
27	1700	John Unton	Husbandman	6	S	31	52	1 *	Parlour, Another Roome, Chamber, Hall, Another Little Roome

1660-1700: Six Rooms

Inv	Date	Name	Status	Hld	Loc	Acr	£	Hth	Rooms and Farm Buildings
	1684	Richard Barrs	Yeoman	106	Fl	(112)	117	2	Bedchamber, Chamber over Kitchen, Cheese Chamber, Millhouse, Kitchin, Little Room; Barne (Will, 1673, names Chamber over Parlour, Parlour, Chamber over Hall)
	1693	Richard Barrs	Yeoman	105	Fl	(74)	167		Kitching, Dareye House, Parlor, Little Parlor, One Chamber, Cheese Chamber, Garner, Barne
	1667	James Boland	Yeoman		Ca		94	3	Chamber over Kitchen, Chamber at Starehead, Cheese Chamber, Parlor, Buttery, Kitchen
	1690	Richard Cashmore	Cordwainer	72	Ca	97	229		Parlor, Hall, Chamber over Hall, Cheese Chamber, Buttery, Meale House; Barne
25	1689	Thomas Higinson	Yeoman	79	Cr		155		Parlor, Chamber over Parlor, Chees Chamber and another Chamber, Kitchen, Dayry House; Barne
	1676	Richard Hobley		39	A	60	231	2	Parlour, Middle Parlour, Hall, Kitchin, Cheese Chamber, Wool Chamber; Barne
	1693	Edward Lee	Yeoman	79	Cr	(348)	438		Parlor, Chamber over Parlor, Chamber over Hall, Hall, Buttry, Chees Chamber; Barne
	1667	William Lynes	Husbandman	19	S	0	28	2	Parlour, 'Adioyning to the sayd Parlour', Hall, Over Hall, Over Parlour, Kichen, Buttrey
	1693	Mary Malin	Widow	64	St	29	72	2	Parlar, Another Room, Back Kitchen and a Room by it, Cheese Chamber, Kitchen
	1699	Henry Phillips	Yeoman/ Husband	3	S	59	127	3	Parlor, Chamber over Parlor, Another Chamber, Another Little Room, Hall, Kitson
	1669	Richard Skudemore		34	A	36	112	3	Parlour, Hall, Chamber over Hall, Cheese Chamber, Another Room, Kitchin; Barne
35	1660	Thomas Smith	Yeoman	84	Hu	12	138	1E *	Parlour, Buttery, Chamber over Parlour, Chamber over Hall, Dayehouse, Hall, Barne
	1673	Mary Stringfield	Widow	50	A	14	311	4	Hall, Buttery, Kitchen, Chamber over Hall, Chamber over Kitchin, Study Chamber (Study occupied by son-in-law?)

1660-1700: Seven Rooms

Inv	Date	Name	Status	Hld	Loc	Acr	£	Hth	Rooms and Farm Buildings
	1661	Edward Burbery	Husbandman	4	S	66	59	3 *	Hall House, Parlour, Kitchen, Dayrie House, Chamber over Parlour, Chamber over Hall, Butterie; Barne
	1700	John Gibbs	Yeoman	34	A	36	280	2 *	Parlar, Little Parlar, Hall, Back Kitchen, Chamber over Kitchen, Cheese Chamber, Hall Chamber; Barne, Garnor
	1680	Edward Goddard	Husbandman	10	S	15	185	2	Parler, Hall, Kitchen, Milkehouse, Chamber over Parler, Chamber over Hall, Chamber over Kitchen; Barne

Inv	Date	Name	Status	Hld	Loc	Acr	£	Hth	Rooms and Farm Buildings
	1662	Roger Hudson	Shoemaker	14	S	3	16	1	Hall, Little Parler beyond Hall, Little Roome beyond Shop, Little Buttery, Chamber over Hall, Chamber over Parler, Shop; Barne
	1668	James Mayo	Fuller	7	S	29	162	3	Halle, Parler, Kichen, Dee House, Cheese Chamber, Chamber over Hall, Chamber over Kichen; Mill
	1670	Edward Stirton	Tailor	17	S	3	67	1	Hall or Kitchen, Parlour, Hall Chamber, Parlour Chamber, Butterie, Roome next to Shopp, Shopp; Barne

Inv	Date	Name	Status	Hld	Loc	Acr	£	Rooms (and Farm Buildings)
	1713	Samuel Adkins	Yeoman	80?	Cr	(197)	251	Chamber over Parlor, Chamber over Kitchen, Parlor, Kitchen, Brewhouse (*Suspected incomplete*)
	1729	Sarah Blason	Widow	20a	S	0	10	Parlour, Kitchen, Chamber over Parlour ('Parlour over Chamber' in text), Chamber over Kitchen, Buttery; Barn
34	1728	Edmund Casemore		73	I	87	277	Parlour, Kitchen, Chamber over Parlour, Chamber over Kitchen, Well House; Barn
	1717	Ann Crosse	Widow	X4	Fi		19	Parlour, Roomes over Kitchen, Kitchen, Buttery
31	1730	John Elliott		46	A	37	51	Kitchen, Parlour, Dairy, Chees Chamber, Other Chamber
	1713	Richard Grisold	Husbandman	15	S		57	Parlour, Hall, Buttery and Dairy, Chamber
	1723	Edward Hancox	Husbandman				106	Parlour, Chamber over Parlour, Chamber over Dwelling House, Buttery, Dwelling House
	1726	Hugh Heassall	Husbandman (*Yeoman erased*)	99	Fl	26	64	Kitchin, Parlor, Dary, Citchin Chamber, Chees Chamber; Barn
	1705	Richard Hiron	Husbandman	34	A	252	252	Parlor, Chamber over Kitchen, Another old Chamber, Hall, Kitchen; Barn
	1728	Francis James	Husbandman	84	Hu	41	108	Parlour, Dwelling House, Dairy, Chamber over Parlour, Chamber over House; Barn
	1712	John Jeffries	Miller	102	Fl		62	Parler, Kitching, Buttery, Chamber over Parlor, Chamber over Kitching; Mill
	1745	Joseph Middleton	Weaver	12	S	9	23	Kitchin, Shop, Pantry, Chamber over Shop, Chamber over Kitchin
	1726	John Russell	Husbandman	42	A	39	113	Hall, Parlour, Dairy, Chambers; Barn
	1753	Thomas Smith	Husbandman		St		117	Parlour, Best Parlour, Kitchen, Rooms above Stairs
	1728	William Spooner					276	Garret, Chamber over Kitchen, Chamber over Dareie, Dairie, Kitchen; Barn
	1736	Thomas Stoaks	Plowright /Carpenter	49	A	14	16	Shop, Kitchen, Chamber over Kitchen, Chese Chamber, Darey

1701-56: Six Rooms

Inv	Date	Name	Status	Hld	Loc	Acr	£	Rooms (and Farm Buildings)
26	1722	Joseph Badhams	Husbandman	89	Ca	36	159	Chamber over Parlour, Chamber over Kitchen, Chamber over Dary, Parlour, Kitchen, Dary; Barn, Stable, Hovell
	1719	Isaac Gumbley	Husbandman	72	I	97	160	Kitchen, Parlour, Chamber over Kitchen, Chamber over Parlour, Little Chamber, Dairy; Stable, Barn
	1709	William Hancox	Weaver				34	Shop, Parlor, Chamber, Upper Chamber, Dwelling House, Buttry

 **1701-56: Five Rooms** 

Inv	Date	Name	Status	Hld	Loc	Acr	£	Rooms (and Farm Buildings)
	1749	Rebecca Jaggard	Widow	15	S		125	Kitchen, Parlour, Dairy and Pantry, Chamber over Parlour, Chamber over House; Barn
	1727	Richard Tompson		80	Cr	197	31	Kitchen, Parlour, Nether Room, Brewhouse, Buttery, Chamber
33	1756	William Watton	Yeoman	26	S	2	32	Kitchin, Meal House, Parlour, Chamber over House, Chamber over Parlour, Pantry, Stable, Barn

1701-56: Seven Rooms

	Date	Name	Status	Hld	Loc	Acr	£	Rooms (and Farm Buildings)
	1720	Abraham Baker	Husbandman	103	Fl	111	260	Chamber over Parlour, Parlour, Kitchin, Chamber over Kitchin, Chamber over Buttery, Buttery, Cheese Chamber
	1710	Robert Bennett		103	Fl	111	242	Dwelling House, Parlour, Parlour Chamber, Chamber over Dwelling House and Dairy, Dairy, Single Bay, Chamber over Single Bay; Stables, Barn
	1722	John Hancox	Husbandman	16	S	12	176	Chamber over Hall, Chamber over Kitchen, Chamber over Parlour, Parlour, Buttrey, Hall, [Kitchen]; Barn. [Second seven-room House at Finham]: Chamber over Parlour, Chamber over Kitchen, Chamber over Brewhouse, Brewhouse, Parlour, Kitchen, Daryhouse; Barn
	1705	Thomas Middleton	Tanner (Husbandman)	59	St	80	78	Hall, Buttory, Other Buttory, Parlor, Chamber over Parlor, Chamber over House, Little Roome by it; Barn
	1731	Elizabeth Russell	Widow	42	A	39	157	Hall House, Parlour, Chamber over Hall, Next Room, Cheese Chamber, Dairy, Pantry; Barn
	1730	Thomas Whitmore	Husbandman	71	I	103	150	Dwelling House, Parlour, Dairy, Pantry, Chamber over Dwelling House, Chamber over Parlour, Chamber over old Stable; Barn

* For notes, see Table 4.1, p.53

Chapter 7

Homes of the Poor

In the early 16th century, the size of a person's house was no reflection of his wealth or standing but by 1600 their relationship was very clear. The two-, three- and four-room houses examined in this chapter were the homes of labourers, poor husbandmen and the poorest craftsmen, holding just their house croft perhaps with a few acres more (Table 7.1; p.144). There were exceptions. George Whitmore (1681) and Thomas Barrs (1700) held farms, of 103 and 110 acres respectively, which had only recently been created in Wainbody Wood and Fletchamstead Park. Their small houses contrast with the size of their farms and their wealth. Wainbody Farm retains three timber-framed bays in a linear plan with an added bay of stone; it has been much rebuilt in brick.

At this social level, the chance of a probate inventory being taken was relatively small. Thus only 20 of the 59 inventories are for holdings described by more than one inventory. It is also clear that the assessors might omit either the names of the rooms or details of their contents (as occasionally found for middling houses); of the notable group of 23 poor estates (less than £20; p.183) for the period 1701-25, only eight inventories give room names (though seven others are for non-householders).

These villagers lacked the resources to furnish their houses lavishly, and their lifestyles were demonstrably simpler than for the people already considered. This is reflected particularly in the use of the rooms. The principal rooms in all the houses were the living room and bedchamber, the latter almost always on the ground floor. Before 1650, the chambers were rarely considered worthy of the name 'parlour', though later in the century a shift of names took place as with middling houses. 'Kitchen' or 'house' superseded 'hall', and 'parlour' replaced 'chamber'; the eccentric John Whitehead (1703) had a parlour and a chamber, with the latter furnished as a kitchen. At the very end of the period a few inventories show all the bedchambers upstairs, a change which became general in the 19th century. This had one important consequence; it allowed two-bay houses to be divided into two cottages, perhaps with the addition of lean-to pantries.

The simple life led in the smallest of these houses is illustrated by the inventory of John Morice (1697) (**36**) (recreated in Chapter 12, Figure 50). He lived in one room, with just a lean-to for his bed-chamber, in a style reminiscent of 50 years earlier. His table board, apparently useless without any trestles, probably rested on the upturned pails. It is remarkable that he had a cheese press, though by February all his cheese had been eaten or sold (p.192). Presumably it would have shared the lean-to with his and Judith's bed.

36 *John Morice of Stoneleigh, day labourer (1697)*
He held a cottage standing on Westwood Heath, on a holding that was established in 1602 for a new watermill (SBT.DR18/1/1149). The mill remained in use until 1645 but is not mentioned later; the cottage disappeared from the estate rentals in 1730. John Morice was survived by his widow Judith, who was almost certainly the Judith Lockington, spinster that he succeeded as tenant in 1684 (though no record of their marriage has been found). Her parents were tenants from 1666 to 1679. The cottage had one hearth, generally exempted from tax.

Inventory appraised by Thomas Gibbs, Richard Thompson, Lawrance Hands, 10th February 1697 (deceased 4th February 1697).

His purse and wearing aperill	1	13	4
Debts spesial	15	0	0
Desperate debts	7	3	0
In the <u>Dwelling house</u> one old cubard and a table boarde, two chaires and a form, one tub and two pailes, four puter dishes and a flagon and a tancard and one palenger, three little cettles and a pot and some bacon	1	14	8
In the <u>leanto to the house</u> one bed and bedstead and two blankids, a little trunk and two boxes and three pare of sheets, one barell, a chesepress and a cofer and a drainer	1	17	9
One quarter of oates		10	0
One heafer and two calves	3	3	4
Thirtene sheep	1	6	8
One pig and two gese		6	8
Fodder		6	8
Lumber and trash and things forgot		3	4
Total	33	5	5
Money that he oweth	5	7	0

Most houses with a third room included a second chamber upstairs (12), sometimes an upstairs 'room' (2) or a 'loft' (1). Only three houses had an extra service room (one milkhouse, one buttery and one kitchen). A few four-roomed houses simply combined three chambers with their hall, but predominantly they had two chambers, usually with only one upstairs. Benjamin Burnabye (1626) was exceptional in having two rooms on each floor, with chambers over both hall and buttery. As here, the service room was almost always a buttery, but it usually doubled as a dairy and sometimes a bolting house or salting house. Cheese-making was clearly less important than for wealthier tenants and only one cheese room is named (1730), though a few people left moderate amounts of cheese. Some of the subsidiary chambers found wider uses. William Brookes' 'inner chamber' contained pots, kettles and pewter—the contents of a buttery (1635). Thomas Garnett nominally had four rooms counting his wheelwright's shop, but he effectively occupied two: a parlour and a crowded little room that served him as a hall, while his 'backroom' was a store for the workshop (1678).

One notable feature of the 17th-century houses is the number of times the boards for an upper floor were named (like the two examples in the last chapter). Even more than in larger houses, the insertion of a floor was clearly seen as a valuable improvement. Thomas Lewis' inventory (1609) makes an interesting distinction between the old boards over the chamber and the poles over the bolting house on which perhaps he kept tools or the old bags and the winnowing sheet named next. The mention of 'plankes under feete' in the inventory of William Kelsoe (1603) shows that comfort at ground level was not neglected, even if it is rarely recorded.

Furnishings

In the early 17th century these small houses much resembled those of half a century earlier, and one hall was very much like its fellows. A table, its form and a bench, a chair or two, and a cupboard made up its complete furniture and a few cushions were the only concessions to comfort. Painted cloths hung in almost every hall and chamber at the beginning of the century but were out of fashion by the 1620s (last mentioned in 1624). As none of these houses had a separate kitchen, the hall also contained the fireplace fittings, the pothooks, spits and cobirons. The kitchenware and dishes were also generally in the hall, and might be of surprisingly good quality. Alice Clark, the poorest of this group, had three pewter dishes and a brass (latten)

candlestick, while others owned a dozen pieces of pewter. If the house had a buttery, this served as a dairy as well as holding barrels (e.g. Ralph Kent, two barrels, powdering tub, churn, two looms; Thomas Smyth, two cheese shelves and 40 little cheeses).

Some mattresses seem to have lain directly on the floor,[1] though most houses had at least one bedstead and William Dunton was not alone in having both a joined and a standing bedstead. Apart from the beds and painted cloths, the chambers normally only held coffers, as many as six in the most prosperous of these households. The subsidiary upper chambers also collected a miscellany of oddments including yarn, wool, corn, butter and cheese.

The life that went on in these houses is well illustrated by the inventory of Robert Stocken (**40**), and by that of Thomas Burton (1610) (**37**). The latter's bedchamber is notable for including the pewter and brass as well as the churn and some cloth. His upper chamber held a spinning wheel and a cheese rack, though the April date explains why there was no cheese on it.

37 *Thomas Burton of Canley (1610)*

He occupied a 23-acre farm in Canley, and also owned a small freeholding there. His main holding was a moated site called More Hall (the later Moat Farm, cf. **26**) which had no house when he took over in 1585 though one had been built by 1597. His widow Elizabeth remained as tenant until c. 1620, but no other relatives are recorded. He was a juror almost every year, and tithing man or surveyor of the highways on several occasions. However, he also kept 26 sheep belonging to a stranger on the common (1593), and had a subtenant in his house (1596).

Inventory appraised by Edward Marburie, gentleman, Edward Symcox and Hercules Spooner, 23th April 1610.

All his apparell both wollen and lynnen		13	4
In the Hall a longe table with frame, a bench and a forme		10	0
An old cubbard, a twiggen cheare and an other cheare, three payles, a cover [*kiver?*]with all the dishes and spoones and other implementes in the hall		8	0
One brasse pott, one kettell, three skilletes, two spites, potte hookes, hangers, cobyrons		10	0
In the Bed chamber one joyned bedsteed and an other old bedsteed		6	8
One fetherbed, two boulsters, one pillow, three blanketes, two coverletes, curtaynes and vallans	2	0	0
Five coffers and one wych		10	0
Six pere of sheetes, three table clothes, three napkins, two pillowbeers and a drinking cloth, three handtowles	2	0	0
Five yards of course wollen cloth, a basket, two little barrells, one cherne and certayne other old implementes		13	4
Two candlestickes, a pewter salt, two pewter dishes, three porringer dishes, three sawcers, one frying pann, a brasse ladle		13	4
In the Upper Chamber one old bedsteed with an old fetherbed, an old bolster, two winnow sheetes an old blankett, a pannell and wollen wheele, a cheese cratch, a pere of harrowing traces, with the broken bords and other implementes in that roome	1	0	0
One oxe harrowe and a smale harrowe, one trough, a plough and all the woode about the ground		15	0
In the barne three pick forkes, two rackes, one great baring bill, two little bills, a mattock		2	0
All the muck in the close		5	0
3 Yearlinges and 3 two yeare olde heifores	5	0	0
Six kine	12	0	0
Fiftie eight sheepe	12	0	0
3 Quarters and six stricke of oates	2	0	0
3 Henns		1	6
Total	40	18	2

The later 17th century saw little change in these houses though the bedchambers might be better furnished (e.g. a table and a form for John Wall, 1661). This half century also saw the beginnings of earthenware as an alternative to pewter and wood. The inventory of Joane Barber (1677) (**38**) shows the modest comfort in which a long-standing widow organised her life at this time, making cheese and cream from her milk and otherwise principally engaged in spinning. Her contemporary, Ellen Driver of Hill, pursued rather different interests. Her inventory (1687) contains the entry: 'Trees, grafts, seats, stocks and hearbs and whatsoever grows in the garden 12s.'. Although unique in Stoneleigh, such items have occasionally been noted elsewhere in the inventories of professional gardeners (which Ellen must surely have been).[2]

38 *Joane Barber of Stareton, widow (1677)*
Her husband Howel Barber became tenant of a small farm (11 acres) in Stareton in 1640 (SBT.DR18/30/23/4). One child, Abraham, was born in 1648 (*Reg.*), and a daughter, Sarah, married John Watts in 1675. Joan was widowed between 1652 and 1655 (*Manor*). Her only references in the court records relate to scouring ditches and making mounds (1655, 1670), and surprisingly she received no bequests from other villagers. John Watts administered her estate and succceeded to her tenancy; he was followed by his son Isaac.

Inventory appraised by Thomas Casemore, yeoman, Humphrey Hooe, tanner, and Joseph Emmins [Hemmings], husbandman, all of Stareton, 24th May 1677.

Her purse and weareing apparrell	13	4
In the <u>Parlour</u>		
One joynd bedsteed and boarded bedsteed, one hillen, one coverlett, two pare of blanketts, three paire of sheetes, two flock bedds, one sett of curtaines	1 0	0
One joynd table and forme, one coffer, two boxes and other lumber	10	0
In the <u>Chamber over the Parlour</u>		
One boarded bedsteed, one table and other lumber	3	0
In the <u>Kitchine</u>		
One fallinge table, three chaires, two stooles, one cubbert, three pewter platters, three brasse kettles, one brasse potte, one cheese press and other lumber	1 0	0
In the <u>Butterie</u>		
Two barrells, one churne, two earthen panns, one earthen creame pott, three cheese fatts, one wheele to spinne wooll, one wheele to spinn flax and other lumber	7	0
Cattle		
Two calves and one heifer	4 6	8
Total	8 0	0

By the early 18th century, the basic furnishings of these houses had changed only a little. A couple of parlours contained chests of drawers, replacing some of the coffers and chests. Two houses had a kitchen as well as a 'dwelling house'. Catherine Jeacock's inventory (1710) is particularly informative for one of these, as it closely parallels her husband's (1705). He had a buttery, holding barrels, tubs and pails. Catherine had moved these into the dwelling house and her kitchen held a table and furnace (p.63). Thus the cooking and small-scale brewing was done in the main room (with 'four little brewing vessels') while the kitchen was used as a bakehouse.

The inventory of John Curtis (1723) (**39**) illustrates that fashions from higher up the social scale were penetrating to this level. He had chairs in his kitchen rather than a bench, and his parlour was a comfortable sitting room, though it still held a bed. The most significant change was in the upstairs chamber, which had a firegrate. As a heated upper room, it is unique in this group. The use of a grate in the kitchen was more general, first appearing in 1710 in these smallest houses.

39 *John Curtis of Western Heath, husbandman (or yeoman) (1723)*
He was tenant of a 45-acre freeholding lying on the north side of Westwood Heath (bought by Leigh in 1832) (CRO.Acc.96/box1; SBT.DR18/10/25). His daughter Ester was left £40 when 21, while his widow Mary received the (non-existent) residue of his property. She succeeded him as tenant.

Inventory appraised by John Pirks, Edmund Casemore, 2nd November 1723.

Wearing apparrell and mony in his purse	2	0	0
One old horse and 2 mares	5	0	0
4 Cowes and 2 yearling heiffers and 2 calves	7	0	0
One little stack of corne	5	10	0
One waggon and one tumbrill	3	0	0
One plow and 3 harrows	1	5	0
One cartsaddle, 3 collars and hames, 4 pair of traces, 4 bridles, one hackney saddle & bridle	1	2	0
One sow and nine piggs	1	12	6
In the Parlor one bedstead with the furniture to the bed		10	0
2 Chests, 4 chaires, 2 little tables, 2 little stooles	1	3	6
In the Chamber over the Kitchen			
One bedstead with its furniture belonging to the bed	1	10	0
One coffer and 3 boxes, 1 chaire, one firegrate, one truckle bedstead with the furniture belonging to it		14	6
3 Coffers, 2 trunks, five boxes, 3 chairs	1	2	6
Six paire of sheetes		15	0
In the Kitchen seaven pewter dishes, 1/2 dozen of plates		18	6
2 Tables, one screene, 5 chaires, 4 stooles, one warming pan	1	0	0
One cauldron, 2 brass potts, one gunn, fire shovell and one pair of tongs, 2 candlesticks, one cullinder, one pair of pott lincks	1	5	0
3 Barrills, 4 tubbs with all other lumber		15	6
Total	36	4	0

Surviving Small Houses

A remarkable number of small houses survive in Stoneleigh, well outnumbering their larger counterparts, though few can be related to inventories. Two exceptions do give us a chance to visualise the structures behind the documents. 9 Birmingham Road, Stoneleigh is an excellent example of a two-bay house though its external wall-framing is fragmentary. In addition, its construction can be closely dated from the estate rentals. The earliest entry is in 1569, a rent of 2s. for 'the tithe barn', and in 1570 it appears as 'a cottage that was the tithe barn'; this date is entirely consistent with the structure.

9 Birmingham Road, Stoneleigh (Figures 1 & 28)
The inventory of Robert Stocken, labourer (1630) (**40**) relates to this house. It shows that the room over the parlour was in full use, but the listing of loose boards over the hall suggests that the floor there had only recently been inserted. The house has just the simplicity to be expected at this social level.

40 *Robert Stocken, labourer (1630)*
He was the son of a Stoneleigh husbandman, and became tenant of a cottage with ½ acre croft in 1596. His father left him the crop from one acre of corn, 'one land [strip] of which acre I gave him for helping me to sow' (1602). Robert was only a juror once, no doubt because of his modest status, but he was frequently presented at the manor court, for a variety of offences including exceeding his common stint, picking acorns in the wood, and encroaching on other tenants' land. He left three daughters and a son (with children). The bulk of his belongings went to his wife, though daughter An received some household goods (*Stoneleigh Villagers*, p.24).

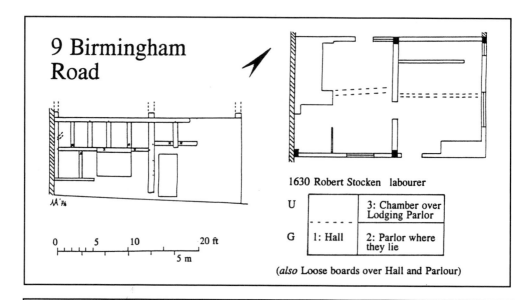

The following is transcribed from the figure:

9 Birmingham Road

0 5 10 20 ft
5 m

1630 Robert Stocken labourer

| U | | 3: Chamber over Lodging Parlor |
| G | 1: Hall | 2: Parlor where they lie |

(*also* Loose boards over Hall and Parlour)

Although small, Birmingham Road house is well-constructed, with jowled posts. heavy tiebeams, curved windbraces and tenoned purlins; no main braces survive, but pegholes suggest that they were large and curved (type II). The north gable has curved queen-struts. The hall ceiling beam is roughly chamfered (draw stops); the other beam is unchamfered. Some original framing elements on the side elevation survive (Figure 1), suggesting a simple pattern of widely-spaced studs.

28 *9 Birmingham Road, Stoneleigh, plan, elevation (added timbers marked X) and inventory interpretation.*

Inventory appraised by Henry Bellingham, David Draper, Thomas Hunt, Thomas Hall, 20th May 1630.

In the Hall one table, a forme, a bench, a wicker chear, a cubbard	13	4
Three bigger kettells, two lesser kettles, a dapnet, a brasse pott, a chafing dish	15	0
Halfe a dozen of cushens	1	6
Four pewter dishes, a salt, 3 woodden candlestickes, two sawcers, a skimmer, a earthen dripping pan, pansions, steanes, dishes, spoones, a reaping hook, paynted clothes, a shilf, with all other ymplementes in that roome	5	0
In the Parlor wher they lye two old bedsteedes, two flockbeddes, 3 boulsters, 2 pillowes, two coverletes, two twillies, 3 blancketes, foure pere and one sheet, a coffer, one pillowber, four table napkins, two table clothes, two hand towells	1 6	8
Two old presses, an old cherene, an old tub and a dough tubb, three seeves, the paynted cloths about the beddes and in that roome and all other ymplementes in that roome	3	8
All his waring apparrell, lynnen and woollen	1 0	0
In the Chamber over the Lodging Parlor one old bedsted, an old cubbard, an old bedsted, a flockbed, a pere of sheetes a pere of blanketes, a paire of twillyes, two hillinges, two boulsters, a table, a cheer, a forme, a coule, with all other ymplementes in that roome	1 10	0
All the corne in the house and barne	1 10	0
All the loose bordes over the hall and parlor	10	0
the wood in the yard and in the leanto	1 0	0
The curb of the well with bucket, chaines and ropp to the well	3	4
Two ladders with the heay in the barne	10	0
All the straw, muck, fures [*furze*] about the yard	6	8
An ax, a bill, a moulstaff, three forkes, a peale, tow rakes with other such ymplementes	2	6
Total 9	17	4

The Elms, Broad Lane

A similar house, The Elms, Broad Lane (in Fletchamstead), that dates from the earlier 17th century, has one original upper floor. The rather brief inventory of Joanna Sly (1717) (**41**) shows that the hall ('dwelling house') was still open. At this time the house also had a buttery which may well have been on the site of the 19th-century kitchen.

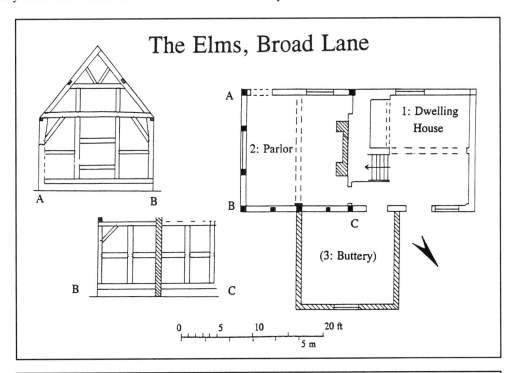

The Elms has two bays of type III framing with a rear wing of 19th-century brickwork. The roof includes short straight windbraces, and the purlins are trenched into the principal rafters. The parlour ceiling beam has rough chamfers and scroll stops. It appears to be original as it is held on a projecting post integrated with the framing. The other beam has draw stops and is carried on an applied post. The original entry was possibly in the position of the present door. This house was part of a freeholding until 1764. The deeds [SBT.DR18/10/60] cover two properties; this one (deeds from 1560) was originally a 'grove' adjoining Broad Lane. By 1691, it had become a messuage with two closes, in the tenure of Thomas Slye.

29 *The Elms, Broad Lane, Stoneleigh plans and elevations.*

41 *Joanna Sly, widow (1717)*

Members of the Sly family had lived in Fletchamstead since the 1640s, though the family connections are unclear. She succeeded her husband Thomas (a pauper, *Reg.*) in 1710. She left no will but her estate was administered by Stephen Sly, labourer, presumably her son.

Inventory appraised by Joseph Lant, John Bars, 12th March 1716[/7].

Wareing apparelll	18	0
In the <u>Dwelling House</u> one small grate, fire shovle and toungs, one table, too chears, one old cobord, one joine stoole, one forme and brass and peuter and other od things belonging to that roome	1 12	6
In the <u>Parlor</u>, one bed and beadsted and blankets and other furniture belonging to it, and one chest and one cheare	1 2	6

In the <u>Buttery</u> too barells, one small tub, one civer, one paile, one churne and other od things in that roome		8	0
In the <u>Chamber</u> too bedsteads and beds and bolsters and pillows and blankets and sheets and some other linen, one cofer and other od things	1	5	0
Too cows and caulfes	7	10	0
Hay in the barne	1	10	0
A few coales and lumber and trash forgotten		3	0
	Total 14	9	0

3-5 Ashow (Figure 30)

Much of the house recorded in the inventories of John Collet, labourer (1622) and Margaret his wife (1628), and of Thomas Smith, labourer (1698) also survived until recently, though it had undergone alteration and enlargement. In 1622, it had four rooms all apparently on one floor: hall and three chambers. Six years later, Margaret's inventory records five rooms, with an upstairs chamber, a buttery and 'nether room' instead of two of her husband's chambers. In 1698, Thomas Smith's hall, parlour, buttery and chamber may have been on one floor, but an upstairs chamber seems more likely. The major change in the history of this house came in 1737 when it was converted to three cottages. The physical structure reveals a complex development with three stages, each providing two bays.

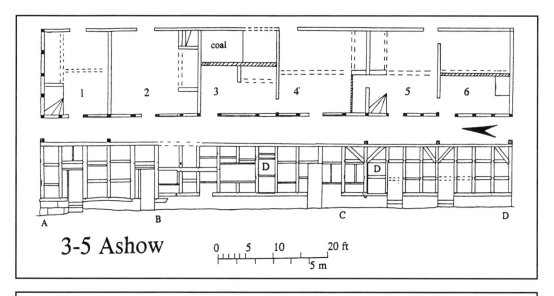

The long range of 3-5 Ashow, at one time four cottages, has had a complex development, shown most clearly on the front elevation, though the divisions in the framing do not correspond to the rooms of the building. Of its 23 framing panels, the first five (from the left, A-B) appear to be of one build, part of two bays truncated at the right end, framed with three panels in each section. The next nine sections (B to C) have a high sill with two-panel framing, and an original doorway. The final part (C to D) is of uniform three-panel framing with diagonal braces, and another original door (blocked by the later stair). Internally, rooms 1, 5 and 6 have scroll-stopped beams, and rooms 4 and 5 have chamfered fireplace lintels. The north gable has the standard A-frame structure with queen posts below and V-struts above the collar. The building can be interpreted as involving successive additions to a two-bay unit. The first two stages were perhaps completed by 1700 and the final two rooms must have been added by 1737, to give each of the three cottages a two-room plan.

30 *3-5 Ashow, plan (partly sketched) and elevation (D = probable original door positions).*

Cottages without Inventories

The conversion of 2-3 Ashow is one of several responses to increasing population between the later 17th and middle 18th centuries by which additional cottages were created in the parish. These responses took rather different forms in the villages and on isolated sites. Several village houses were rebuilt as one or more cottages. In about 1730 two moderate-size holdings, one in Stoneleigh and one in Ashow, were split up;[3] their lands were assigned to other tenants and the houses rebuilt as identical pairs of semi-detached cottages. No accounts survive for this, but the uniformity of the structures shows that the work must have been undertaken by the estate. The accommodation was relatively spacious with two good-sized rooms on each floor.

4-5 The Bank and 15-16, Ashow

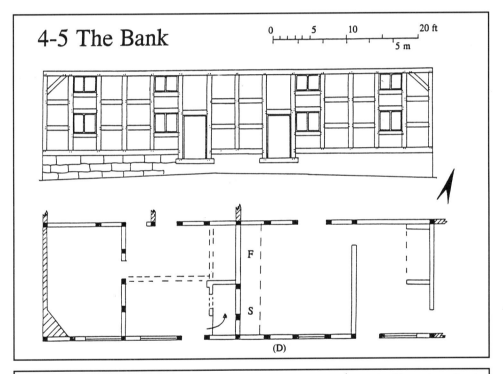

4-5 The Bank: This range was built as a pair of semi-detached cottages, each with one heated and one unheated room; no. 4 (right) has been re-planned, probably when a brick extension was added at its east end. The roof includes thin straight windbraces. The framing is distinctive, with each section carefully organised according to its function, with rails for ground- and first-floor windows, and the studs extended downwards past the 2 ft high sillbeam for the doorframe.

15-16, Ashow (mostly demolished): This was almost identical to 4-5, The Bank; its central chimneys were built up against an ashlar stone dividing wall.

31a *4-5 The Bank, Stoneleigh, plan (existing) and elevation (reconstructed)*

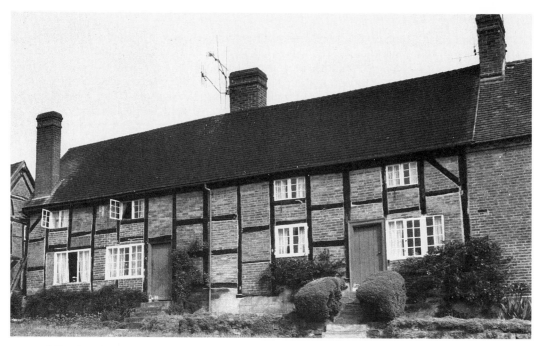

31b *4-5 The Bank, Stoneleigh. A pair of semi-detached cottages built between 1727 and 1732.*

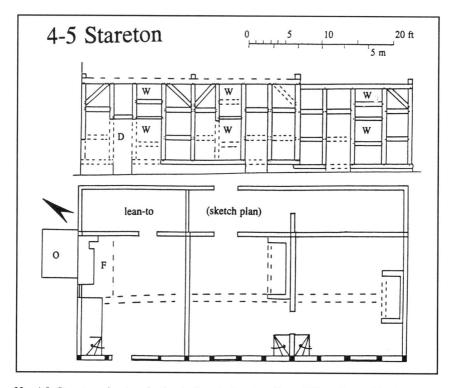

32 *4-5, Stareton, plan (partly sketched) and elevation (D and W as Figure 24; O=oven).*

4-5 Stareton is very similar in plan to half of 4-5 The Bank, including the entry adjacent to the fireplace/stair, but both rooms were heated. The original structure was extended with a very similar but slightly lower bay. The framing is similarly designed, though with four panels rather than three in each bay. The ceiling beam in the north room has a step stop (16th century) and must be re-used. The bake-oven is built of sandstone blocks and carries numerous graffiti, including WS 1767, RB 1774. Both stages probably date from the first part of the 18th century, later than 1710 from the lack of correlation with the inventory of William Middleton. A rear lean-to range in brick was probably added in the 19th century when the house was converted into cottages. A fragmentary timber-framed barn now part of Park Farm belonged to this holding.

An enigmatic house, 4-5 Stareton (Figure 32) is very similar to these semi-detached blocks in its structure, though it was built as a single house with both ground-floor rooms heated. Although it provides no more accommodation than one of these cottages, it relates to an 80-acre farm (holding 59) for which it seems hardly adequate. A series of inventories list 4, 8, 9, 7 and 4 rooms, but the house clearly post-dates the last of these which perhaps described an old and nearly derelict building.

Another development involved the reconstruction of large houses on a scale more appropriate for cottages. Several small Stoneleigh holdings were occupied by craftsmen whose inventories describe disproportionately large houses. A notable example is 10 Vicarage Road, Stoneleigh (Figures 33a and b) held in the 17th century by two fullers, Richard Hewett, father and son, with respectively eight (1608) and seven (1636) rooms listed. The house we see now is much smaller but complete, a two-bay late 17th-century timber-framed building. Clearly the Hewetts' house had been rebuilt. An intriguing feature of the present house is its use of a cruck blade as one tie-beam, giving a hint of the earlier house's structure.

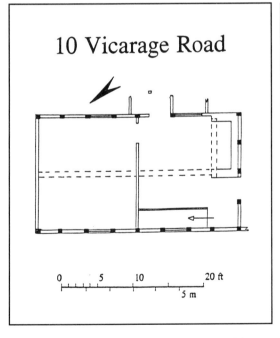

10 Vicarage Road, a two-bay cottage, has very simple two-panel framing, over a high sill. The entry was certainly in the gable, as the side wall frame is uninterrupted (and the studs carry a continuous series of assembly marks). The tiebeam of the central truss is a re-used cruck blade. The ceiling beam in the heated room has a step stop, and is probably re-used, the other being very roughly finished. The spindly framing and high sill suggest a date in the late 17th or early 18th century.

33a *10 Vicarage Road, plan*

By 1800, many of the cottages had been subdivided, moving towards the pattern of one-up and one-down dwellings characteristic of the 19th century. On the 1813 map of Stoneleigh village, only eleven of the 33 cottages were occupied by single families. All the others either had more than one named tenants, or had a tenant and an 'inmate'.

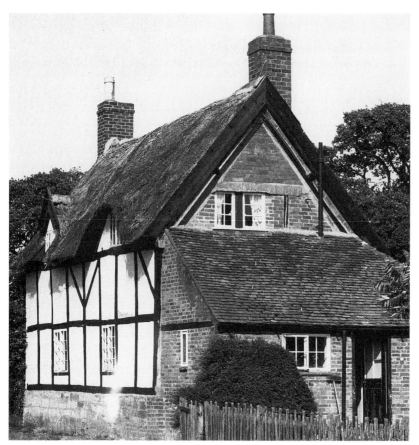

Reduction of village farms to cottages took place both in the 18th century and later. In 1750, a 60-acre farm in Stoneleigh was converted into five cottages (occupied by seven tenants in 1813); this house was demolished in the 19th century but the Leigh estate's conservatism led to the retention of many timber-framed buildings. 5 Coventry Road, Stoneleigh had been a farm, with inventories listing 8-10 rooms. It had 104 acres in 1766, but lost this land during 19th-century consolidation. Demolition of part of the house took place after 1813 but before the 6in. Ordnance Survey mapping in 1887, and it now consists of a two-bay timber-framed block embedded in later brick ranges. The structure is apparently 17th-century (using straight braces), but it has clasped purlins, hinting at an earlier origin.

In its present form, 5 Coventry Road is remarkably similar to 9 Birmingham Road, Stoneleigh (Figure 28). The detailed documentary evidence shows how different are their histories and illustrates the pitfalls of interpretations based only on structures, where similarities are taken to imply similar development rather than convergence, in this case from a two-room labourer's cottage and a ten-room farmhouse.

Several well-preserved 17th-18th century cottages also survive, that are documented only by the rentals and maps (Figures 34-7). Their character is fairly uniform, almost always of two bays with square-panel framing; one (Chestnut Cottage) includes a very small third bay. Most can only be assigned building dates from their structures, though one of the smallest, Avon Cottage, Ashow, appears in the rentals in 1721 probably its building date. It was occupied by John Tims (a labourer, *Reg.* 1726).

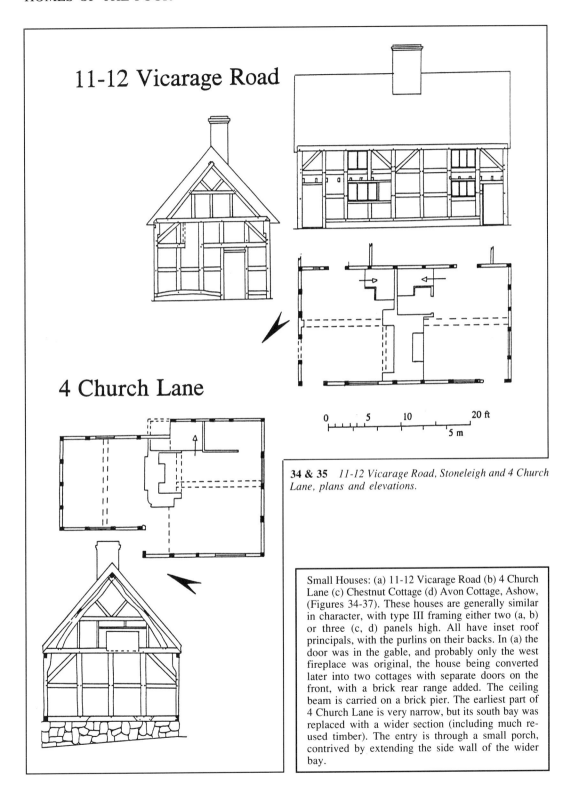

34 & 35 *11-12 Vicarage Road, Stoneleigh and 4 Church Lane, plans and elevations.*

Small Houses: (a) 11-12 Vicarage Road (b) 4 Church Lane (c) Chestnut Cottage (d) Avon Cottage, Ashow, (Figures 34-37). These houses are generally similar in character, with type III framing either two (a, b) or three (c, d) panels high. All have inset roof principals, with the purlins on their backs. In (a) the door was in the gable, and probably only the west fireplace was original, the house being converted later into two cottages with separate doors on the front, with a brick rear range added. The ceiling beam is carried on a brick pier. The earliest part of 4 Church Lane is very narrow, but its south bay was replaced with a wider section (including much re-used timber). The entry is through a small porch, contrived by extending the side wall of the wider bay.

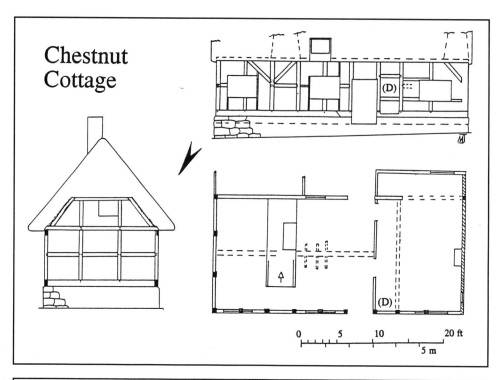

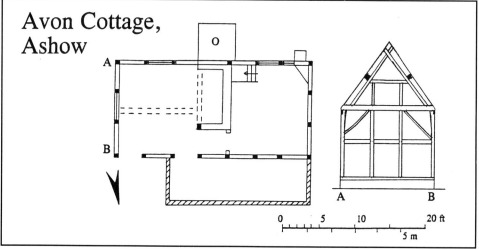

Chestnut Cottage is the only three-room house in this group of cottages, though its third room is extremely narrow. It had a cross-passage, later thrown into the adjoining room (perhaps when the rear lean-to was added); this end was apparently single-storey. Avon Cottage, Ashow is the smallest of the village cottages, with each bay only 12 ft by 11 ft internally. The fireplace lintel is carried on a post, suggesting a possible timber firehood. However, the ashlar stone oven (like that at 4-5, Stareton) is probably original. A brick lean-to was added later.

36 & 37a *Chestnut Cottage, Stoneleigh and Avon Cottage, Ashow, plans and elevations (O = oven).*

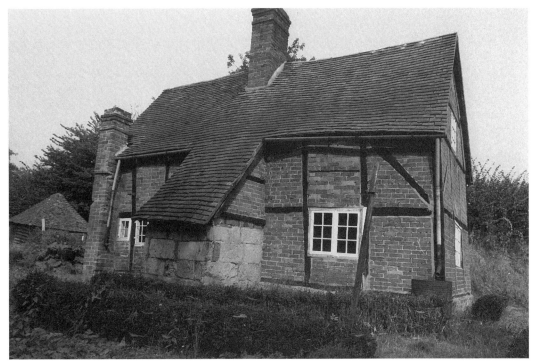

37b *Avon Cottage, Ashow*

We cannot directly name the rooms in these houses, but comparison with the inventories suggests that they would have contained a kitchen or 'house', a parlour and one or two upper chambers. The little extra room in Chestnut Cottage was perhaps a buttery.

Scattered Cottages

The subdivision of village houses in the 1730s was not the first response to population pressure in the parish. In the late 16th century several barn conversions are recorded, including Croome Cottage and 9 Birmingham Road, Stoneleigh (pp.44,125). A prophetic reference in 1564 (*Manor*) is to the collection of 2s. rent 'of a pore woman dwelynge under Flechamstede hedge in the farther syde of Westwode'. It is hard to imagine just how simple her house might have been.[4]

More important developments began in about 1650. Between then and 1730, the housing stock increased by almost a half through the building of cottages on waste land, particularly on Westwood Heath, and the verges of the wide lanes at the north end of Stoneleigh parish (Figure 23). These cottages seem to have been erected by their occupiers, though the estate did not object and on occasion laid out plots for this purpose. The estate also collected annual rents of a shilling or two from the occupants, as an acknowledgment of its ownership, and in 1666 required seven cottagers to make specific declarations to this effect.[5] They still found it necessary in 1801 to print a severely worded handbill, warning against purported sales of these cottages (Figure 39).

Rents for the cottage were administered separately from the main estate rentals, though they were included in the 1766 survey. Before the first list of 'cottage rents' in 1729 we can therefore only follow their growth in outline. The first reference comes in about 1650, when one Thomas Crosse was presented for building a house on the lord's waste (*Manor* 59, 112). By 1666, seven cottages had been built on Crackley and Westwood Heaths. 1669 probably saw the first cottage at Burnt Post, as George Miller of Fletchamstead, labourer, was indicted at Quarter Sessions for

erecting a cottage without four acres.[6] At almost the same time, Lord Leigh's bailiff set out sites for several cottages on Hearsall Common.[7]

A list of about 1717 entitled 'cottiers' includes 32 names, many of which recur in the later rentals,[8] and by 1729 the number had grown to 55. By 1766, 88 cottagers are recorded, rising slightly to 92 by 1807. From that year a remarkable document survives—a survey of all these cottages itemising their materials and plans.[9] Apart from its significance as a comprehensive description of the housing standards of the lowest strata of society, this survey is particularly important because the buildings surveyed have disappeared, with only a single exception. A number were swept away in 1816 when Westwood Heath and other commons were enclosed. The estate steward noted in this survey, 'The cottages in general are miserable buildings'; they were scarcely worth keeping up as they would require roads 'in so many directions'. Others have been lost through the spread of Coventry over the northern end of Stoneleigh parish, where they were concentrated. Some brick cottages do still stand around Westwood Heath on old sites, but all seem to post-date 1807.

The 1807 survey descriptions (Table 7.2) are rather uniform, reading, for example, 'a cottage of one room and two small chambers, part brick, part studwork and thatched with a pretty good garden', or 'a brick and tiled cottage of two rooms, two chambers, with a hovel, sty, garden and two plecks'. The first of these was a semi-detached cottage, as were many others, certainly as a result of subdivision in response to the demand for housing. All the cottages had 'rooms'

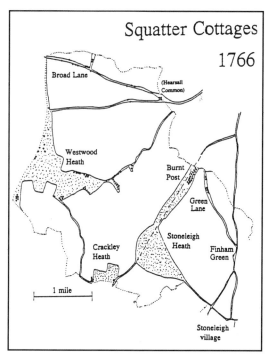

38 (above) *Squatter cottages in Stoneleigh. Each dot marks the position of a cottage on the waste, as recorded on the 1766 map.*

39 (right) *Cottage sale handbill, 1801. [SBT.DR18/3/ 47/48/4]*

A Caution.

WHEREAS several

COTTAGERS, residing within the MANOR of

STONLEIGH,

have heretofore offered their

Cottages for SALE:

To prevent any Person or Persons from being deceived by Purchasing in future, the Public are informed, that the above Description of Persons have no RIGHT or TITLE whatever, to

DISPOSE thereof.

Stonleigh-Abbey,
Jan. 30th, 1801.

ROLLASON, PRINTER, COVENTRY.

at ground level and 'chambers' on the upper floor. The majority were of brick, most commonly with a 'room', a chamber and a pantry (probably in a lean-to). A variety of other materials are recorded, mainly forms of timber-framing; just what distinction was intended between stud-and-mud and stud-and-wattle is not clear. The presence of mud-walling and stone is surprising. In the parish, the latter is only found in a couple of good-quality houses (Figures 21, 25). Mud as a building material is used elsewhere in Warwickshire, e.g. in 18th-century cottages on Dunsmore Heath (G.R. SP485715) and in cottages built at Halford (G.R. SP261456) by the overseers of the poor in 1821.[10] It does not survive as a building material nearer at hand, but was probably used in Stoneleigh as elsewhere, as a cheap material particularly suited to 'self-help'.

Table 7.2: *The 1807 survey of cottages*

Material

Size	Brick	Brick+ Stone	Stone	Stud+ Bricknog	Stud+ Brick	Stud+ Mud	Stud Wattle	Mud-walled	Unstated	Total
1 Rm	1									1
1 Rm + 1 Ch	3		1			1			1	6
2 Rm	1					1			2	4
1 Rm + 1 Ch + Pantry	16			3		4	2		1	26
1 Rm + 1 Ch + lean-to					1					1
1 Rm + 2 Ch					1	1				2
2 Rm + 1 Ch	1					2				3
2 Rm + Pantry			1							1
2 Rm + 2 Ch	8		2	1		2				13
1 Rm + 2 Ch + Pantry	6									6
2 Rm + 1 Ch + Pantry	1					1	1			3
2 Rm + 2Ch + Pantry	3			2		1				6
3 Rm + 2 Ch + Pantry	1									1
Unstated	4	1	1	2		2	1	4	4	19
Totals	45	1	5	7	2	15	4	4	8	92

Roofs: 12 tiled, the rest thatched
Ancilliary Buildings: 24 Hovels, particularly with larger cottages though not those with larger enclosure 6 stys; 1 cowhouse; 6 shops

The sole survivor of the original 90 cottages is that known as Crackley Barn, now extended but incorporating a complete two-bay cottage (Figure 40). It is most remarkable for the character of its carpentry, far simpler than that used elsewhere.

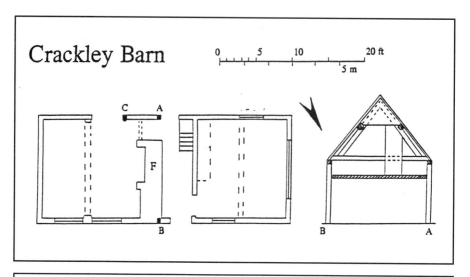

Crackley Barn stands on what was the edge of Crackley Heath. It has two orginal rooms, with a modern extension. The east room beam is roughly chamfered with scroll stops, and a few joists are chamfered but have rough waney edges; the beam in the other end has an ovolo moulding, but is clearly re-used. The fireplace is concealed, but a post in the south wall may mark the corner of a chimney bay. The wall post/tiebeam junction uses a notably simple design, and the tiebeam is virtually flat; there may well be no collar (though one is possibly concealed).

40 *Crackley Barn, Stoneleigh, plan and section; C marks the position of a wall-post, possibly relating to a smoke-hood.*

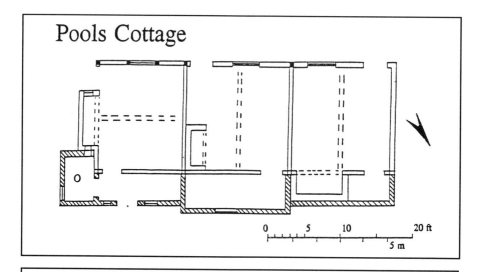

Pools Cottage stood on the edge of Westwood Heath. It was totally rebuilt in 1967, and the description is based primarily on photographs. It probably originated as a two-bay cottage (west), with a worse-quality addition to the east. The framing, mainly seen at the east end, was similar to that at Crackley Barn.

41a *Pools Cottage, Bokendon, Stoneleigh, plan (reconstructed from photographic evidence and some measurements).*

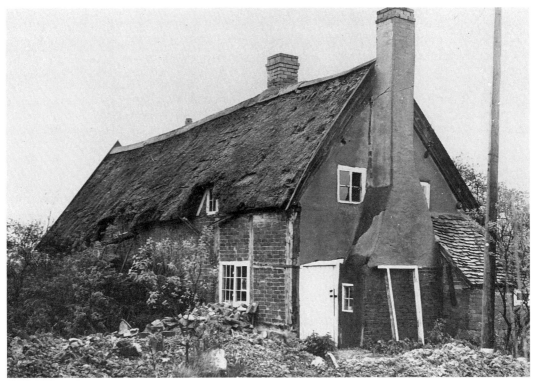

41b *Pools Cottage, Bockendon, Stoneleigh in 1967, from the south.*

42 *A cottage at Burnt Post, 1870s. Drawn c.1870 by W. G. Fretton at the Katherine Bayley School, Coventry. Coventry Record Office, Acc.368/101/15.*

One other building, Pools Cottage, was photographed in 1967 (Figure 41a and b) before rebuilding, and its plan can be reconstructed in outline. It comprised three cottages, each of one-room plan with added rear lean-tos. A final contribution to the visual evidence for these vanished buildings comes from drawings made in the 1870s by Coventry school-children. Several naive but consistent pictures of a cottage at Burnt Post show that it was of very much the same character as those just described, with one framed bay and one of brick (Figure 42). Which of the several cottages at Burnt Post this was is uncertain, so we cannot match it with the 1807 survey.

Remarkably, the early 18th-century enthusiasm for inventory-taking has led to a handful of inventories surviving for these people from the lowest level of society (Table 7.3).

Table 7.3 *Inventories for cottagers*

Date	Name	Rooms	Value (£)	Cottage details
1682	Eustace Salmon	4	30	Cottage built on Hearsall Common
1714	Jacob Gibbs, day labourer	2	41	Of Fletchamstead on 1717 'cottier' list
1729	Richard Ash, husbandman	3	40	Cottage tenant, on Middle Road (south of Broad Lane)
1730	Edward Lee, labourer	4	16	Cottage tenant at Crackley Heath, also holding about 15 acres
1731	William Elliott, labourer	-	14	Cottage on Broad Lane (no room names in inventory)
1736	Thomas Ansley	3	53	Cottage tenent on Middle Road
1738	Richard Edge, labourer	3	18	Cottage tenant on Broad Lane

It seems that all these individuals had prospered to a modest level, even though their houses remained among the smallest recorded. Jacob Gibbs (**42**) had a reasonable range of possessions in his two rooms, including some pewter. His £30 in cash is particularly notable.

42 *Jacob Gibbs, day labourer (1714)*

He is named under Fletchamstead in the 'cottiers' list of 1717, though his cottage cannot be exactly located. He left £30 for the child his wife Mary was expecting (presumably the £30 in his inventory). However, a son John (from an earlier marriage) was to have £10 if he returned from beyond the sea while, if the child died before reaching 21, his two brothers and sister were to share the £30.

Inventory appraised by William Holbech, Edward Casemore; 8th May 1714.

Purse and apparrell		1	0	0
In the Kitchen				
One cubbard, three calldrons, five pewter dishes, one stool, one little table, two formes, three chears, one paile, one frying pan		1	1	0
In the Parlour 2 Bedsteds & two flock beds, 3 pair of sheets and other small linings [*linens*], 3 pair of blankets, 2 bolsters & 2 pillows		1	10	0
One coffer, one chest, 1 trunk, two boxes, one cow one earling [*yearling*] calf		5	3	0
Frying pan			12	0
Five sheep		1	2	0
Hay		1	1	0
One hatchet & spade, etc.			5	0
Sixteen little cheeses			5	0
In money		30	0	0
	[Total	41	19	0]

The earliest inventory, that of Eustace Salmon, gives few details of the house contents, but he owned a wagon and two ploughs, three mares and four cows, and had eight acres of growing crops.[11] Richard Edge had three cows and a mare, and Thomas Ansley six cows, three calves, four sheep and a filly. Richard Ash was regarded as a husbandman, significantly higher in status than most of these cottagers, and he even had a clock in his kitchen.

Edward Lee's spartan inventory (**43**) gives the best impression of a slightly larger cottage. Judging by the 1807 survey, his lean-to was a typical addition to a cottage of two ground-floor rooms with one chamber upstairs.

43 *Edward Lee, labourer (1730)*

He paid 1s a year for his cottage on the edge of Crackley Heath in the 1729 cottage rental, but also rented about 15 acres of land there, part of which he had held since 1699. Other members of the Lee family farmed at Canley, Cryfield and Hurst, and he made small bequests to several relatives. He was apparently unmarried, and left the residue of his possessions to Elizabeth, daughter of Stephen Mander (perhaps a niece).

Inventory appraised by William Thompson, John Axson, 8th January 1729[/30].

Purse and Apparrell		15	0
In the Kitchen			
Brass and Pewter, two tables, four cheirs, two pailes, fire irons and other od things 1		1	6
In the Buttery			
Three Barrels, one wheele and earthen vessels		5	0
In the Leanto			
One bed and furniture, one chest, one box, one coffer and one cheir		12	0
In the Chamber			
One old bed, two coffers & one old box		6	8
One poor mare and two small colts	2	8	0
Three old cowes, two small heifers & one calf	5	10	0
Three and twenty sheep	2	12	0
One small store pig		5	0
A small quantity of corn and oates	1	5	0
Two small parcells of hay		10	0
One old cart, one old plow and harrow and the gears		6	8
Lumber and things not herein before vallued		2	6
	Total 15	19	4

The Almshouses

Almshouses give a valuable if neglected guide to standards of housing for single people. Their founders would see to it that they were soundly built, to provide acceptable but never luxurious accommodation according to the expectations of the times. In Stoneleigh, a fine range of ten almshouses stands beside the village green. However, they have had a more complex history than the date of 1594 on their stone exterior might suggest (Figure 43). The accommodation seems always to have comprised a heated ground floor room with a chamber over. Thus they correspond in size to other small houses of the later 16th century, though the latter always had both rooms on the ground floor.

A licence in mortmain of 1576 providing for the endowment of the almshouses names their first inhabitants.[12] By comparing these with the detailed 1570 rental, the process by which the almshouses were established becomes clear. Four of the five almswomen and two of the almsmen were cottage tenants in Stoneleigh village of 10-15 years standing; another man may have been the elderly brother of a tenant in Hurst who had died some years previously (**17**). The almshouses occupied the site of three village cottages. One of their tenants (Thomas Knight, a weaver; *Manor*, 1568) moved straight into an almshouse, and the other two took over cottages vacated by almswomen, retaining in one case the meadow, croft and field land belonging to the demolished cottage.

About 60 occupants of the almshouses can be identified, mainly from their burial entries in the parish register but including the names listed in 1576 and those in one Hearth Tax list

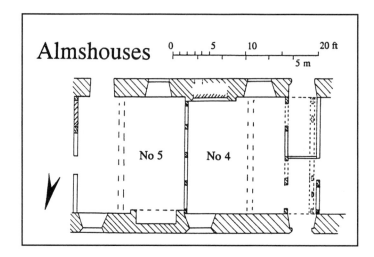

The ten almshouses are arranged in pairs, with a common outer door, having their chimneys alternately on the front and back walls. The walls are of red sandstone, with the date 1594 on the front; the main doorways and the fireplaces have four-centred heads. The roof contains curved windbraces. The ceiling beams and joists are chamfered with scroll stops. The original stair positions are uncertain. The structure shows evidence of alterations, particularly in the door positions leading from the common hallway between each pair of almshouses. The probable explanation is that the original (1576) building was timber-framed, and was cased in stone in 1594.

43 *Stoneleigh Almshouses, plan.*

(1663). Many of the men can be recognised from rentals and suitor lists as former tenants of village cottages. Thus, John Newey was tenant of a cottage in Ashow for the very long period, 1625-1660. In 1664, the Hearth Tax lists him among the almspeople, and he died in 1667. He seems to have led a totally blameless life, never being mentioned in the court rolls, and is only otherwise recorded as the recipient of small legacies in three wills. The almswomen are more elusive, perhaps because most were not tenants in their own right, but moved to the almshouses when their husbands died; almost all appear to have been widows.

Remarkably, one inventory (**44**) apparently relates to the almshouses. Richard Hargrave's burial entry describes him as *proseuchie* (almsman);[13] in the inventory he is called a husbandman. He is otherwise unrecorded, though the inventory suggests he was a carpenter and he perhaps lived in Hurst.[14] His two rooms were well if simply furnished, at least to the standard of labourers in the village. The inventory's distinctive feature is that it clearly relates to a house-holder, but lacks even a labourer's farm stock and corn. The substantial debts due to Richard Hargrave are surprising but did not necessarily represent realisable assets. Without them, his estate would have been very modest and their existence probably accounts for the need to make an inventory and to obtain a formal grant of probate, to legitimise any attempt at collecting them.

Apart from the information about the almshouses, evidence concerning the formal support for the poor in Stoneleigh is very sparse because no overseers' accounts or papers survive. As in many other Warwickshire parishes, a workhouse was built in the late 18th century (1787).[15] It passed out of use in 1817 when its site was taken over for a new vicarage.

44 *Richard Hargrave, husbandman (1640)*

Inventory appraisers Martin Daniell, Thomas Smith, Thomas Hall, 28th April 1640.

His wearinge apparell	2	0	0
One joyned chest		6	8
3 Table napkins		1	0
1 Woolbedde, 1 pillowe, 2 blankettes & 2 paire of sheetes, 1 twillie		15	4
1 Olde bedsted		2	0
2 Coffers		5	0
2 Ticknell platters and 1 woodden can			6
1 Strike bagge			6
2 Little kettles		2	0
1 Wimble [*auger*], 1 hand sawe with other implements		1	0
2 Little firkins		1	0
2 Iron wedges			4
1 Hatchett and 1 bille			6
1 Borde and 3 slabbes			10
4 Little stooles			4
1 Ladder and wood about the howse		17	8
1 Old lanthorne			2
1 Forke			4
1 Pewter tunne			6
Money owinge upon specialties in wrytinge	43	0	0
Total	47	15	8

Notes

1. Warwickshire had no tradition of built-in beds which would not have been recorded in inventories.
2. *Telford Inventories*, 192; J. A. Johnston, *Probate Inventories of Lincoln Citizens, 1661-1714*, Lincoln Record Soc., 80, 1991.
3. This took place between 1727 and 1732, when one volume of the estate rentals is missing.
4. In 1575, it was noted that several houses had been built near Canley which had no common rights (*Manor* 187). However, these seem to have been farmhouses rather than cottage.
5. SBT.DR18/3/53/4, 9 April 1666. The dozen declarations relate to seven cottages (one occupied by four women) on Crackley and Westwood Heaths, and also to two barns and a parcel of ground.
6. *Q.S.* VI, 172, also PRO.C22/408/12, replies of John Downes and Robert Samon. Miller's house was first built at Hearsall, but the owner of Whoburley required him to take it down (giving 45s. towards the cost), and Lord Leigh provided a new site for it.
7. PRO.C5/533/61 and C22/408/12, complaints and interrogatories in a dispute about common rights on Hearsall.
8. SBT.DR18/30/24.
9. SBT.DR18/31/693.
10. N. W. Alcock, 'Halford Parish Cottages: Mud Construction', *Birmingham and Warwickshire Archaeol. Soc. Trans.* 87 (1975), 133-6.
11. He lived in one of the cottages on Hearsall Common built in the 1660s, but the land he was farming must have been sub-let from neighbouring farms. His family continued to live in Stoneleigh for another century, becoming steadily more prosperous. They eventually rose to be tenants of Fletchamstead Hall.
12. SBT.DR18/671/1.
13. A word from classical Latin suggesting, with the other Latin terms in his brief surviving register, that Edward Mansell, who graduated from Emmanuel College, Cambridge, was something of a classicist.
14. His appraisers, Daniell and Smith, were tenants there. His niece Anna Court, the administrator, may have been of Berkswell as was one of her sureties, John Court, husbandman.
15. SBT.DR18/3/69/1-17.

Table 7.1: *Homes of the Poor: Two to four rooms, 1601-1750**

Inv	Date	Name	Status	Hld	Loc	Acr	£	Rooms (and Farm Buildings)
	1601-50: Two Rooms							
	1610	Philip Cleadon	Labourer	25	S	2	11	Hall, (Floor over hall), Chamber; Barn
	1609	William Dunton	Husbandman		H		76	Bedchamber, Hall, (Boards and planks ov chamber)
	1639	Thomas Jervis	Gunsmith	15	S	4	39	Parlour, Hall [rented 27 acres additional land]
	1602	John Plante	Yeoman	104	Fl	14	75	Bedchamber, Hall
	1601-50: Three Rooms							
37	1610	Thomas Burton		89	Ca	24	40	Hall, Bedchamber, Upper chamber; Barn
	1608	Alice Clerke	Widow	63	St	20	8	Hall, Inner Chamber, Chamber above; (Barn *will*)
	1613	Thomas Freeman	Husbandman		A		20	Hall, Bedchamber, Upper chamber
	1632	Edward Hopkins			Fl		14	Hall, Lodginge Roome, Milkhouse; Barn
40	1630	Robert Stocken	Labourer	20	S	0	10	Hall, 'Parlor wher they lye', Chamber over t Lodging Parlour, (Loose bordes over hall a Parlour); Barn
	1601-50: Four Rooms							
	1635	William Brookes	Husbandman		Ca		17	Chamber, Inner chamber, Hall, Upper chamber
	1626	Benjamin Burnabye					16	Hall, Chamber over Hall, Chamber over Butter Nether Room (=Buttery?)
	1622	John Collet	Labourer	47	A	4	14	Hall, Chamber next the Hall, Lodginge Chambe Little Chamber; Barn
	1603	William Kelsoe	Fuller	23	S	0	26	Bedd Chamber, Buttery, Hall, Shop; Bar Cowhouse
	1624	Ralph Kempe	Husbandman		Hu		73	Hall, Parlor, Chamber over Parlor, Buttery; Ba
	1626	Henry Kirbie	Labourer		Cr		36	Hall, Buttery, Upper Chamber, Neither Rome
	1609	Thomas Lewes	Labourer	24	S	0	13	Bedchamber, Little Chamber, (old bords that ly over the Chamber), Hall, Boulting house, (pol lying over the Boulting House); Barn
	1640	Joan Rawbone	Widow	X3		Ca	12	Chamber, Upper chamber, Hall, (Buttery ? *as next*)
	1634	William Rawbone	[Cooper]	X3	Ca		13	Chamber, Upper chamber, Hall, Buttery
	1603	Thomas Smyth	Husbandman	65	St	7	40	(Bedchamber), Loft over bedchamber, Hall hous Buttery; Barn
	1629	John Stone		107	Fl	(19)	31	Hall, Parlour, Buttrie, Upper Chamber; Barn (£6 *gross*)
	1624	John Wilde	Fuller	18	S	0	41	Hall, Chamber next hall, Lodging chamber, (Bord that lye over the Chamber with the ioystes), Sho Barn

Inv	Date	Name	Status	Hld	Loc	Acr	£	Hth	Rooms (and Farm Buildings)
	1661-1700: Two Rooms								
36	1698	John Morice	Day-labourer	86a	I	1	28	1E *	Dwelling house, Lean-to to the house (£33 gros
	1661-1700: Three Rooms								
	1700	Thomas Barrs	Husbandman	103	Fl	(111)	209	1 *	Kitchen, Chamber, Over the house (*Suspecte incomplete*)
	1688	Ellen Driver	Widow		H		8		Kitchen, Parlour, Chamber
	1673	Richard Kennell			Fl		34	1	Room over hall, Hall, Backroom; Stable, Barr Other barn, Hovel
	1661	John Wall	Husbandman	99	Fl	(26)	62	1 *	Parlour, Chamber, Dwelling house; Barn
	1670	William Worth	Husbandman	22	S	0	29	1 E	Chamber, Loft, House
	1661-1700: Four Rooms								
	1699	Robert Adams		83	Hu	2	19	1	Dwelling house, Other nether room, Buttre Room over the house

Inv	Date	Name	Status	Hld	Loc	Acr	£	Hth	Rooms (and Farm Buildings)
38	1677	Joan Barber	Widow	62	St	21	8	1	Parlour, Chamber over the parlour, Kitchen, Butterie
	1678	Thomas Garnett	Wheelwright		S		29	1	EParlour, Little room next the parlour, Backroom, Shop
	1684	Humphrey Keene		53	A	13	41	1/2 E*	Parlour, Chamber, Hall, Kitchen; Barn
	1669	Dorothy Lockwood	Widow	21	S	3	13	1 *	Parlour, (Boards over parlour), Little lodgeing room, Hall house, Buttery; Barn
	1682	Eustace Salmon			Fl	(0?)	30	1 E	Parlour, Entrie, Chamber, House
	1698	Thomas Smith	Labourer	47	A	6	12	1	House, Parlour, Buttery, Chamber
	1681	George Whitmore	Husbandman	71	I	(103)	191	1	Hall, Buttery, Parlour, Chamber; Barn

Inv	Date	Name	Status	Hld	Loc	Acr	£	Rooms (and Farm Buildings)
		1701-50: Two Rooms						
42	1714	Jacob Gibbs	Day labourer		Fl	0?	41	Kitchen, Parlour
	1710	James Gibbs	Yeoman/ Carpenter	42	A	39	164	Bedchamber, Hall [probably other unnamed rooms]
	1708	Richard Pratt		46	A	(8)	9	House, Parlour
	1703	John Whitehead	Labourer	22	S	0	14	Parller, Chamber
		1701-1750: Three Rooms						
	1736	Thomas Ansley		108	Fl	1	53	Chamber, Parlour, House
	1729	Richard Ash	Husbandman	109	Fl	1	40	Kitchen, Parlour, Chamber over Kitchen
39	1723	John Curtis	Husbandman	87	Fl	15	36	Parlour, Chamber over Kitchen, Kitchen
	1738	Richard Edge	Labourer	98	Fl	0	18	Kitchen, Parlour, Upstairs
	1719	Edward Hancocks	Yeoman	88	I	51	85	Dwelling House, Parlour, Chamber over Parlour; Barn
28	1702	Joseph Hart	(Husbandman)	6	S	56	9	Parlour, Hall, Upper chamber [*Gross value* £52]
	1717	James Jobson	Labourer		Hu		18	Chamber, Dwelling house, Buttery
	1731	Hannah Pinchback	Widow	45	A	11	35	Dwelling House, Kitchen, Parlour; Barn
		1701-1750: Four Rooms						
	1709	Thomas Burden		64	St	28	89	Parlour, Another little room, Upper chamber, Hall
	1705	Thomas Cross	Labourer	X4	Fi		18	Bedchamber, Another room, 'The low rooms'
	1719	Elizabeth Hancock	Widow		Fi		16	Further chamber, First chamber, Hall, Back chamber
	1710	Catherine Jeacock	Widow	40	A	(24)	46	Parlour, Little parlour, Dwelling house, Kitchen
	1705	John Jeacock	Husbandman	40	A	(24)	18	House, Parlour, Little parlour, Buttery; Barn
	1748	Samuel Jeffery			A		67	Chamber, Little buttry, Dwelling house, Great buttry
43	1730	Edward Lee	Labourer	92	I	(30)	16	Kitchen, Buttery, Leanto, Chamber
	1710	William Middleton	Husbandman	59	St	80	48	Parlar, Hall, Buttrey, Chamber; Barn
41	1717	Joanna Sly	Widow	96	Fl	(41)	14	Dwelling house, Parlor, Buttery, Chamber; Barn
	1730	Thomas Walton	Miller	102	Fl		74	Kitchen, Chamber over kitchen, Cheese chamber, Parler; Barn
	1717	William Whitmore	Husbandman	63	St	23	127	Parlour, Hall, Room over Parlour, Room over Hall; Barn

* For notes, see Table 4.1, p.53.

Chapter 8

18th-Century Farms

In many ways, the largest houses recorded after 1700 (eight rooms upwards; Table 8.1, p.161) belong with those of the previous century (Chapter 5) with which they share a proliferation of rooms and of household goods. However, at this social level the changes in room name and room use that took place around 1700 are particularly marked. Additionally, although many 16th- and 17th-century houses remained in use with little alteration, new 18th-century farmhouses show great differences in plan and architectural character from their predecessors.

Patterns of Housing

The most obvious changes in room names concern the hall. As with smaller houses, by the 18th century this was occasionally renamed as 'Dwelling House'; in Richard Casemore's house (8 rooms) it was the 'Fire Room', an unusual term most often found in south-east England.[1] Much more significant is that half these houses did not have halls at all.

Typically, a parlour and a kitchen were the principal rooms in houses with up to ten rooms, though several had both Great and Little Parlours. These rooms were usually accompanied by a couple of service rooms, a dairy and either a buttery or a pantry (slowly replacing butteries as the century proceeded). The larger the house, the more likely it was to have a brewhouse and a cellar. A cheese chamber was almost universal, even if occasionally implied by the room's contents rather than its name. Most cheese chambers also held wool and sometimes corn; only one separate wool chamber is recorded. These houses generally contained four or five bedchambers, described by their position rather than their use, though a few inventories mention maids', mens', fellows', or servants' chambers. 'Room' and 'chamber' normally referred to ground and upper rooms respectively, though a 'room' might occasionally be on the upper floor, as was William Ward's 'Room over the Parlour' (1741).

The largest houses (11 rooms and upwards) differed little from those just described, except that the majority included a hall as well as a parlour and a kitchen, or sometimes two parlours and two kitchens (**46**). However, as the next section demonstrates, these halls were completely different in use from the halls in earlier houses. The second 'little' parlours tended to be the master's private sitting room, while the second 'back' kitchens combined the functions of brewhouses and dairies. These big houses might also have garrets or cocklofts, while some of their best chambers had adjoining closets.

Room Use

The apparent confusion of the alternative names for halls, kitchens, back kitchens and brewhouses becomes clear when their contents are examined. We can take as an example the 1731 inventory of Robert Davis (**45**), whose nine rooms included a kitchen and a brewhouse.

45 *Robert Davis (or Davies) of Ashow (1731)*

He was tenant of Dial House Farm (71 acres) for less than five years (after 1727), being followed by his widow Mary. She was the daughter (or sister) of 'Mr Winter', tenant of Cross Grange, Leek Wootton, a large farm on the Stoneleigh estate (*Reg.* Leek Wootton, 1720). Dial House was established on an isolated site some time after the 1649 enclosure of the Ashow fields. The house was rebuilt in the late 18th century.

Inventory appraised by Samuel Winter, 23rd November 1731.

Wearing apparrell	2	0	0
In the <u>Kitchen</u> one firegrate & fender, fireshowle, tongues & bellows, fire links & firehooks, five cheirs, two little tables, one forme & stoole, three spitts, one coffer & fryeing pan		17	6
One clock & case, six pewter dishes, three parrengers, two brass candlesticks, one brass ladle, one warming pan, three tin puding pans, one candlebox, two iron candlesticks & other small things	2	2	0
In the <u>Parlor</u> six cheirs, one ovall table, one chest, one box, one cubbord, two Delf basons, two Delf plates, too drinking glasses & earthern parengers		16	0
In the <u>Cellar</u> two barrells & brass cocks, six dozen of glass bottles & one wooden bottle & a small quantaty ale & cyder	2	2	0
In the <u>Brewhouse</u> one small furnace, two kettles, one Belmettall pot, two old pewter dishes, one cleaver, trenchers, dishes & spoones	1	17	6
Three tubbs, two kivers, three pailes, one lade gallon, one cleansing sive & one paire of land irons		13	6
In the <u>Dairey</u> one Cheesepress, one churn, one cheesetub, three kivers, cheesefatts & suiter, scales, weights, milk vessells & other small things		15	6
In the <u>Buttery</u> one little furnace, one barrell, tressill, dough tub & serch		17	6
In the <u>Chamber over the Brewhouse</u> two bedsteds, two flock beds, one flock bolster, three flock pillows, three old blankets, one set of curtains and one spinning wheel		15	0
In the <u>Chamber over the Kitchen</u> two bedsteds, one set of curtains, one flock bed, one feather bed, one flock bolster, six blankets, one box & coffer	1	2	6
In the <u>Chamber over the Parlor</u> one bedsted, set of curtains, featherbed & bolster, three blankets & one civerlet	1	15	0
One chest of drawers, one table, four cheirs, one box, coffer & bellows		13	6
A small quantaty of cheese & two cheeseboards		10	0
<u>Linnen</u>			
Six pair of course sheets, two table cloaths, six napkins & other linnen	1	0	0
In & near the <u>Yard</u> one waggon, one tumbrill, pair of harrows & plows	6	0	0
Five cowes, four heifers & four calves	16	0	0
Nine sheep	2	0	0
One sow & nine pigs & five bigger pigs	4	10	0
One mare & one gelding	2	10	0
One cartsadle, two collars, four pair of holmes [*hames*], three pair of traces, one spokeing chain, one rope, backbands & three bridles	1	0	0
One measureing strike & seves, forkes, rakes & working tooles		5	0
A quantaty of hay	5	0	0
Oates upon a rick	5	0	0
Lean maslen upon a rick	4	10	0
Wheat upon a rick	5	5	0
Barley unthrashed in the barn	1	15	0
Blew pease unthrashed		17	6
<u>At Leek Wootten</u>			
One old harvest waggon & two mares	6	10	0

Money received by Mary Davis for goods sold since the decease of her
husband Robert Davis untill this 23rd day of November 1731,

five quarter of barley	4	10	0
Thirteen hundred of cheese	13	0	0
One porket pigg & one sucking pigg	1	13	0
Three sheep	1	8	0
Things which are not herein before vallued		2	6
Total	99	13	6

His kitchen was the main cooking room, equipped as in all these inventories with both a grate
and spits. The principal brewhouse fittings were a furnace (p.63) and a selection of pots and
kettles. Old-fashioned houses with hall and kitchen, rather than kitchen and brewhouse/back
kitchen, simply exchanged these functions; for example, Laurence Hand's hall (1706) contained
the main cooking hearth and his kitchen held tubs and brewing vessels (1706). In his son's
inventory (1721) the rooms had the same functions but were called kitchen and brewhouse.[2]

Robert Davis, in common with about half the other members of this group, used his parlour
only as a living room, with table, chairs and a cupboard displaying his Delft bowls and plates.
Surprisingly, although glasses were common and most dairies held earthenware vessels,[3] china is
hardly mentioned, and dining services of pewter remained the standard for everyone in Stoneleigh.
However, they had other items of quality. The clock was usually in the parlour but might be on
the staircase, in the hall, or even in the kitchen. A looking glass in the parlour or best chamber
was hardly less common, and a few people had other decorations, like Thomas Hart's five maps
and John Scotton's four pictures. Old-fashioned lifestyles were sometimes tenacious in the parlour
as well as the hall, and Laurence Hands, the warrener, kept his nets and ferrets in the parlour. His
son James had smartened the house up, with six black chairs and 'nine pictures with frames' in
the parlour, while the ferrets had been banished to the yard.

Robert Davis probably slept in the chamber over the parlour, where a chest of drawers
supplemented the coffers and boxes of the previous century. Many of his contemporaries also
had fire grates in their chambers, which must have made an even greater contribution to comfort;
by this period, coal rather than firewood was commonly listed.

Robert Davis was well-supplied with service rooms: buttery, dairy and cellar. Other inven-
tories show the ambiguities in the uses of their service rooms that have already been noted for
earlier periods (e.g. p.69). Thus, we may find the cheese press in the buttery, barrels in the dairy,
or the churn in the brewhouse.

The distinctive feature of the largest houses has already been mentioned: the reappearance
of the hall. These halls were not however kitchens, as in the smaller houses, but their furnishings
identify them clearly as *dining rooms*;[4] they were rather austere, with tables and chairs but little
else. John Barr (1720) (**46**) had a dining hall, as well as a kitchen and a back kitchen where he
baked and made cheese (though apparently he did not brew ale). His kitchen furnishings were
very similar to those of Robert Davis (**45**); his pewter was of better quality and he had discarded
his trenchers, but had not acquired any Delftware.

Even though the Great Parlour was his best living room, it had still collected some odd-
ments and the woman's hand in his household had clearly been missed. The suite of brass kettles
were there for display unlike the porridge pots. The 15 black chairs could have been for more
than ordinary entertainment, hinting at serious (religious?) gatherings. The little parlour was a
sparsely furnished sleeping room, with a comfortable bed, though nothing like as valuable as that
upstairs in the best chamber. The children's bed-linen was here, but they probably used the
chamber over the kitchen, with its two good beds, looking glass and close stool, and chest and
coffer holding the family linen and valuables.

46 *John Barr of Fletchamstead, yeoman (1720)*

The Barr family had been prominent in Fletchamstead since about 1650, when Richard Barr the elder appeared, probably as tenant of Tile Hill Farm. He was succeeded by his son Joseph who received a 21-year lease of this farm in 1691 (SBT.DR18/1/994); this he left to his son John in 1701. John was constable in 1714, and frequently acted as inventory appraiser for people from the north of the parish (e.g. **20**, **40**). His wife Eleanor died in 1716, and when John died his three children were all under 21 (John, b.1705; Elinor, b.1709; Joseph, b.1714); they petitioned the Consistory Court and Joseph Baddams and William Bradford were appointed guardians. The younger John succeeded his father as tenant, and on his death in 1733 was followed by his brother Joseph.

Inventory appraised by William Holbech, Joseph Lant, James Hands, 27th August 1720.

His purse and apparrell	18	5	0
In the Kitchen			
One grate, fender, fire shovell, 4 pair of tongs and hath grate		18	0
One jack, 2 spitts, one chaffing dish, one hanging iron, 4 bras candlesticks, one bras mortar and pestill, one toasting iron, 3 iron wracks, 2 bras knobbs, one dripping pan, one bras ladle, one pair of bellowes, 2 lock irons with 5 heaters and 2 flesh forks	1	13	8
One gunn		5	0
19 Pewter dishes, 2 dozen of plates, 2 cheese plates, 2 pewter tanckards, one pewter bason, 3 pewter porrengers, 4 chaires, 2 joynt stooles and one table	5	3	0
One salt coffer		2	0
Bacon		10	0
In the Hall			
One clock and case	1	10	0
2 Tables, 1 form, 1 chair & 4 joynt stooles		8	8
In the Little Parlour			
One feather bed, bolster, flock bedd, curtains & vallence, sheets & 2 blancketts	4	10	0
One old cuppoard		3	0
One side sadle, 1 joynt stool & a bridle	1	5	6
In the Great Parlour			
15 Black chairs, 2 tables and one couch	1	13	0
One grate		2	6
Ten bras kettles	6	16	6
3 Porridge potts	1	13	4
2 Iron beames, scales, lead weights & cords		16	6
Seventeen sack baggs		17	0
In the Back Kitchen			
One furnace and bras boyler	2	10	0
2 cheese presses, 2 great tubbs, 2 cheese tubbs, 2 pailes, 2 gallons, 5 kivers, one chirne, 2 little tubbs, one table, tenn cheese fatts and two shooters	2	6	0
One brass pann		16	0
One dough tubb, eight barrells, two sives with a search	1	11	0
One warming pan and two frying panns		7	0
In the Best Chamber			
One feather bed, curtains, vallence, bedstead and all furniture thereunto belonging	12	0	0
Seaven cane chaires, 2 tables with drawers, 2 stands, one chest, one looking glas, one hanging pres and one chest of drawers	6	0	0
Window curtains		12	0
Child bed linnen	1	10	0
3 Gownes and 5 petticoats	2	10	10
In the Chees Chamber			
8 Hundred of cheese	8	0	0
17 Shelves and one tressell	1	0	0
In the Cocklaft			

4 Wheeles		10	0
In the Chamber over the Brewhouse			
2 Feather beds with all the furniture thereunto belonging, one chaff bed,			
one chest and two little coffers	7	10	0
In the Servants Room			
One flock bed, feather bolster, with the furniture thereto belonging and one coffer	1	1	0
In the Chamber over the Kitchen			
4 Feather beds with the appurtences thereunto belonging and 2 bedsteads	11	10	0
3 Chests, 2 trunkes, one little looking glas, one box and one coffer	1	10	0
One close stool		3	0
In the Chest			
24 Pair of flaxen sheetes, 4 pillowbeers, 3 tablecloths, 1 dozen and 1/2 of			
napkins and one Holland sheet	19	18	0
2 Pair more of flaxen sheets		18	0
24 Ells of new cloth	2	0	0
3 Silver spoons, 2 silver bodkins, one pair of silver buckles and one pair			
of silver studds	1	6	0
In the Coffer			
One pair of sheetes, 2 dozen and 1/2 of napkins, 2 table clothes and			
2 cubbord clothes	2	3	6
6 gold rings, a silver thimble & some old silver	4	15	0
In the Feild			
5 3-year old heiffers	13	15	0
4 Yearling heiffers	7	0	0
16 Sheep	8	16	0
10 Lambs	2	10	0
A rick of hay in the meadow	6	0	0
In the Old House			
One old cuppoard, one table and form		4	6
One mault mill and mault garner	2	10	0
One old bedstead		2	0
15 Cowes	52	10	0
One bull	2	15	0
24 Acres of barley, peas and beans	41	0	0
3 Tunn of hay on a rick in the Grove Meadow	3	0	0
In the Yard			
One rick of white peas	10	0	0
One rick of wheat	15	0	0
One rick of hay	16	0	0
Three staddles		15	0
In the Barn			
Wheat valued at	8	0	0
Hay valued at	10	0	0
6 Horses and mares	25	0	0
6 Pair of geares, mullen halters, traces, bridles, sadles, pannells, 2 pillions			
and pillion clothes	3	10	0
2 Waggons, 2 tumbrells, 3 harrowes, 4 plowes, shares and coulters	18	5	0
8 Cow cribbs	1	0	0
4 Piggs in the sty	4	0	0
One fann and wheele, one wheelebarrow, and hand-barrow		15	0
One waggon chaine		4	0
22 Sheep in the feild called Cattle Feild	9	18	0
In the House			
27 Strike of wheat	5	8	0
Mault valued at		14	0
Course linnen used about the house	1	0	0

Money sealed up in a bag at John Hills house in Coventry	35	0	0
Books valued at	1	0	0
Forks & rakes, scythes, ladders, coales, old iron, lumber and things forgot	2	10	10
Carridge of wood	6	0	0
Rent	3	0	0
For wool due from Mrs Bennion	4	10	0
Debts goode and bad	148	11	6
Total	609	3	4

The sophistication these households might achieve is shown by the inventory of Mr. John Atkins (**47**). It gives the most detailed impression of the furnishing of one of the largest houses, Nether Fletchamstead Hall, itemised even down to the drying horse and the mousetrap in the Meal House. The barometer and punch bowl in his Little Parlour are particularly notable as luxuries, as are the coffee pot and the picture in the Parlour Chamber. The contents of the closet adjoining this room, just a bed and chairs, parallel those of other closets; it may have been used by his personal servant. John Atkins inventory can be directly compared to that for the same house taken 50 years earlier on the death of William Meigh (**20**). The house was almost unchanged apart from the creation of the Little Parlour and the closet.[5] Both show the same luxury and comfort, but the contrast between old-fashioned and newer lifestyles can be seen in the furnishings of all the major rooms.

47 *John Atkins of Fletchamstead, gentleman ('Mr') (1745)*
He was tenant of Nether Fletchamstead Hall from c. 1727 (250 acres; rent £110 per year). He owned several houses in Coventry which were to be sold by his trustees (John Webster of Canley, Joseph Gibbs of Stoneleigh and his brother Jonathan Atkins of Woolscott, Grandborough). From the proceeds, with his personal estate, they were to pay £150 each to his seven younger children when they reached the age of 22; his wife had died in 1737. The legacies were to remain in William's hands (the eldest son) until paid, he taking care of their upbringing and receiving the residue of the estate. William took over the farm until his death in 1746, when he was succeeded by Richard Wigan, who married William's eldest sister Ann in 1748.

Inventory dated 15th January 1744[/5]; no appraisers listed.

Purse and apparell	10	0	0
Cash in hand	100	0	0
Debts good and bad	93	12	6
In the Kitchen			
One jack, 2 spitts, 2 gunns, 1 iron dripping pan, stilliards, 1 coffee pot, 4 brass candlesticks, pott hooks, fire shovell & tongs, 2 iron doggs; 2 copper cans, 1 cubboard, 1 dresser, 10 drawers, 1 screen and salt box, 1 table, 6 chairs, 1 looking glass, 1 warming pan & lumber	4	7	0
30 Pewter plates, 16 pewter dishes, 1 salver, 1 cheese plate	2	9	0
Beeff and bacon	7	0	0
In the Mealhouse			
One malt mill, 2 cheese presses, 7 barrells, 1 kneading trough, 2 frying pans, 1 drying horse, 2 tubbs, 1 bing, 1 mousetrap, 1 iron barr and 2 saws, 2 bolting sieves	4	3	0
In the Dairy			
One barrel churn, 2 cheese tubbs, 2 kimnells, 4 cheese fatts & sutors, 1 pestle & morter, lead weights, shelves, earthenware and lumber	3	11	6
In the Brewhouse			
One copper furnace, 2 trays, 1 rearing fatt, 1 pair of bellows, pott hooks, 9 tubbs, 1 dresser, 3 wooden bowls, 2 wooden bottles, 2 pails, 1 gallon and lumber	5	9	0
Five kettles, 3 potts, 2 sauce pans	4	0	0

In the Little Parlour
One corner cubboard, 1 borameter, 2 tables, 1 punch bowl, 6 chairs, fender, tongs and fire shovell	1	10	0

In the Hall
One clock & case, 1 oval table, 1 long table, frame and forme, 6 leather chairs	3	17	6

In the Best Parlour
One ovall table, one square table, 3 chairs	1	0	0

In the Passage to the Cellar
Two saddles, 3 bridles, pillion and cloth	1	15	0

In the Pantry
One table, 1 salting tub, 3 woodon bottles, dresser and shelves	1	10	0

In the Cellar
Three large vessells filled with cyder	3	0	0
Nine barrells, thralls and 2 brass cocks	2	2	0

In the Chamber over the Hall
A parcelle of hops, 1 couch, 2 chairs, 2 hampers, 1 half strike, a parcell of linen & woollen yarn, a parcell of threshed wheat and lumber	6	6	0

In the Garretts
A parcell of apples & lumber	1	10	0

In the Chamber over the Parlour
One feather bed and bolster, curtains & vallens, bedstead, 2 blanketts & coverlid	7	0	0
One looking glass, table, window curtains, 1 stand, 5 cushions, 7 chairs, one chest of drawers, 1 picture	4	5	0

In the Closett adjoining
One feather bed and bolster, bedstead, curtains & vallens, 2 blanketts, 1 coverlid & 2 chairs	4	15	0
A parcell of new linen cloth	2	0	0

In the Cheese Chamber
A parcell of cheese, beame and scales, cheese shelves and frame	19	15	0

In the Chamber over the Brewhouse
Two flock beds & bedsteads, 2 pair of sheetts, five blanketts, 2 coverlids, 1 close stool and pan	2	5	0

In the Chamber over the Dairy
One malt garner, 1 hanging press, 3 coffers, 2 boxes, 2 bedsteads, old furniture, 2 old feather beds and bolsters, 2 pair of sheets, 4 blanketts, 2 coverlids	8	17	6

In the Chamber over the Kitchen
One hanging press, 1 chest of drawers, 1 bedstead & furniture, 1 feather bed & bolster, 2 blanketts & coverlid, 1pair of sheetts, 1 table, 2 chairs	4	10	0
3 Diaper tablecloths, 5 napkins do. [*diaper*]		18	9
5 Huckerback tablecloths, 12 napkins	1	15	0
16 Pair of sheetts	5	16	0
6 Pillow beers		6	0

In the Barnes
A parcell of threshed barley	9	0	0
A parcell of unwrought flax	1	0	0
30 Baggs, fann and frame, 1 piling iron, sieves, 2 shovells, 1 strike	3	10	0

In the Yards
A parcell of forks, rakes, sythes, 1 grinding stone, spades & shovells, billhook and hatchett	1	0	0
Two ladders, 2 cartropes, 1 spokeing chain, 7 flitting tyes	2	15	0
Three tumbrills £9, 3 waggons £30	39	0	0
Three pair of harrows, 3 ploughs & one role	6	10	0

In the Rick Yard
6 Ricks of wheatt, with threshed corn in three of them	206	14	0
Two ricks of barley	28	0	0

A piece of a rick of oats	5	0	0
2 Stumps of old hay	10	0	0
A parcell of new hay	10	0	0
A parcell of clover and ryegrass	2	10	0
Part of a rick of fitches	2	0	0
7 Staddles	8	0	0
Cattle			
Four store piggs	4	0	0
Eight horses & mares with their harnish	73	0	0
Two feeding cowes, 1 steer, 1 heifer	22	0	0
Six barron cows	22	10	0
Eleven incalved cows and a bull stag	59	2	6
Ten sturks	40	0	0
Seven year-old calves	14	0	0
Two ram shear hogs and 4 ram lambs	5	0	0
57 Store sheep	38	4	0
21 Feeding sheep	15	3	0
17 acres of wheat growing	20	0	0
A dunghill lying upon Hersall	18	0	0
Lumber and things omitted	2	0	0
	Total 987	3	9

Standing Buildings

Several of the inventories relate to earlier buildings which have already been described (e.g. Figures 20 [**21**] and 25), though they were often altered after 1700. At Bokendon Grange, Thomas Davis (1706) had made great improvements since the death of his predecessor Zachariah Grove (1693; 8 rooms), creating a dining hall and an extra storage room for the dairy (the 'little room' containing earthenware), as well as another chamber. Furzenhill Farm, Stareton had a much shorter history. It was a 180-acre farm created in 1682 on part of the Abbey demesne.[6] Its plan was old-fashioned, simply a long timber-framed range, though it has been extensively cased in brick and rebuilt and the detailed layout cannot be recovered. However the 13-room inventory of Edward Parsons (1722) lists just the same combination of functions as the other houses in this group. It is striking how their uniform organisation was achieved within very different structures. When this is coupled with the remarkable variety found in the plans of this period, it clearly becomes very difficult to deduce the type of house from the rooms listed in the inventory.

Generally in Warwickshire, the end of the 17th century saw great changes in farmhouse plans. Innovations starting with U-shaped houses rapidly developed into fully double-pile structures which by the early 18th century had also acquired entrance stair-halls. At the same time, brick superseded timber-framing as the main structural material. Figure 44 shows a selection of these plans drawn from near-by parishes. Although none of the houses shown can be precisely dated, those with lobby entry plans appear to be earlier than those with central stair halls. Ram Hall and Image House, Berkswell are both of the later 17th century, the period when lobby entries appeared briefly in smaller Stoneleigh houses (Figures 10, 26); the other examples probably date from after 1700. Surprisingly, despite the many new farms established in Stoneleigh in the later 17th century, such innovative plans only came into use there well after 1700.

A number of large farms whose houses may have belonged in this group occupied isolated sites in the Fletchamstead area. The expansion of Coventry over this part of the parish has led to their demolition without record. Some surviving Stoneleigh houses were rebuilt in these new styles rather after the period for which probate inventories survive, e.g. Canley Hall (Figure 45), Milburne Grange and Dale House Farm (rebuilt in 1777-9, following a fire). Happily, for one such new house the rooms can be identified even without an inventory. 16 Birmingham Road, Stoneleigh (Figure 46) was rebuilt in 1766-7, and accounts survive, measuring the brick walling,

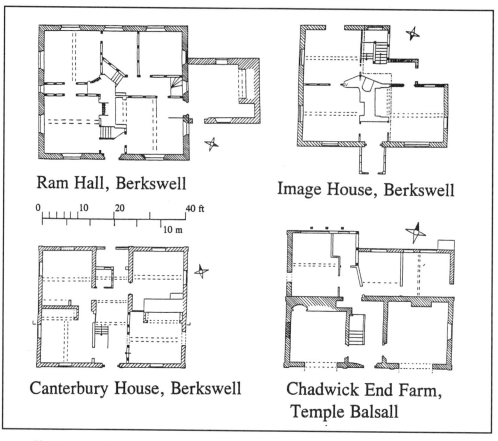

Ram Hall, Berkswell

Image House, Berkswell

0 10 20 40 ft
10 m

Canterbury House, Berkswell

Chadwick End Farm,
Temple Balsall

44 *Innovative plans in Warwickshire farmhouses of the late 17th and early 18th centuries.*

45 *Canley Hall, Canley in 1973. A typical late 18th-century symmetrically planned brick farmhouse.*

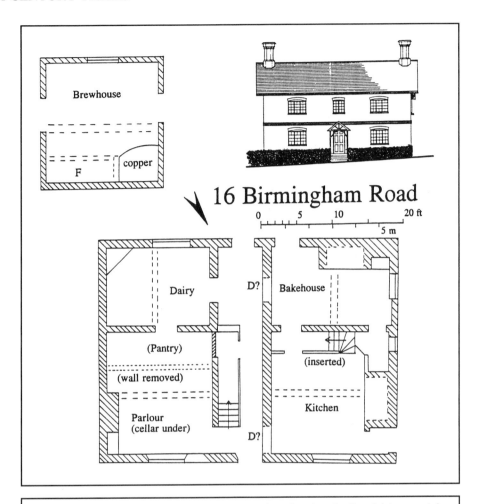

16 Birmingham Road

The brickwork has the characteristic 18th-century form found on the Stoneleigh estate (cf. Figure 10b), with segmental window arches (single brick-on-edge) and a raised plat band. It had four rooms on the first floor (and a small room over the passage), with attics above, and there is a vaulted cellar (brick arch) under the parlour. Some original internal doors survive, with two fielded panels; the internal doorways have arched heads. Surprisingly, the ceiling beams are exposed and have roll stops. The fireplaces are concealed, but presumably the kitchen and bakehouse had large openings, while the parlour chimney held a grate. The single-storey brewhouse at the rear survives unaltered apart from the removal of its big chimney.

Originally it served a 70-acre farm but it was later divided into two cottages, with a stair added, two internal doors blocked and the pantry wall removed. This must have been necessary because the building of the adjoining house to the east would have blocked whatever window the pantry had. The roof was entirely reconstructed (c.1840), changed from a hipped form with tiles, to a low-pitched slate roof; the chimneys were also rebuilt. The house was reconverted to one dwelling in 1971.

46 *16 Birmingham Road, Stoneleigh. Front elevation and plan as existing in 1971 before reconversion from two cottages to one house, with room names and reconstruction evidence from the 1767 building accounts. The brewhouse is shown in its correct position relative to the main house. Based on plans kindly loaned by Stoneleigh Estate Office.*

flooring, carpentry, plastering and roof work.[7] These give the original dimensions and names of all the rooms. The pattern of rooms corresponds closely to the 18th-century inventories, and is particularly similar to the next example.

New House Farm, Stareton (Figures 47a - c)

For one house we can match an inventory (**48**) with an innovative plan. New House (sometimes Stone House) was established in 1716 as a 300-acre farm on part of the former demesne land of Stoneleigh Abbey. The house was commissioned from the architect Francis Smith of Warwick, who was then working on the rebuilding of the west range of the Abbey. For the sum of

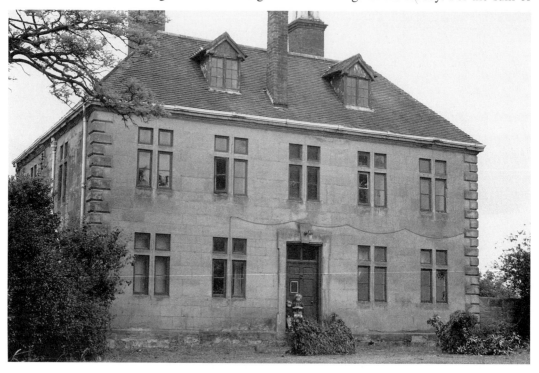

New House Farm was built in 1716. It is extremely plain, with the wall surfaces embellished only by the quoins, doorcase and cornice. The tiled roof is hipped all round, with a central valley. Interior doors have simple beads to their frames, and the only surviving doors have planks and battens.Although the ceilings were plastered, surprisingly the principal beams in Kitchen, Parlour and passage have chamfers and scroll stops, surely a very unfashionable feature by 1716; that in the Brewhouse is unchamfered. The original large Kitchen and Brewhouse fireplaces survive behind later work; The Brewhouse oven is concealed, and is not certainly original.The evidence for the original subdivision of Pantry and Dairy is clear from the stud mortices in the dividing beam, but their door positions are hypothetical; the position of the first-floor division at this corner is also uncertain.

The house was occupied by the Garlick family from 1716 until the death of George Garlick (a bachelor) in 1863, aged 75; his successor, Thomas Umbers (tenant until 1886) was a great-nephew. By 1863, the house no doubt seemed very old-fashioned, and it underwent a major reconstruction. This involved building on a new outer kitchen, brewhouse and dairy (since demolished) and converting the brewhouse into the main kitchen. The original kitchen became the dining room, and a 'smoke room', with corner fireplace, was created by enlarging the pantry.The stair was converted give a shallower flight, and as a result the door to the 'drawing room' had to be moved. The new room names are identified in a valuation of fixtures of 1886 (W.R.O. CR2433/31/290).

47a *New House Farm (later Stone House), Stareton, 1972. The house.*

£100,[8] he provided a building of some architectural style, but extremely plain, with cross-transomed windows lacking any decoration, as if cut straight through the stone walling (Figure 47a). For the plan, he simply chose a standard double-pile design with central passage and stair, as used in many 18th-century Warwickshire farms. It has undergone some alteration, particularly involving the staircase which must originally have been very steep, but the plan can readily be reconstructed and fitted to its description as a 15-room house in the 1728 inventory of Richard Garlick. When previously published, the house was considered to have had a hall which had been omitted from the inventory.[9] However the present analysis shows that the absence of a hall is not unexpected at this period. New House can be interpreted as having three main and two small

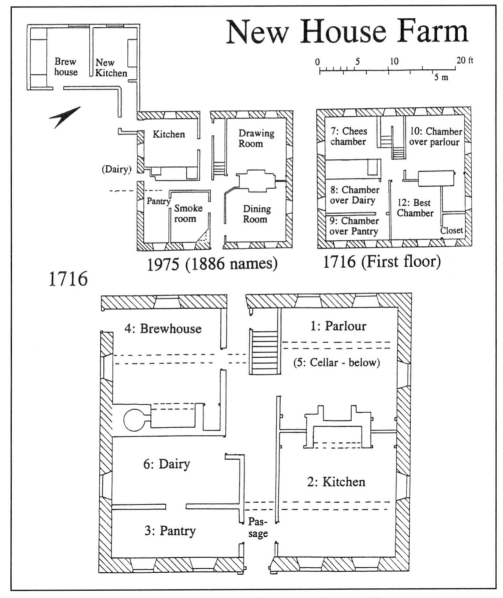

47b *New House Farm (later Stone House), Stareton. Plans.*

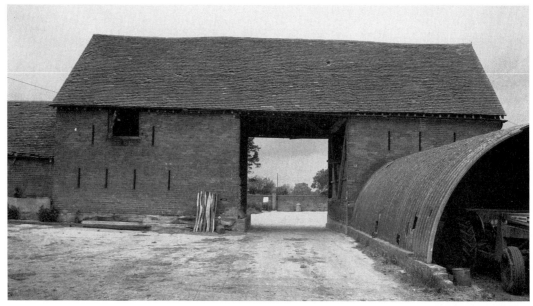

47c *New House Farm (later Stone House), Stareton, 1972. One of the two stone barns (since demolished).*

rooms on each floor, with one cellar placed under the parlour, giving that room the benefit of a boarded floor.[10] The two principal chambers had closets which still survive, rather uncomfortably produced by partitioning off one side of the best chamber.

48 *Richard Garlick, yeoman (1728)*

He was probably born in about 1690 and possibly married in about 1717, when he became the first tenant of the newly built New House Farm. His father was George Garlick, also a yeoman and a Leigh tenant in Stoneleigh village from *c.*1690 until his death in 1716. Richard had four children, George (born 1719), Mary (1722), Richard (1723) and Elizabeth (1728), and the bulk of his goods were left to his brother Thomas and another kinsman, to be held to the use of his widow Elizabeth and son George. Two of the witnesses of his will, Mary Ingram and Elizabeth Palmer, were probably his maid servants. Another member of his household was Thomas Eeds, a parish apprentice, aged nine in 1727 when he ws indentured.

Inventory appraised by Joseph Russell, Thomas Congrave (brothers-in-law of Richard Garlick), 5th September 1728.

Wearing apparrell and money in purse	5	0	0
In the Parlour			
Two tables, 1 clock, 1 grate, 3 pair of cobb irons, 6 chairs, 1 stool, 6 pictures	4	0	0
In the Kitchen			
Two tables, 6 chairs, one jack, 2 warming pans, 3 spitts, 1 coffee pot, 4 brass candlesticks, 3 iron candlesticks, 1 mortar and pestell, 1 chaffing dish, 1 fire shovell, 1 pair of tongs, 1 plate iron, 2 drudging boxes, 1 pair of potthooks, 1 salt box, 1 cradle, 1 bacon rack, 2 flitches of bacon, 1 pair of bellows, 1 gun, 1 stool	5	0	0
In the Pantry and Passage			
One leathern bottle, 1 wood bottle, 1 lanthorn, 1 table, 3 chairs 1 stool, 1 dozen of tinn patty pans, 18 plates, 12 pewter dishes with earthen ware and other things	3	0	0

In the Brewhouse
Two boylers, 3 potts, 3 kettles, 1 dough tubb, 6 other tubbs, 1 pair of potthooks,
1 buckett and chain with other odd things

6	10	0

In the Cellar
Fifteen barrells & 5 thralls

| 4 | 0 | 0 |

In the Dairy
Two brass pans, 2 cheese presses, 1 churn and staff, 3 milk tubbs, 4 pailes,
2 dressing sieves, 4 shelves, 1 powdering tubb, 12 trenchers with other things

| 3 | 15 | 0 |

In the Cheese Chamber
One wheel, 1 coffer, 6 boxes, wool, flax, cheese and cheese boards

| 24 | 0 | 0 |

In the Chamber over the Dairy
Two flock bedds & bedsteads with blanketts and sheets & 1 hundred of cheese

| 2 | 5 | 0 |

In the Chamber over the Pantry
Two flock bedds & bedsteads, with blanketts and sheets, 1 chair, 1 stool

| 2 | 0 | 0 |

In the Chamber over the Parlour
An iron beam and scales, 2 feather bedds, 2 bedsteads with curtains, vallence,
sheets and blanketts on them, a close stool & pan, 1 hanging press, 1 table,
1 chest, 1 box, 6 chairs, 1 brass fire shovell, tongs and fender, 1 pair of bellows,
window curtains and a brace of pistolls

| 9 | 15 | 0 |

In the Closett adjoyning
One flock bed with blanketts and sheets thereon, one chair

| | 12 | 0 |

In the Best Chamber
One feather bed, bedstead, curtains, sheets and blanketts, 1 chest of drawers,
1 looking glass, 2 tables, 6 cane chairs, 1 brass fire shovell and tongs, 20 pair of
sheets, 1 side saddle, 30 pounds of linnen yarn, 4 dozen of napkins, 12 table
cloths, 6 silver spoons, 1 silver cup

| 30 | 0 | 0 |

In the Closett adjoyning
Bottles and boxes & a piece of hurden cloth

| 1 | 1 | 0 |

In the Garretts
One malt garner, 1 strike and strickless [sic], 20 baggs, 3 sieves, 3 bags of pease,
2 quarters of oats

| 5 | 10 | 0 |

In Lechmore Barn
One whole bay & half of flax

| 36 | 0 | 0 |

Grain and hay, two ricks and 1 bay of hay

| 30 | 0 | 0 |

Three ricks of wheat and maslin and one bay in the Corn Barn

| 225 | 0 | 0 |

Two bays of barley in the Barley Barn and one bay of barley in the Corn Barn

| 62 | 0 | 0 |

Two ricks of pease and one rick of vetches in the Rick Yard

| 55 | 0 | 0 |

Three ricks of oats at both ends of the Barley Barn and part of a rick of old oats

| 75 | 0 | 0 |

Living Cattle
Six horses, 8 mares & 3 colts, with traces, saddles, holms, collars, bridles,
cart saddles and all kind of harnishing

| 100 | 0 | 0 |

Twenty two milch cows and one bull

| 74 | 0 | 0 |

Five heifers

| 17 | 0 | 0 |

Nine sturks

| 18 | 0 | 0 |

Fourteen rearing calves

| 14 | 0 | 0 |

One hundred and nine sheep and lambs

| 50 | 0 | 0 |

Three hogs, four sows and 13 younger piggs

| 21 | 0 | 0 |

Poultry as turkeys, geese, ducks and hens

| | 15 | 0 |

In the waggon hovell
Two waggons, 2 tumbrills, 2 old wheels, an old tumbrell barge, old axle trees,
and other lumber

| 16 | 0 | 0 |

In the Gatehouse
Two old waggons, a pen and standard

| 5 | 5 | 0 |

In the Yards
Seven tons of coales

| 6 | 10 | 0 |

Eight cow cribbs	1	0	0
One role, 7 harrows, 4 plows, 2 cartropes, 2 hoppers, 4 swingle trees	5	5	0
3 stone pig troughs in the <u>Yard</u> and 2 in the <u>Pig Stys</u>	0	6	0
Dung in the <u>Yards</u> and Dunghill in the White Feilds	15	0	0
Offall straw in the <u>Rick Yard</u>	1	0	0
Ash and oak timber in the yard	8	10	0
Forks, spades, shovells, axes, hammers and old iron	1	5	0
Money in hand and upon bond	60	0	0
Other good and bad debts	60	0	0
Lumber and trash and things forgott	5	0	0
Total	1069	14	0

In both room use and contents, this inventory is typical of the large 18th-century houses, with its living parlour, kitchen and brewhouse, service rooms and garrets. Richard Garlick was well provided with comfortable furnishings, though he did not have many notable luxuries apart from his pictures, his silver cup and his cane chairs. In a wider view, the identification of New House and its inventory is important in showing that houses of this size, though not necessarily of this layout, are characteristic of the most prosperous Stoneleigh farms.

Notes

1. M. W. Barley, 'Glossary of names for rooms in houses of the sixteenth and seventeenth century', in I.Ll. Foster and L. Alcock (eds.), *Culture and Environment,* Routledge, 1963, p.489.
2. They were warreners, living in the lodge on Westwood Heath.
3. This may often have been Ticknall ware, like that listed in the middling inventories (p.97), though at this social level its place of origin was of no interest.
4. A term never found in Stoneleigh. It was used at a somewhat higher social level, for example in the inventory of Sir Clement Fisher of Packington Old Hall in 1683 (PRO.PROB4/3441).
5. Meigh's assessors passed over the garrets, and also the buttery and backhouse (though not the chambers over them).
6. SBT.DR18/1/807.
7. SBT.DR18/17/15/2-4. It is not clear whether the work went on mainly in 1766 or 1767, as these accounts are dated alternatively January 1767 and January 1768. Building in 1767 is the more likely, except that the 1766 map shows the plan of the house in its new form.
8. SBT.DR18/3/47/38 is the building contract.
9. *Ag. Hist.*V(ii) p.646.
10. The possibility of a brewhouse being included within the main structure is confirmed by the contemporary plan of a house at Kingsbury, N. W. Alcock, 'Warwickshire Timber-framed Houses: a Draft and a Contract', *Post-Medieval Archaeol.,* 9, 213-218 (1975). It also has the cellar under the parlour.

Table 8.1: *Eighteenth Century Farms: Eight rooms and over, 1701-71**

Date	Name	Status	Hld	Loc	Acr	£	Rooms (and Farm Buildings)
Eight Rooms							
1730	Joseph Austin	Yeoman		Hu		170	Kitchen, Parlour, Buttery, Chamber over Kitchen, Chamber over Buttery, Chamber over Parlour, Newhouse, Newhouse Chamber
1728	Mary Ball	Widow				61	[Hall], Little Chamber, Kitchin, Dairy, Bed Chamber, Chamber over Hall, Chamber over Little Parlour, Shopp, (lumber over Shopp)
1706	Jane Barrs	Widow	105	Fl	74	211	Kitchin, Dehouse, Parler, Little Parler, Mans Chamber, Little Chamber, Cheese Chamber, (Corn) Chamber; Barn
1702	John Barrs	Husbandman /Yeoman	107	Fl	19	138	Old Parlour, Kichin, New Parlour, Buttery, Dairy Hous, Chamber over New Parlour, Chamber over Kichin, Chees Chamber; Barn
1716	George Garlick	Yeoman	5	S	104	387	Parlour, Hall, Citchin, Cheas Chamber, Darey House, Over the Darey Hous, Over the Hall, Over the Kitchine
1708	Zachariah Groves	Yeoman (Husbandman)	79	I	348	459	Chichin, Parlour, Chamber over Parlour, Chamber over Buttery, Chamber over Chiching, Chamber over Entry, Cheese Chamber, [Buttery]; Barn
1706	Laurence Hands	Warrener	90	I	22	40	Littell Roome, Parlor, Hall, Kitching, Buttry, Chamber over Parlor, Chamber over Hall, Chamber over Kitching
1740	Benjamin Higginson	Husbandman	73	I	87	302	Kitchen, Brewhouse and Buttery, Dairy, Parlour, Chamber over Dairy, Chamber over Kitchen, Cheese Chamber; Barns, Hovell
1746	John Higginson	Yeoman	95	Fl	89	169	Kitchen, New Room, Meal House, Dairy, Parlour, Cheese Chamber, Kitchen Chamber, Garrett; Barns, Hovell, (additional) Barn, Hovel
1771	Thomas Stoakes	[Carpenter]	49	A	14	-	Kitchen, Dairey, Tub House, Litle Pantry, Cheese Chamber, Boys Room, Girls Room; (no farm goods listed) (SBT.DR18/33/23-4)
1741	William Ward		40	A	(24)	163	Kitchin, Parlour, Pantry, Dairy, Back Kitchen, Room over Parlour, Cheese Chamber, Chamber over Brewhouse
Nine Rooms							
1724	Francis Casemore	Yeoman	56	St	153	400	Chamber where he lay, Best Chamber, Servant Mens Room, Maids Roome, Parler, Dary, Kitching, Buttrey, Fire Room; Barn, Stable
1731	Robert Davies		54	A	71	100	Kitchen, Parlor, Cellar, Brewhouse, Dairey, Buttery, Chamber over Brewhouse, Chamber over Kitchen, Chamber over Parlor
1717	John Franklin	Husbandman	81	Hu	63	254	Dwelling House, Dairy, Back Roome, Chamber over Kitchen, Chamber over Dairy, Chamber over Entrey, Chamber over Back Room, Cocklofts
1719	John Harbutt	Yeoman	X5	H		267	Kichen, Little Parlor, Great Parlor, Dairy, Chamber, Another Chamber, Another Chamber, Great Chamber, Another Little Room
1731	Richard Stokes	Yeoman	57	St	87	305	Kitchen, Brewhouse, Dairy, Cheese Chamber, Chamber over Brewhouse, Cellar, Parlour, Chamber over Parlour, Chamber over Kitchen; Barn, Barn in fields
1729	Thomas Watson	Yeoman	85	Hu	103	172	Kitchen, Buttery, Brewhouse, Dary, Kitchin Chamber, Chamber over Bruhouse, Chamber over Buttery, Garret, Cheese Chamber, (Starecase)

Inv	Date	Name	Status	Hld	Loc	Acr	£	Rooms (and Farm Buildings)
		Ten Rooms						
	1701	Joseph Barrs	Husbandman /Yeoman	106	Fl	112	282	Great Parlour, Little Parlour, Hall, Kitchen, Buttery, Cheese Chamber, Chamber next to it, Chamber over Hall and Kitchen, Millhouse, Chamber over it; Barn, Stable
	1721	James Hands	Yeoman	90	I	22	116	Parlour, Chamber over Parlor, Chamber over Brewhouse, Chamber over Kitchen, Farther Chamber over Little Parlour, Dary, Little Parlor, Kitchen, Brewhouse, Sellar; Barn, Hovell, Pigstie, Stable
	1778	Charles Heath	Widower/ (Park-keeper)	1a	I		1273	Left hand room on the great staircase, Room fronting the staircase, Back staircase front room on left hand, Bedchamber on the right hand, Bedchamber on the left hand, Kitchen and Scullery, Brewhouse and wash house, cellar, venison house; Stable and outhouses [PRO.PROB31/658/ 400]
	1728	Edward Higginson	Yeoman	95	Fl	89	201	Kitchen, Parlor, New Room, Buttery and Dairy, Chambers over Parlour and Kitchen, Cheese Chamber, Eaves, Millhouse
	1738	John Perkes	Yeoman	91	I	129	231	Kitchen, Dairy, Parlour, New Room, Two Butteries, Chamber over Kitchen, Cheese Chamber, Lean Too, Chamber over Parlour; Cart Hovels
		Eleven Rooms						
46	1720	John Barr	Yeoman	106	Fl	112	609	Kitchen, Hall, Little Parlour, Pantrey, Great Parlour, Back Kitchen, Best Chamber, Chees Chamber, Cock Loft, Servants Room, Chamber over Kitchen; Old House; Barn, Sty
	1733	John Bars	Yeoman	106	Fl	112	341	Kitchin, Hall, Little Parlor, Great Parlor, Brewhouse, Mill House, Dairey, Chamber over Brewhouse, Chamber over Kitchen, Best Chamber, Cheese Chamber; Further House
	1730	Edward Casemore	Yeoman/ Husbandman	56	St	153	309	Dwelling House, Parlor, Pantry, Brewhouse Dairy, Cellar, Chamber over House, Chamber over Parlor, Two other Chambers, Cheese Chamber
	1706	Thomas Davis	Yeoman	93	Hu	149	269	Hall, Parlor, Kitchen, Dairy, Little Roome, Meale House, Chamber over Kitchin, Cheese Chamber, Felows Chamber, Chamber over Hall, Little Chamber; Barn
	1730	Mary Herbert	Widow	X5	H		253	Parlor, Entry Chamber, Chamber over Kitchen, Garner, Cheese Chamber, Hall Chamber, Furthest Parlor, Dairy, Bakehouse (=Kitchen?), Old Dairy, Dwelling House; [Barn, *deduced from corn counted in 'bays'*]
	1718	John Scotton	Yeoman	101	Fl	251	268	Kitchen, Back Kitchen, Hall, Celear, Parlour, Best Chamber, Closet Chamber, Hall Chamber, Chamber next to it, Cheese Chamber, Swan Chamber
		Twelve Rooms						
	1742	Edward Casemore	Innholder	9	St	79	184	Lodging Roome, Well Chamber, Kitching, (Starecase), Long Parlour, Bruehouse, Green Roome, Green Roome Closset, Chamber over Long Parlour, Chamber over Starehead, Mudflore Chamber, Weel Chamber, Sellar; Barn, Stable, Gatehouse
	1755	Richard Hands	Warrener/ Husbandman	90	I	22	98	Kitchen, Pantry, Litle Roome, Parlour, Chamber over Parlour, Over the Kitchen, Little Chamber, (Staircase), Little Chamber over Pantry, Over the Brewhouse, Brewhouse, Dairey, Cellar; Barne

Inv	Date	Name	Status	Hld	Loc	Acr	£	Rooms (and Farm Buildings)
	1713	William Meigh	Husbandman	100	Fl	193	601	Parlor, Kitchen, Dairey, Brewhouse, Cellar, Little Room, Chamber over Parlour, Maids Chamber, Best Chamber, Porch Chamber, Cheese Chamber, Garret; Barn

Thirteen Rooms

Inv	Date	Name	Status	Hld	Loc	Acr	£	Rooms (and Farm Buildings)
	1714	Francis Clayton	Husbandman	2	S	183	295	His Roome, Parlor Chamber, Hall Chamber, Kitchin Chamber, Cheese Chamber, Corn Chamber, Backhouse Chamber, Parlor, Hall, Kitchin, Backhouse, Deary, Sellar; Haybarne, Barne
	1709	Thomas Hart	Gentleman	101	Fl	251	466	Hall, Parlour, Kitchen, Back Kitchen, Pantry and Millhouse, Cellar, Room over Parlour and Closett, Room over Hall, Room over Kitchen, Room over Back Kitchen, Cheese Chamber; Barne, Stable
	1722	Edward Parsons	Yeoman	68	I	182	727	[Hall], Parlor, Pantrie, Back Kitchin, Dairy House, Parlor Chamber, Hall Chamber, Pantry Chamber, Kitchin Chamber, Cheese Chamber, Cockloft Chambers, Little Chamber called the Staire Chamber; Barn
	1727	John Webster	Yeoman	78	Ca	100	660	Hall, Parlour, Kitchen, Brewhouse, Cellar, Best Chamber, Hall Chamber, Grove Chamber, Little Chamber, Kitchen Chamber, Court Chamber, Wele House Chamber, Cheese Chamber; Barn

Fifteen Rooms

Inv	Date	Name	Status	Hld	Loc	Acr	£	Rooms (and Farm Buildings)
48	1728	Richard Garlick	Yeoman	67	I	291	1069	Parlour, Kitchen, Pantry and (Passage), Brewhouse, Cellar, Dairy, Cheese Chamber, Chamber over Dairy, Chamber over Pantry, Chamber over Parlour, Closett adjoyning, Best Chamber, Closett adjoyning, Garretts; Two Barns, Waggon Hovell, Gatehouse

Seventeen Rooms

Inv	Date	Name	Status	Hld	Loc	Acr	£	Rooms (and Farm Buildings)
	1705	Joseph Symcox	Gentleman (Esquire)	78	Ca	100	1391	Hall, Parlour, Kitchen, Dairy House, Beer Buttery, Strong Beer Buttery, White Chamber, Chamber over Parlour, Greene Chamber, Maids Chamber, Chamber over Kitchen, Mans Chamber, Cheese Chamber, Garretts, Malt Garner, Wool Chamber; Barn

Eighteen Rooms

Inv	Date	Name	Status	Hld	Loc	Acr	£	Rooms (and Farm Buildings)
47	1745	John Atkins	Yeoman/'Mr'	101	Fl	251	987	Kitchen, Meal House, Dairey, Brewhouse, Little Parlour, Hall, Best Parlour, (Passage to Cellar), Pantrey, Cellar, Chamber over Hall, Garretts, Chamber over Parlour, Closett adjoining, Cheese Chamber, Chamber over Brewhouse, Chamber over Dairy, Chamber over Kitchen; Barns

Larger

Inv	Date	Name	Status	Hld	Loc	Acr	£	Rooms (and Farm Buildings)
	1710	Thomas Lord Leigh		1	I		4027	70 Rooms (SBT.DR18/4/6)
	1738	Edward Lord Leigh		1	I		4822	105 Rooms (SBT.DR18/4/9)
	1749	Thomas Lord Leigh		1	I		3354	100 Rooms (SBT.DR18/4/20)

* For notes, see Table 4.1, p.53.

Chapter 9

Homes but not Houses

Of the 430 Stoneleigh probate inventories, the 307 which give room names clearly describe working households. At least one third of the remaining inventories relate to people who made their homes in other people's houses. Sometimes they owned no more than their clothes and a bundle of bonds for money out on loan. Bridget Osborne of Canley, widow, who died in 1708, is characteristic. Her inventory (**49**) is the simplest possible.

49 *Bridget Osborne, of Canley, widow (1709)*

Inventory appraised by John Warner and Robert Harper, 16th January 1708[/9]. She was buried on 18th December 1708.

Her purse and apparrell	5	0	0
Money at interest due upon bond	150	0	0

She probably lodged with her cousin William Holbech of Canley, to whom she left the residue of her money after making substantial gifts to three other relatives. Her main legacy, £4 a year for life, to her brother William Christopher, represented a large proportion of her estate, as it can be equated to £80 at 5 per cent interest.

Quite often, as with Bridget Osborne, the only record of these lodgers is at their death, suggesting that they were recent arrivals in the parish, returning perhaps after many years away. However, the available evidence is so strongly biased towards tenants and householders, that this conclusion can only be tentative.

The opposite in every respect to Bridget Osborne was Joyce Phillips, widow of Henry Phillips, a fuller of Hill.[1] At her death in 1668, she had what seems to be a full set of household goods spread between the houses of George King of Coventry, John Gamble and Frances Phillips, widow, of Hill, and her two sons Henry and Edward Phillips of Stoneleigh (where she was lodging). Her nuncupative will implies a sad estrangement from her family, relating how she sent for Edward Stirton the tailor of Stoneleigh, 'a very honest understanding man'; she said to him: 'I have noe friende neere me but you', and declared that her grandchild should have £10; her son Edward should 'bring me home' (pay for her funeral); the rest of her estate was to be divided between her children; 'shee being then weary with speaking sayed no more'.

Inventories for widows living as lodgers are rather fewer than for householders. However, because only a small proportion of widows left inventories (p.17), this may underestimate the fraction who did not continue farming after their husband's death. Sampling of the estate rentals for farms in Stoneleigh village (holdings with 10 acres of land or more) in the periods 1601-40 and 1701-50 shows that about a third of male tenants were succeeded by their widows. This figure is a minimum, because a woman remaining as tenant was only recorded if she neither died, remarried, nor moved before the next rental was taken. Rather fewer cottage tenants were widows (about 15 per cent, e.g. 13 of the 92 in 1807). Allowing for male tenants who were either single or widowers, it seems that the inventories give a true picture of the widows who became farming tenants. The small number of their inventories can partly be explained by the husbands' wills which left the household goods to their widows for life only.

164

Widows who lived as lodgers are matched by a group of single women, and unexpectedly by one wife. Mary Harris (1615) was able to bequeath the bed, chest and linen itemised in her inventory because of the agreement she made with her second husband on their marriage, that she should retain the goods from her first marrriage. The spinsters are an enigmatic and poorly documented group who appear mainly to comprise maiden aunts whose chambers were comfortably equipped (**50**), and whose occasional wills included small bequests to innumerable nephews, nieces, cousins, godchildren, and friends. However, few of them left wills.

50 *Susanna Colman, 'spincer' (1641)*

She left no will, but Thomas Hoo (son of James Hoo; see **14**), her 'brother' was her administrator (with his brother Alexander). Although James Hoo's will names a daughter Susan, Susanna was more probably Thomas's sister-in-law. The administration grant also names Henry and Maria Coleman, minors, who were probably her heirs; they may have been a brother's children.

Inventory appraised by Edward Maunsell, Alexander Hoo, fuller and John Poours, joyner; proved 20th January 1641/2.

On band of £9 and the use unpayd for 3 yeers past	11	0	0
On other band £6 and the use unpayd for 3 yeers past	7	7	0
On cow and a calfe	4	0	0
A deske		3	4
2 Littell boxes		1	6
On standing press		6	0
2 Trunckes & a warminge pan		15	0
2 Boxes & on desk		5	0
On platter & other peuter		2	0
2 Gownes & on aperin	1	10	0
2 Peety coates		13	4
On feattherbed ticke, 2 pillowes, on boulster	1	0	0
On bible & other bookes		10	0
On dosen & a halfe of napkins		10	0
2 Pillow beers		4	0
3 Paire of sheetts & a table cloth	2	0	0
One skerss [*searce = sieve*] & 3 barrels, on wollen whelle		7	0
On loade of hay		10	0
On load of wood		5	0
Total	31	9	2

Among the men we find three groups of lodgers. Corresponding to the widows were old men whose names sometimes still occur in the rentals, but whose inventories reveal clearly that they had handed over control of their farm. Typically for this group, George Gregory (1628) (**51**) had almost his entire assets in the form of debts. It is much less typical for them to be listed in such revealing detail (including an unexpectedly desperate debt from the wife of the vicar of Stoneleigh), illuminating the network of economic relationships both within and beyond the village.

51 *George Gregory (1628)*

He died intestate (administrator unknown as the Act book is lost). He was probably not a member of the Gregory family of Stivichall, but his own family connections have not been identified.

Inventory appraised by Henry Wilkes, Richard Gregory; 14th April 1628.

Millers band of Princethorpe for £3 6s 0d whereof he hath proved payment of all but	1	0	0
A band of Smith of Stychall for	6	0	0
A band of Lee of Hurst [*Probably Edward Lee, tenant of South Hurst Farm from 1625]*of £4 for	2	0	0

A bill of Jervis *[Edward Jarvis, tenant in Stoneleigh from 1613,*			
possibly a gunsmith like his father and uncle]	1	0	0
A bill of Garnett *[Henry Garnett, cottage tenant in Stoneleigh from 1606]* for	1	0	0
Chaplin of Stonley *[Nicholas Chaplin, cottage tenant in Stoneleigh from 1614]*		15	6
On Browne of Cubbington	1	0	0
Widdow Shorman *[tenant of a quarter yardland holding in Stareton]*	1	0	0
Total	7	15	6

This is good debt

Mistris Billingham *[wife of the vicar of Stoneleigh]* oweth	3	0	0
On Fither	1	0	0
Hughe Crosse *[cottage tenant in Stoneleigh from 1613]*		15	0
Mr Wildinge *[possibly Humphrey Wilding of Leek Wootton]*	1	12	0
Buckbyes band for	2	4	0
Wastes band for	2	10	0
Kinges band for	2	10	0
Frannces Dytoe *[A weaver, a young man in 1628; tenant of Fir Tree Cottage,*			
Ashow until 1662]	2	0	0
Taylor of Hurst *[Possibly Humphrey Taylor (not the tenant of Fletchamstead Hall)]*		10	0
Brunt of Stychall	2	0	0
Thomas Gregory owes	1	0	0
Smith of Stychall owes		9	0
Widdowe Jessey *[Widow of John Jessey, a prominent inhabitant of Fletchamstead]*			
owes	1	10	0
Total	21	0	0

All this is very desprate debt

A coffer a boxe		2	0
His wareinge apparell		10	0

A more unusual record is that of George Hubbold (**52**), an Ashow yeoman who was tenant of a 77-acre farm (holding 36) from 1613 till 1638, when he was succeeded by Francis Eburne, his son-in-law (identified in the probate grant). At his death in 1646, his total possessions were some rather smart clothes, a bible and a trunk, all no doubt in one of the rooms of his old house.

52 *George Hubbold of Ashow [yeoman] (1640)*

Inventory appraised by Thomas Stringfield, rector, Richard Hobley, Thomas Tyme, 14th November 1640.

One bible, one trunke with ten shillings in his purse	1	10	0
Two hattes, foure capps, two ruffes, foure fauling *[falling]* bandes with six paire			
of cuffes, foure handkerchiefs, foure shirtes	1	0	6
Foure shutes of apparrell, two clokes and three coates, foure paire of stockinges,			
two paire of shoes, two paire of bootes, two paire of gloves with some other			
implements	7	10	0
Total	10	0	6

The second group of inmates were servants. Many worked at the Abbey, including Lord Leigh's coachman, his porter, and his keeper (owning three guns, a pistol, a rackbow, and two gafflebows [*crossbows*]), with others whose posts are unspecified. Among the latter, the inventory (1707) of Thomas Dale, gentleman, included the extraordinary sum of £420 in ready money; nothing is known of him, apart from the links revealed in his will with the Casemore and Hartley families in Stoneleigh.

A few lesser servants are identified from their wills, like Richard Alibone (1740) who appointed 'my Mistress Garlick which I now dwell with' as executrix. Mistress Garlick was

Elizabeth, the widow of Richard Garlick of New House Farm (**48**). Similar wording identifies James Hickin (1717) (**53**) as one of Richard Garlick's servants. His status of labourer in the inventory is belied by his wealth, but probably indicates his role on the farm. His two sheep probably ran with the New House flock.[2] He left Sary Garlick (Richard's sister) £30, his largest bequest outside his family, hinting at a romance cut short by death. Five years later, she married one George Grendon.

53 *James Hickin, labourer (1717)*

Inventory appraised by William Hickin, Henry Yarwood; 23rd April 1717.

The testators wearing apparrell		5	0	0
Ready money in his pockett			4	6
Two sheepe			10	0
In seperate debts		227	0	0
Total		232	14	6

The servants are not totally distinct from an interesting small group of lodgers who were also craftsmen. These include a fuller, Alexander Leake (1610) who worked for Humphrey Hoo (**14**), but owned his own tenters and shears.[3] Stephen Aston (1692) was a weaver living in the house of Zachariah Grove (Cryfield Grange), but not apparently in his employ. He owned the tools of his trade, 'two loomes, geares, warping fatt and barrs', valued at £5 15s. 2 ½d., which he bequeathed to his brother John Aston of Berkswell, another weaver. The most unusual member of this group was Thomas Lee of Hurst, 'yeoman and single person' (1722) (**54**), who apparently carried on the trade of charcoal merchant with considerable success. He left his possessions equally to his brothers Edward and William, with the latter to have the team, charcoal bags and waggon.

54 *Thomas Lee of The Hurst, 'yeoman and single person' (1722)*

Inventory appraised by William Thompson, Job Bates; 13th December 1722.

Purse and apparrell		10	0	0
Seaven working mares and geldings with one waggon, charcoall baggs and implements belonging to the said teem		45	0	0
Book depts		61	4	4
One chest or coffer and one box			5	0
Total		116	9	4

He was 28 years old and had probably lived with his father (another Thomas Lee) and stepmother at South Hurst Farm; she had succeeded as tenant after the former's death a few months earlier.[4]

Only occasionally do we have glimpses of another sort of lodger, poor 'inmates' whose presence in the parish was severely discouraged by the manor court for fear they would obtain a settlement. Francis Dito of Ashow, for example, was ordered in 1662 to 'avoid his house of a traveller' within a week. A general order was made in 1681 that no inhabitants were to lodge any travellers above two nights (reduced in 1739 to one night) or beggars above three nights in a month.

Servants, Households and Beds

Servants being as a group both relatively young and poor are very incompletely revealed by the probate evidence. They were occasionally admonished for their antisocial activities.

It is ordered that for as much as mens servants in the town of Stoneleigh have unduly gathered themselves to feast and banquet, as well to the wastinge of their masters goods as

their own and, by reason of the sufferers thereof, have uncivilly disordered themselves by walking abroad in the night time with uncivil songs of ribaldry to the disquiet and offence of the neighbourhood by very base and unseemly usage and misdemeanors, to the great offence of many, that no inhabitants of this town by day or night shall give entertainment to other mens servants to feast or banquet, but at their own charge and not any time after eight of the clock at night, and that no servant shall walk abroad in the night time and after eight of the clock without having special business or occasion of their masters household, and every one to forfeit for every offence 10s. [*Manor*, 1607]

However neither these references nor their occasional probate records give a clear view of their place in village society. A small clue comes from a statistic obtainable from the inventories as a whole: how many beds each household possessed. Median values are given in Table 9.1 with, for comparison, the number of rooms in which beds are found (subdivided by holding size, as in Chapter 11).

Table 9.1: *Beds and Chambers**

		1530-1600	1601-50	1660-1700	1701-50
Cottages	Beds	3	3	2	2
	Rooms with beds	1	2	2	2
Smaller	Beds	3	3	3	3
Farms	Rooms with beds	1	2	2	3
Larger	Beds	4	8	5	6
Farms	Rooms with beds	3	4	3	4

* Median values for inventories relating to identified holdings; size divisions as in Chapter 11. Sample sizes (by period): Cottages: 7; 19; 10; 8. Smaller farms: 15; 27; 16; 27. Larger farms: 23; 23; 28; 32.

These figures should not be regarded as very precise because of the obvious problems involved in their compilation, in particular whether 'bedsteads' or 'beds' (mattresses) should be counted. For the most part, these correspond, though some large houses had bedsteads in odd rooms without any bedding, that must have been out of use. Bedding without bedsteads was also rare, though some of the recorded bedsteads were probably no better than Elizabeth Addington's 'two beds of bords nailed together' that accompanied her joined bed (1664). The notable exception to this equivalence is the regular listing of one bedstead but two beds in best chambers. It is unlikely that one mattress would lie on the floor there, where lesser rooms had beds and bedsteads together. The explanation is found in Humfrey Hoo's inventory (**14**) where the bedstead in the 'chamber beneath the entry' had on it 'one feather bed, one flockbed, three blankets, one hilling, two bolsters and a pillow'.

Truckle beds (or trundle beds, sliding under a high bedstead), often supposed to be standard furnishings in the 16th and 17th centuries, were surprisingly rare, with only 20 references in 220 inventories; they were found at all periods, most often but not exclusively in the larger houses.

One cannot, of course, determine household size from the number of beds, unless the number of people sleeping in each bed is known. Indeed, the reverse calculation is probably more useful. If the households on the smaller holdings contained the expected 4-5 people, then each bed must have been used on average by two people. It is more informative to compare *relative* household sizes. We can reasonably assume that few cottage households extended beyond the family itself. The table indicates that the same must have been true for the smaller farms throughout the period. Thus these also were *family* holdings.

In the 16th century, larger farms typically had one more bed than the smaller ones, suggesting the employment of one or two servants, an impression consistent with the occasional

mention of mens' or maids' chambers. A few households stand out: two with six beds, one with seven and a truckle bed, and one with 11 bedsteads and 17 beds! What use Thomas Dunton of Stoneleigh Grange (1580) made of these is beyond surmise; they must surely have far exceeded the farm's needs. Unfortunately the inventory does not list the rooms in full, so we do not know how the beds were arranged.[5]

After 1600, the number of beds on large farms increased sharply. Even if they were not all used regularly (as suggested by the occasional bedsteads without bedding), this must reflect an increase in household size, with more servants living in. Improved comfort and privacy may also have led to more people having their own bed rather than sharing one. We can perhaps associate the modest reduction after 1660 with the growth of cottages in Stoneleigh, suggesting that the labourers employed on these farms were more often living out. In one respect the large farms apparently provided less privacy than the smaller ones. Their bedchambers more often held more than one bed, while houses on the smaller holdings typically only had one bed in each room. However, as more people seem to have had a bed to themselves, the final result was probably much the same.

The special requirements of the inn at Stoneleigh were met by its 5-6 bedchambers, with a total of 7-10 beds (according to its four 17th- and 18th-century inventories). Thus it was similar in this respect to one of the larger farms.

Notes
1. P.C.C. will, 1660; present in the Suitor lists from 1650.
2. The ownership of a few sheep or a cow and calf was common among single men and women (cf. **50**).
3. *Stoneleigh Villagers*, p. 46.
4. Edward Lee the cottager (**43**) was probably his cousin.
5. The 1522 muster [*Manor*, 85], which provides the only direct evidence for the numbers of servants in the 16th century, confirms their relative rarity, with only five out of 41 households including able-bodied male servants.

Part III
Community and Village

Chapter 10

Benchmark Years: Population and Growth

In Part III, the evidence for Stoneleigh and Ashow is used to provide a quantitative background to the impressions gained in Part II of individual people and their homes. The starting point is an examination of how the population of the two villages grew and, crucially, what proportion left probate records. This is then related to the economic structure of the parishes, and especially the agricultural organisation and its changes with time.

Benchmark Years

An overview of the peopling of Stoneleigh and Ashow from the 16th to the 19th century can only be achieved through counts of *households*. All the available sources provide lists of tenants or heads of households, rather than of individuals; fortunately, these numbers can be compared directly to the probate records. Six benchmark years are analysed in detail in the following sections. Of them, only 1665 (Hearth Tax) and 1811 (census) cover both parishes comprehensively. For the others we have most information for the Stoneleigh Abbey estate, and are less certain about the remaining holdings. However the latter are a small proportion of the total, so that any errors should not introduce appreciable inaccuracy. The 1597 and 1766 benchmarks are based on the main estate surveys. They therefore also provide detailed information about land distribution and farm size (Chapter 11).

Table 10.1: *Total Numbers of Households*

Year	Stoneleigh	Ashow	Total	Population*	
1533	110	22	132	528-594	
1597	121	27	148	592-666	
1664-5	149	24	173	692-779	
1766	201	27	228	912-1026	
1811	279	30	341	1488	(multiplier 4.36)

* Household total multiplied by 4.0-4.5 (figures directly from census for 1811)

Table 10.1 summarises these benchmark estimates of total households. Their overall three-fold increase was not uniform in either time or place. From the 16th century onwards, new houses and cottages were gradually appearing; for example in 1575, the manor court noted the building of ten new houses in Fletchamstead and Canley, because they were not entitled to common pasture. However, the largest 16th-century change was the net increase of seven households in 1574-5 when the ten Stoneleigh almshouses replaced three cottages (p.141).

Much of the 16th-century increase seems to have involved the creation of small farms on land that had previously been pasture (or in one case woodland). Some new farms were also laid out between the mid-17th and the early 18th centuries. However the growth from 1650 to 1760 resulted from the construction of squatter cottages along the wide lanes and the fringes of the heaths of Stoneleigh (which did not occur in Ashow). The first half-dozen cottages are recorded in 1666, and their numbers rose steadily, to about 55 in 1729, 88 in 1761 and 92 in 1807 (p.135).

172

These cottages do not explain the increase from the mid-18th to the early 19th century. In contrast to the earlier growth, this did not include any real increase in the housing stock. It was instead the result of subdivision of what were originally single houses, to give groups of attached cottages. This development has not been followed in detail through the estate records, but it is clearly revealed by the 1813 map of houses in Stoneleigh village. It shows 46 houses, almost unchanged from 1766; most indeed remain to the present day. However, the map's key lists about 60 households.

Population Change

Before the first census in 1801, national sources for estimating the total population of Stoneleigh and Ashow include the Hearth Tax, the 1563 Harleian returns and the 1676 Compton Census. None of these record the total population directly, and the necessary multipliers cannot be easily determined. The ranges in Table 10.1 are derived from the number of households using multipliers of 4.0 and 4.5. The 1801-21 census data indicate multipliers ranging between 4.4 and 4.9.

The following sections review each of the benchmark years.

1533: Stoneleigh Abbey rental

This rental is almost comprehensive, reflecting the dominance of Stoneleigh Abbey in the two parishes. In particular it includes Kingshill and Finham which were sold after the Dissolution and never reunited with the main estate. Some 15 tenants held pastures or coppices in the western part of Stoneleigh; these holdings have not been counted as they apparently lacked houses, though the rental is not entirely clear on this point. The principal uncertainty concerns the number of tenants of the small estates of Kenilworth Abbey and the Knights Hospitaller.

Table 10.2: *1533 Benchmark (excluding Abbey residents)*

Place	Abbey tenants	Individual freeholds	Independent estates
Stoneleigh	39	2	6 (Kenilworth Abbey)
Canley	5	2	-
Cryfield	2	1	-
Hurst	8	1	-
Fletchamstead	2	5	2 (Hospitallers)
Finham	9	1	-
Hill	6	2	-
Stareton	15	1	-
Allesley	-	-	- (probably waste only)
Whoburley	-	1	-
Ashow	15	3	4 (Kenilworth Abbey)
Totals	101	19	12
Overall total	132		

Principal source: Rental SBT.DR18/30/24/73
Additional sources: Hospitallers estates: PRO.E315/36
 Kenilworth Abbey estates: SBT.DR18/30/24/85; DR18/3/3/2

1597: Stoneleigh Estate survey

The 1597 survey with its map leaves no doubt about which tenant holdings included houses. An important distinction is made in the labelling of some holdings as cottages, i.e. houses without significant land attached and with reduced common rights. In contrast to the later position, these cottages all stood within the three principal villages. The survey is not very informative about freeholdings, and in particular does not list the freeholders in the Canley-Hurst area. However, they can be identified individually from deed evidence, while other sources provide estimates for freeholdings elsewhere. Each freeholder has been counted as one tenant, though some may have had subtenants.

Table 10.3: *1597 Benchmark*

Place	Houses	Cottages	Freeholds
Abbey	1	-	-
Stoneleigh	14	30	2
(almshouses)	-	10	-
Canley	5	2	3
Cryfield	2	-	2?
(+ Milburne)			
Finham	-	-	2 houses, 7 cottages
Fletchamstead	5	-	5
Hill	-	-	9?
Hurst	4	2	2
Stareton	10	2	1
Allesley	-	-	- (park and waste?)
Whoburley	-	-	1
Ashow	18	5	1
Bericote	1	2	-
Totals	60	53	35
Overall total	148		

Principal source: Estate survey, SBT.DR18/30/24/279
Additional sources:
 Allesley: Sussex Archaeol. Soc, Lewes, Ms.Abergavenny 68 (1587 survey);
 WRO. CR623/14 (1626 survey)
 Cryfield: WRO. CR561/2 (1638 survey)
 Finham: John Rylands Library, Bromley-Davenport, Finham, 1597 I.P.M. (George Kevett)
 Fletchamstead: BRL.357334, (1599 IPM)
 Hill: SBT.DR10/1536 (1658 rental)

1664-5: Hearth Tax assessment

Warwickshire is magnificently endowed with Hearth Tax records, with near-complete assessments surviving for eight years between 1662 and 1674. These have been the subject of detailed study by T. Arkell who has shown that fluctuations in numbers for individual parishes are largely due to greater or less care being taken in listing houses exempt from the tax; he suggests that the most reliable assessment is that giving the maximum number of households. The fluctuations for Stoneleigh are not large, with the household total ranging between 132 (1670) and 149 (1664-5). The latter has been chosen as the benchmark year. For Ashow, the year-to-year fluctuations are very small, though this particular year suffers from a scribal omission of the list of exempt households; these are supplied from the preceding year.

Table 10.4: *1664-5 Benchmark*

Place	Liable	Non-Liable
Abbey	1	-
Stoneleigh	25	19
Almshouses	-	10
Canley	13	4
Cryfield	5	-
Finham	9	2
Fletchamstead	18	9 (inc. Whoburley and Allesley manor)
Hill	6	1
Hurst	8	7
Stareton	12	-
Ashow	18	[6] [+]
Totals	115	58
Overall total	173	

Source: Hearth Tax assessment, PRO.E179/259M/10 (Photostat at WRO.Z336/2)
[+] Non-liable for Ashow omitted; supplied from WRO.QS11/5, for 1664

A benchmark between 1666 and 1766 would be valuable, to pinpoint the substantial changes during this century. Unfortunately, no general survey exists within this period. The last list of suitors to the manor court (c. 1723; Manor 449) lists 217 names, suggesting about 222 households, after adding the 4-5 in Allesley manor.

1766: Stoneleigh Estate survey

The 1766 estate survey is extremely detailed and is accompanied by a superb set of maps. Holdings with and without houses can therefore easily be distinguished. The consolidation of Leigh ownership through purchases in the Fletchamstead area had been considerable since 1666, and most of the remaining freeholds formed parts of other substantial estates. Separate 18th-century maps survive for the freeholdings in Allesley, Bokendon, Finham, Kingshill, and Whoburley, and as a result this benchmark should be particularly reliable.

Table 10.5: *1766 Benchmark*

Place	Houses	Cottages (landless)	Waste cottages	Freeholds
Abbey	1	-	-	-
Stoneleigh	21	27		2
(almshouses)	-	10	-	-
Canley	5	1	15	2
Cryfield	6	-	6	-
Hurst	7	-	10	1
Fletchamstead	11	1	38	1
Finham	-	-	1	3
Hill	-	-	17	6
Stareton	12	-	-	-
Allesley	-	-	1	4
Whoburley	-	-	-	2
Ashow	12	14	-	1
Totals	75	53	88	22
Overall total	228			

Principal source: Estate survey at Stoneleigh Abbey (Photostat WRO.Z142(l))
Additional sources: Allesley: 1770 map, WRO.CR623; E.A.Philpott, *Allesley and its people* (Typescript at WRO); Finham: 1762-1776 rentals, SBT.DR45/1; Hill: 1758 survey and maps, SBT.DR10/1470; Whoburley: 1760 map, WRO.CR949

1811: Census Abstract

Of the early censuses, that for 1811 is selected as closest in date to the 1807 cottage survey (p.137), and the 1813 map of Stoneleigh village. The original enumerators' books do not survive, and the printed abstract is used as the source. The population totals vary only slightly and irregularly between 1801 and 1831. However the number of houses in Stoneleigh given by the 1811 abstract has obviously been misprinted. In 1801 and 1821, 280 and 299 houses are recorded in Stoneleigh, indicating that the 1811 figure of 179 must be an error for 279.

The abstracts distinguish between houses and a rather larger numbers of families; the former is probably more appropriate for comparison with the earlier benchmark years. However, the distinction seems to have been unclear even to the census enumerators. They listed 30 houses and 41 families in Ashow in 1811, but 42 houses and 43 families in 1821. There is no evidence for new building in Ashow at this period, and it seems most likely that the 1821 enumerators identified more pairs of cottages as two houses rather than one.

Table 10.6: *1811 Benchmark*

	Houses	Families	Population
Stoneleigh	279*	299*	1306
Ashow	30	41	182
Totals	309	340	1488

* Corrected from 179 and 199 (see text).
Source: Abstract of Answers and Returns ..[to 1811 Census], House of Commons, 1812, p.346.

Probate Population

The evidence of probate inventories for lifestyles and living standards is often questioned on the grounds of incompleteness. The comprehensive picture of Stoneleigh and Ashow revealed in Part II demonstrates that such doubts are qualitatively invalid. However, it is also clear that the poorer sections of the community are under-represented in the probate documents. At the other end of the social scale in Stoneleigh at least, the deficiencies in the P.C.C. records are mitigated by inventories surviving in the estate archives.

The *existence* of under-representation is easy to establish, simply from the small proportion of (say) labourers in the probate record. Discovering its *extent* is generally impossible, but the abundant evidence for Stoneleigh allows us to calculate exactly what proportion of the total population formed the *probate* population: those who became involved in the probate process. It is also possible to differentiate between the more and less prosperous sections of the community, and from this to correct for the bias in the probate evidence (Chapter 12).

Parish Registers

The most obvious way to estimate the probate population is to compare the probate records and the burials recorded in the parish registers. The deficiencies in the parish registers (p.15) restrict such comparisons to the later part of the period. Because of the fluctuations in numbers of deaths from year to year, it is essential to use averages, and these have been compiled for all periods in which the Stoneleigh parish registers appear to be complete (Table 10.7).

The obvious approach is a simple comparison between the number of probate entries and the number of burials. However, the burials are of four types which have very different exposure in the probate record: adult men; wives; other adult women (widows and spinsters); children. Neither wives nor children generally left probate documents while other women occur infrequently. Thus the most significant figure is the proportion of adult males with a probate record. Overall, this is exactly one third, with an exceptionally high ratio in the early 18th century (probates for more than 40 per cent of burials); this has notable effects on the wealth profile (p.181).

Table 10.7: *Correlation with Parish Registers*

For comparison with the tabulations in Chapters 3 and 11, alternative groupings are given for the period 1691-1750, using either 20- or 25-year blocks.

Period	Years	Men	Wives	Other	Children	Men In reg(%)	Abs	Women In reg(%)	Abs
			Burials in Registers			**Probate Records**			
1634-1640	6.5	37	14	22	21	15(41)	2	5(23)	1
1665-1679	15.0	71	22	29	13	24(34)	8	3(10)	1
Grouping A									
1691-1710	19.7	85	51	50	85	29(34)	8	7(8)	1
1711-1730	20.0	124	53	84	72	46(37)	15	7(8)	5
1731-1750	20.0	87	55	45	129	21(24)	14	2(4)	2
Grouping B									
1691-1700	9.7	41	13	25	40	13(32)	4	3(9)	1
1701-1725	25.0	110	67	71	89	46(42)	14	11(15)	4
1726-1750	25.0	145	79	83	157	38(26)	19	4(5)	3
Totals	81.2	404	194	233	320	135(33)	47	24(10)	14

A significant decrease took place after 1725 which was perhaps a consequence of the diminishing use of inventories. When an inventory was no longer demanded, it became less important to take out a grant of probate for someone who died intestate. For widows and spinsters, only one in ten left a probate record, and the fall-off towards 1750 is even more marked.

Caution is needed in interpreting these figures, as the register and the probate records are not sampling precisely the same population. The register records burials of some 'travellers' (unspecified abode), and of a few people identified as living elsewhere. No doubt most of these had family connections in the parish, like Richard Branston, a wandering tailor (*scissoris peregrinus*) buried in 1638, who was father-in-law to William Cooke of Hurst.

Much more significant is the opposite effect: Stoneleigh people who were buried elsewhere. Probate records for people not listed in the burial registers make up no less than a quarter of the total for men, and a third for women. Some Stoneleigh people must have died away from home, but this can only account for a few of the missing burials. Three other explanations can be considered. The burials may simply have been omitted from the register; they may have taken place in neighbouring parishes; they may have been made in Nonconformist cemeteries. We have no reason to suspect the first for the periods when the register appears to be well-kept. The shape of the parish makes the second factor plausible, but a limited search in the Allesley and Berkswell registers shows that they do not contain a significant number of Stoneleigh burials; nor do the printed Coventry registers. Unrecorded Nonconformist burials are therefore the likely cause of most of these probate records lacking burial records. This inevitably introduces uncertainty into the percentages given in Table 10.7. We can only assume that people buried elsewhere had the same chance of becoming involved in probate as those buried in Stoneleigh.

Probate and Occupation

For two short periods, 1634-40 and 1699-1708, the parish register gives the status or occupation of almost everyone buried (summarised with other occupation data in Table 11.1). Men of almost every sort had some chance of leaving a probate record, though even in this small sample, the correlation between higher status and probate is clear. Only 'old men' and paupers (apparently equivalent) and servants escaped probate completely. Occasional probate records ae found for servants, though none from these particular periods. A very few wills and inventories for aged

members of the community can also be identified. However, they are only just visible through probate evidence. For the aged widows and single women we have no probate evidence at all. Fortunately for both groups, we can call on the additional evidence of the standing buildings and of estate records (Chapter 7).

Notes

1. As a consistent though arbitrary choice, the almshouses have been counted as ten households rather than one. Their contribution to the overall population, one person per household, counterbalances Stoneleigh Abbey which is also treated arbitrarily as one household.
2. T. Arkell, 'Multiplying factors for estimating population totals from the Hearth Tax', *Local Population Studies*, 28 (1982), 51-57.
3. T. Arkell, 'Assessing the reliability of the Warwickshire Hearth Tax returns of 1662-1674', *Warwickshire History*, 6 (1986), 183-197.
4. L. Weatherill, *Consumer Behaviour and Material Culture in Britain*, 1660-1760, 1988, p.13 identifies such evidence as coming exclusively from the middle ranges of society, lacking both the poorer households and the gentry.
5. As the Ashow and Stoneleigh registers have gaps in different years, they cannot be amalgamated for this analysis.
6. These groups are clearly distinguished in the register, though we do not know the age at which 'A son of B' ceased to be used of a child.
7. One wife did write a will (1615), bequeathing the goods she had retained from her first marriage (p.165). For other examples of this unusual behaviour, see M. Prior, 'Wives and wills, 1558-1700' in J. Chartres and D. G. Hey (eds.) *English Rural Society* 1500-1800, C.U.P., 1990, pp.201-225.
8. In the earlier period, the designations are in Latin. They include some unusual terms, identifiable from other sources: *operarius*, labourer; *agricola*, husbandman; *ingens*, yeoman; *diversorarius*, inn-keeper. Women are designated as single women, as widows, or by the occupation of their husband.

Chapter 11

Economy and Society

Social structure, occupations and the probate record

In Stoneleigh, probate records provide the primary evidence for social status and occupations (Table 11.1), though they can be supplemented from occasional references in other sources and from the parish registers for the short periods that these list occupations. Inevitably the information is incomplete, even for status in the probate population. In the 16th century no more than the broadest outline of social structure in the village can be recognised. The only evidence to supplement the probate record comes from the 1522 certificate of musters, and this contains a large group without identified status, who were probably husbandmen and labourers.

For the 17th and 18th centuries, correlation with the parish registers shows that the middling and higher ranges of village society—the prosperous husbandmen, craftsmen, yeomen and village gentry—have a high chance of appearing in probate records. Labourers and lesser tradespeople occur only rarely. Among men, only one group is virtually absent, the 'aged poor', paupers and almsmen; the one almsman who is known to have left a probate inventory (p.142) would not have been recognised without the evidence of the parish registers, because he is described as a husbandman in his inventory. For women, the probate evidence is much sparser. Even widows are thinly recorded, while married women are not covered at all (with the single exception noted above [p.165]).

The backbone of the community were its farmers, the yeomen, husbandmen and labourers. There seem to have been about equal numbers of yeomen and husbandmen, with a slight increase in the proportion of the former after 1700, probably linked to the growing number of large farms (p.186). However, the less prestigious term was clearly neither down-graded nor abandoned. Indeed, in 1700 the vicar seems to have taken a jaundiced view of the standing of his neighbours; he hardly recognised the existence of yeomen and in four cases describes as husbandmen people called yeomen by the appraisers of their inventories.

The proportion of labourers is less certain. They may roughly have equalled the combined number of husbandmen and yeomen in the 17th century, but certainly increased after 1700, in line with the growth in small cottages. Many of the men lacking identified status in the probate records at this period were probably labourers, judging from their meagre possessions.

Most of the servants leaving wills or inventories worked at the Abbey, though a few were employed by village yeomen. They are probably under-recorded both in the probate records and the registers, and maid-servants in particular are not identified. The listing of seven servants in the 1522 muster provides the most complete evidence. Of them, two each lived with the miller and the bailiff, one with a yeoman and the last two had masters whose status is not stated.

The scattering of village crafts is much what might be predicted. The probate records include some lower status village trades, naming two shoemakers, three tailors and a baker, but no butcher. The tanners, carpenters, blacksmiths and millers seem to have been of higher standing, more frequently leaving wills or inventories. Almost all these craftsmen farmed as well and their wealth (as revealed in their probate inventories) was dominated by their farming stock and crops. The tanners in particular were among the wealthiest inhabitants, because of the value of the hides

Table 11.1: *Social status, occupations and probate*

Sources: probate records (Stoneleigh and Ashow); parish register and certificate of musters (Stoneleigh).

| Status | Probate Records | | | | Register[a] | | Muster |
	1533-1600	1601-50	1651-1700	1701-56	1634-40	1699-1708	1522
Noble	-	1(baronet)	1(baron)	2(baron)	-	-	-
Esquire	-	-	-	-	-	1+0	-
Gentleman	2	5	6	6	-	1+0	-
Yeoman	11	23	21	35	3+0	1+0	1
Husbandman	15	24	27	30	2+1	8+1	4
Labourer	1	10	2	15	2+7	4+6	4
Pauper	-	-	-	-	-	0+2	-
Almsman	-	-	-	-	1+3	-	-
'Old man'(senex)	-	-	-	0+3	-	-	
Servant		3	2	5	0+2	0+2	7
Rector/vicar	4	3	2	1	-	-	-
Innkeeper	-	3	1	1	-	-	-
Miller	4	-	3	2	-	-	1
Fuller	4	9	3	-	2+1	-	1
Tanner	-	3	-	1	0+1	-	-
Wire-drawer	-	-	-	-	-	-	4
Carpenter	-	2	2	1	1+0	0+1	-
Wheelwright/ plow-wright/cooper	-	1	1	2	-	-	
Blacksmith	1	2	2	-	0+1	-	-
Gunsmith	-	1	-	-	1+0	-	-
Mason/stonecutter	-	-	-	2	-	-	-
Weaver/ clothworker	1	-	2	1	-	0+1	1
Tailor	-	1	1	1	1+1	-	1
Shoemaker	-	-	2	-	-	0+1	-
Other[b]	1	1	1	2	1+1	-	2
Almswoman[c]	-	-	-	-	0+2	0+2	-
Widow	5	22	15	21	5+12	4+8	2
Spinster	-	2	2	4	0+2	0+1	-
Wife	-	1	-	-	0+14	0+36	-
Totals							
Known:							
Men	43	94	80	107	14+21	15+14	26
Women	5	25	17	25	5+30	4+47	2
Unstated:							
Men	72	14	26	46	0	2+5	20
Women	3	1	1	4	0+1	2+2	-

a (with probate) + (without probate)
b Probate: 1533-1600: clothier (1); 1601-50: baker (1);
 1651-1700: bachelor (1); 1701-5: warrener (2)
 Register: 1634-40: huntsman (1; probate), cook (1; no probate)
 Muster: 1522: bailiff (1), butcher (1)
c Three widows also described as almswomen.

maturing in their tan-pits. The innkeepers were also men of status, often called yeomen. The inn (the *Three Swans* in 1726, when the manor court met there) must have found much of its custom in the village, as shown by the numerous presentments in the manor court for breaking the assize of bread and ale, and for allowing 'unlawful games'. It certainly also drew visitors from wider afield, probably travellers between Birmingham and Southam or Banbury using a route avoiding Coventry. Even the local aristocracy might use it. Robert Osman bequeathed with pride in 1638, 'my red coate and the suite wherein I wayted upon the Sherife, and my rapier'.

The villages naturally boasted several ale-houses, frequently the concern of the manor court. They were generally kept by the wives or widows of small-holding tenants, who no doubt used their brewing to supplement their husbands' meagre farming and labouring income. As a class, ale-house keepers did not leave probate inventories, though the one recorded baker, Richard Winsmore of Ashow (1620; proved 1621), also kept an ale-house. His customers must have used the 'potts and juggs' in his buttery, while consuming the contents of the seven barrels there and in his kitchen.

Four village crafts formed part of a wider economy. The most significant of these was fulling, exceptionally important in Stoneleigh.[1] At its height around 1600, the parish had at least six fulling mills fed by its various streams and rivers, two on the Finham brook (at Milburne and Pypes Mill), three on the Sowe, two just north of Stoneleigh village and one at the Abbey, and one on the Avon in Ashow. The fullers were clearly involved in the Coventry cloth trade and indeed were organised as part of the Coventry Guild of Fullers.[2] In 1586 they dominated the guild; Richard Worsley of Ashow was Master and 13 of the 28 fullers who put their marks to an agreement can be recognised as Stoneleigh men—James and Thomas Devis, Henry Elliot, Richard Hewett, Alexander, Humphrey (**14**) and James Hoo, Richard Lant, Alexander and Charles Man, Henry Warren (**4**), Alexander and Richard Worsley. The fullers were in the lower and middle ranges of wealth, and few of their inventories list any cloth, so they were probably fulling for Coventry clothiers, rather than buying unfulled cloth for marketing when finished. Most of the mills passed out of use with the cloth trade's decline in the later 17th century. By 1766, only three mills remained, all used for corn. An insight into the organisation of the industry comes from the claim for damages sustained in 1642 by Alexander Hoo, son of James Hoo and his successor at Stoneleigh mill (cf. **14**). He lost a dozen lengths of cloth plundered by the Scots, of many different types including kersey, linsey wolsey and russet, worth £13. The cloth had come from a whole series of villages around Coventry, Astley, Barnacle, Corley, Exhall, Foleshill, with one piece from Stoneleigh; Francis Dyto (p.166) had produced a three-yard length of green cloth worth 6s.[3]

The 1522 muster names only one fuller, but it includes no less than four wire-drawers, a craft named in some other contemporary sources but not later. The wire-drawers probably also served the Coventry cloth trade, supplying wire for use in wool-carding combs, though it may also have been used in pins or needles. The nature of the craft technology at this period is uncertain, and it is not clear if it required water power; if this was already being used, it would explain the location of the industry in Stoneleigh.

In the years around 1600 several cloth merchants used the parish as a base. Thomas Dunton of Stoneleigh Grange (d.1580) had 11 lengths of cloth in his house, ranging from nine broad yards of medley to three remnants of russet, and also including red and white kersey, blankets, flannel, linen and flaxen cloth (of total value £9 6s. 8d.). In 1599, John Bott and Johanna Kevett of Finham were presented in the manor court for having 'practiced the art or secret of a clothier', by selling woollen cloths; they were fined the substantial sum of £2 for each month of the three they had offended.

Another craft which could only have found its market in Coventry is recorded in Stoneleigh around 1600. Edward Jervis, gunmaker, was fined in the manor court in 1594 for shooting a stock dove, no doubt with one of his pieces. His brother (?) Thomas died in 1639, leaving among his modest estate of £39 his 'gun barrels, steele, walnut tree plankes and tooles', valued at £2 1s. 8d.

They were members of an extensive Stoneleigh family, including an earlier Thomas Jarvis who was the village miller from 1560 to 1586, but no evidence exists for how they acquired their specialised craft skills.

An unexpected and enigmatic craft was that of glassmaker. Although no one is named as a glassmaker, Richard Baylis in his will (1656) was 'of the Glasshouse' in Ashow. He occupied an isolated plot deep in Thickthorn Wood, which belonged to the Duchy manor in Kenilworth rather than to the Leigh estate.[4] When surveyed in 1581, it was simply a close of pasture.[5] Richard Baylis is first mentioned in the Ashow court rolls in 1618, so he probably established the glasshouse shortly before this. His brother, Edward Baylis, was of Brewood, Staffordshire, suggesting that Richard was a Staffordshire glassmaker, brought down to Warwickshire to establish the craft.[6] However, this attempt seems to have suffered the general fate of the glass industry in Warwickshire at this period, which was abandoned after opposition because of the woodland destruction it entailed.[7] Certainly, when Baylis' holding was surveyed again in 1650, it comprised only a five-room cottage and two barns (p.114).

By-employments can sometimes be recognised in the probate inventories. The most widespread of these seems to have been spinning, especially of flax. From 1600, small-scale flax-growing was widespread (p.18), and many villagers were also concerned with its processing. William Kelsoe (fuller, 1603) had in his bed-chamber 5s. worth of hemp, a linen wheel and a woollen wheel, and a hatchell for combing (heckling) the flax (separating coarse from fine fibres). Other inventories record the 'slippings' (hanks) of woollen and linen yarn that had been produced. Thomas Coxe, carpenter of Ashow (1639) had a pair of winding blades, two slippings of yarn and a piece of new cloth. He did own a load of hardwood though the old trees in his yard were 'fit only for the fire'. Women, especially widows, must often have depended on spinning to supplement their income. Elizabeth Russell (1731) had jersey spun and unspun in her cheese chamber; she was probably spinning on commission, like Anne Loone, a widow from Fillongley, who in 1729 was going to a Mr Hunt in Coventry to exchange her spun jersey for unspun jersey when this was unfortunately stolen from her.[8]

Weaving was not one of the by-employments. The occasional looms were only used by professional weavers (e.g. **3** and p.167); James Gaundy, a fuller (1549) owned a pair of broad looms, which were probably operated by journeymen working for him. However, carpenters' tools were often owned by non-professionals, though it is not clear whether they were used for more than odd jobs around the farm.

Wealth

Probate inventories appear to provide ideal evidence for wealth, both of individuals and of the community. However, close examination shows drawbacks in both respects. For individuals the worst problems are the exclusion of real estate and the frequent omission of debts owed by the deceased. Sometimes also inventories may omit the wife's dower and goods bequeathed by will.[9] Fortunately, in Stoneleigh, these difficulties are less serious than elsewhere. Both dower goods and bequests seem to be listed while almost all the villagers were tenants and their wills show that the ownership of freehold property elsewhere was rare. A fair number of wills and inventories (especially those before 1650) also list debts, showing that generally they were not substantial.[10]

Estimation of the changing overall wealth of the community is much more difficult, because of the difficulty in converting from the probate population to the whole population. Questions of method also arise: e.g. should everyone's wealth be calculated at a single date as a 'snapshot', or should only the values at death be used. Although these calculations have occasionally been attempted, they rest on assumptions of very doubtful validity, and those for Stoneleigh would be equally uncertain.[11]

However, two wealth calculations are possible for Stoneleigh: the spread of wealth among those leaving inventories, and the relative wealth of particular sections of the community. For

the latter we have only enough data to examine the main social groups in the farming community, but these figures provide a scale with which other individuals' wealth can be compared. Both sets of values need to be converted to 'real money', to compensate for inflation in the 16th century. As the index of agricultural prices was almost constant from 1630 to 1750, this period has been taken as a baseline, with earlier values multiplied by an appropriate factor.[12]

Overall wealth

After correcting for inflation, the overall distribution of wealth was remarkably uniform from 1530 to 1650 (Table 11.2). This suggests that two factors remained constant in this period: overall village prosperity and the relative proportions of richer and poorer people leaving probate inventories. The probability of an inventory surviving is smaller for someone dying before rather than after 1600, but this evidence suggests that richer and poorer were affected equally.

Table 11.2: *Distribution of wealth*

(a) Net wealth (corrected for debts and inflation)* 1533-1750 (£)
(Bracketed figures before inflation correction)

Date	No	Lower Quartile	Median	Upper Quartile
1533-65	41	29(10)	44(15)	104(30)
1565-1600	45	21(12)	53(30)	122(60)
1601-25	58	31	58	105
1626-50	52	22	54	107
1661-80	52	32	77	158
1681-1700	53	42	116	194
1701-25	76	18	68	237
1726-50	41	40	110	241

(b) Distribution of estates 1661-1750 (£)

Date	<10	<20	<40	<60	<80	<100	<150	<200	<250	<300	>300
1661-80	3	3	11	4	5	5	6	6	3	3	3
1681-1700	3	3	6	5	2	2	9	10	4	2	7
1701-25	4	19	3	10	3	2	7	6	3	8	11
1726-50	2	4	4	3	5	1	3	7	2	3	7

* Revalued relative to 1630-1750 = 100 by a sliding scale using the following factors: 1530-9, 4.6; 1540-9, 3.8; 1550-9, 2.4; 1560-9, 2.3; 1570-9, 2.0; 1580-9, 1.8; 1590-1609, 1.4; 1610-29, 1.2 (Indexes of agricultural products, *Ag. Hist.*, IV, p.862; V(ii), p.856)

By contrast, after 1660, the median values increased, almost certainly reflecting greater prosperity. Estates of £350-500 were not uncommon among yeomen and their widows at this period, while in the first half of the century this was only achieved by Stephen and Anne Wilson (p. 83). It is surprising then to see that, after 1700, the median and lower quartile were almost half their previous values, though they recovered in the final period. The reason becomes apparent from a more detailed breakdown (Table 11.2(b)). Comparing 1701-25 with 1681-1700, the number of wealthy estates (exceeding £150) increased slightly, but the main difference lay in the group of 23 poor inventories (below £20) found after 1700, contrasted to the six before. It seems that in this swan-song of the probate inventory (before its rapid decline after 1725), it was reaching further down society than ever before. This was also the period of rapid growth in the numbers of new cottages. A few of their occupiers can even be recognised among the poorest inventories, though the majority relate to people from the established communities. The important information from this group of inventories for the life of the poorer section of the community is examined in Chapter 7.

Social Status and Wealth

The limited evidence correlating social status and wealth is shown in Table 11.3; it is affected by the lack of sufficient examples in some categories. The picture corresponds broadly to that found elsewhere.[13] The median values for labourers, husbandmen, yeomen and gentlemen show a clear stratification that also reflects the early stability and later increase in overall wealth just discussed. However, within each group the range of values is very large. There were many poor as well as rich yeomen, and even a few labourers wealthy by all the standards of their time (for James Hickin, worth £232 in 1717, see p.167).

Table 11.3: *Wealth and Status*

(corrected for inflation as in Table 11.2; uncorrected values bracketed)

Date		Labourers	Husbandmen	Yeomen	Gentlemen
1532-1600	No	1	14	80	
	Median	58(32)	58(25)	346(193)	
	Range		14-311	118-2107	
			(9-173)	(49-916)	
1601-50	No	10	21	20	1
	Median	19(19)	65(58)	150(120)	62(87)
	Range	9-62	16-162	46-1330	
		(7-62)	(13-135)	(33-1330)	
1661-1700	No	2	26	18	6
	Median	19	79	177	404
	Range	11-27	10-263	70-1550	92-1000
1701-56	No	14	25	29	4
	Median	15	117	267	366
	Range	7-232	18-609	32-1069	68-1391

In this comparison, the undoubted under-reporting of labourers' estates needs to be remembered. The better-off ones surely had a much greater chance of an inventory being taken, so the picture may well be biased. For those of higher status, the good proportion of inventories should make bias less of a problem. At the other end of the scale, however, wealthy gentry must also be under-represented because of the sparsity of surviving PCC inventories. This likelihood of sample bias casts doubt on the validity of rescaling from probate wealth to overall wealth, whether this rescaling is based on hearth tax assessment, on holding size (as would be possible for Stoneleigh), or on an assumed national distribution of social status.[14]

For the 17th century, the median values can be compared with data for Lincolnshire (from the 1630s to the 1680s).[15] There, the median inventory values for labourers, husbandmen and yeomen were respectively £29, £62 and £149, not at all dissimilar to the Stoneleigh figures. In that study the results could be compared with evidence from probate accounts, which showed that there had generally been considerable outgoings from the estate after the inventory was taken. The corrected medians were respectively £11, £13 and £26, a dramatic reduction, and one that does not correspond closely to the limited Stoneleigh evidence for debts. However, the only surviving executor's account for the parishes is that of Richard Skudemore of Ashow in 1670.[16] This does indeed show substantial outgoings, the main items being rent paid (£30) and unspecified 'sums of money' (£48); the net estate was only £21, contrasted to the gross total of £111.

Farms and Cottages: Tenure and holding size

An individual's position in the village economy was accurately indicated by the size of his landholding, and to a lesser extent this also correlated with his social position; craftsmen were the only exceptions, generally being more wealthy than would be expected from their holding. The pattern of holdings therefore provides a vignette of the economic and social structure of the village. Figure 48 shows this pattern for the two dates at which the overall picture can be well defined, 1597 and 1766; this figure also displays the range of probate evidence (Chapter 12).

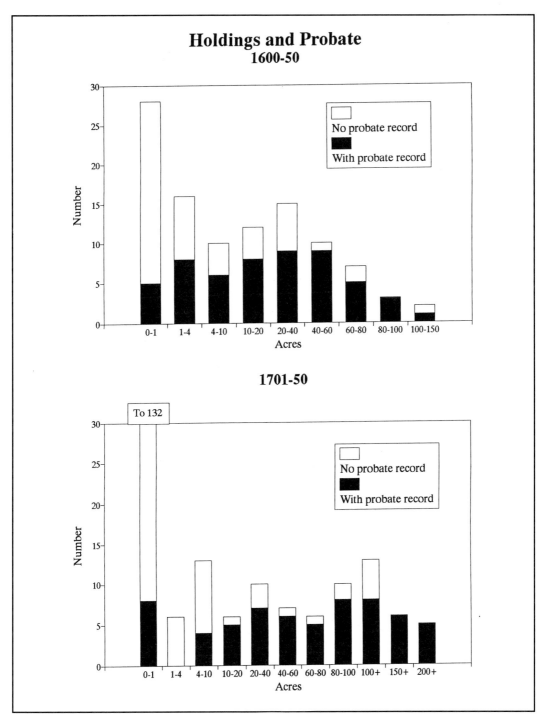

48 *Distribution of holding sizes in 1597 and 1766, showing the proportion with and without probate records in the periods 1597-1650 and 1701-1766 respectively. Only holdings on the Stoneleigh estate are covered (with the two freeholdings in Stoneleigh and Stareton villages in 1597).*

Qualitatively, the 17th- and 18th-century patterns are similar. Both show a group of landless or almost landless cottages, together with farms varying widely in size from those that were hardly more than smallholdings up to the handful in the 100-200 acre range. Socially, the cottage holdings were dominated by labourers and the poor of the village but they also included most of the craftsmen. The most obvious change between 1600 and 1766 is seen at the bottom of the scale, with the great increase in landless cottages (discussed in detail in Chapter 7). It reflects the reaction in Stoneleigh to national population expansion; most significant for village society is that it had the tacit approval of the Leighs. These new inhabitants were regarded as second-class citizens, prohibited even the modest access to common grazing of the old-established cottages (p.190).

Although the farm sizes show no clear groupings, in social terms the smaller farms tended to be those of husbandmen, the larger ones those of yeomen. The median farm sizes for these two groups in the early 17th century were respectively 25 and 59 acres. By the 18th century these had become 59 and 104 acres. Thus yeoman farms tended to be about twice as large as those of husbandmen. However, as with wealth, farm sizes frequently overlapped; between 1600 and 1650, the lowest two yeomen held as little as 15 and 20 acres, while the largest husbandmen farmed 66 and 70 acres.

By 1766, the number of larger farms had increased while smaller ones had disappeared, and a group of very large farms had been created (150-300 acres). Neither change can be taken completely at face value. The parish did contain some very large farms in 1597, but these were not yet in Leigh ownership. The three granges that belonged to the estate had all been split up between numerous tenants, so that the core holdings were small, 20 acres at Bericote Grange, 47 acres at Stoneleigh Grange, and only one acre at Milburne Grange. In the course of the 17th century these were reconstituted, becoming farms of 252, 207 and 116 acres by 1766. Other large farms were created on the Abbey demesne (which must have been farmed by Sir Thomas Leigh himself in 1597), and by the splitting-up of the largest grange, Cryfield; this comprised 658 acres of farmland and 255 acres of woodland in 1638.[17] The two new farms, Cryfield House Farm (197 acres) and Gibbet Hill Farm (87 acres), were created in about 1680. One farm in Ashow, Dial House (holding 54) was rebuilt on a new site outside the village in the 1680s (though the existing house dates from *c*.1800). This example of a classic aspect of the Enclosure Movement was followed by others but only in the 19th century, linked to the conversion of village farmhouses into cottages. Earlier, sufficient land was still available for new farms to be created, without taking it away from the less efficient village holdings.

Individual farms often increased in size between 1597 and 1766, leading to the shift that can be seen in the whole pattern towards larger farms. Some of these increases involved amalgamation with smaller holdings, whose houses then become landless cottages. Examples (Appendix 1) include Stoneleigh holdings 4 and 8 with two and one yardland respectively in 1597 which both lost all their land (probably in the late 17th century).

However, some enlargement was more apparent than real. In 1597, large parts of the parish (including much of Bericote, Milburn and Stoneleigh Granges, and land in Fletchamstead) was held in small parcels as supplementary pasture for tenants whose main holdings were open-field arable. These subsidiary holdings changed hands quite frequently in the 17th century. By 1700, they were consolidated with the main holdings in the rentals (when they survived the re-creation of the large grange farms). The 1766 survey makes no distinction between the original holding and any added parts, so Figure 48b gives a correct picture of 18th-century farm sizes. The additional land only became available late in the 16th century, after the Leigh family acquired the estate. Figure 48a therefore represents the traditional holding size in about 1550 fairly accurately, but rather under-estimates the effective size of many holdings in 1597. Because of the rapid turnover in the tenancies of the extra land, this basic pattern still provides the firmest foundation for describing the economic structure of the village around 1600.

The Farming Economy

As the occupational analysis has shown, the economy of Stoneleigh was dominated by farming. The general pattern of agriculture in Warwickshire at the end of our period was described by the writers of the period, Wedge (1794) and Murray (1815),[18] and has been briefly examined for earlier periods, while a detailed study has been made of the Forest of Arden from 1500 to 1700.[19] Mixed farming was found throughout Warwickshire, though it showed different patterns in the two agrarian regions. Felden parishes frequently retained their open fields until well into the 18th century, and concentrated on arable farming, with sheep folded on the fallow field to manure it. The Arden was dominated by pastoral farming, especially dairying, but tillage was increasing during the 17th century, particularly growing barley for cattle food. Stoneleigh must have felt the same economic influences as both areas; its development was similar to that of the Arden, but with a more Felden-like emphasis on arable crops. Its extensive commons allowed farmers whose land lay in the open fields good access to grazing.

The inventories offer excellent though incomplete evidence for the practice of farming in Stoneleigh. They provide full lists of stock, but crops are only visible at the instant the inventory was taken. Reliable calculation of the relative importance and profit of arable and pastoral farming is probably not possible from inventory evidence, but in favourable cases we can discover the balance of land use, and the principal concerns in each type of farming.

The Stoneleigh inventories have the major advantage that they can be broadly correlated with holding size; this correlation is imperfect, because the available estate records do not always indicate when land additional to the main holding was being rented, and they never show sub-tenants. By grouping the inventories by date and holding size, clear patterns are revealed despite the variations between individual inventories. All tenants were constrained in their freedom to exploit their holdings, not only by its size, but also by the invisible cords of local tradition and accepted practice. Thus changes were slow, visible only over 50- to 100-year periods. The following analysis concentrates on the inventories which can be assigned to farms of known size (including those not listing rooms); a simple division is used into larger and smaller holdings. For the three periods before 1700, a dividing line at a nominal 30-acre size gives almost equal groups of 'smaller' and 'bigger' farms, but for 1700-50 the corresponding division comes at 80 acres. As already noted, the change in farm size was not as large as this difference suggests and the true acreages in the 17th century were often somewhat larger than those recorded.

Smaller farms generally had the same patterns of husbandry as the larger ones, but on a lesser scale, with a few specific differences such as their lack of draught animals. The agriculture endeavours of the cottagers were always minimal, with a few sheep, a cow if they were fortunate, and perhaps an acre or two of crops. The produce of their crofts and gardens was not mentioned directly in their inventories, apart from the 'trees, grafts, seats, stocks and herbs' of Ellen Driver (p.124). Richard Millard, labourer, had 'fruite' valued at £1 in February 1641, which may have been garden produce as it was distinguished from corn, flax and oats.

Crops and arable husbandry

Inventories are informative about the pattern of arable farming, but are much less useful in establishing its profits and costs. The perceived value of arable crops fluctuates through the farming year. From autumn to spring, it is represented by the cost of the ploughing and sowing, and then by the value of the growing crops, both of which were often omitted from inventories; records of the planted acreages are disappointingly rare. Just after harvest, crop values should be accurate, but thereafter as crops were sold or consumed, they become less and less reliable.

For the open fields, village custom controlled their use in a three-year rotation: winter corn (wheat; rye), spring corn (oats; barley; peas and beans); fallow. So ingrained was this pattern that when the tenants of Stareton agreed on the enclosure of their open-field holdings in 1598, the redistribution noted whether each allocation was in the Fallow, Oat or Rye Field, even though

Table 11.4: *Crop Acreages in inventories*

Date	Name	Farm Size	Acreages and crops				
------	------	-----------	Winter		Spring		
June 1537	Richard Partrich	54 acres encl. (?)	5 acres rye		5 acres oats	2 acres peas	
June 1552	Robert Dene	16 acres[a] open	13 acres rye		9 acres oats		
Jan. 1569	Humphrey Partrige	54 acres[b] enclosed	6 days grass rye		6 days erth (sown) oats		
May 1571	John Hancorne	49 acres enclosed	12 days rye		10 days oats	2 days barley	7 days peas
May 1609	William Farre	29 acres open	8 acres rye		11 acres oats	2 acres barley	
June 1616	William Morrey	98 acres enclosed	12 acres rye		5 acres oats		
Apr. 1687	Basil Holbech	152 acres enclosed	14 acres (?) winter corn[c]		33 acres barley + peas + oats		
Apr. 1687	Richard Bolt	15 acres enclosed	11 days winter corn		16 days oats		
June 1695	William Meigh	251 acres enclosed	3 acres wheat 7 acres maslin	14 acres rye	4 acres oats	5 acres peas + vetches + oats	
June 1708	Zachariah Groves	348 acres enclosed	12 acres wheat	20 acres rye	50 acres barley + oats + peas + vetches		
Aug. 1709	Thomas Hart	231 acres enclosed	26 acres hard corn		47 acres lent tillage		
Apr. 1717	John Franklin	63 acres enclosed	10 acres wheat + rye		33 acres oats + peas + barley		
July 1738	John Perks	129 acres enclosed	8 acres winter corn		6 acres barley	19 acres oats	2 acres peas + beans
May 1740	Benjamin Higginson	87 acres enclosed	9 acres wheat		7 acres barley	12 acres oats	5 acres peas 1 acre vetches
July 1742	Edward Cashmore	40 acres open + 39 acres enclosed	Snitehil[O] 12 acres winter corn		Home [E] 6 acres barley	Cloud[O] 6 acres oats	
May 1746	John Higginson	89 acres enclosed	7 acres wheat	3 acres fallow	16 acres oats + seeds	4 acres barley	3acres peas 'few' vetches

a The crop acres listed were probably strips (perhaps 1/2 acre each) rather than statute acres, but he also owned 110 sheep suggesting that he had leased additional pasture land.

b Same farm as Richard Partrich.

c The 33 acres of spring crops are valued at £33; the winter corn is valued at £14 but its area is not given.

these names were significant only during that year.[20] Farming open-field land undoubtedly limited the possibility of concentrating on pastoral rather than arable husbandry. However, this constraint was of decreasing importance as the open fields in the parish successively underwent enclosure (p.7). In reality very few Stoneleigh farmers used their fields exclusively for pasture, even when their land was enclosed.

Over the whole period only 16 probate inventories give crop acreages, all of them taken in the early summer (Table 11.4). Three calculate the crop value in terms of days' work, which may be roughly equated to acres, conventionally the ploughman's daily task. These inventories give the clearest impression of the development of arable farming.

In the 16th century, the main crops on both larger and smaller farms were rye as winter corn and spring-sown oats. Peas and barley are mentioned six and four times in 43 inventories; they were combined in the September inventory of Thomas Rowley (**16**) (59 ac. open-field farm) which lists 40 qr. each of oats, rye and (mixed) barley and peas. Wheat was even rarer with three occurrences, once as toll wheat in a miller's inventory (Richard Grifine, 1585).

In the early 17th century, both the acreages planted and the valuations of harvested grain show that the principal crops were still rye and oats with occasional barley and peas. Wheat remained very rare (five references only in 54 inventories), though it may be concealed within such entries as 'winter corn growing upon the ground'. Maslen (mixed wheat and rye) is also listed twice. However, by the latter part of the century the farming pattern was changing. Rye was being superseded by spring-sown barley rather than the other winter-sown crop, wheat (only common after 1700). From 1680 to 1750 only eight out of 85 inventories mention rye (though by chance three of these are included in Table 11.4). This replacement of rye by barley is one of the few changes that correlates clearly with farm size. Between 1660 and 1680, it was well under way on the larger farms but six of the nine smaller farms were still planting rye. At the same time, legumes were also becoming important, with peas and beans, and sometimes vetches listed. They were grown on about half the larger farms by the end of the 17th century, and after 1725 were found on virtually every farm, large or small. At the same time, different types were being developed. Grey and white peas were distinguished in the 17th century, with blue and white peas mentioned after 1700.

Both these changes appear to have been related to the increasing emphasis on dairying, with the extra barley and legumes intended for cattle feed. A similar trend has been noted in Shropshire, linked to the 17th-century rise in dairy farming there.[21] Clover was also planted on a number of farms after 1700 (first noted in 1714; George Garlick), and rye grass twice (Francis Clayton, 1718; 1745;**47**). Root crops were not popular in Stoneleigh, mentioned once only (Thomas Davis, 1706). His 'parcel of roots' was probably intended for cattle feed.

The essential accompaniment of arable farming, manure, was mentioned fairly frequently though only one farm (Cryfield Grange, see below) had a sophisticated fold-yard system. It could be remarkably valuable (£18 for John Atkins' dunghill on Hearsall Common;**47**). Lime seems hardly to have been used; a 'heap of lime' occurs only in John Perks' 1738 inventory. Loads of broom are occasionally mentioned; these were probably for animal litter. The manor court often concerned itself with manure, attempting to keep the village streets clear of dung-hills and of straw or fern piles (1681). In 1675, it also stamped on an opportunistic plan in Ashow, with a prohibition, 'No inhabitant shall throw any straw or other stuff to make compost or soil in the Pinfold'.

Small amounts of hemp and flax were often listed among household contents though one 18th-century inventory included 1½ bays of flax in the barn (**48**). Flax was probably grown by many people on a small scale in village crofts and 'hemp in the garden' is mentioned once (1660; **35**); however, it was generally omitted from inventories because of the legal distinction between crops harvested by cutting (included) and those harvested by pulling, such as flax, turnips and potatoes (excluded). Despite its insignificance as a farm crop, its processing was labour-inten-sive,[22] and other evidence reveals its importance in the village economy. The processing of flax

required 'retting'—soaking it for a month or more, to rot away everything except the tough fibres. Because of the pollution, people were forbidden to use brooks and rivers for retting. The innumerable people fined in the manor court for this antisocial activity show how widespread was the processing of flax.

Draught animals

In the 16th century, a large farm typically had a team of six to eight oxen, with three to five horses for lighter farm tasks, such as harrowing, as well as for transport. The smaller farms had at most half a team of oxen and often lacked any at all; they must have collaborated with their neighbours for ploughing.

From about 1625 draught oxen were rapidly being replaced by horses, with the last two ox teams recorded in 1669 and 1676. Typically these comprised four and six beasts only; none of the 17th-century inventories list full teams of eight oxen. The reliance on horses is particularly obvious in the 1634 and 1650 inventories for the largest farm in the parish, Cryfield Grange, which include no oxen at all (**55**). The number of horses was rather variable, though after 1625 larger farms generally had between five and eight. In the 18th century these numbers increased somewhat, eight to ten being typical.

In the 17th century as before, few smaller farmers had any draught animals and they must have continued to rely on their better-supplied neighbours. Only in the 18th century did these farms (now enlarged) regularly carry three to five horses.

Pastoral farming and animal husbandry

Inventories generally give a much clearer picture of pastoral than of arable farming. Only if stock fattening is a major concern do the numbers of livestock on a farm vary greatly with the time of year, and this seems not to have been generally important in Stoneleigh. The value and type of animals listed should therefore give a good indication of pastoral activities. However, livestock values do not directly reflect profitability.[23] Only surplus stock would be sold each year, which might include almost all the male lambs, but few of the ewes, and draught oxen only at the end of their useful life (7-10 years).[24] In Stoneleigh the sale of dairy products, especially cheese, and wool was probably of equal importance to the sale of stock.

The open-field farmers in Stoneleigh were able to keep substantial flocks and herds pastured on the fallow and the commons. The number allowed (the *stint*) was laid down by the manor court, proportional to the holding size, with 60 sheep, 12 cattle and three horses for each yardland. The grazing was apparently under pressure, as the court order was very regularly repeated. Cottagers were treated differently in the three villages, being allowed one cow in Ashow, two cows and ten sheep in Stareton and two cows and a horse in Stoneleigh. However, this was strictly reserved for the old-established cottages, not the new squatters on the waste. After the enclosure of Ashow and Stareton, some common grazing along the grassy lanes still remained. The limits for every one were reduced to four sheep, two cows and a horse at Ashow, six sheep or a horse but no cattle at Stareton. Geese especially were prohibited, probably because their droppings fouled the grazing (1649). Earlier, they were only to be kept on the common with a keeper (1565).

The court also controlled the grazing on the meadows on the second growth of grass after hay cutting (the 'eddish'). A group of prominent villagers was appointed each year to determine how this would be allocated, and a copy of their decisions in 1573 is preserved, no doubt typical of many that were not written down [*Manor*]. It includes

> Baldwyne Hyll, Robard Hudson, Goerge Botteris and Thomas Stocken shall have Washeford and Washeford Medowe.
> All the cottagers shall have Woodefelde and Stockelands.
> No tenant of Stonle shalle seyet [*lease out*] no cows gres nor horse gres wethein the edes felde.
> All the forenamed feldes shall stand severall [*not be grazed*] untyll St Lukes Day [*18 October*].

As well as grazing, the commons provided furze and fern (bracken) for litter. Fern was also burned for 'ash balls', providing potash for soap-making. This was carefully controlled. Both cutting and burning fern were strictly limited to Stoneleigh inhabitants and the thirdboroughs (sub-constables) were instructed to put out any foreigners' fires; the ash-balls were also not to be given or sold to foreigners, and the fern was not to be burnt before Saint Bartholomew's day [24 August]. Breaches of this order in 1679 by Sarah Bond, widow, and the wife of Benjamin Hall, identify fern-burning as a poor woman's activity.

Larger 16th-century farms had a dozen dairy cattle (not always distinguished from stock for fattening) and 20-40 sheep, though a few flocks were very much bigger. Four farms already well provided with other livestock had respectively 160, 199, 280 and 476 sheep. The crude estimate of ¼ acre per sheep[25] shows that these farmers must have been leasing more than their basic 40-60 acre holding. Half a dozen pigs and a few poultry made up the farm's complement, unless it had some beehives; two inventories note 20 hives and 12 'stalls' of bees respectively. The pigs were pastured in the woods and the manor court insisted vociferously every year that they had to be 'rung' (having rings placed in their noses) to prevent them damaging the woods by rooting with their tusks. In 1581, swine were also not to be 'served in troughs or pails in the street'.

By the early 17th century the inventories clearly reveal the importance of cheese-making, but the number of cattle had hardly changed. Instead, the only significant increases were in the flocks of sheep, with 50-70 head typical for larger and even many smaller farms (though there were fewer very large flocks).

Later in the century, dairy herds did increase with larger farms typically carrying about 18 head in the 1660s, rising to 30-40 after 1700; by then even the smaller farms regularly had 8-10 head of cattle. Numbers of sheep changed little apart from a slight fall after 1700, indicating a shift towards pastoral farming by this period. The inventory for one of the largest flocks (John Hancox, October 1722) distinguished the 15 'pasture' sheep, valued at 6s. 8d. each, and the 100 'common' sheep worth only 5s. each, which must have had meagre cropping on the fallow field.

The number of pigs gradually declined. By 1700, most smaller farms had just one or two pigs, quite often 'the' pig, marking its special place in the family economy, fattened on scraps and becoming the 'pig in salt' or 'hog in powdering' in the winter. Most of these pigs were probably being kept in stys rather than running free. In 1766 the court finally prohibited the turning loose of pigs in the wood.[26]

Warwickshire cheese

In the 17th and 18th centuries, Warwickshire cheese was modestly celebrated. It was sought after by the nobility, one commenting, 'you sent me the best cheese I ever eat [*sic*]', and was supposedly Queen Anne's favourite.[27] It is also notable that on occasion Gloucestershire cheese was sold as Warwickshire.[28]

Cheese-making equipment begins to appear in probate inventories with the dairies in which it was made in the later 16th century. Jane Wynter at Milburne Grange (1556) was precocious in having both a cheese press and a cheese rack (in the first dairy mentioned); a rack is next listed in 1569, a press again in 1556 (**1**) and then not until 1580. Dairy equipment seems to have been modest in scale and was not often listed in detail but, by the start of the next century, a dairy like that of Thomas Smallwood (1605) might contain:

3 barrels, a payle, 4 cheesefates (*the vessels in which the curds were first pressed*),

3 milk pans, a bole, four butter pootes.

He must have had cheese boards (the 'sutors' used to separate the cheeses in the press) though these are not mentioned, while his cheese press was in the kitchen and the cheese rack in an upstairs chamber; the latter is sometimes called a cheese ladder, indicating the use of a pair of vertical ladder-like structures whose rungs supported the cheese shelves.

Thomas Smallwood had twelve cheeses valued at 6d. each. Amounts of cheese in other inventories were also more modest than might be expected, though to some extent this reflects

the farming year. Cows gave most milk in late spring and early summer and most cheese was made then.[29] After maturing, the largest stocks would be held in the early autumn, while inventories cluster in the winter when the cheese was being gradually sold or eaten. A few inventories list large amounts. Thomas Sothern (January 1636) had 100 cheeses valued at 66s., Nicholas Samon (August 1638) had 176 cheeses at £8, and Stephen Wilson of Cryfield Grange (November 1633) had 215 'cheeses hard and soft' worth £16. A somewhat later inventory (Thomas Phillips of Hill, May 1664) shows a side of cheese-making that is generally hidden, its marketing: 'One hundred of cheese that's gone to London with sum more left in the house £1 6s. 8d.'[30]

By the 18th century, the biggest farms were making cheese on a large scale, and several needed two cheese presses (e.g. William Meigh, 1713 and Richard Garlick, 1728;**48**). The latter had about £25 worth of cheese, but the largest amount precisely described was in the September 1706 inventory of Jane Bares. She had 290 cheeses weighing 12½ hundredweight (i.e. just under 5 lb per cheese), valued at £8 16s., rather less than the normal figure of about £1 per 'hundred' (presumably hundredweight, 112 lb).[31] The inventories of this period generally lump the smaller items in the dairy together under such headings as 'earthenware and lumber' (1744;**47**), accompanying the cheese press, cheese fatts and sutors. The fittings of the cheese chamber were sometimes given in more detail, e.g. 'cheese shelves, cheese tressells, cheese bords' (Benjamin Higginson, 1740).

Other ways to farm

We know from independent evidence that one Stoneleigh resident had adopted an entirely different farming pattern. William Wright of Fletchamstead is recorded in 1601 'going up and down the beast market in this town [Shrewsbury]', to buy stock for fattening.[32] Unfortunately, his inventory is not preserved, although we have that of his father (also William; September 1591). Its list of 11 head of cattle but no sheep might possibly be interpreted as the autumn residue from stock fattening. During the first half of the 17th century, a few summer inventories list six to ten bullocks or steers (e.g. Francis Perkins, May 1644; John Stone, July 1629). The largest such group are the 47 beasts at Cryfield Grange in November 1633 and the 29 there in April 1650 (see below).

A few tenants took advantage of distinctive niches in the farming economy. Edward Lee at Cryfield Grange (Oct. 1693) had £100 worth of 'corn old and new', 6 great swine and 17 pigs, while his successsor, Zachariah Groves (1708), had 20 pigs. Their place in the farm economy was rather different from that of the family sow; they disposed of the quantities of whey from cheese and butter-making produced by large-scale dairying. Their neighbour William Meigh (June 1695, **22**) had 20 sheep and four rams brought from Dudley, and his appraisers valued his 'mowing grass' at £33. Richard Bolt (April 1687) may have traded as a butcher; his 15-acre farm seems small for the 5½ flitches of bacon (weight 220 lbs) and two spare ribs in his kitchen.

From 1650 to 1750, the inventories give no evidence of cattle fattening. However, we know that one Stoneleigh farmer played a major part in the improvement of the Warwickshire longhorn, the main 18th-century breed of beef cattle. John Webster of Canley provided the stock from which Robert Bakewell's great bull, Twopenny, was bred. Its mother was the Canley cow, Old Comely, bred in 1765 (and dying in extreme old age in 1791); the breed was notable for heavy carcases and rapid growth, though it was poor for dairying.[33] John Webster was also noted as a horse-breeder, and his celebrated chestnut stallion, Bonny Bachelor, was advertised at stud for the substantial fee of one guinea in April and May 1744 in the *Worcester Journal* and *Aris's Gazette*.[34]

It is clear from William Marshall's report (1790),[35] that the originator of the Canley breed was the first John Webster, the father of 'Webster of Canley'. His wife Sarah jointly inherited the 100-acre Symcox freehold in Canley from her uncle Joseph Symcox (d.1705).[36] They moved to Stoneleigh by 1713 when John leased the other half of the farm from the co-owner. Marshall states that Webster brought the original nucleus of the herd 'from the banks of the Trent', when he first settled in Canley. John Webster's will [dated 1714, though he died in 1727] shows that he owned land in Coton, Rosliston and Cauldwell, Derbyshire, and Norrington-on-Soar, Notting-

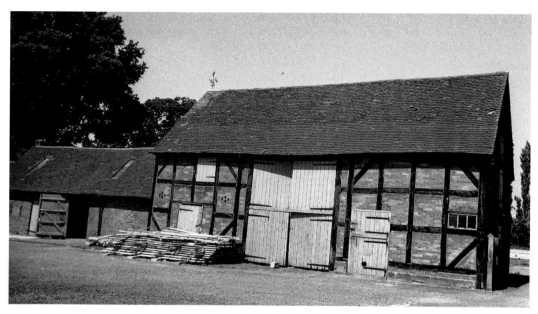

49 *Barn at Ivy Farm, Canley, probably of the late 17th or early 18th century.*

hamshire. Disappointingly, his inventory does not itemise the stock, though its importance is clear; he had horses, mares and colts worth £56, cows heifers and calves (£68), and sheep, lambs and wool (£40).

Farm Buildings

The probate inventories frequently name farm buildings, though this information is less reliable than their listing of house rooms. In the spring, the barn might be empty, and the stable and cow house could be ignored when listing the stock within them. It is also noticeable that the lists of farm buildings in pairs of inventories describing the same holding are often completely different. Despite these omissions, our picture of the pattern of buildings drawn from the inventories is much clearer than anything the pitifully few survivors can tell us.

In general, Stoneleigh farmers appear poorly equipped with buildings, apart from barns which were almost essential for arable husbandry even on ten-acre holdings. In the 16th century, the one named oxhouse probably hides many others; oxen were valuable beasts needing considerate treatment. Otherwise, only a few 'hovels' and a couple of workhouses for tools were mentioned.

After 1600, the lists of buildings become more varied. This probably represents a real improvement, corresponding to the proliferating service rooms in the houses. Larger holdings could find use both for a corn (or rye) barn and a hay barn. They probably also had an oxhouse or cowhouse and a stable (Figure 53). The inn had a common stable and a second stable, both with hay lofts; the former was probably for guests, the latter for the innkeeper's own horses. The long series of inventories for the inn also illustrate the erratic recording of farm buildings. The barn and these stables are given in Alexander Preist's inventory (1619); one other inventory includes no buildings, two name only the barn and the last (Edward Casemore, 1742) lists the barn, the stable and the gatehouse, where he kept his farm implements.

Most farmyards probably had a building or two for storage, perhaps a 'hovel' for implements, a wainhouse (James Cox, 1612) or a carthovel (John Perkes, 1738). Hovels also served as workshops; Benjamin Higginson, for example, kept his spoking chain there (1740). Thomas Smallwood's inventory (1605) records a barn, a 'duckcote' (presumably an up-market hen-

house), and a hovel for a pigsty. This level of detail is unique, though the pattern was probably typical for most village farms.

Even though the inventory descriptions are incomplete, finding early buildings to match them is impossible. No farm buildings survive as such from before the middle of the 17th century, though we do have one hint of the character of a 16th-century barn. The rentals show that Croome Cottage, Stoneleigh was converted from a barn in 1572 (p.42). Its two cruck-built bays probably remain from this barn; they are indistinguishable in structure from the cruck houses. A handful of later timber-framed barns survive. One at Ivy Farm, Canley is the best preserved (Figure 49), while that at Furzenhill Farm, Stareton probably dates from the laying out of the farm in 1682.

It is not surprising that no recognisable hovels survive. That listed in the inventory of Thomas Nelson (1627), 'all the wood with one old hovill', probably gives a good indication of their poor quality. The only early building that might have been described as a hovel is a timber-framed shelter shed in the centre of Stareton Park, probably of the 18th century. This and its accompanying barn (also timber-framed) may have been built for feeding deer, but were probably later used for cattle.

17th-century farming: an illustration

The inventory of Anne Wilson of Cryfield Grange was taken in April 1650 (**55**); a survey of 1638 shows that the farm then covered 659 acres, though it was later subdivided.[37] The farming section is particularly revealing of the innovations being made by the leading farmers of the parish at the beginning of the 17th century, when new practices were superseding the traditional husbandry seen for example in the inventories of Thomas Rowley (1551; **16**) and Robert Dene (1552; **9**). It can be compared especially with the late 17th- and 18th-century large farm inventories of William Meigh (1695; **22**), Richard Garlick (1728; **48**), and John Atkins (1744; **47**).

It is also interesting to compare Anne's inventory with that for her husband Stephen (November 1633). They are generally similar but the different points in the farming year lead to some informative contrasts. His 215 cheeses have already been noted; she had only supplies for the household: beef, bacon, cheese, butter, bread and beer. The manure collected in the fold yards was valuable at the end of the winter but was not noted in November; the evidence for its careful retention in 'ground racks' is unique in Stoneleigh. Their farm stock were similar; Stephen had 47 beasts (£120), 303 sheep (£100), and 14 swine (£9) (and also 11 stocks of bees). His 21 horses and Anne's 19 are the largest group in any Stoneleigh inventory, suggesting that they included horse breeding among their multifarious activities. Both had poultry worth £1, but Anne gives the only early Stoneleigh reference to turkeys. He had £30 of hay to see the winter through, and £250 in harvested crops (rye, barley and oats), as well as £70 in growing rye.

55 Anne Wilson of Cryfield, widow, 7th April 1650

Stephen Wilson, yeoman (d.1633) and Anne had a large family including numerous grandchildren, some of them married by 1650; sheep, lambs and cows were distributed widely to them both in their wills and inventories. Stephen was highly regarded in the parish and was overseer, witness and appraiser of many wills and inventories, even including the inventory of Sir Thomas Leigh in 1626. He served as juror and surveyor of the highways, but he seems to have had a soft spot for playing bowls and was fined twice (1599 and 1619) for playing at times prohibited by the statute of 1541.

Inventory appraised by William Benyon, Thomas Devis, Lawrence Nicholls, John Taylor, John Sherington, 7th April 1650.

Her wearinge apparrell	5	0	0
One bible		6	8
In <u>the Chamber over the Parlor</u> one joyned bedstid, one feather bed, one greene rug, two blankettes, one boulster, one trundle bed & one sett of curtaines	4	10	0

	£	s	d
Three great coffers, one chest, one little coffer, one box & ones twiggen chaire	1	10	0
One great charger, twentie seven pewter dishes, three candlesticks, three chamber potts and divers other small pieces of pewter with some other implementes	2	6	8
Twenty foure paire of fine sheets, twenty three paires of courser sheetes, eight paires of pillowbieres, twelve table cloathes, sixe of them fine, the other courser, foure dozen of napkins, three longe towells, six short towells	20	7	4
In the Chamber over the Buttry one joyned bedstid, one feather bed, one flock bed, three blanketts, one coverlid, two boulsters, one pillow and one sett of curtaines	2	13	4
One coffer, one deske with some other implements		5	0
In the Chamber over the Hall two bedstids, one trundle bed, one feather bed, two flock beds, one chaffe bed, foure paire of blankets, two coverlids, two boulsters, one pillow & one piece of woolen cloath with some other implementes		5	0
In the Cheese Chamber over the Hall one coffer, one cheese rack, one dry fatt, two wheeles and divers other implements	1	0	0
In the Servants Chamber three bedstids, three wooll beds, six paire of blanketts, six boulsters, two pillowers, three twilleys with some other implementes	2	13	4
In the Chamber over the Mill House one bedstid, one feather bed, one coverlid, one blankett, one twilley, one flock bed & one sett of curtaines	2	0	0
One little table, one trunke & other implements		6	8
In the Lathshooters Chamber one bedstid, one bed, three blankets and other implementes		10	0
In the Chamber over the Dairy House one bedstid, five blanketts, one pillow and other implements	1	3	4
In the Cheese Chamber [for Corn Chamber] one garner, foure quarters of oats and other implementes	4	0	0
In the Dairie House the milk vessells, shelves and other implements	1	0	0
In the Mill House one malt mill, one cheese presse and other implements	1	10	0
In the Brewhouse one copper, one mashing fatt, two great cowles, two lesser cowles with some other implementes	1	13	4
In the Cellor six hogsheads, foure barrells, one dry fatt, one dough kiver and other implements	1	0	0
In the Parlor one table, one great cubbard, one liverie cubbard, two chaires, foure stooles and other implements	1	10	0
In the Buttery on table one forme with other implements		10	0
In the Hall one long table, one short table, one foorme, two brasse pannes, five great kettles, foure brasse potts, three little kettles, foure skellets, two scimmers, one chafinge dish, two dripinge pans, one warminge pan, two spits, one paire of cobbarts & other implementes	5	13	4
One peice		6	8
In the Farther Barne eight quarters of oates	5	6	8
In the barne yard, the soyle and eight ground racks		16	0
Rye in the Corne Barne	24	0	0
In the little fold yard, the soyle and eight ground racks		5	0
In the corne barne yard, eight racks and the soyle therein	2	10	0
Twenty loads of broome	1	10	0
In the Hay Barne, the hay therein and some implements	1	6	8
Twelve loads of wood	1	6	0
One silver spoone		6	8
Twentie milch cowes and one bull	80	0	0
Eleven weaninge calves	7	6	8
In the Millfield, foure beast two yeares old and ten yearlings	24	0	0
Fifteene young beasts in Potters Field	40	0	0
In the Millfield, fortie nine hogrills	24	10	0
In the Wallfield, eightie seven ewes	43	10	0
In the Pinfold field, sixtie five barren sheepe	30	0	0

Three colts in the Millfield	6	0	0
In the Wallfield, foure fillies	16	0	0
Ten draught mares & two stoned horses	70	0	0
Two long carts, two dung carts, two great harrowes, two paire of small harrowes, two plowes, two sett of geares, some plow and cart timber & other implements of husbandry	14	6	8
Five store swine	3	15	0
Turkeys, geese & other poultrie	1	0	0
Winter corne growinge upon the ground	100	0	0
Oats growinge upon the ground	150	0	0
Beefe, bacon, cheese, butter, bread, beere and all manner of lumber	5	0	0
Three stocks of bees		13	4
Desperate debts	15	7	4
Money found in the house at her death	37	0	0
Total	771	11	8

Notes

1. For fulling, see inventory **4**.
2. This is remarkable for craftsmen not resident within the city. The Guild records were kept erratically, with no list of masters or admissions. However, their order book (CRO.Acc.30) contains lists of names for 1580, 1586, 1623 and 1627, of which that for 1586 is the longest.
3. PRO.SP28/182.
4. J. H. Drew, 'A glasshouse at Ashow near Kenilworth, Warwickshire', *Birmingham Archaeol. Soc. Trans.*, 84 (1967-70), 186.
5. PRO.LR2/185, f.314v.
6. G. H. Kenyon, *The Glass Industry of the Weald* (Leicester University Press, 1967), p.214f.
7. *VCH*, II, p.244.
8. Her deposition is on the dorse of a Corley settlement examination, DR259/49/1.
9. M. Spufford, 'The limitations of the probate inventory', in J. Chartres, D. Hey (eds.), *English Rural Society 1500-1800*, 1990, pp. 139-174. Her recommendation that executors' accounts should be used to remedy these defects cannot be applied here, because hardly any accounts have survived.
10. Legally for debts secured by bond, it was the bond itself which was the 'chattel' to be listed in the inventory; however appraisers in Stoneleigh were more realistic and listed both secured and unsecured debts. Significant debts are noted in the main tables in Part II.
11. C. Shammas, 'Constructing a wealth distribution from probate records', *J. Interdisciplinary Hist.*, 9(2), 1978, 297-307.
12. The correction factors are listed in Table 11.2. Median (mid-point) and quartile (upper and lower quarter) values are used, rather than arithmetic means (averages), because they are less affected by unsymmetrical distributions (resulting from the few very large estates). Members of the Leigh family have been excluded from these analyses.
13. E.g. M. Spufford, *op. cit.*
14. As has been attempted for Worcestershire, C. Shammas, *op. cit.*
15. M. Spufford, *op. cit.*
16. Lichfield Record Office, Consistory Court Records. This account survives accidentally among a small group of accounts from the 1680s.
17. WRO. CR55/2. Although four houses are named in this survey, three seem only to have been cottages, accompanied by half-a-dozen acres at most.
18. J. Wedge, *General view of the agriculture of the county of Warwick*, London, 1794; A. Murray, *General view of the agriculture of the county of Warwick*, London, 1815.
19. V. Skipp, 'Economic and social change in the Forest of Arden, 1530-1649', in J. Thirsk (ed.), *Land Church and People*, Ag. Hist. Rev. 18(suppl.) 1970, pp.84-111; the agricultural economy he records is noticably different from that in Stoneleigh, in particular in showing an increase rather than a decrease in arable husbandry from the 16th century onwards. See also J. A. Yelling, 'Livestock numbers and agricultural development, 1540-1750: a study of East Worcestershire', in T. R. Slater and P. J. Jarvis (eds.), *Field and Forest*, Norwich, 1982; *Ag. Hist.*, IV and V(i).
20. SBT.DR18/30/23/3.
21. P. R. Edwards, 'The development of dairy farming on the North Shropshire plain in the seventeenth century', *Midland History*, IV (1978), 175-190; p.183.

22. V. Skipp, *Crisis and Development*, C.U.P., 1978, p.59.
23. J. A. Yelling, (*op. cit.* in note 19) has used 'livestock units' for the comparison of stock listed in inventories. These count oxen and steers at 1.2, horses at 1.0, cows at 0.8, sheep and pigs at 0.1. However, their use has been criticised (M. Overton, 'English probate inventories and the measurement of agricultural change' in A. van der Woude and A. Schurman (eds.), *Probate Inventories*, Utrecht, 1980). Although livestock units were calculated for the Stoneleigh inventories, they did not prove very informative and are not commented on here.
24. *Ag. Hist.* IV, 655.
25. Derived from the sheep farming accounts of Peter Temple in the mid-16th century; N. W. Alcock, *Warwickshire Grazier and London Skinner*, 1981.
26. The same change from free-running to farmyard pigs took place in the Lake District in the late 18th century; S. Denyer, *Traditional Building and Life in the Lake District*, Gollancz, 1991, p.106.
27. Lord Bolingbroke writing from Battersea to Lady Luxborough at Henley-in-Arden, 10 August 1745; Brit. Lib. Add. Ms.34196, f.49. I thank Dr Joan Lane for this reference.
28. P. Rance, *Great British Cheese Book*, Macmillan, 1982.
29. *Ag. Hist.* V (ii), 437.
30. Further evidence for the London trade as well as for dealing in cheese comes from the 1682 probate account of John Wilson of Berkswell (the parish adjoining Stoneleigh to the west). This includes the item: A considerable parcell of cheese the deceased had bought and not paid for and carriage of the same to London £75 12s. [Lichfield R. O. B/C/5/1682/106].
31. The largest Gloucestershire cheese makers operated on an even bigger scale (*Gloucestershire Inventories*). Five tons of cheese valued at £100 and three tons' worth £78 are recorded in 1709 and 1716 (inventories 269 and 307).
32. Shropshire Record Office, Shrewsbury Borough Records, 2211, cited by P. R. Edwards, 'The cattle trade of Shropshire in the late sixteenth and seventeenth centuries', *Midland History*, 6 (1981), 72-94 (p.80).
33. N. C. Russell, 'Who improved the eighteenth-century longhorn cow?', in W. Minchinton (ed.), *Exeter Papers in Economic History,* 14 (1981), 19-40.
34. Information kindly provided by Dr Joan Lane.
35. W. Marshall, *Rural economy of the Midland counties*, 1790, I, p. 268.
36. The farm had belonged to the Symcox family since 1578, paying a chief rent of 11s. 1d. and a fee farm rent of £9. The 18th-century deeds are in SBT.DR18/10/26; the immediate heirs of Joseph Symcox were his sisters Mary Collins (will, 1716, CRO.101/141/21) and Sarah Davell; Sarah Webster seems to have been the latter's daughter.
37. WRO.CR561/2.

Part IV:
The Wider View

Chapter 12

Tradition and Innovation

Houses in the Parish

The Stoneleigh probate records reach almost all levels of village society, but they do so unevenly. Almost every yeoman whose death was recorded in the parish register left an inventory, but these are accompanied by a quarter or less of those that might exist for labourers. Our view of the village houses is therefore a biased one, and we do not know how this bias changes with time. It appears from a simple tabulation (Table 12.1) that after 1600 houses most commonly had five rooms and that the only later development was a slight decrease after 1650 in the number of very large houses, with an apparent increase again in the 18th century. But can this be valid for the parish as a whole? If nothing else, the explosion of cottages after 1700 must cast doubt on this conclusion.

Table 12.1: *Room-by-Room Probate Inventories*

Period	Rooms															Total
	2	3	4	5	6	7	8	9	10	11	12	13	14	15	>15	
	Old Style															
1532-1600	7	16	9	4	5	3	7	2								53
							New Style									
1601-50	4	5	12	16	13	9	6	6	4	3	5	3	1	2	5	94
	Homes of			*Middling*												
1661-1700	1	5	8	14	13	6	9	5	3	2	1	1	1		4	73
	the Poor			*Sort*			*Eighteenth Century Farms*									
1701-50	4	8	11	15	5	6	10	6	4	6	2	4		1	4	86
1751 on				1	1		1			1		1				5
Totals	16	34	40	50	39	23	32	19	12	11	9	8	2	3	13	Total: 311

Rescaled values*	2	3	4	5	6	7	8	9	10	11	12	13	14	15	>15	
1601-50	14	10	26	26	19	12	8	9	6	2	6	4	2	1	2	138
1664-5	17	22	39	30	18	13	13	5	6	2		3			7	175
1701-50 (all)	38	68	33	43	5	4	10	5	4	5	3	4		1	3	226
(cottages)	18	53	18													89

* The rescaled totals differ slightly from the benchmark values on which they are based, because of rounding effects in the calculation

We can get a simple but complete snapshot of housing for the whole parish for a brief period in the 17th century. The Hearth Tax in 1664-5 (Table 10.4, p.175) lists 173 households. Of these, 105 had one hearth and 23 had two, ranging up to 10 with five hearths or more. But of the 23 houses with two hearths, we can identify inventories for 12, including two five-room houses, three with six rooms, etc. *We can reasonably assume that the identified inventories are a random sample of the whole group of two-hearth houses.* We can therefore estimate the total

number of these houses with (say) six rooms as 3*23/12, i.e. about six. Applying this procedure further, the distribution of house size for all the 173 houses can be calculated from the known sizes for 63 houses (in the *Rescaled* section of Table 12.1). The calculations are obviously affected by the small size of some sample groups, and so their reliability should not be over-estimated. However, as the final distribution is produced by summing numerous individual values it is reasonably insensitive to perturbations in the data.[1] A similar approach can be applied to the periods 1600-50 and 1700-50, based on the holding size, but for 1537-1600 the lack of corre-lation between house and holding means that rescaling is not meaningful.

The effect of rescaling is to increase the proportion of small houses at all periods, but the peak size drops only slightly, to between four and five rooms, apart from the squatter cottages for which the sparse evidence suggests that three rooms were the commonest, as seen in 1807 (Table 7.2). Even without correction, the inventories give a true picture of the great enlargement that took place between the middle and end of the 16th century. However, the table conceals the reorganisation that took place in the household during the later 17th and 18th centuries, but which did not enlarge its physical framework. For this we need the inventories and the houses together. New-built houses of the 1680s, such as that of Richard Camill (p.35) provided eight rooms within the same footprint as its three-bay 16th-century predecessor, though in 1610 the house probably had two or three extra bays and twice the plan area of either a century earlier or later. In the 19th century, with pressure for agricultural reorganisation and increasing population, these com-pactly planned houses were often converted into pairs of cottages, each with a main room and lean-to pantry, and one or two bed-chambers. As a result, they have survived intact when more sprawling houses have been reduced in size or completely rebuilt.

Although this last phase of cottage creation lies at the very end of the present study, it only extends what was a pervasive development in housing from 1600 or before. Its most dramatic manifestation was the sprouting of cottages on the waste, but it also appeared in the conversion of barns, the replacement of large landless houses and the extension or subdivision of existing cottages. It is the ability to give these developments their full weight that makes the combination of evidence for Stoneleigh so powerful. Without it, the 16 two-room inventories can only hint at cottager lifestyles, neither identifying their extent nor defining their social context. In empha-sising the growth of cottages as the most notable change in the post-medieval period, we must not lose sight of the majority in the parish even in the 19th century, the middling and substantial farmers, husbandmen and yeomen. They benefited from improved housing standards in ways that were impossible for cottagers, because their greater financial resources could be laid out on furnishing, and most simply because their houses provided more space.

Warwickshire and beyond

As well as providing an overview of housing standards in Stoneleigh, the Hearth Tax also gives access to wider comparisons. Notable differences have been found between different parts of Warwickshire in the numbers of hearths and by implication in the size of houses.[2] The proportion of exempt households is particularly informative. For rural parishes over the whole county this averages 36 per cent, but it rises to 60 per cent and higher for some parishes in the north-east (on the Warwickshire coalfield or associated with quarrying) and in the lower Avon valley. These contrasts clearly reflect the economic diversity within the county. A dependence on mining led to a high proportion of cottagers, while pastoral farming (in the Arden) had the opposite result. Stoneleigh's middling figure (34 per cent exempt) is appropriate for its mixed farming economy; were the same data available for 1766 as for 1666, the squatter cottages would certainly tip the balance in Stoneleigh towards poorer households.

Although differences in the social mix in the villages led to the observed variations, the types of houses are rather uniform over the county (excluding the stone-building region in the south). Three-bay cruck houses seem to be a standard late medieval design in Stoneleigh and elsewhere, though some more sophisticated examples have been recorded which have two-bay

halls, spanned by arch-braced open trusses. Small 17th- and 18th- century cottages with two- and three-room plans are found throughout the county, with only minor variations in door and fireplace positions. Their roofs have inset principals, and they have square framing, either two or three panels high with diagonal braces. Stoneleigh's semi-detached cottages have not been matched elsewhere. However in reality they are early and specialised examples of the conversion of larger houses to rows of cottages. This was general throughout Warwickshire as an accompaniment to the building of new brick farms, whose plans after initial experimentation (Figure 44) settled down to the central stair-hall pattern (Figures 25, 45-47). Only in the 16th century do the Stoneleigh houses seem distinctive, though they are too few for any clear patterns to emerge. In Warwickshire generally, houses of this period also show a variety of forms, though fieldwork has not yet clarified their development and relationships.

On a national scale, building types reflect regional traditions in vernacular architecture and detailed comparisons are not very informative. However, Hearth Tax statistics show that average living standards were considerably more variable than is found in Warwickshire alone. The most effective comparison is with the number of one-hearth houses (whether exempt or not). In Warwickshire, this is relatively uniform with a mean of 69 per cent (regional range 62-72 per cent); Stoneleigh lies precisely at the mean. In contrast, one region of east Sussex had considerably higher standards of comfort and only 31 per cent of the houses had one hearth, while in east Devon the proportion was even lower. In Glamorgan, a county of varied prosperity, the percentage varied between 49 and 70 per cent, while in North Yorkshire housing standards were demonstrably lower than in Warwickshire.[4]

Domestic Comfort

The house provided the frame, but the furnishings made it a comfortable home. Improvement in the quality and variety of household goods has recently been linked with the developing market in consumer goods in the later 17th century,[5] but in Stoneleigh these changes are part of a continuum. The doubling of the size of houses at the end of the 16th century certainly doubled the amount of furniture in them, even if some new rooms (like dairies) were merely stocked with the overflow from a crowded kitchen. New furniture meant new fashions. Court cupboards or dressers replaced aumbries; chairs and falling tables might supersede trestle tables and forms; painted cloths were deemed out of date and discarded.[6] All these improvements depended on professional expertise, the joiner for new furniture or wainscot; weavers for better bed-linen; the pewterer, the cooper or the potter for kitchenware.

As observed elsewhere, in the years around 1700 goods appeared which were produced for mass distribution, such mundane but useful items as Ticknall ware for the dairy and tin dripping pans for the hearth. Fashionable items, the clocks and looking glasses, the Delftware and pictures, also began to add sophistication to the better homes. These changes have been specifically associated with consumerism and the growth of demand underlying the beginning of the Industrial Revolution. In Stoneleigh, though, it is hard to see any great distinction between the appearance of these goods in 1720 (say), and the new furnishings of a century earlier. Both enhanced comfort and provided better living standards within the village houses, and to acquire both the people of Stoneleigh must have gone to markets and shops in Coventry, even if the centres of production were further away in the 18th century.

Much more important for life in the village were the changes that new furnishings brought with them. No doubt these sometimes resulted from imitation and fashion, but often the process must have been almost accidental. A smart round table was bought and put in the parlour, accompanied by the best chairs from the hall. More of the household's social activities followed them into the parlour, leaving more cooking in the hall. The son took over the farm and his wife decided they would go on sleeping in the chamber over the parlour, even though his father's bed was still downstairs; in due course they got rid of the bed completely. We look at the house through the appraiser's eyes, and see it transformed from 'hall and parlour' to 'parlour and kitchen'.

Only modestly did these new ways of organising old houses begin the differentiation between the socially 'public' and 'private' parts of the house. In 1600, the hall was for family living, the parlour the private bedchamber. Visitors came into the hall, but as the parlour furniture increased, it must also have begun to function as a reception room. A century later the shift in room names and uses had not so much created new public and private spaces as moved these functions sideways. The hottest and smelliest cooking was in the back kitchen or brewhouse; the kitchen had become more specialised for cleaner cooking. Moving the sitting, eating (and receiving) into the parlour in turn squeezed the beds out to a room upstairs. This was perhaps newly constructed, but was certainly smarter and with better access than the pokey solars of the 16th-century houses. Only in the largest houses was the differentiation of room functions taken far enough to create formal parlours or dining halls as new spaces, separating the family space from that used by the servants and common callers.

Pressure for the development of privacy has been highlighted in other studies but in Stoneleigh it cannot be seen as a dominant force. In part the survival of houses of many periods, predominantly small in scale, limited the scope for innovation. In part the character of the village itself was significant; the estate contributed to this through its conservatism and perhaps through the conscious choice of 'appropriate' plans. In the smallest houses from the 15th century (Pypes Mill) to the 18th (4-5 The Bank) and indeed to the 20th century, every visitor walked directly into the heart of the house. The chamber was further in, a private space behind its closed door, though, while the hall remained open, it had also to be a passage to the stair and upper floor. Once the stair found a place beside the chimney, both the parlour and the upper chambers became self-contained. The brief appearance of the lobby-entry plan in Stoneleigh coincided with the development of the living parlour.[7] It gave a choice, taking visitors on ordinary occasions to the kitchen, while special guests could be ushered deferentially into the parlour without being subjected to the bustle and smell of the daily activities in the humbler surroundings through the other door.

The adoption of the central stair-hall plan crystallised this development and produced a house with a real circulation pattern reflecting the different activities in its different rooms. However these houses were only for the select, the substantial farmers for which the estate had to provide a modern house if it was to attract up-to-date tenants able to apply and profit from new farming methods.

People at Home

The contrasting lifestyles in Stoneleigh are graphically demonstrated by a sequence of characteristic houses, drawn out with their contents as revealed by their inventories. The story starts in 1556 with the medieval life led by Humphrey Hylles in his three rooms (**1**, Figure 50). Despite its simplicity, his home had touches of smartness and fashion, in the round table and the painted cloths in the hall. The characteristic lack of furniture in the kitchen may have been slightly relieved by the kneading trough, whose lid could have been used for food preparation as well as kneading dough.

After 1600, his simple life was matched only at the margin of society, as seen here in the cottage of John Morice (1697, **36**, Figure 50), which was furnished even more sparsely than the preceding example. His house boasted a table top, but its only support came from a pair of upturned pails. The cheese press in Humphrey Hylles kitchen marked the beginning of a market in dairy produce. What might even have been the same press, passed on to a poor neighbour in Hurst when it was replaced by one of Humphrey's successors, appears in John Morice's bedroom. For him, it played a vital role in the family economy, essential to win even his modest living from the cow he grazed on Westwood Heath.

More characteristic of the modestly prosperous majority in Stoneleigh was the home of his contemporary Thomas Higinson (**25**, Figure 51). He and his family lived in some comfort in the six rooms of his newly-built house, surely with glazed windows. An indication of the quality of his lifestyle is that he had a grate in the parlour, as well as a fireplace in another bedchamber

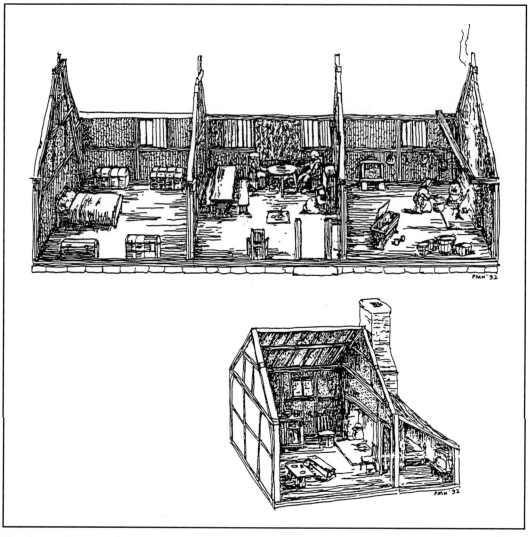

50 *Upper: the home of Humphrey Hylles in 1556 (**1**). The house is based on the three-bay cruck houses in Stoneleigh.*
*Lower: the home of John Morice in 1697 (**36**). This is modelled on the evidence for the squatter cottages; an arbitrary choice has been made of an end rather than a side lean-to. Drawings by Dr Pat Hughes.*

and the kitchen hearth (with young Elizabeth's cradle rocking before it). The upper chambers were rather under-employed, storing cheese, grain and miscellaneous farm produce including a parcel of feathers (for a new mattress?); they would certainly have become much more crowded if he had lived to have a large family grow up in the house.

In their different ways, the next examples achieved notably greater comfort and even luxury. Thomas Hill's house in 1631 (**17**, Figures 52 and 53) illustrates how additions and improvements to an already substantial 16th-century house created rooms in which the special-ised needs of the household found their own niches, with space for a bolting house, a dairy and a cheese chamber, as well as extra chambers. The so-called buttery in the new bay was probably built as such, but then proved so much more convenient for cooking that the old kitchen in the yard was demoted for cheese making and brewing. The bedchamber contained far more solid,

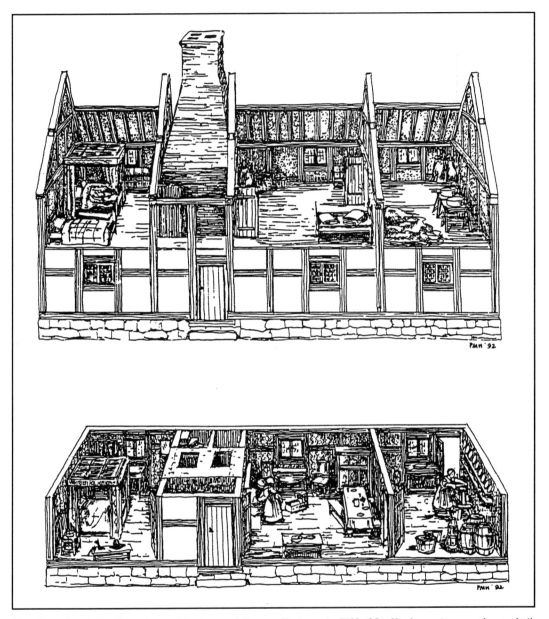

51 *Ground and first-floor views of the home of Thomas Higinson in 1689 (**25**). His house (apparently new-built in about 1680) is based on typical examples of that date with lobby-entry plans. Drawings by Dr Pat Hughes.*

comfortable and useful furniture than had been available to Humphrey Hylles in the previous century, while Thomas's hall gave his visitors a clear impression of his prosperity with its panelled walls, glazed windows, brick chimney and joined cupboard, chairs and stools.

Although Richard Garlick (**48**) still called himself a yeoman in 1728, his new stone house and its furnishings would certainly have been acceptable to any of the 'gentleman' tenants of the largest Stoneleigh farms (Figures 54 and 55). His parlour, with its pictures, chairs and tables, was a suitable room in which to receive Lord Leigh if he should call. Perhaps the family also dined

there sometimes, to escape the bustle of the kitchen. That room's position in the house, as well as its contents, shows that it was still the focus of the household. Little Elizabeth's cradle spent the day there in front of the fire, though she probably slept in her parents' chamber, while the other children may have used the closets. The maids and the men farm servants (including Thomas Eeds the parish lad) probably used the chambers over the pantry and dairy respectively. The latter had to put up with the overflow from the cheese chamber which in September must have been full to bursting with 1,000 cheeses.[8] The good room over the parlour may have been used by Richard's bachelor brother George until his death in 1727. Perhaps he shared it with the principal farm servant, the successor of that James Hickin who had expectations of a marriage to his master's sister Sarah (p.167).[9]

It is notable that the family still walked on stone flags except in the parlour. Even there the boards were uncovered; floor carpets had appeared in country houses but were not used anywhere in the village. One bedroom in Richard's house did boast window curtains, though surprisingly this was not the best but the second chamber.

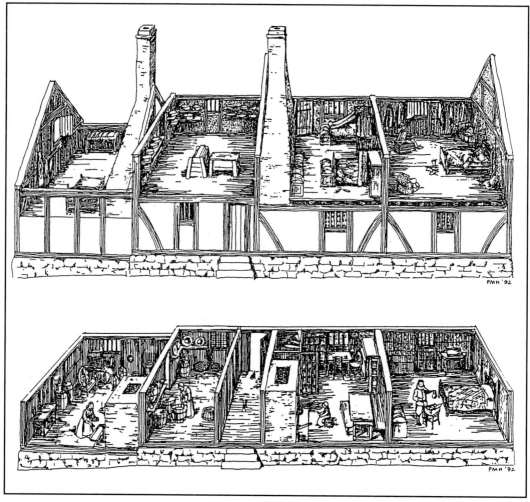

52 *Ground- and first-floor views of the home of Thomas Hill in 1631 (16). He lived in 11-12 Coventry Road, Stoneleigh, and good structural evidence survives for the form of the house at that date. Drawings by Dr Pat Hughes.*

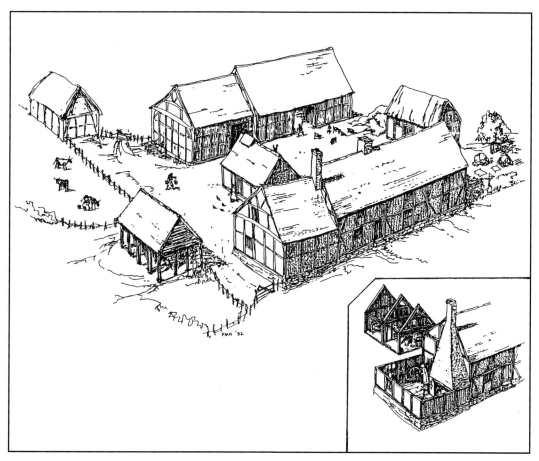

53 *A perspective view of the farmstead of Thomas Hill in 1631. The dimensions of the main barn were recorded in 1650, and it is placed in the position of the barn shown on the 1766 map. The other farm buildings (conjectural) were recorded in the inventory of Robert Baker (1610). The detached 'kitchen' and boulting house are in the only likely position, adjacent to the rear of the house. Inset: the interiors of the buttery, kitchen and boulting house. Drawings by Dr Pat Hughes.*

Notes

1. The method would be even more powerful if applied on a regional scale to increase the sample sizes, matching Hearth Tax numbers with inventories for (say) the following 15 years.
2. T. Arkell, personal communication. I am most grateful for the provision of this information in advance of publication.
3. [D. Martin], *Historic Buildings of East Sussex*, 1(5), Rape of Hastings Architectural Survey, 1980, p. 106; N. W. Alcock, unpublished work.
4. Royal Commission on Ancient and Historical Monuments of Wales, *Inventory of Ancient Monuments in Glamorgan*, H.M.S.O., 1988, IV(2), p. 26; B. Harrison and B. Hutton, *Vernacular Houses in North Yorkshire and Cleveland*, John Donald, 1984, Chs. 10-12.
5. L. Weatherill, *Consumer behaviour and material culture in Britain 1660-1760*, Routledge, 1988.
6. What replaced them is obscure. Perhaps the walls were painted, though only one example has been seen in Stoneleigh (early 19th-century stencil work at Manor Farm). In Essex, almost 300 examples of domestic wall painting have been recorded; M. Carrick, *Sixteenth and Seventeenth Century Domestic Wall Paintings in the County of Essex*, M. Phil. Thesis, Univ. of Essex, 1989.
7. This correlation was probably not present when the plan appeared in East Anglia a century earlier, even though a detailed study of room use in Norwich shows that fashions were much more advanced there and only half the parlours contained beds even in the 1580-90s. U. Priestley and P. J. Corfield, 'Rooms and room use in Norwich housing, 1580-1730', *Post-medieval Archaeol.* 16 (1982), 93-123.
8. Joan Bares in 1706 had 290 cheeses worth £8.
9. Unless indeed Sarah and her husband George Grendon were living at New House. He is not recorded as a Stoneleigh tenant, but they had a child baptised there in 1723 and two buried in 1727 and 1737.

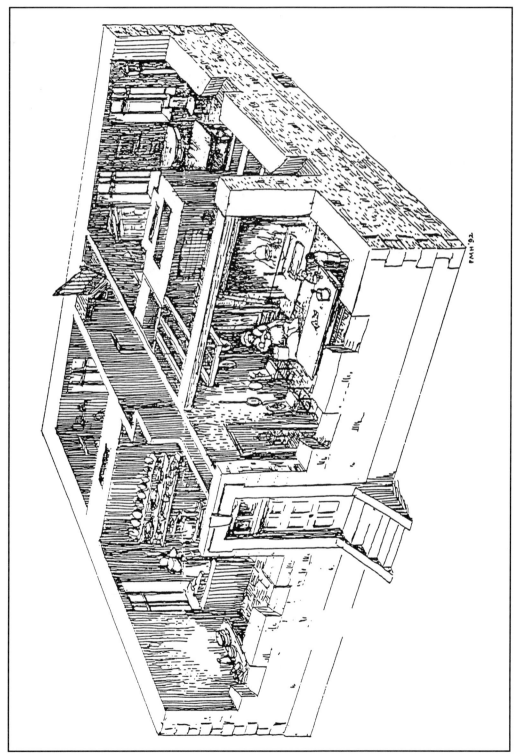

54 *Ground-floor view of the home of Richard Garlick in 1728 (New House Farm, Stareton).*

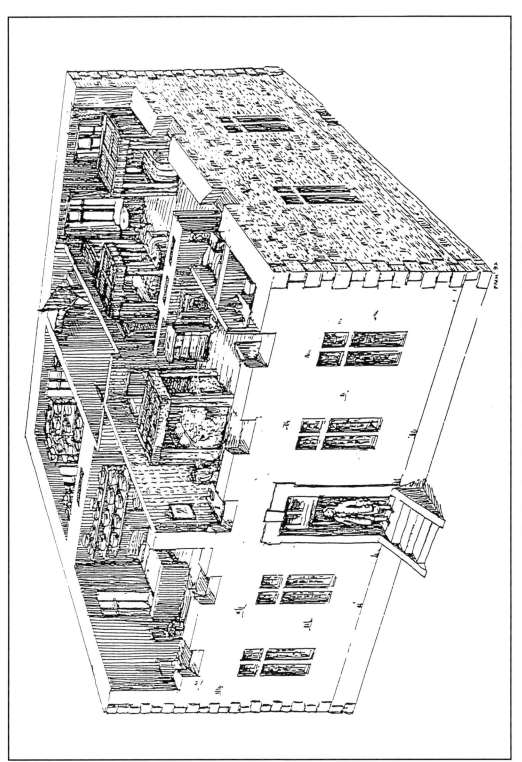

55 *First-floor view of the home of Richard Garlick in 1728.*

Appendix 1

Correlation of holdings and probate records

Names with bracketed dates and numbers refer to inventories included in the summary tables:

Table 4.1	2-4 rooms	1537-1600
Table 5.1	5 rooms upwards	1547-1600
	and 8 rooms upwards	1601-1700
Table 6.1	5-7 rooms	1601-1750
Table 7.1	2-4 rooms	1601-1750
Table 8.1	8 rooms upwards	1701-1756

Bold numbers identify printed inventories. Dates with the letters P, W or I indicate that the named occupant of the holding is recorded in a probate reference respectively with no surviving documents, with a will, or with an inventory that does not give full room names. Dates given are those of the inventory if dated, or of probate (sometimes a year later). Letters attached to holding numbers indicate the location of the holding; the same letters are used in the inventory tables. S, Stoneleigh; A, Ashow; Ca, Canley; Cr, Cryfield; Fi, Finham; Fl, Fletchamstead (scattered holdings); H, Hill; Hu, Hurst; I, isolated holdings; St, Stareton. Acreages are given in yardlands as recorded in 1597, as well as in acres then (1598 for Stareton; S.B.T.DR18/30/23/3) and in 1766 (and 1649 for Ashow, 1683 for Stareton). A dash (-) in the acreage column indicates that the holding either did not exist or that its area is uncertain at the relevant date.

Groups of inventories which relate to the same holding but which cannot be precisely identified are listed at the end of the table (X1-X5). Inventories assignable only to their hamlet or entirely unlocated are also listed at the end.

No/ Place				Modern address/ location	Names
1	I			Stoneleigh Abbey	Thomas Dadley (1558,7); Sir Thomas Leigh (1626,81); Dame Katherine Leigh (1639,86); Thomas Lord Leigh (1672,102); Thomas Lord Leigh (1710,71); Edward Lord Leigh (1738,105); Thomas Lord Leigh (1749,100)
1a	I			Stareton Park (?)	Charles Heath (1778, 10) [Of Stoneleigh Park]

Stoneleigh Village

No/ Place	yd	1597	1766 (acres)	Modern address/ location	Names
2	S 2.0	73	183	Manor Farm	Christopher Leigh (1673,20;**18**); John Holbech (1687,10); Francis Clayton (1714,13); 1543P (Robert Carter); 1752I (Richard Farmer)
3	S 2.0	59	82	11-12 Coventry Rd	Thomas Rowley (1551,6;**16**); Robert Baker (1610,7); Thomas Hill (1631,10;**17**); Henry Phillips (1699,6)
4	S 2.0	66	0	('Stonehouse')	Thomas Burbery (1568,3); Thomas Burbury (1646,7); Edward Burbery (1661,7)
5	S 1.0	29	104	5-7 Coventry Rd	William Farr (1567,3); William Farre (1609,12); Francis Perkins(on) (1644,8); Thomas Garrett (1683,9); Catherine Garrett (1684,8); George Garlick (1716,8)
6	S 1.0	31	56	Bridge Cottage	John Unton (1700,5;**27**); Joseph Hart (1702,3;**28**); 1591WI (William Hunt), 1686W (Richard Flavell), 1740W (Thomas Dee)

No/ Place	yd	1597	1766 (acres)	Modern address/ location	Names
7	S 1.0	29	70	16-17 Birmingham Road	James Mayo (1668,7); 1603WI (Thomas Stockton), 1720W (Joseph Mayo)
8	S 1.0	29	0	(Vicarage Rd)	Robert Baker (1628,5;**23**); Matthew Falkoner (1670,8); 1726W (Joseph Ladbrook)
9	S 0.5	20	79	(Inn)	Walter Hunt (1621,13); Alexander Preist (1629,14); Robert Osman (1638,11); Christopher Brookes (1670,13); Edward Casemore (1742,12)
10	S 0.5	15	-	4 Church Lane(?)	Thomas Hunt (1604,6); Agnes Hunt (1610,6); Edward Goddard (1680,7)
11	S 0.5	16	-	2-3 Church Lane	Robert Dene (1552,4;**9**); Thomas Owles (1607,5;**10**); Thomas Elliott (1675,5;**11**); 1584W (Edward Aston)
12	S 0.75	22	9	(Motslow)	Mary Winsmore (1641,6); Joseph Middleton (1745,5); 1670I (William Buckerfield)
13	S 1.0	29	25	Motslow Cottages	1568P (Nicholas Hudson)
14	S 0.1	4	0	1-2 Coventry Road	John Allyt (1537,4;**3**); Henry Waren (1597,4;**4**); Roger Hudson (1662,7)
15	S 0.1	4	-	(21 Birmingham Road)	Thomas Jervis (1639,2); Richard Grissold (1713,5); Rebecca Jaggard (1749,6); 1741W (William Jaggard)
16	S 0	5	12	1-2 Bank	John Hancox (1722,7)
17	S 0.05	3	0	6-9 Bank	John Lorde (1557,3); Edward Stirton (1670,7); 1583P (Thomas Freckleton)
18	S 0	0	0	(Bank)	John Wilde (1624,4); 1664WI (Elizabeth Addington)
19	S 0	0	-	(5 Birmingham Road)	William Lynes (1667,6) (probable)
20	S 0	0	100	9 Birmingham Road	Robert Stocken (1630,3;**40**); 1724WI (Thomas Ladbrook), 1738W (Thomas Harrison)
20a	S 0	1	0	18-19 Birmingham Road	Sarah Blason (1729,5)
21	S 0.08	3	2	22-25 Birmingham Road	Godfrey Parton (1559,4;**8**); Dorothy Lockwood (1669,4)
22	S 0	0	0	(Vicarage Road)	William Worth (1670,3); John Whitehead (1703,2)
23	S 0	0	4	(Vicarage Road)	Richard Cotton (1583,3); William Kelsoe (1603,4)
24	S 0	0	4	5 Vicarage Road	Thomas Lewes (1609,4)
25	S 0.02	2	0	6-7 Vicarage Road	Philip Cleadon (1610,2)
26	S 0	2	2	8-9 Vicarage Road	Roger Hudson (1610,6;**32**); William Watton (1756,6;**33**); 1722 WI (Thomas Biram)
27	S 0.02	1	10	10 Vicarage Road	Richard Hewett (1608,9); Richard Hewett (1636,7)
28	S 0.02	24	-	(Vicarage Road)	James Hoo (1611,10); Thomas Lord (1675,11)
29	S 0	0	4	(Green)	1705I (Humphrey Goddard)
30	S 0.05	2	0	11-12 Vicarage Road	1559P (William Lee)
31	S 0	0	-	(Vicarage Road)	1582W (John Colton)
32	S 0	1	2	Vicarage	Henry Billingham (1632,13); Edward Agborow (1692,8); 1546P (Richard Mawdesley), 1600I (William Drax)
33	S	47	116	Stoneleigh Grange	William Robinson (1668,17); 1546P (Thomas Downton), 1580WI (Thomas Dunton), 1632W (David Draper)
33a	S	0	0	Almshouses	1640I (Richard Hargrave;**44**)

Ashow

No/ Place	yd	1597	1649	1766 (acres)	Modern address/ location	Names	
34	A	-	20	36	252	Bericote Grange	Henry Elliott (1626,5); John Clarke (1668,9); Richard Skudemore (1669,6); John Gibbs (1700,7); Richard Hiron (1705,5); 1543WI (John Kent), 1734W (Ann Hyrons), 1747W (Richard Hiernes)
35	A 1.5	70	61	-		Richard Dadley (1601,9)	
36	A 1.1	77	73	89		Ralph Gressold (1556,5); 1598P (John Fryer), 1602W (John Fryer), 1728P (Robert Boddington)	
37	A 1.1	50	81	98	Abbey Farm	Thomas Coxe (1580,8;**12**); James Cox (1612,12); Thomas Jeacocke (1647,12); 1725W (Edward Boddington)	
38	A 1.0	48	46	-		Francis Shrewsbury (1650,6); Thomas Tym (1669,5); Mary Tym (1684,5); Daniel Tym (1685,5)	

No/ Place	yd	1597	1649	1766 (acres)	Modern address/ location	Names
39	A 1.0	52	60	92	Grove Farm	Thomas Dadley (1582,8); Baldwin Warde (1585,8); Richard Hobley (1676,6); 1659W (Richard Hobley)
40	A 0.5	24	1	0		John Jeacock (1705,5); Catherine Jeacock (1710,4); William Ward (1741,8); 1744W (Rachel Ward)
41	A 0.5	25	22	1	Fir Tree Cottage	John Wright (1612,5;**24**)
42	A 0.35	15	16	39	Trinity Cottage	Thomas Cox (1639,9); James Gibbs (1710,2); John Russell (1726,5); Elizabeth Russell (1731,7); 1714P (Thomas Gibbs)
43	A 0.16	9	12	12		James Gaundy (1549,4);[1] 1597WI (William Dadley), 1722W (Mary Clarke)
44	A 0.16	10	8	37	Roseland	William Powres (1556,4;**29**); Thomas Powrse (1622,5;**30**); John Elliott (1730,5;**31**); 1742W (William Pickford)
45	A 0.16	10	11	-	Ashow shop	Richard Winsmore (1620,7); Hannah Pinchback (1731,3)
46	A 0.11	4	5	-		Richard Pratt (1708,2)
47	A 0.1	4	6	0	2-3 Ashow	John Collett (1622,4); Margaret Collett (1628,5); Thomas Smith (1698,4); 1665I (Margaret Smith)
48	A 0.06	6	7	0	15-16 Ashow	Richard Griffine (1585,5); Richard Worsley (1600,6)
49	A 0.05	2	15	14	Grove Cottage	John Greene (1603,5); Ralph Reade (1610,5); Abraham Boyes (1612,5); Thomas Bryans (1650,6); Thomas Stoakes (1736,5); Thomas Stoakes (1771,8)
50	A 0.16	8	14	14	Rectory	Henry Berydge (1581,8); Martin Delene (1611,8); Thomas Stringfield (1663,9); Mary Stringfield (1673,6); 1732W (Richard Farmer)
51	A 0	0	5	5		1720I (Thomas Clarke), 1736P (Thomas Clarke)
52	A 0	28	-	40	Crew Farm[2]	Edmund Hudson (1556,4)
53	A -	-	-	13	('Glasshouse')	Humphrey Keene (1684,4); 1658W (Richard Baylies)
54	A -	-	-	71	Dial Ho., Chesford	William Clarke (1696,5); Robert Davis (1731,9;**45**)

Stareton

No/ Place	yd	1598	1683	1766 (acres)	Modern address/ location	Names
55	St 2.0	158	-	-	(Stareton Grange)	Nicholas Samon (1638,11); 1538I (William Bannaster), 1640P (Eleanor Samon)
56	St 1.5	98	88	153	Park Farm	Thomas Couper (1558,3); William Mourey (1616,12); Elizabeth Morrey (1624,11); Thomas Casemore (1684,8); Francis Casemore (1724,9); Edward Casemore (1730,11); 1533I (John Cowper); 1675WI (Thomas Casemore)
57	St 1.25	84	81	87		John Sotherne (1553,2); Edward Sotherne (1602,8); Thomas Sotherne (1636,10); Anne Sotherne (1640,8); Richard Stokes (1731,9)
58	St 1.5	94	94	-		Humphrey Hoo (1616,15;**13**); 1582WI (Alexander Howe)
59	St 1.25	79	75	80	4-5 Stareton	George Kockes (1558,4);[3] Thomas Holland (1593,8); Thomas Nelson (1627,9); Thomas Middleton (1705,7); William Middleton (1710,4)
60	St 0.75	38	50	49		Thomas Harper (1593,3); Edward Malen (1609,6); 1561WI (Thomas Harper), 1714WI (Edward Gilbert), 1723W (Elizabeth Gilbert)
61	St 0.75	43	21	20		John Munckes (1617,8); Margery Monckes (1622,6); Thomas Smith (1753, 5); 1568P (George Baker), 1722WI (William Eagles), 1738W (Elizabeth Eagles)
62	St 0.25	17	10	10	Yew Tree Cottage	William James (1586,3); Joan James (1608,6); Joan Barber (1677,4;**38**); 1716I (John Watts)
63	St 0.25	20	23	91		John Clarke (1581,3); Alice Clerke (1608,3); Henry Clarke (1624,7); Edward Robins (1649,5); William Whitmore (1717,4)
63a	St 0.25	-	-	-		William Convey (1538,2);[4]
64	St 0	19	29	28		John Malin (1641,7); Thomas Malyn (1676,10); Mary Malin (1693,6); Thomas Burden (1709,4); 1723W (Mary Burden)

No/ Place	yd	1598	1683	1766 (acres)	Modern address/ location	Names	
65	St 0	7	8	8		Thomas Smith (1603,4); 1592WI (Ralph Gandie), 1727P (Isaac Gibbs)	
66	St 0.5	29	31	43	1-2 Stareton	Thomas Tuter (1558,3;**5**); Symon Tyler (1575,3;**6**); Leonard Hemmings (1616,7); John Heminges (1640,6); Richard Camill (1694,8;**7**); 1563WI (Alice Tutor), 1709WI (Elizabeth Cammill)	
67	I	-	-	-	291	Newhouse Farm	Richard Garlick (1728,15;**48**)
68	I	-	-	-	182	Furzenhill Farm	Edward Parsons (1722,13)

Scattered

No/ Place	yd	1597	1766 (acres)	Modern address/ location	Names
69	I	-	-	Pypes Mill	William Pyppe (1557,6;**2**); 1545WI (Thomas Pype), 1622W (Thomas Grissold), 1674I (Thomas Grissold)
70	I	-	207	Milburne Grange	Jane Wynter (1556,8); William Lee (1699,9); 1576WI (Thomas Gorge), 1652W (Thomas Wright), 1744W (Thomas Harbourne)
71	I	-	103	Wainbody Farm	George Whitmore (1681,3); Thomas Whitmore (1730,7); 1748W (Abraham Whitmore)
72	I	-	97	Tocil Farm	Richard Cashmore (1690,6); Isaac Gumbley (1719,6)
73	I	-	87	Gibbet Hill Farm	Edmund Casemore (1728,5;**34**); Benjamin Higginson (1740,8)
74	Ca	59	129	Ivy Lane Farm	Margaret Ball (1559,2);[5] Thomas Balle (1573,5) William Syers (1598,9); Hercules Spooner (1618,8); Laurence Nicholls (1667,8); Thomas Bagshaw (1689,5); 1558W (Thomas Ball)
75	Ca	49	167	Ivy Farm	John Hancorne (1571,8); Agnes Hancorne (1574,3); Johanna Hancorne (1627,10); 1667WI (Nicholas Dilworth), 1732W (Thomas Gibbs)
76	Ca	(28)	-	(Canley)	Thomas Handcorne (1585,6)
77	Ca	-	152	Canley Hall	Basil Holbech (1687,8); Ann Holbech (1695,8); 1605W (Edward Marbury)
78	Ca	-	100	(Canley)	Joseph Symcox (1705,17); John Webster (1727,13)
79	Cr	-	282	Cryfield Grange	Stephen Wilson (1633,16); Ann Wilson (1650,16;**55**); Edward Lee (1693,6);[6] Thomas Higinson (1690,6;**25**);[6] Zachariah Groves (1708,8); Samuel Adkins (1713,5):[6] 1588W (Andrew Ognell), 1679WI (John Hartley)
80	Cr	-	197	Cryfield House Farm	Richard Tompson (1727,6)
81	Hu	54	63	South Hurst Cottages	Humphrey Partrige (1569,6;**19**); Anthony Spencer (1604,12;**20**); John Franklin (1717,9;**21**); 1537WI (Richard Partrich)
82	Hu	4	-	(Hurst)	John Paine (1613,6); John Cooke (1673,5)
83	Hu	-	2	(Hurst)	Robert Adams (1700,4)
84	Hu	12	41	(South Hurst)	David Benyon (1606,5); Thomas Smith (1660,6;**35**); Francis James (1691,5); Francis James (1728,5); 1568WI (Thomas Ravis)
85	Hu	-	103	Hurst Farm	Thomas Watson (1729,9)
86	Hu	38	110	South Hurst Farm	Humphrey Hylles (1556,3;**1**); 1704WI (Edward Lees)
86a	I	(1)	-	(Westwood Heath)	John Morice (1697,2;**36**)
87	I	-	15	(Westwood Heath)	John Curtis (1724,3;**39**)
88	I	-	51	(Westwood Heath)	Edward Hancocks (1719,3)
89	I	24	36	Moat House (Canley)	Thomas Burton (1610,3;**37**); Joseph Badhams (1722,6;**26**); 1689WI (Richard Timm)
90	I	-	22	Lodge Fm	Walter Heynes (1618,8); Laurence Hands (1706,8); James Hands (1721,10); Richard Hands (1755,12)
91	I	-	129	Westwood Heath Farm	John Perkes (1700,5); John Perkes (1738,10)
92	I	-	30	(Crackley Wood Farm)	Edward Lee (1730,4;**43**)

No/ Place	yd	1597	1766 (acres)	Modern address/ location	Names
93	I	149	152	Bokendon Grange	John Benion (1597,9); Zachariah Grove (1693,8); Thomas Davis (1706,11); 1544P (Thomas Benyon)
94	I	0	38	(Bokendon)	John Trickett (1641,5); 1671WI (Peter Mills)
95	Fl	-	89		Edward Higginson (1728,10); John Higginson (1746,8)
96	Fl	-	41	The Elms, Broad Lane	Joan Sly (1717,4;**41**)
97	Fl	-	-	(Broad Lane)	William Darnell (1665,5)
98	Fl	-	0		(Broad Lane) Richard Edge (1738,3)
99	Fl	-	26		John Wall (1661,3); Hugh Heassall (1726,5)
100	Fl	128	193	Fletchamstead Hall	Sir Thomas Leigh (1626,47); William Meigh (1713,12)
101	Fl	-	251	Nether Fletchamstead Hall	Humphrey Taylor (1634,13); John Tayler (1680,16); William Meigh (1695,14;**22**); Thomas Hart (1709,13); John Scotton (1718,11); John Atkins (1745,18;**47**)
102	Fl	-	-	Fletchamstead Mill	John Jefferies (1712,5); Thomas Walton (1730,4)
103	Fl	-	111		Thomas Barrs (1700,3); Robert Bennett (1710,7); Abraham Baker (1720,7); 1741W (John Rotherham)
104	Fl	14	-	(Tile Hill Wood)	John Plante (1602,2)
105	Fl	-	74		Richard Bars (1693,6); Jane Barrs (1706,8)
106	Fl	-	112	Tile Hill Farm[7]	Richard Barrs (1684,6); Joseph Barrs (1701,10); John Barr (1720,11;**46**); John Bars (1733,11)
107	Fl	-	19	Limbrick Farm[7]	Alice Wright (1617,9); John Stone (1629,4); John Barrs (1702,8); 1591WI (William Wright)
108	Fl	-	1	(Middle Road)	Thomas Ansley (1736,3)
109	Fl	-	1	(Broad Lane)	Richard Ash (1729,3)
110	Fl	-	1	(Eastern Green)	William Elliott (1731,5)
111	I	-	1	(Kirby Corner)	1739W (Matthew Lee)
112	Fl	-	15	The Firs, Broad Lane	Richard Bolt (1688,10)
113	Fl	-	45	Whoburley Hall	Samuel Wade (1668,11); 1619W (Samuel Wade), 1677P (Catherine Wade), 1728P (Samuel Wade), 1731W (Francis Wade)
114	Fi	-	-	Finham (Hall)	Thomas Stacey (1665,10); 1598P (George Kevett), 1647W (Joan Stacy), 1692W (John Boun)
115	H	-	-	Stivichall Grange	Richard Hyll (1547,5); Cuthbert Hill (1567,6); Thomas Hill (1567,6); 1654W (Loveisgod Gregory), 1745W (Thomas Rhodes)

Other Room-by-room Inventories

(a) Paired Inventories for Unidentified Holdings

X1	Hurst	Richard Chapman (1561,3); Agnes Chapman (1571,3)
X2	Hurst	William Hunt (1613,6); Isabella Hunt (1615,5; also described as of Cryfield)
X3	Canley	William Rawbone (1634,4); Joan Rawbone (1640,4)
X4	Finham	Thomas Cross (1705,4); Ann Crosse (1717,5)
X5	Hill	John Harbutt (1719,9); Mary Herbert (1730,11)

(b) Inventories assignable only to particular hamlets

Stoneleigh	Thomas Garnett (1678,4)
Ashow	Thomas Freeman (1613,3); Samuel Jeffery (1748,4)
Stareton	Thomas Gecok (1547,2)
Canley	Thomas Smallwood (1605,9); John Greene (1639,7); Robert Bagshaw (1633,5); William Brookes (1635,4); James Boland (1667,6)
Cryfield	Christopher Shawe (1584,4); Henry Kirbie (1626,4);
Hurst	Ralph Kempe (1624,4); George Baker (1691,5); James Jobson (1717,3); Joseph Austin (1730,8)
Fletchamstead	William Waren (1562,3); Edward Hopkins (1632,3); Basil Hall (1634,5); Richard Kennell (1673,3); Eustace Salmon (1682,4); Jacob Gibbs (1714,2;**42**)

Finham William Nycolles (1556,2;**12**); George Chaulton (1640,5); John Man (1673,5); Robert Burbery
 (1682,9;**15**); William Smith (1682,5); Elizabeth Hancock (1719,4);
 Hill Thomas Hobley (1538,2); John Godfrey (1592,3); William Dunton (1609,2); John Westbury
 (1640,6); Ellen Driver (1688,3)

(c) Unlocated Inventories
 John Gesse (1559,3); Benjamin Burnabye (1626,4); William Hancox (1709,6)); Edward Hancox
 (1723,5); Mary Ball (1728,8); William Spooner (1728,5);

Notes

1. He also held the fulling mill at Stoneleigh Abbey.
2. No.52: This freeholding was originally located in Ashow with land extending into Kenilworth Parish, but during
 the 17th century the farmhouse was rebuilt in Kenilworth Parish (and probate records for the house there have
 not been identified). The acreages given are those in Ashow; in 1815, the whole farm comprised 56 acres.
3. George Kockes also held holding 4 in Stoneleigh, but the names of the appraisers, and a comparison with the
 inventory of Thomas Burbery (1568) for holding 4, indicate that this inventory relates to his Stareton holding.This
 is directly confirmed by DR18/30/24/106, replies to an Inquisition on Depopulation(t. Ed.VI), which notes that
 George Kockes had sub-let his Stoneleigh holding as a cottage.
4. William Convey held one of two quarter yardland holdings, either this one or no. 63.
5. Although the probate records for Thomas Ball the elder and his widow Margaret, describe them as of
 Fletchamstead, he is clearly the Thomas Ball granted a copyhold in Canley in 1544 (SBT.DR18/30/24/98), later
 held by their son Thomas.
6. Edward Lee and Thomas Higinson held parts of Cryfield Grange farm; Samuel Adkins is identified in his
 inventory as occupying Cryfield House, which was probably also part of it.
7. Nos. 106-7: Joseph Barrs (d. 1701) was Lord Leigh's tenant of Tile Hill Farm by a 21 year lease granted in
 1691 (DR18/1/994), which he bequeathed to his son John. Joseph's brother, John, (d.1702) bought Limbrick
 Farm (No.107) and bequeathed it, also to Joseph's son, John. The inventories of the latter (d.1720) and his
 son John (d.1733) clearly relate to the same house, which is identifiable as Tile Hill Farm, rather than Limbrick
 farm, because of the correspondence to Joseph's (1701) rather than John's (1702) inventory.

Appendix 2

Standing Buildings

For holdings with identified probate records, the reference numbers correspond to those in Appendix 1. Other houses are given letter identifications (a-s). All houses with probable 18th century structure are included together with a few 19th century houses and demolished buildings for which structural evidence has been recorded. Grid references refer to square SP.

No	Grid	Ref	Address	Character	Page
1	3284	7120	Stoneleigh Abbey	Great house, 12th-19th centuries	86

Stoneleigh

No	Grid	Ref	Address	Character	Page
2	3290	7265	Manor Farm	Large timber-framed house, 16th + 17th centuries	71
3	3313	7275	11-12 Coventry Rd	Timber-framed house, 4 bays, 16th + 17th centuries	64
5	3284	7259	5-7 Coventry Rd	Timber-framed cottage, 2 bays, 17th century	132
6	3326	7279	Bridge Cottage	Timber-framed cottage, 3 bays, 17th century	101
7	3292	7279	16-17 B'ham Rd	Brick, square 4 room plan, 1767 & later	153
10	3308	7267	4 Church Lane	Timber-framed cottage, 2 bays, late 17th century	133
11	3308	7265	2-3 Church Lane	Three-bay cruck house, c.1500	40
12	3287	7242	Motslow	Two room, brick, mid/late 18th century	
13	3290	7242	Motslow Cottages	Three-bay timber-framed house, c.1500	28
14	3315	7276	1-2 Coventry Rd	Timber-framed cottage, 4 bays, late 16th century	31
15	3313	7279	3 Coventry Rd	Brick cottage, 18th/19th century	
16	3310	7279	1-2 Bank	Timber-framed house, 3 bays, brick-cased, 16th century	
17	3304	7278	6-9 Bank	Complex timber-framed house, 16th century	34
19	3290	7281	4 Birmingham Rd	Apparently 18th-century brick; demolished 1950s	
20	3285	7283	9 Birmingham Rd	Timber-framed cottage, 2 bays, 16th century	125
20 a	3294	7278	18-19 B'ham Rd	Timber-framed cottage, 2 bays, brick-cased, 16th century	
21	3297	7277	22-25 B'ham Rd	Three-bay cruck house, c.1500	40
24	3284	7259	5 Vicarage Road	Timber-framed cottage, 2 bays, brick-cased	40;107
25	3278	7257	6-7 Vicarage Road	Brick, later 18th century	
26	3286	7278	8-9 Vicarage Road	Three-bay cruck house, c.1500 + 17th century timber-framed bay	
27	3289	7261	10 Vicarage Road	Timber-framed cottage, 2 bays, late 17th century	131
30	3298	7268	11-12 Vicarage Rd	Timber-framed cottage, 2 bays, 17th century	133
32	3305	7263	Vicarage	Brick, c.1700 with later alterations	
33 a	3302	7282	Almshouses	1597 stone casing of 1575 timber-framing	141
a	3300	7269	Stoneleigh School	Brick, c.1740	
b	3298	7270	Vicarage Road	Stone row of 1840s, replacing holdings 9, 22, 23	
c	3295	7280	1 Birmingham Rd	Three-bay cruck house, 3 bays, c.1480	40
d	3293	7281	3 Birmingham Rd	Two-bay cruck house, c.1450	42
e	3285	7288	5-6 B'ham Rd [Croome Cottage]	Two cruck bays + 17th-century framed bay	42
f	3307	7275	Chestnut Cottage	Timber-framed cottage, 17th century	134
g	3307	7278	4-5 The Bank	Timber-framed semi-detached pair of cottages, 1727/1732	129

Ashow

34	3118	7005	Bericote Grange	Brick, 18th century	
37	3107	7052	Abbey Farm	Brick, some timber-framing, 17-18th centuries	
39	3133	7019	Grove Farm	Brick, 18th century	
41	3107	7039	Fir Tree Cottage	Timber-framed, 2 bays, 16th + 17th centuries	31
42	3107	7037	Trinity Cottage	Two cruck + two framed bays, brick-cased, 15th + 16th centuries	43
44	3110	7050	Roseland	17th century timber-framed, 3 bays, brick-cased	104
45	3110	7020	Ashow shop	Timber-framed + stone, 17th century, demolished 1973	
47	3109	7040	3-5 Ashow	Timber-framed, 6 bays, 17th century, demolished 1973	128
48	3109	7034	15-16 Ashow	Timber-framed semi-detached pair of cottages, 1727/1732, virtually demolished 1973	129
49	3128	7019	Grove Cottage	Timber-framed, 2 bays, brick-cased, 17th century	113
54	3030	7010	Dial House, Chesford	Brick, 18th century	147
h	3115	7020	Avon Cottage	Timber-framed, 2 bays, 1721	134
i	3115	7025	Church Cottage	Timber-framed, 2 bays, 17th century, demolished 1973	18

Stareton

56	3345	7134	Park Farm	Three-storey brick house, mid-18th century	
59	3353	7142	4-5 Stareton	Timber-framed cottage, 3 bays, 18th century	131
62	3388	7147	Yew Tree House	Timber-framed cottage, 2 bays, brick-cased, moved c.1700? from earlier site	
66	3332	7137	1-2 Stareton	Two bay timber-framed cottage, c.1680, brick-cased, c.1770	35
67	3343	7044	New House Farm	Square-plan stone house, 1716	156
68	3459	7024	Furzenhill Farm	Timber-framed house, brick-cased, c.1682	153

Scattered

69	3280	7388	Pypes Mill	Timber-framed, 2 bays, 1490	26
70	3035	7362	Milburne Grange	Brick, later 18th century	153
71	3162	7442	Wainbody Wood Farm	Timber-framed, 4 bays, late 17th century	121
72	3022	7595	Tocil Farm	Brick, 18th century; demolished c.1926	
73	3048	7524	Gibbet Hill Farm	Stone, 2 bays, late 17th century, enlarged (brick) early 19th century	109
74	3052	7654	Ivy Lane Fm, Canley	Brick, 18th century ?	
75	3082	7671	Ivy Farm, Canley	Timber-framed, with cross-wing, 17th century	64
77	3087	7662	Canley Hall	Brick, 18th century	153
79	3000	7471	Cryfield Grange	Timber-framed + stone, 16th century and later	83
80	2958	7550	Cryfield House	Brick, c.1820	
81	2841	7506	South Hurst Cotts	Timber-framed, 16th century	75
85	2852	7540	Hurst Farm	Brick, 18th century	
86	2834	7500	South Hurst Farm	Timber-framed, 2 bay house, brick-cased, 17th century	18
89	3044	7720	Moat House, Canley	Brick house (19th century), timber-framed barn	100;123
90	2760	7654	Lodge Fm, Westwood	Timber-framed, brick-cased, 17th century	
91	2875	7650	Westwood Heath Farm	Brick, 18/19th century	
93	2772	7578	Bokendon Grange	Brick, 18th century with timber-framed fragments	
96	2863	7934	The Elms, Broad Lane	Timber-framed, 3 bays, 17th century	127
100	2903	7797	Fletchamstead Hall	Large timber-framed hall (old drawing)	84
106	2833	7848	Tile Hill Farm	Brick, 18th + 19th centuries	
112	2891	7922	The Firs, Broad Lane	Timber-framed, 17th century, demolished 1964	
115	3261	7608	Stivichall Grange	Stone, c.1635	81
j	2975	7363	Crackley Barn	Timber-framed cottage, 2 bays, 18th century	137
k	2814	7579	Pools Cottage	Timber-framed cottage, 2 bays, 18th century	138
l	2969	7630	Kirby Corner Farm	Brick cottage, 1753?, demolished 1966	
m	3022	7595	Dale House Farm	Brick, established c.1746; rebuilt 1777-9	153
n	3284	7463	Hill Farm, Hill	Timber-framed, hall + crosswings, 17th century	
p	3273	7453	Cottage, Hill	Timber-framed cottage, 2 bays, 17th century	
q	3254	7446	The Hill, Hill	Brick, 18th/19th century	

Glossary of Architectural Terms

Some of the definitions are restricted to meanings relevant to the buildings examined here; for additional detail and illustrations, see N.W.Alcock, M.W.Barley, P.W.Dixon and R.A.Meeson, *Recording Timber-Framed Buildings: an illustrated Glossary* (Council for British Archaeology, London, 1989).

Arcading, blind	Row of decorative stone arches set against a wall
Arch, segmental	Arch forming part of a circle
Arch, four-centred	'Tudor' arch, made up of sections of four circles
Ashlar	Masonry composed of squared blocks of stone
Assembly marks	Incised numerals or symbols used to indicate matching prefabricated timbers
Bay	One portion of a framed building between two pairs of principal wall posts or crucks, used as a unit of measurement (e.g. three-bay house). A **chimney bay** is a narrow bay for a chimney.
Beam, half	Narrow ceiling beam, chamfered or moulded on one side only, set against a wall
Box-frame	Form of construction in which roof trusses are carried on a frame composed of posts, tiebeams and wallplates
Brace	Subsidiary timber, curved or straight, normally running between vertical and horizontal members of a frame.
Brace, diagonal	Short straight brace between post and wallplate, characteristic of 17th-century work in Stoneleigh
Brace, down	Brace from a post to the sill beam
Brick-on-edge arch	Arch made up from the ends of bricks set on their shorter sides
Carpenters marks	See **assembly marks**
Chamfer	Edge of a beam cut off at an angle (usually 4°); see stop
Close-studding	See **stud**
Collar	Transverse timber connecting a pair of rafters or cruck blades about half way between the roof apex and the wallplates
Coving	Curved surface, generally under a jetty or eaves, formed by a series of brackets with plaster infill
Cruck truss	Pair of timbers (**cruck blades**), stretching from the roof apex down to the sill beams and forming the principals of a roof
Dendrochronology	Dating of timber by matching its pattern of growth ring widths with those of a previously dated sequence
Door, planked and battened	Door made up of vertical planks secured to horizontal battens
Jetty	Cantilevered overhang of one storey or a gable (a **jettied gable**) over the storey below it
Joint, lapped	Joint made by applying one timber to the face of another
Joist	One of a series of horizontal timbers carrying a floor; heavy square joists are characteristic of 16th-century floors
Lintel	Horizontal beam over a fireplace, door or window opening
Lobby-entry	House plan in which the entrance leads into a small lobby in front of the main chimney; the staircase is sometimes in the lobby

Mid-rail	Horizontal beam in a wall-frame, centrally placed in a storey or between wallplate and sill beam
Mouldings	An ogee moulding combines a round and a hollow; an ovolo moulding has a quarter-round set between two small flats; a quirk is a small sharp projection running along a moulding.
Mullion	A vertical member separating the lights in a window
Ogee	See **moulding**
Oriel window	Projecting window resting on brackets
Ovolo	See **moulding**
Panel, fielded	Panel containing a raised central portion
Plat band	Raised horizontal band of brickwork, between two storeys
Post, jowled	See **wall post**
Post, storey	See **wall post**
Principal	The principals (or principal rafters) are the main rafters in a roof, carrying the purlins; inset principals have the ends of the rafters set well in from the ends of the tiebeam.
Purlin	Longitudinal timber set in the roof plane, supporting the rafters; a **tenoned purlin** (butt purlin) is tenoned into the sides of the principal rafters; a **trenched purlin** passes across the backs of the principal rafters in a trench.
Queen-struts	A pair of struts between the tiebeam and the collar of a roof truss
Quirk	See **moulding**
Quoin	Stone at the corner of a building or of a door or window opening
Scarf joint	Joint between two timbers meeting end-to-end
Segmental arch	See **arch**
Sill beam	Horizontal timber at the bottom of a framed wall into which the posts and studs are tenoned
Soot-blackening	Soot deposit on roof timbers indicating the former presence of an open hearth
Stair, open-well	Staircase surrounding a square void, with a newel post at each corner
Stop, chamfer	Decorative end of a chamfer; a run-out stop has a smooth curve; in a step stop, this curve is interrupted by a step; a scroll stop has an ogee curve; a straight-cut stop has a flat-cut end.
Strap-work	Elizabethan/Jacobean style of decoration using raised bands
Struts, V-	Pair of struts in V-form above the collar in a roof truss
Stud	Subsidiary vertical member in a framed wall; in **close-studding** the spaces between the studs are approximately the same width as the studs.
Thrall	Shelf or low stone platform in a dairy, providing a cool surface for keeping milk, etc.
Trimmer	Short timber set across the ends of shortened joists to provide a stair opening
Truss	Major transverse framework in a roof, or the compete framing structure from roof to ground defining each bay. An **A-frame truss** consists of a pair of rafters and a collar; a **box-frame truss** consists of posts and a tiebeam, carrying rafters, etc. A **flying truss** does not have wall posts below it, but is only supported by the wall plate. See also **cruck truss**.
Valley	Meeting of two roof slopes
Wall plate	The horizontal timber at the top of a wall on which the feet of the roof trusses rest
Wall post	Post in a timber-framed wall, usually carrying a tiebeam; a **jowled wall post** has an expanded head. A **storey post** rises through two or more storeys.
Windbrace	Brace in the plane of a roof, tying together a purlin and a principal

Glossary of Inventory Terms

Several of the words have more than one meaning and those given here are believed to be appropriate for these texts but may not apply elsewere. Only a selection of spelling variants are given; y and i were frequently interchanged. Inventory numbers are included for the rarer words. Principal Sources: *Banbury Inventories*; *Gloucestershire Inventories*; *Oxfordshire Inventories*; *Telford Inventories*; *Stoneleigh Villagers*; English Dialect Dictionary (EDD); Oxford English Dictionary (OED).

Alchemy (p.64)	Probably describing a brass alloy imitating gold (OED), rather than a silvery antimony alloy (*Telford*)
Andirons (handirons, landirons)	large fire-dogs, sometimes incorporating hooks to hold a spit; cf **cobirons**.
Aperin	apron
Aumbry (amber, halmere)	cupboard (n.22, p.52)
Axle tree	axle, i.e. the *fixed* bar between the wheels of a cart
Backband (45)	strap passing over a cart saddle, supporting the shafts of a vehicle
Backstool (22)	chair (p.63)
Balons	balance (scales)
Band	see **bond**
Bands (35, 51)	loose turn-over collar; falling bands: pair of short strips of cloth hanging down from a collar
Banker (8, 13)	cloth or cushion on a bench, or sometimes a cupboard
Baring bill (37)	see **bill**
Bassone bolles (24)	presumably large basin-like bowls
Beam and scales	weighing beam and pans for large scales
Beetle (26, 34)	heavy wooden mallet
Bell-metal (belmettle) (26, 45)	alloy of copper and tin used for casting vessels, especially mortars and pots
Bill (30)	bill-hook; chopper with a hooked end; a 'great baring bill' (37) was perhaps for stripping turf (baring; OED)
Bing (47)	bin, for corn or meal
Boardcloth (1, 4, 8, 9)	table cloth
Boarded bedsteed (17)	bedstead with panels at the head or foot
Boiler; brass boiler (46, 48)	copper for boiling water for brewing, laundry, etc.
Bolter (18)	bolting sieve (OED)
Bolting	sieving to remove bran from flour
Bolting fatt (8), tubb (14, 16),	container for bolted flour and for doing the bolting in; see **fatt, which** (2)
Bolting sieve (47)	sieve for bolting
Boltinges (13)	bran produced by bolting
Bond	written agreement to pay a penal sum on failing to repay a debt (or fulfil some other agreement); see n.10, p.196
Bottes	boots
Brandart (brandiron, brendert)	see **gridiron**
Brewing fatt (3), lead, loom	see **fatt, lead, loom**
Broach (4,16)	spit
Brodlom (3)	see **loom** (ii)

221

Bucking tubb (18) — wash-tub for steeping (bucking) clothes in lye
Buckskins (7) — see **pair of buckskins**
Bull stag (47) — bull castrated when full grown (OED)
Burdeclothe — boardcloth

Calldron (42) — cauldron
Camlet (chamblett, 13) — an expensive decorative fabric, originally of oriental manufacture (*Telford*)
Cane chair (46) — chair with cane seat
Cann (21, 34) — probably a drinking pot
Canopie (20) — canopy; see **field bedstead**
Cantch (23) — small quantity of unthreshed corn in the corner of a barn
Card — small handled board with projecting iron teeth for combing wool or flax
Carpittes (20) — placed on furniture rather than the floor
Carsie — kersey
Caudle pot (20) — for caudle, a hot drink of thin gruel mixed with wine, given to invalids
Chafer (9, 16) — Small dish containing hot ashes or charcoal to keep food warm
Chaff bed (46) — bed containing cut straw
Chafing dish (chafin) — dish containing food to be placed on a **chafer**; probably often including the chafer.

Chamblett — **camlet**
Charger (16, 24,55) — large pewter plate
Chaving dish — chafing
Cheesbord — see **suter**
Cheese fatt — vat in which curds were placed to press out the whey in making cheese
Cisterne (18) — large vessell, often expensive and highly decorated
Civer — **kiver**
Cleaner (18) — in the hearth, so possibly a container for ashes
Clensinge syve (13) — possibly identical to **bolting sieve**
Close stool (18, 26, 46, 47, 48) — stool including a chamber pot
Cobirons (cobberdes, cobbords, gouberts) — pair of iron bars with hooks to support a spit; they leaned against the chimney-back or had feet and were free-standing
Coffer — small chest with a rounded top
Compasse (23) — compost, i.e. manure
Conttor [counter] tabell (3) — possibly a side table, but precise meaning uncertain
Cooler (couler) (18) — vessel used for cooling, especially of the wort (boiled up malt and hops) in brewing
Coppe pyn (12) — probably a pin with a similar function to a **copsole**; (1) had both a pin and a copsole
Copsole (coppesoll; 1) — wedge to keep the coulter of a plough in place
Cotte — coat
Couforlet (3) — coverlet
Coulter (9, 19, 46) — cutting blade in front of a plough share
Counterfeit (p.**38) — two distinct meanings, *either* wrought with a pattern, *or* made according to a pattern, with matching decoration (i.e. copied)
Counterpoint (18) — counterpane
Court cupboard — cupboard in two parts, the lower stage generally with doors, the upper open
Cowl (coule) — large tub (cooler)
Cratch (34) — rack, for bacon (21, 34) or cheese (37)
Creepers (low) (20) — small iron fire dogs; a set were placed between the andirons
Crewett (18) — cruet
Cribb (46, 48) — rack for fodder (manger)
Croe (17 — crow bar
Cultur (9) — coulter
Cupboard — appears generally to have the modern meaning (n.22, p.52)
Cupboard cloth (20) — cloth to lay on a cupboard (probably in the sense of a board to stand cups on)

Cussyns — cushions

Dabnet (dapnet, dobnet)	cooking pot, exact form unknown
Daglocks (22)	locks of wool clotted with dirt
Darnixe (20)	dornix
Delf (26, 45)	blue and white earthenware (p.99)
Desperate and sperate debts	respectively unlikely and likely to be repaid
Diaper (dapore) (3, 7, 47)	twilled linen cloth woven in patterns, used for napkins, table cloths, etc.
Dobnet	dabnet
Dornix (darnix)	coarse linen damask, originally from Tournai, fashionable for hangings
Doughkiver (11)	see kiver
Dragg (23)	in the hearth, possibly a rake for ashes or logs
Drainer (36)	for draining, perhaps of whey from curds (OED)
Draw box (21)	possibly a box with a drawer
Dredge (13)	mixed grain, generally oats and barley
Dripping pann (14, 17, 20)	large pan placed beneath meat on a spit to catch the fat
Drudging box (18, 48)	dredger for flour, etc.
Dry vessell (14); dry fatt (55)	vessel or vat to hold dry material
Dublet (8)	doublet, man's jacket
Dyapur	**diaper**
Ell (15, 46)	measure of cloth (generally 45 in; 115 cm)
Erthe (19)	used of crops planted but not growing
Ewer (ewolle) (20, 29)	water jug
Falling bandes (52)	see **band**
Fallinge table (35, 38)	table with hinged flap (gate-leg)
Fan (22, 46)	for winnowing; **fann and frame** (47) presumably had the fan in the form of a cloth mounted in a wooden frame
Fatt (8,13, 16)	large open vessel (vat)
Featherbed	mattress (bed) filled with feathers; the tick (50) was its **ticking** cover
Fedur, feyder	feather
Fellye (25)	felloe, section of a wooden wheel rim; **trine of felloes**, set of three for a wheel
Field bedstead	bed with curtains hanging from a central point above it as a canopy
Fire-pan (p.**51)	portable grate or brazier (OED)
Firkin (firkyn; 20, 44)	wooden barrel of standard size (varying according to contents; eight gallons for ale, nine gallons for beer, etc.)
Firse (13)	**friese**
Fitches (47)	**vetches**
Flagg chair (26)	chair with woven rush seat
Flasket (flaskitt, 20)	shallow basket; also small flask or bottle
Fleake (14)	**flake**, type of hurdle
Flechen	see **flitch**
Flesh forke (18, 26, 46)	large fork for handling hot joints of meat
Flitch, (fletchen, flitchen, flitchens)	side of bacon (sometimes of beef)
Flitting tye (47)	stake for tethering animals which could be moved (**flitted**)
Flock	wool refuse from shearing off the nap
Flock bed	mattress stuffed with flock
Flower pot (13, 18)	see n.26, p.52
Forkes (20)	frame of a pack saddle
Form	bench
Fosser (13)	small coffer for jewellery and valuables
Fourromes	forms
Fowling peeces (7)	shot-guns
Frame (for a table)	fixed support for the table top, in contrast to trestles
Friese	a coarse woollen cloth with a rough nap
Furnace	vessell for heating water for brewing or washing, originally probably hanging over a fire, later probably built-in (p.63)
Fustian (20)	coarse cloth made from cotton and flax, for furnishings and heavy clothes

Gaket — jacket

Gallon — gallon measure

Gandard — gander

Garner (Garnard) — grain bin

Gears (geers) — parts of plough or cart harness for horses; also parts of a weaving loom (3)

Gouberts (goubardes, goubyrons) — see **cobiron**

Grater (18) — implement for grating (as modern usage)

Grease (grese) pot (19) — pot for fat for cooking and for tallow candles

Gridiron (gredeyron) — flat rack for pans to stand on; cf. **brandiron** (p.49)

Ground rack (55) — rack holding dung

Gyrken (8) — jerkin

Hackney (22) — riding horse

Hackney saddle (34, 39) — saddle for a hackney

Hair cloth (13, 14); also hair sieve (20,26) — made from the long mane and tail hairs of a horse; in a kiln, hops or malt were placed on a hair cloth for drying

Half-headed beedstead (17) — bedstead with short corner posts without a canopy

Hames (holmes) — curved bars of wood, part of the collar for a cart-horse

Hanging iron (46); to warm bear on (26) — presumably an iron case hanging on the wall in which a heater was placed

Hanging press (34, 46, 47) — **press** hanging from the wall rather than free-standing

Hatchell (hechyll) (12, 13) — implement for 'heckling' hemp, combing coarse fibres from fine

Hath grate (46) — possibly 'hearth grate', meaning a pit-grate, a hole in the hearth with a grid over it, to collect ashes

Haulmere — aumbrey

Heals (25) — probably scribal error for **heaters**

Heare (13); heare cloth (14) — **hair cloth**

Heater (18, 26, 26) — block heated in the fire and placed in an iron

Hechyll — **hatchell**

Heeling — **hilling**

Heighford — heifer

Hempen — fabric made from hemp

Hen pen (23) — dresser for dishes (p.50)

Herden — **hurden**

Herdencomys (8) — probably combs for carding coarse flax (**hurden**)

Hilling — bed covering

Hog, hogrell — one-year old sheep

Holland — fine linen cloth, originally from Holland

Holmes — **hames**

Hopper (25, 48) — basket for carrying seed for sowing

Hous of postellment (3) — from the context an object, not a building; house (OED, sb.7c) = receptacle + pose (OED v.3) = hoarding, i.e. savings box.

Hovell (13,48) — roughly-constructed shed/shelter, possibly with open sides (p.193)

Huckaback (huckerback) tablecloth (47) — made of a stout linen fabric with a rough surface, commonly used for towels

Hurden — coarse cloth, made form hemp or flax refuse, used for cheap sheets

Hyllinge (hylly) — **hilling**

Ioyned — **joined**

Iron-bound wain — See **wain**

Jack — mechanism to turn a spit, driven by weights or rising hot air

Joined (joyne, joint) — made of joinery, as opposed to turned or nailed construction, used of beds, stools, tables, presses, etc.

Keaver — **kiver**

Kersey (32) — a coarse narrow cloth, usually ribbed

Kimnell (kemnell, kymnell)	tub
Kiver	shallow wooden tub
Kiverlet (26)	coverlet
Kneding kyver (14)	**kiver** for kneading
Knyng (3)	Coney, i.e. rabbit fur
Kymnell	**kimnell**
Lade gaune (gallon, 45)	can used for lading (ladling) liquid out of a vat, originally of gallon capacity (OED)
Latten (2, 16, 23, 32)	type of brass; cf **maslen**
Laver (2, 9)	wash basin
Leade (14)	large vat, generally for brewing
Linnen lines (18)	unidentified
Livery cupboard (55)	cupboard for storage of food (livery)
Lock iron (26, 46)	possibly iron with a catch to keep its **heater** in place
Logger (19)	heavy block of wood attached to a horse's feet to stop it straying
Loom (lombe, lome)	(i) open vessel or tub (ii) broad loom or narrow loom: for weaving broad or narrow cloth
Lowe creepers (20)	see **creeper**
Malt mill	for grinding malt
Martinmas (often Martillmas) beef (23)	beef killed and salted around St Martin's day (11th November) that would keep until spring (OED)
Mash fatt (18)	vat for stirring ('mashing') malt and water in brewing; probably identical to a **brewing fatt**
Maslin (maslen)	(i) metal alloy (pewter or brass); (ii)a mixture of wheat and rye
Matt (20)	lies on the cords strung between the sides of a bedstead under the **bed**
Meel (13, 14)	bucket or measure for meal
Melesyve (19)	sieve for meal
Moulding bord (14)	board on which dough is loaded
Moulstaff (40)	possibly the handle of a maul (heavy wooden mallet)
Mullen halter (46)	halter with blinkers (OED) or one made of untanned leather (EDD)
Napery (napre, 3)	linen, often table linen
Narrow lomys (3)	See **loom** (ii)
Nave (25)	hub of a cart wheel
Nougers (8)	auger
Painted cloth	wall hanging of canvas decorated with painted figures and texts
Pair of cardes (24)	see **card**
Paire of bucskins (7)	probably breeches made from buckskin
Palenger	porringer
Pannar (9)	pan (?)
Pannell	pannier for pack horse
Pansion (40)	puncheon (large cask)
Parenger	**porringer**
Pasty pann; patty pann (26); puding pan (45)	pan for baking pies, pasties or puddings
Peale (18, 34, 40)	long-handled implement with a flat blade for putting bread in an oven
Peety coates	petticoat
Pello	pillow
Pelobere	**pillowbeer**
Pen and standard (48)	unidentified; possibly for penning animals
Pentyt	painted (cloth)
Pestell (13)	pestle for a mortar
Piece (55)	gun
Piggen, piggin (24, 32)	small vessel made by a cooper, with one stave longer than the rest as a handle
Piling iron (47)	iron for **peeling** (debarking wood) (OED)

Pillion (15) — light saddle placed behind a normal saddle
Pillowbeer (pelobeare) — pillowcase
Pillowdrawers (15, 27) — pillowcase
Pinsins — pincers
Pint (15, 25, 27) — drinking pot holding a pint
Plate iron (48) — iron flat in some sense, perhaps the same as flat iron
Playing tables (20) — pair of folding boards for games (like a backgammon board)
Porket pigg (45) — young pig
Porringer (palenger, parenger, pottenger) — bowl suitable for porridge, possibly with one or two flat handles
Porringer dish (13, 31) — presumably a dish shaped like a porringer but perhaps larger
Posnett — small metal pot with a handle and three feet
Pot hooks (pottehokes and hengges) — pair of hooks suspended from the chain or hanger, hooking into the pierced handles (ears) of the pot
Pothangers (potthengles) — part of the suspension for a pot over a fire, presumably the rack allowing the height to be adjusted
Pott lincks — presumably the chain portion of pot hangings
Pottenger — **porringer**
Powdering (powthering) trough or tubb — for salting and pickling meat
Press; press cubart (15) — cupboard for clothes
Presse iron (22) — iron for pressing, smoothing iron
Puding pan (45) — see **pasty pan**
Putter — pewter
Pynne (1) — see **copsole**

Quishens, qwssyons, qwyscions — cushions
Qwyche — **which**

Rearing fatt (47) — variant on **aleing** or **yelding vat**, a brewing vat in which the wort is left to work after the yeast is added
Reele (18) — possibly a spool for spun yarn; usually associated with a spinning wheel
Reparell — apparell
Rewe (of onions, 13) — presumably a string of onions
Riddle (34) — sieve
Riplinge combes (13) — combs to clean flax from seeds (**ripple**)
Role (22, 47, 48) — roller
Ront oxen (16) — runt, i.e. small
Rubbing brush (18) — hard brush for rubbing
Rugg (15) — blanket for a bed
Russia leather — hard red leather (OED)
Ryal (16) — gold coin

Saller — either cellar or solar, depending on context (p.24)
Sallett dyshes (20) — dishes for salads, raw vegetables or pickles
Salt — salt cellar
Saye (20) — fine serge cloth
Scellet — skillet
Scemer, scymmer — skimmer
Schette — sheet
Scleddeyrons (9) — possibly irons for sledge runners
Screen — generally a fire-screen, possibly small and hand-held
Screene for linnen (18) — unidentified
Scurtte — shirt
Searce (search) — fine sieve or strainer
Sharman sheres (4) — shears used by a shearman or fuller, to cut the nap from fulled cloth
Sheaf (shefe) corn (11) — corn in sheafs

Shear hogs (47)	gelded two-year old sheep
Shooter, shuter	**suter**
Shute	suit
Side table (10)	small table standing at the side of a room
Skillet (skellet)	metal pan with three legs and a long handle, similar to posnet
Skimmer (skemer)	metal spoon for skimming fat from a pot
Slabbes (44)	of wood
Smoothing iron (18, 25)	term for a flat iron
Socer	saucer
Spade tree (20)	handle for a spade (OED, tree 5)
Sperate	See **desperate**
Spette	spit
Spokeing chain (45, 47)	used to fit spokes to a wheel
Spudstaffe (24)	handle for a **spud**, a digging implement with a narrow blade (OED)
Staddle (34, 46)	stone support for a rick
Staff (48)	the paddle of a churn
Standing bed (10)	tall bedstead with high panelled headboard
Standing chiste (20)	presumably a high chest
Standing press (50)	presumably a high press
Standish (18)	ink and pen stand
Steane	earthenware vessel
Steane pot (18, 32)	presumably an earthenware pot
Steep fatt	vat for soaking (steeping) malt in brewing
Steep fatt	vat for soaking (steeping) malt in brewing
Steer (stere, stery)	bullock
Still (7, 18)	for distilling 'strong waters'
Stilliards (47)	possibly steelyards, though the context is unexpected
Stirk (31)	young bullock
Stone, stoned horse (21, 55); colt (22)	uncastrated
Stone pottes (20)	presumably of hard earthenware (stoneware)
Stonebowe (24)	type of crossbow that shoots stones (OED)
Store pig	for fattening
Strick (strike, stryck)	corn measure (generally a half-bushel)
Strickle (strockles, strickless, 23, 48)	straight-edge to smooth contents of a strick
Strong waters (18)	distilled liquor, e.g. brandy; also toilet preparations
Sturk	**stirk**
Suter (shooter, shuter, suiter, sutar, sutor)	round wooden board placed between two cheeses in a cheese press; also **cheeseboard**
Swingle tree (48)	bar, part of a plough, etc. harness, pivoted in the middle, allowing free movement to the draught animal's shoulders
Table board	table top, to rest on trestles
Tammy (tamy, 3)	fine worsted cloth, often with a glazed finish
Tanker (2)	tankard
Teowe (13)	**tow**
Tester	canopy over a bed, supported on the posts
Tewes	**tows**
Tewtawed (tutawed, 21)	beaten or dressed flax
Theale	plank of wood (from deal)
Thrall (47, 48)	support for barrels in a cellar (or dishes in a dairy)
Thrave (21)	measure of straw (12 or 24 bundles)
Ticking	close-woven and therefore relatively costly fabric, used for example, to cover mattresses stuffed with feathers
Ticknall (Ticknell) ware (25,44; p.98)	earthenware, generally black-glazed, from Ticknall, Derbyshire (but probably also made in Staffordshire), often used in dairies

Tin	tin-coated ironware, used for dripping pans (15, 25), patty pans (48), etc.
Tod (todd)	measure of wool (28 lb)
Tonge tree (for a wain) (13)	pole or **swingle tree**
Tow	coarse part of hemp or flax
Tows (touys, towes, towyes)	traces (with yokes)
Trencher	wooden platter
Tressel boards (7)	presumably table boards
Trine of fellyes (25)	see **fellye**
Trowell (32)	probably a trowel-shaped ladle or slice (OED) as it is in the kitchen, though a mason's trowel is possible
Troye (5)	sieve
Troyght	trough
Truckle bed(stead)	small bed on slides or wheels, kept under the main bed
Trusse bed (16)	apparently a portable bed, that could be trussed up
Tumbrell barge (48)	probably the cart-body of a tumbril
Tumbril (tumbrell)	two-wheeled cart
Tunn (15, 44)	funnel
Tutawed	**tewtawed**
Twiggen chaire	see **wicker chair**
Twilly (twylle)	coarse linen fabric woven with a twill pattern; commonly a bed-covering of twilly
Twyllecloth (4, 5, 8, 12)	apparently a **twilly bed-covering**
Unwrought (flax) (47)	awaiting spinning
Valence	length of material fixed to a frame, generally the **tester** of a bed
Verjuice (vergys) (19)	juice of unripe fruit, especially apples, much used in cooking
Vetches	a leguminous crop, grown as fodder, and also because of its fertilising effect
Wafer irons (18)	iron plates between which wafer dough is baked (as waffle irons)
Wain (wene)	wagon; wains may possibly have been used by oxen, wagons by horses. **Iron-bound** refers to the wheels
Wainscot (waynscott, wenscott) (17,20)	panelling; also used of boxes (20) and furniture made of panelling
Walkers earth (4)	fuller's earth
Weighinge beame (13)	see **beam**
Wene	**wain**
Wheel	used for spinning wheel
Which (wich, wych)	wooden bin, generally for meal
Whisket (15, 18, 20)	wicker or straw basket
White pot (18)	white earthenware pot
Wicker chear (40); twiggen chaire (37, 55)	chair made of woven wickerwork
Wimble (44)	auger
Winnow sheet (37)	sheet used in winnowing, cf. **fan**
Wiper (4)	'or handtowel'
Wodde	wood
Wolinge	woolen
Wolsted, wolstyd	**worsted**
Woolbed (28, 44)	mattress (bed) filled with wool
Worsted	yarn from long-staple wool, and cloth made from this yarn
Wrack (15)	rack
Wyndrowed (13)	winnowed
Yewer	ewer
Yoke (youcke) (often with towes)	bar for yoking together pairs of horses or oxen

Index of Persons

Both surnames and Christian names are given in standardised forms. No distinction is made between different individuals with the same name; additional information for their identification is included in the transcripts and indexes deposited at the Shakespeare Birthplace Trust Record Office, Stratford-on-Avon.

Index of Subjects